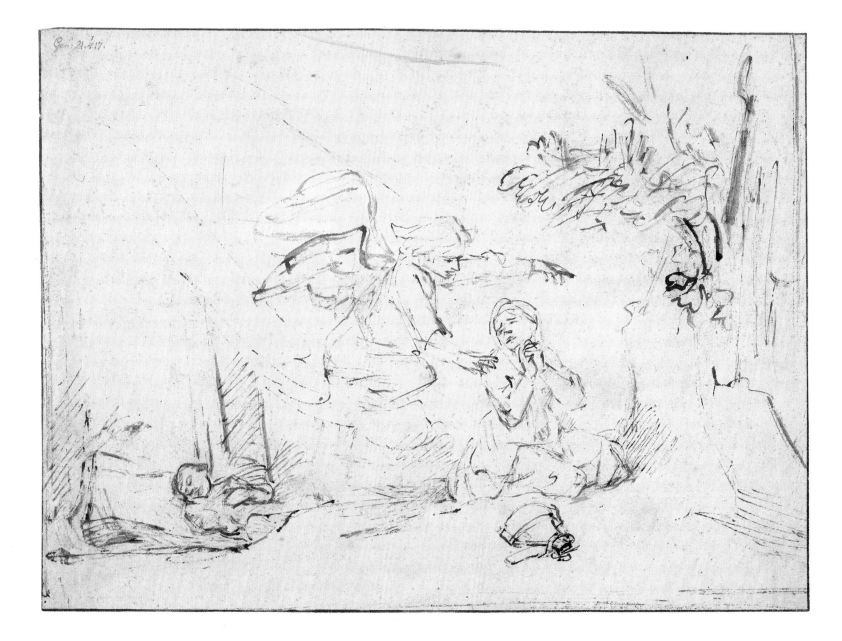

Sponsored by AMERICAN EXPRESS FOUNDATION

Holm Bevers, Peter Schatborn & Barbara Welzel

Rembrandt: the Master & his Workshop

Drawings & Etchings

Yale University Press, New Haven and London
in association with
National Gallery Publications, London

Exhibition dates:

Kupferstichkabinett SMPK at the Altes Museum, Berlin: 12 September 1991–27 October 1991
Rijksmuseum, Amsterdam: 4 December 1991–19 January 1992
The National Gallery, London (Etchings only): 26 March 1992–24 May 1992

Exhibition Organiser: Uwe Wieczorek

Edited by Sally Salvesen

Designed by Derek Birdsall RDI

Translators: Elizabeth Clegg, Fiona Healy, Josine Meijer, Paul Vincent

Typeset in Monophoto Van Dijck by Servis Filmsetting Ltd, Manchester
Printed in Italy by Amilcare Pizzi, s.p.a., Milan on Gardamatt 135 gsm

Library of Congress Catalog Card Number 91–65961

British Library Cataloguing-in-Publication Data

Bevers, Holm
 Rembrandt: the master & his workshop: drawings and etchings.
 I. Title II. Schatborn, Peter. III. Welzel, Barbara
 769. 924

ISBN: 0–300–05151–4
ISBN: 0–300–05152–2 (paperback)

Frontispiece: Rembrandt,
The Angel appearing to Hagar and Ishmael in the Wilderness
Hamburg, Kunsthalle, Kupferstichkabinett

Cover illustration: Rembrandt,
Portrait of Saskia van Uylenburgh (detail).
Berlin, Kupferstichkabinett SMPK.

Contents

Patrons

Her Majesty Queen Elizabeth II

Her Majesty The Queen of the Netherlands

His Excellency Dr Richard von Weizsäcker
President of the Federal Republic of Germany

Directors' Foreword

Rembrandt has changed in the last twenty years. A steady flow of documentary research has combined with unprecedented stylistic and technical examination, carried out for the most part by the Rembrandt Research Project, to give us a view of the artist and his work materially different from that presented by the Rembrandt exhibition in Amsterdam in 1969. Many works long loved and admired are now believed to have been painted by other artists. Berlin's *Man with the Golden Helmet*, the Frick Collection's *Polish Rider* and the Chicago *Girl at the Door*, along with many other paintings previously attributed to him in museums around the world, are now questioned as the work of Rembrandt, or, by many scholars, rejected outright.

If we exclude these pictures, some previously revered as the summits of his achievement, we have to ask what sort of Rembrandt we are now left with. Who, in short, is Rembrandt in the 1990s? And, no less important, who are the other artists that we have been unwittingly admiring for so long? If Dou, Drost and Hoogstraten are the true creators of paintings that have for years delighted and inspired us, it is clearly time that we took another look at them as well. Rembrandt remains a giant, even if not quite the one we thought we knew; but he is a giant surrounded no longer by pygmies, but by artists of real stature, whom we ought to know better.

The investigation of this new Rembrandt and of his contemporaries are the two main purposes of this exhibition. There is, however, a third. We wanted to show the public how decisions about attribution are made. Paintings, drawings and prints we believe to be definitely by Rembrandt are therefore shown with works definitely by other artists. With them are exhibited paintings once given to Rembrandt, now attributed to one of those others. In the same way drawings by Rembrandt and his pupils and followers are exhibited in two sections, which also take account of the recent research in this area. Visitors to the exhibition will therefore be in a position to examine the Paintings and Drawings, weigh the evidence and decide for themselves whether the conclusions drawn in this catalogue are sound.

However, in the etchings section of the exhibition we encounter the authentic Rembrandt with absolute certainty. Forty outstanding examples provide clear evidence that Rembrandt's use of the print medium was as original as his approach to painting and drawing.

The Kupferstichkabinett, the Rijksmuseum and the National Gallery are all fortunate in having rich Rembrandt holdings. The curators who look after them, all distinguished Rembrandt scholars, have between them written most of this catalogue. Other distinguished scholars of Rembrandt and of Dutch art and society in the seventeenth century have contributed essays and catalogue entries. Yet we could not have thought of organising an exhibition like this one, an exhibition able to address these very particular questions, without the support of lenders, both private and institutional, throughout the world. And no less could we have embarked on so ambitious a venture, had not American Express Foundation supported us financially with generosity and encouraged us throughout with its enthusiasm for the project.

We hope that both sponsors and lenders will find their generosity of spirit repaid not only by our thanks, but by the enjoyment of hundreds of thousands of visitors.

We are particularly indebted to Simon Levie, former General Director of the Rijksmuseum, who was a driving force behind the exhibition in its early stages.

Alexander Dückers
Director
Kupferstichkabinett SMPK
Berlin

Henk van Os
General Director
Rijksmuseum
Amsterdam

Neil MacGregor
Director
National Gallery
London

Lenders

Private collections, 2, 23, 27, 28, 29, 30, 31, 47

Amsterdam, Rijksmuseum, Rijksprentenkabinet, 1, 12, 16, 19, 34, 37, 40, 41, 43, 44, 51
Berlin, Staatliche Museen Preußischer Kulturbesitz, Kupferstichkabinett, 3, 4, 5, 7, 11, 24, 36
Birmingham, The Barber Institute of Fine Art, 8
Bremen, Kunsthalle, 45
Chicago, The Art Institute, 38
Cleveland, The Cleveland Museum of Art, 18
Dresden, Kupferstich-Kabinett der Staatlichen Kunstsammlungen, 10, 48
Haarlem, Teylers Museum, 6
Hamburg, Kunsthalle, Kupferstichkabinett, 25, 32
Munich, Staatliche Graphische Sammlung, 39, 50
New York, The Pierpont Morgan Library, 9, 14, 46
Oxford, The Ashmolean Museum, 33
Paris, Institut Néerlandais, Fondation Custodia (F.Lugt collection), 20, 21
Paris, Musée du Louvre, Département des arts graphiques, 15, 26
Rotterdam, Museum Boymans-van Beuningen, 17, 42, 49
Stockholm, Nationalmuseum, 35
Wroclaw, Library of the Ossolinski Institute of the Polish Academy of Arts and Science, 22
Vienna, Graphische Sammlung Albertina, 13

Introduction

Rembrandt was a draughtsman of originality and versatility. This catalogue aims to reflect these qualities in a balanced way. Although only forty of the large number of extant drawings are included, they provide a representative selection of the finest examples of the most important subjects depicted by Rembrandt. The choice was limited by a restriction in the number of drawings that could be included, and the impracticability of arranging the loan of some important sheets. Nevertheless, it is a particular pleasure that lenders' generosity has enabled such a varied survey to be offered, showing Rembrandt at his best.

As the Kupferstichkabinett in Berlin and the Rijksprentenkabinet in Amsterdam have organised this exhibition, it is only natural that a large selection has been made from their collections. Requests for the loan of drawings have been limited to one or two from other collections in Europe and the United States. The British Museum, which has an extremely important collection, was excluded from participation from the outset because drawings from its own collection, accompanied by a separate catalogue, will be exhibited simultaneously with the exhibition at the National Gallery. The length of the exhibitions in Berlin and Amsterdam is also restricted because the fragility of the drawings makes it impossible to exhibit them for more than three months.

The catalogue testifies to the unique quality of Rembrandt's draughtsmanship. During its making, the author has been grateful for the use of earlier publications, and the advice of experts. In the descriptions, special emphasis has been placed on the quality of draughtsmanship, and the individual way in which Rembrandt depicted his subjects. Extensive discussion of the literature on the drawings has not been included.

As Rembrandt's pupils imitated his work, and since there is uncertainty of attribution in respect of various drawings, the exhibition has been supplemented by a small group of drawings previously attributed to Rembrandt, but now accredited to pupils. In each case, an undisputed drawing by the pupil is included and the comparison of these drawings with those previously attributed to Rembrandt is intended to clarify the new attributions. These new attributions, which are mainly fairly recent, are in most cases generally accepted. In a few cases, the comparative work in the exhibition may support the new attribution. That confrontation with the original drawings will still provide surprises makes the inclusion of this group particularly exciting, not least for the author of the catalogue who, although familiar with the drawings, has never before had the opportunity to study them side by side.

The introduction outlines the issues concerning authorship. In addition, a number of the most important aspects of Rembrandt's draughtsmanship are discussed, and it is hoped that the particular nature of Rembrandt's masterly and individual manner of representation is illuminated. My thanks go to the many people who have helped me in the completion of the catalogue of drawings.

In the first place are my colleagues at the Rijksprentenkabinet and the other departments of the Rijksmuseum, and also in the Kupferstichkabinett in Berlin. I also received assistance at exactly the right moment from Nina Wedde from Geneva, who greatly relieved my workload. Without mentioning them all by name, I am of course also greatly indebted to the collectors, and my colleagues the curators of the collections of drawings. Were it not for their willingness and kind help, this exhibition could never have taken place.

Peter Schatborn
Rijksprentenkabinet
Rijksmuseum, Amsterdam

Aspects of Rembrandt's Draughtsmanship
Peter Schatborn

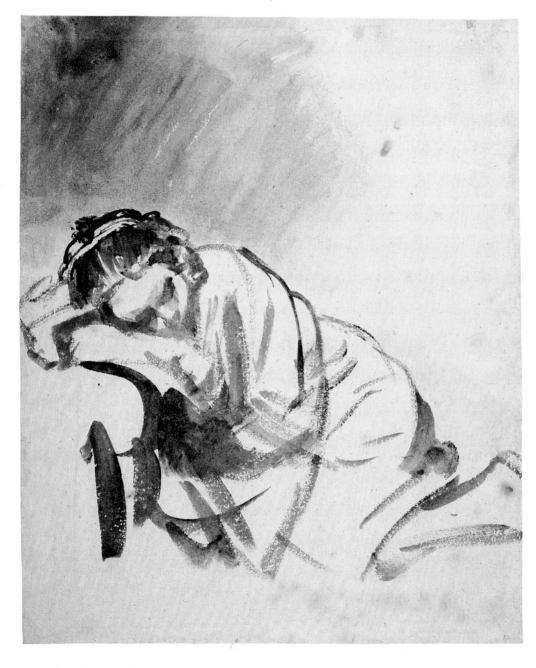

1: Rembrandt, *Hendrickje asleep*,
London, British Museum.

Rembrandt's drawings are strikingly individual. As with his paintings and etchings, their style sets him clearly apart from his contemporaries. Within his œuvre as a draughtsman there is also considerable variety. This is due in equal measure to Rembrandt's artistic development, to his use of different materials and to the different functions that drawings served. Rembrandt was extremely versatile and his work contains virtually all the subjects current in his day.

Rembrandt's pupils imitated his style and produced paintings in his manner for the market, and therefore one finds many Rembrandtesque features in their works, albeit to a lesser extent. The result of this is that many works have been attributed to Rembrandt when they are in fact by pupils. Now that much more material has become available and more research has been carried out, it has been possible in many cases to distinguish the work of the master from his pupils' imitations. However, the process of defining the body of his drawings is by no means complete.

The authentic Rembrandts

In order to be able to make the necessary distinction one must first establish which drawings can be regarded as Rembrandt's work with any degree of certainty. These will then represent the core of the œuvre. With the exception of a few borderline cases there is a fair degree of unanimity among specialists on this group. The authenticity of drawings from this core group is determined by signatures and inscriptions in Rembrandt's hand and in addition by the function of drawings used as preliminary studies for authenticated paintings and etchings. It comes as something of a surprise to find that the group of 'definite' Rembrandt works that can be isolated in this way is small, comprising no more than some seventy drawings.

The drawings are rarely signed. In his Leiden period Rembrandt signed a number of figure studies with the monogram he used at the time (Cat. No. 2). He did this not because the drawings were actually intended for sale, but probably by analogy with paintings and etchings which were put on the market. Later he occasionally signs a piece in full, as in the case of the drawings for Jan Six in the Album Pandora (Cat. No. 31). A monogram or signature gives the drawing a guarantee of authenticity, making it more a work of art in its own right, on a par with paintings and etchings. It may also have been a guarantee of quality, both for Rembrandt himself and for his pupils who used his works as a model. Rembrandt also sometimes wrote texts on drawings, probably with an eye to his pupils, for whom this provided extra information about the subject.

Initially there was insufficient awareness that so many pupils had painted and drawn in the style of the master. Limiting Rembrandt's œuvre as a draughtsman to the core group and those drawings directly associated with it, and querying the attribution of the remaining drawings hitherto regarded as Rembrandt's made it possible to take a fresh look at the body of Rembrandt's work and that of his pupils. In the case of the paintings this led to the setting up of the Rembrandt Research Project in 1968. In the case of the drawings, the starting point was the comprehensive catalogue by Benesch from the 1950s. In reviews of Benesch, in museum and exhibition catalogues and articles, considerable progress was made on a more precise demarcation of the œuvre. The series of comprehensive catalogues of the drawings of pupils by Werner Sumowski which has been appearing since 1979, has proved of inestimable value. As a result of these publications a fairly large number of drawings still regarded as authentic by Benesch, are now attributed by Sumowski or other authors to known or unknown pupils. For example, Benesch lists nearly one hundred Rembrandt drawings in the Printroom of the Rijksmuseum, whereas the Collection's 1985 catalogue contains only sixty authentic works.[1] A somewhat smaller percentage of the drawings in the Louvre in Paris has been discarded,[2] but of the drawings in the Museum Boymans-van Beuningen in Rotterdam half of those included by Benesch are no longer regarded as authentic.[3]

A new view of Rembrandt's draughtsmanship

The revision of what constitutes the body of Rembrandt's drawings has considerable implications for our view of Rembrandt's art. The drawings in the core group differ quite widely from each other, but have nevertheless long been regarded as authentic Rembrandts. Now that other drawings originally considered authentic have been eliminated, the œuvre as a whole has come into sharper focus, with a smaller number of drawings displaying more varied extremes. At various points in his catalogue of the drawings Benesch had placed works as transitions or links between two definite drawings or groups of drawings, and these are precisely the works which have disappeared from the œuvre. Rembrandt was probably not such a prolific draughtsman as has always been assumed.

Rembrandt seldom made preliminary studies for paintings and etchings. There exist only four preliminary drawings that he indented with a sharp instrument for transfer onto the copper plate, including one of the two studies for the *Portrait of Jan Six at the Window* (Fig. 23b). In addition there are a few preliminary drawings that were never indented (Cat. No. 23 and 26). Next there are drawings, mainly of figures, made as preliminary studies for details of a work. These were done by Rembrandt before he began an etching or while work was in progress. In the latter case he was searching for the appropriate form for a particular detail which was giving him some difficulty. For the same reason he also drew on early states of unfinished etchings in preparation for the completion of the print.

Preliminary studies for the composition of paintings are even rarer than for etchings. A few such drawings are based on a composition by another artist, as with the preliminary study for the *Rape of Ganymede* (Cat. No. 10). A number of figure studies, mainly from the Leiden period, were used in paintings. Drawings were also made after Rembrandt had begun a painting, although the precise point in the process cannot always be determined with any certainty. These are also compositional drawings (Cat. No. 40) and figures (Cat. No. 7).

Drawings in Rembrandt's style

Numerous drawings, though not preliminary studies and unsigned, were nevertheless attributed to Rembrandt by virtue of their style. There is at present no unanimity on these attributions. If after thorough comparison drawings can be convincingly shown to be connected with the core group, they can indeed be regarded as genuine Rembrandts. However, in a case of doubtful authenticity, there is always a chance that it is the work of a pupil. If there are sufficient correspondences with the 'definite' drawings of one of the pupils, an attribution to that pupil can be considered. A great deal of misunderstanding surrounds such attributions. Specialists concerned with problems of attribution are guided in the first instance by a kind of visual intuition. Their attributions can be subsequently tested in all kinds of ways. Whatever the outcome of the research, however, pronouncements of necessity retain a hypothetical character.

Rembrandt's drawings under the magnifying glass

Every drawing is different. Constantly changing factors are involved in its creation and every drawing could be seen as the final stage in a process of development. The example of other artists, the function of the drawing and the choice of medium all affect the end result. The style of the drawing is the most obvious aspect. Generally speaking, this is determined by the nature of the forms being depicted. The development of an individual style is a function of the artist's personality. That can be described in general terms, but what is in fact being described in such a case is the overall impression made by the drawing. It makes more sense to distinguish the constituent elements which determine style and to study them separately. In this way it will be possible to establish what elements are most characteristic of Rembrandt. The most important components in the study of a drawing are the medium, the technique and the stylistic features.

The drawing materials used by Rembrandt and his method of working provide information which may prove specific to him. This also applies to the link between the material and what is being depicted with that material. Technical aspects, such as the way Rembrandt constructed his drawings, where he began, and how he made changes and corrections, can be studied separately. In determining authenticity the stylistic traits are the most important aid. Every drawing has many stylistic features, including for example, division of the picture surface, the structure of the composition, the types of figures, the character and expression of the faces and finally the treatment of space and light. The interpretation of the subject being depicted by Rembrandt is sometimes also regarded as a part of the style. Other aspects, such as the nature of the handling of line in pen or chalk, the way in which brush strokes and washes are applied, also help determine the style. Since pupils were attempting to imitate Rembrandt's method of working, stylistic characteristics alone are often not a reliable enough indicator. In such cases it is the combination of such characteristics and the degree to which they are used which must provide the key. This is the most difficult aspect to define and articulate.

Subjects and types of drawing

Once research into his drawings has made further progress, it will probably emerge that Rembrandt actually produced far fewer drawings than has always been assumed. Presumably there were periods when he either drew nothing at all or very little. That may have been the case at the beginning of the 1630s when he worked in the studio of Hendrik Uylenburgh and painted a large number of portraits. Occasionally he produced a portrait drawing (Cat. Nos 3, 4 and 17). Beside the drawings Rembrandt produced in connection with other, works he repeatedly produced groups of drawings on the same or related subjects. These are historical, especially Biblical scenes, genre scenes, figure and animal studies and also model drawings, made especially for teaching

2: Pieter Lastman, *Half-length study of a nude Man*,
Amsterdam, Rijksprentenkabinet.

3: Rembrandt, *Man pulling on a rope*,
Munich, Graphische Sammlung.

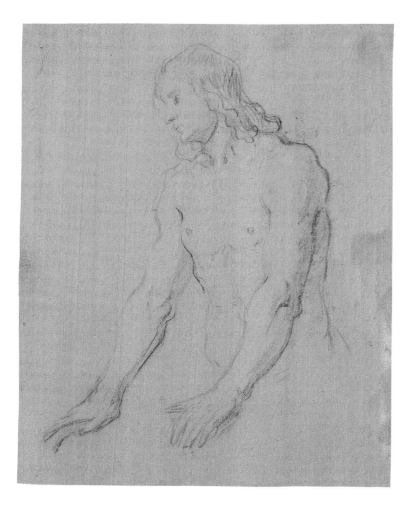

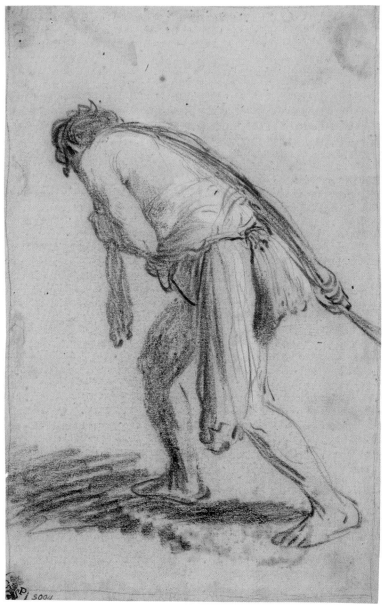

purposes. Then there are landscapes and nude studies, both subjects which were drawn by Rembrandt together with his pupils. Copies from other masters, including Lastman (Cat. No. 11) and from Indian miniatures (Cat. No. 37), form separate categories.

It was customary to produce drawings in groups or series. In a series the same subjects were depicted in different ways or from different perspectives, with variations on the same theme or motif. This was of course a way of familiarising oneself with the subject. Moreover, artists with this kind of experience found it easier to produce similar themes from memory. But such groups of drawings were also instructive exemplary material, as they showed pupils different possibilities.

Of course Rembrandt also drew for his own benefit as a form of practice. His drawings, however, were intended for a collection of his work which served himself and his pupils as a pool on which they could draw. The drawings were kept in albums. In the art collection of which they formed part there were all kinds of works by various artists and in addition natural objects. Rembrandt probably began the collection in Leiden and it was further expanded at the beginning of his Amsterdam period.

Subject and material

In a number of cases there is a clear connection between the choice of material used and the function or subject depicted. For example, all designs for etchings, the outlines of which he transferred to the copperplate with a sharp instrument, were executed in red or black chalk (Fig. 23b); on the other hand, preliminary drawings which were not transferred were done in ink. (Cat. Nos 23 and 25). Nor does his choice of material to depict animals seem coincidental. Rembrandt naturally captured the elephant best in black chalk (Cat. No. 13), while pen strokes were best suited to the birds of paradise (Cat. No. 15). The supple coat of the lions was best conveyed by a wash applied with the brush (Cat. No. 25), and pigs were of course drawn with the pen in order to be able to render their flabby skin.

For most drawings Rembrandt used pen and ink. Chalk tended to be reserved more for those drawings used as instructional material. The chalk figure studies from the Leiden period (Cat. No. 1 and 2), the copies from paintings by Lastman (Cat. No. 11), the group of small landscapes (Cat. No. 22) and the figure and genre studies, may have more the character of practice and preparation than the comparable pen-and-ink drawings.

Rembrandt and his teacher

Rembrandt's second teacher was Pieter Lastman; his influence is clearly evident in the early paintings, and the same applies to the early drawings. Lastman's œuvre of drawings is small, consisting of no more than some fifteen known works. It is the various drawing techniques used by Lastman that we find in Rembrandt's early work.[4] The drawings which are closest to Lastman show Rembrandt following his teacher's formal language, but already adding to it and using different emphases. In the first place Rembrandt is more concerned with the clear rendering of light. Moreover, his approach is freer, more expansive, if necessary at the expense of detail. An example of the difference between teacher and pupil is provided by two chalk drawings, the first by Lastman, a *Half-length male Nude* (Fig. 2)[5] and the second by Rembrandt, *A Man pulling on a rope* (Fig. 3).[6] Rembrandt's figure is freely, almost crudely drawn with strong accents and contrasts, showing a clear awareness of the effect of light. In some places shadows have not been added to drawn shapes as in Lastman, but play an autonomous shaping role. Rembrandt derived his preoccupation with the representation of light from the most avant-garde movement in the Netherlands in the 1620s, the Utrecht Caravaggists.[7]

Rembrandt's early pen-and-ink drawings are also very close to Lastman's work at first. The earliest is probably an *Seated old Man*,[8] which shares a number of stylistic features with a preliminary drawing by Lastman for a window in the Zuiderkerk in Amsterdam.[9] Later in the 1620 drawings appear using a very evocative pen-and-ink technique, in which the effect of light and dark predominated. One of these is the *Seated Man with a tall hat* (Fig. 4).[10] From the outset Rembrandt used the difference in strength of line to convey the effect of light. The shadow to the left of the head and in the eye socket, as well as the powerful outline and shadow of the shoulder and arm make it clear which direction the light is coming from. It is seldom a single line which defines the shapes, but the figure is made up largely from a combination of various parallel and intersecting lines. Some are very characteristic of Rembrandt, such as the twisting line near the bottom of the leg. The contours of legs and arms are often enlivened in this way by Rembrandt. It is not only light that Rembrandt takes great care over, a number of details have been accurately reproduced. The eye in shadow is very subtle but has been made visible and the row of buttons riding up a little over the stomach indicates the shape of the shirt. Besides a powerful feeling for

4: Rembrandt, *Seated Man with a tall hat*, Rotterdam, Museum Boymans-van Beuningen.

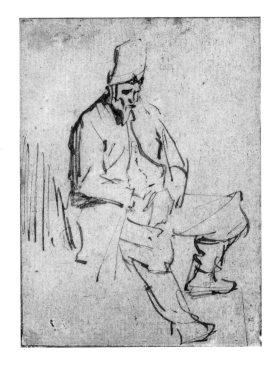

the effect of light, it is the combination of such carefully evoked details with boldly and schematically drawn shapes which is characteristic of almost all Rembrandt's drawings. Generally it is the faces which are carefully drawn, while the rest of the figure is more schematic, depending on how far Rembrandt had worked out the rest of the composition. The *Seated old Man* (Cat. No. 2) is an example of this from the Leiden period.

Outline and elaboration

It was general practice first to draw in fine lines and subsequently to elaborate using heavy lines. These were therefore usually applied last to the composition and also serve to correct the preceding fine lines. When Rembrandt draws landscapes he also first uses fine lines and then proceeds from back- to foreground with darker lines, drawing the foreground last. The countryside and the buildings in *View over the IJ near Amsterdam* (Cat. No. 28) clearly show how subtly and delicately Rembrandt's pen creates the background while the closeness of the foreground motifs is brought out by the dark washes. A nice example of Rembrandt's method of beginning a drawing is afforded by the sketch on the back of *The Entombment* (Cat. No. 19, verso). This sketch was made in connection with an etching, *The Beheading of John the Baptist* of 1640. The kneeling John sits with his hands folded on his knees while the executioner prepares to strike. John is depicted with carefully drawn thin lines and not worked up. The executioner is sketched with equally thin lines, but subsequently retraced with slightly darker lines. This second version improves on the first in several places. The shift in the position of the head, from upright to inclined forward, is the most obvious change, and a clear example of Rembrandt's correction with a darker pen. In addition this sketch shows that Rembrandt's line is more assured when there is a first preliminary version, which can then serve as a starting point and guide for the second version.

This applies in a different way when Rembrandt follows the model of another artist. The copy made for example of a painting by Lastman was largely set down directly in fairly bold lines (Cat. No. 11). It looks therefore as though Rembrandt, especially when starting to draw a figure or composition from memory, begins carefully with fine lines. In numerous drawings this first version can be detected beneath and alongside the subsequent development. However, this is not a characteristic of Rembrandt's drawings alone. Probably all pupils were instructed to make a point of starting with fine lines and subsequently elaborating the composition in darker lines.

The position of the knee in the *Washing of the Feet* is another example of a correction with darker lines drawn over a previous version (Cat. No. 34). By themselves these extra lines would not have the required effect, but added to the existing lines they convincingly suggest the position of the leg, without outlining it precisely. The method, whereby a number of lines which, in themselves are not precisely defining, combine to suggest the forms convincingly, is very characteristic of Rembrandt's drawing, and helps to determine the style.

Rembrandt corrected not only his own drawings, but also those of his pupils. There are a number of examples, especially of the drawings of Constantijn van Renesse, which show beautifully how Rembrandt is able to give his pupil's often pinched forms a new allure. The best example is probably *The Annunciation*, in which Van Renesse's kneeling, static angel is overshadowed by Rembrandt's dynamically drawn figure (Fig. 5).[11]

There are drawings to which Rembrandt made alterations, but without removing the earlier version. He sometimes did this in such a way that the earlier version only becomes visible on closer inspection. This applies for example to the elephant which advances on us with raised trunk, while the earlier lower position of the trunk is integrated into the figure of the elephant's attendant (Cat. No. 13). Another, more immediately recognisable example is found in the drawing of *Saskia in Bed* (Fig. 6).[12] Her right arm was first drawn resting on the covers and subsequently supporting her chin. In this case Rembrandt did not bother to paint out the lines over which the arm was drawn in white, though he did use a heavier line for the arm.

Various examples show that Rembrandt did not abandon a drawing once he had started, not even, for example, when he had made a blot or one part had not worked. If he had used to much ink or made a mistake with the pen or brush he used white paint to cover the offending lines or spots. We find this masking wash in countless drawings, although because of wear and tear it is often not immediately detectable. The white paint has often oxidised because of the lead in it, producing a darker colour, the opposite of what Rembrandt intended. Sometimes Rembrandt simply whited out a number of misplaced lines, such as on the back of the *Man standing with a Stick* (Cat. No. 1), sometimes a whole area is covered in white to soften the tone (Fig. 31a). White could also be used to throw certain sections into relief, or highlight them, as can be seen in the *Seated female Nude as Susanna* (Cat. No. 24).

When a section was clearly beyond redemption, Rembrandt took a knife and cut a hole in the paper. Sometimes he stuck a new piece of paper over the hole from behind and completed the drawing on it (Cat. No. 6), sometimes he covered it with a patch and redrew the figure (Cat. No. 16). Such procedures show that Rembrandt was determined to preserve the successful parts of the drawing. It also sometimes happens that Rembrandt began a drawing and afterwards realised that the paper was not big enough. An example of this is the landscape *The Bend in the Amstel near Kostverloren* (Cat. No. 30), where the right-hand side of the paper has been stuck on.

The hand of the master

In his Leiden period Rembrandt made mostly figure studies and only a few historical drawings are known from that period. In the mid-1630s he produced a group of drawings which are characterised by a very free handling of line (Cat. No. 5 and 12). It is again the faces particularly which have been more carefully executed and elaborated. The remaining lines indicate the form in a seemingly disconnected rhythm. The direction of the hatching lines representing shadows, like the cursory outlining of the shapes are in no way arbitrary but contribute greatly to the plasticity of the figures and the effect of depth in the compositions. If it were possible to examine the pattern made by the hatching separately from the rest of the drawing, it would be clear that the hatching and the direction in which it runs form a balanced pattern which focuses attention on the most important section of the drawing. One example from a group of drawings of actors and actresses is the *Seated Actor in the Role of Capitano* (Cat. No. 12). The actor's head, drawn in profile, is the central point in the composition and given all the more prominence by the way in which the lines and hatching are placed around it.

A drawing from a small group of Biblical scenes, *Christ falling beneath the Cross* is also a characteristic example of Rembrandt's pen-and-ink drawing style of the 1630s (Cat. No. 5). The longer one looks the more sharply the image comes into focus as it were, the more clearly the figures stand out, and the more emphatic a part the individual lines and shading play in the whole composition.

The brush is used not only to add a figure in the foreground, but also to create a darker area above the fallen figure of Mary. This patch suggests shadow and depth, but optically also has another effect: placed centrally between the figures this area emphasises the oval shape of the composition. Rembrandt used such optical effects

5: Constantijn van Renesse and Rembrandt, *The Annunciation*, Berlin, Kupferstichkabinett SMPK.

6: Rembrandt, *Saskia in bed*, Groningen, Museum voor Stad en Lande.

quite often, which particularly enhance the composition as a whole and do not necessarily represent anything definite. As the drawing progressed the composition that emerged under Rembrandt's hand naturally began to assume a proportionally greater significance for what he had yet to draw. The elaboration consisted of correction and emphases, including such optical effects. We also find them in drawings in places where the paper was originally too much like a white empty surface. In such cases Rembrandt simply draws a short line or a number of scribbles, which do not stand out in the overall composition but which counteract the flat impression made by the blank paper. He did something similar when in a small charcoal landscape he placed some zigzag shading at the top of the sheet, which, rather than representing a canopy of leaves, helps to fill the empty space somewhat (Cat. No. 22). In a figure study, *Seated female Nude* (Cat. No. 38) such 'auxiliary lines' are found, which do not appear to represent any direct form in themselves (the short line on the breast), but which have a definite effect (the line through the calf).

Among the group of fine pen-and-ink drawings from the 1630s there is a sheet with three scenes depicting *The Prodigal Son and a Woman* (Fig. 7).[13] Unfortunately one of the scenes has been partially cut off at the top of the sheet. The other two are done in an equally schematic pen technique, with the faces characterised tellingly and carefully. And it was these which counted in the three aspects of the same event. In the first scene at top centre the young man's hands begin wandering, in the scene on the left his behaviour is punished with a furious gesture by the woman. On the right the woman is seen finally to have relented and the young man to have got his way: Rembrandt's ability to impart expression to their faces with just a few lines was probably unprecedented in the history of drawing. The triumphant pleasure of the young man in the right-hand sketch and the acquiescent pleasure of the woman he is petting, are perfect examples of Rembrandt's capacity to represent human feelings in the most succinct form. In drawings from all periods we find examples of this special quality of Rembrandt's drawing and it is often in this respect that the work of pupils is exposed as lacking conviction.

For a group of drawings from the late 1630s Rembrandt used gall-nut ink, often on paper treated with light yellow colour. In this group we find the same astonishing style of characterisation, whether of figures and facial expressions or, for example, animals. It is as though Rembrandt's plastic language has become more resonant than

ever, and he has also become more confident. The way in which he depicted his wife *Saskia at the open window* is extraordinarily direct (Fig. 8).[14] Producing a likeness with so few lines—compare the portrait in silverpoint of 1633 (Cat. No. 3)— requires extreme sureness of touch. An important aspect of this drawing is the use of washes. These give relief to the subject and have been applied with particular care in the figure itself: the fine, almost transparent brushstroke on Saskia's collar, for example, follows the line of her right arm to bring her shoulder a little forward and the slightly curved brushstrokes above her right hand exactly indicate the curve of her breasts beneath the collar. The brush-strokes in the background are transparent and use different tones to indicate the darkness in the room. This transparency of the wash is characteristic of Rembrandt's use of the brush. Much later, when he drew Hendrickje at the window, he added an equally transparent wash in the background of a much bolder pen-and-ink drawing (Cat. No. 35).

Occasionally Rembrandt drew with the brush alone and one of his most famous drawings, *Hendrickje asleep* (Fig. 1),[15] was produced in this way. The secret of this drawing's unequalled expressiveness is in the well-considered pattern of lines produced with transparent brush-strokes. By imposing this limitation on himself and particularly by carefully separating light and dark Rembrandt has produced a evocative portrait of his wife.

Rembrandt's brush is just as effective in depicting light and dark in an interior, whether he is drawing from life as in the case of *Seated Nude in the studio* (Cat. No. 33), or as in one of the drawings from memory in the Album Pandora (Cat. No. 31). In a completely different way from the sleeping Hendrickje every stroke counts. Not only does the brush create a sense of space, but the atmosphere is made tangible. Finally Rembrandt occasionally creates a background with the brush in which shapes are scarcely distinguishable, but where an abstract pattern of lines evokes the space surrounding a seated figure (Cat. No. 38).

Rembrandt as a narrator

In numerous drawings Rembrandt reveals himself as a narrator of Biblical or other historical scenes. His feeling for drama is apparent, for example, from the way he depicts *Christ falling beneath the Cross* (Cat. No. 5). But in less dramatic stories too he is able to convey human feelings poignantly. Sometimes he depicts one moment in a story, sometimes he adds motifs which refer to earlier or later moments. For example, the figure of Simon

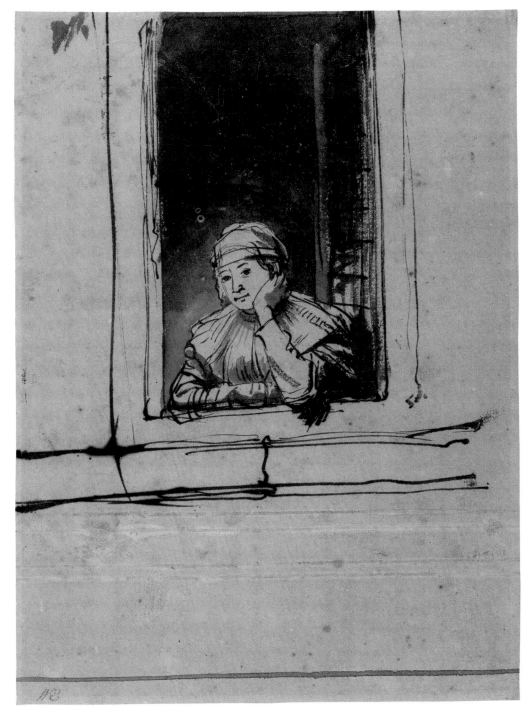

8: Rembrandt, *Saskia at the open window*, Rotterdam, Museum Boymans-van Beuningen.

9: Rembrandt, *David receiving the news of Uriah's death*, Amsterdam, Rijksprentenkabinet.

10: Rembrandt, *Joseph being sold by his Brothers*, Berlin, Kupferstichkabinett SMPK.

of Cyrene on the left in the drawing of *Christ falling beneath the Cross* represents the later moment at which he will take over the cross from Christ (Cat. No. 5); and Sarah enters the story of Tobit only after his blindness is cured and is not a witness, as Rembrandt has depicted her (Cat. No. 18). The custom of depicting more than one moment at a time dates from the Middle Ages and Rembrandt is one of the last artists to work in this way.

It is not only the faces which allow one to read the feelings of the figures, sometimes it is the composition as a whole which helps make the content of a story particularly vivid. A perfect example of this is a drawing of an episode from the story of King David.[16] The composition depicts him receiving the news that Uriah has been slain (Fig. 9). David had made Uriah's wife Bathsheba pregnant after he had seen her bathing from a window of his palace. Afterwards David sent Uriah into battle knowing that he was almost bound to die. In the drawing we see in the background the windows which look out onto the garden in which Bathsheba was bathing, a reference to the beginning of the story. On the left is the chair from which David rose when he heard the messenger approaching. The latter stands on the right with Uriah's armour over his arm, as a sign of Uriah's death. However, David has not gone straight to meet him, but as if to avoid the message he bears, he has turned towards the background. The drawing depicts the moment when he turns his head and looks at the messenger. By arranging things in this way, Rembrandt emphasises David's sense of guilt. The feeling of guilt is also conveyed by David's look, which expresses fear of hearing the truth. At a later moment in the story God sends the prophet Nathan to David. In the drawing the prophet is already standing as though in the wings ready to admonish the king. From his rendering of this story it is clear how Rembrandt has empathised with the situation. In the broad sweep of his composition he narrates events from left to right, referring both to earlier and later events. The disposition and the attitudes and expressions of the figures show Rembrandt as a director who has his actors express aspects of humanity in all kinds of ways.

Not all the Biblical scenes in Rembrandt's drawings are narrated in such depth, but there is always great intensity. An excellent example of this is the concentration with which Tobias heals his father's eyes (Cat. No. 18). Rembrandt was so taken with the powerful profile of the young Tobias, who is carrying out the operation, that he later used it again in a drawing in which the

young Joseph is being sold by his brothers (Fig. 10).[17] Here the sharp profile expresses the brother's intentness on the money, as he stares at it to ensure that he receives the full amount. In this drawing the finely drawn face of Joseph expresses the uncertainty and pain of the little child about to be taken away by strangers in a masterly way. The gentle pressure with which the man urges the child to come with him is also wonderfully conveyed.

No less explicit is the depiction of the contact between Hagar and the angel, in a particularly 'open' drawing using very few lines (Cat. No. 32). The positioning of the figures in the picture space and the way the gestures and the contact between Hagar and the angel are rendered, make the drawing not just an illustration of what happens in the story, but also a personal interpretation by Rembrandt of how the figures experience the event. Even when he draws more schematically he characterises both the story and the various facial expressions just as powerfully (Cat. No. 34 and 36).

The picture space

There are a number of bold and opulent pen-and-ink drawings dating from the 1640s. The *Entombment* (Cat. No. 19) is an example from the beginning of the decade, and the preliminary drawing for the *Portrait of Jan Six at the window* (Cat. No. 23) a similar work from 1647. Here and there Rembrandt appears to draw messily, but on closer inspection his pen is always single-minded in its pursuit of the desired form. The drawing of *Three women and a child at a door* from the mid-1640s shows a characteristic combination of features, (Fig. 11).[18] The old woman in the centre is the focus of the composition, even though she is not placed in the middle of the arch of the doorway. She is the most fully elaborated figure and the most carefully shaded. Her face is the most striking, the more so because she is wearing a bonnet. The figures in the foreground are mainly done with very free strokes of the pen. Their particularly lively interplay gives a very convincing sense of space and plasticity, without defining the shapes precisely. The figures are located within a strict framework. If we look only at those lines outside the figures which indicate the architecture, we see a composition in which every line contributes to the balance: if we take away the horizontal line at bottom right there is a gap; if we take away the vertical lines at bottom left, the composition threatens to veer to the right. Finally, if we remove the arch of the door the figures seem to be outlined against the sky. In short, Rembrandt underpins his freedom of line

11: Rembrandt, *Three Women and a child at the door*, Amsterdam, Rijksprentenkabinet.

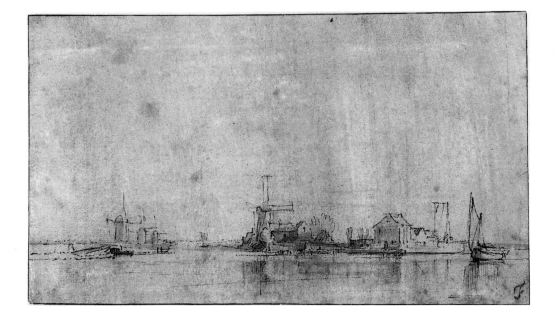

12: Rembrandt, *View of the Omval near Amsterdam*. Private collection.

with a tight framework. Most of his drawings are based on a compositional scheme which gives balance or direction to the scene. The background of the *Portrait of Jan Six at the window* (Cat. No. 23) and of the *Seated woman with an open book on her lap* (Cat. No. 17) has a clear division of picture area. The depiction of *Jacob and his sons* (Cat. No. 16) for example is virtually symmetrical as regards both the figures and the background.

Differences in the position on the sheet and the division of the picture surface can sometimes be explained by the function. With sketches of figures which served as preliminary studies, the division of the picture area emerged as the artist drew, because Rembrandt was concerned only with finding the right form (Cat. No. 7). With sheets intended as examples the composition is very well thought-out. In these cases variation and alternation of motives were conscientiously introduced. The model sheet with heads and figures (Cat. No. 8), one of the most splendid examples of its kind, shows how one head is finished with a brush, another is only cursorily indicated in ink, while in a small sketch is again done in red chalk; one head is drawing from the side, another more frontally. Quite a number of model sheets were probably produced by Rem-

brandt, but many of them were cut up into small sketches by later dealers.

Space and atmosphere

In the 1640s particularly Rembrandt concerned himself with drawing landscapes. However, a few small landscapes done in silverpoint on parchment were produced as early as the beginning of the 1630s. These have a certain linear, graphic character (Fig. 3a). Later landscape drawings were done in chalk, or pen and ink with a wash applied by brush. The expressiveness which Rembrandt was able to impart to all natural forms and buildings in the landscape has the same intensity as that of the figures and faces.

Whether it is the stone walls of the old town gate at Rhenen (Cat. No. 29) or the tall grass on the dyke with the wind blowing through it (Cat. No. 27), every form is characterised with equal accuracy. Of course light plays an extraordinarily important role in the landscapes too, as its treatment determines the effect of space and depth. How impressively Rembrandt could achieve this is shown by the drawings he made on the IJ and along the Amstel. In the Rhenen drawing we can see how he makes the cool atmosphere in the gateway tangibly present. The gateway and the gatehouse are drawn with exceptional care and precision, while the buildings to the left are executed in a balanced rhythm of separate pen strokes. Through leaving the houses on the left out of focus, as it were, Rembrandt directs our eye towards the gateway.

With landscapes he is able to evoke atmosphere in various ways. Sometimes he used cartridge paper, a fairly coarse, grainy type of paper which ensured that, for example, the sky and other areas left open did not have a flat and empty effect (Cat. No. 28). The atmospheric effect could also be obtained by applying a coloured wash to the paper. There are examples where Rembrandt has conjured up a misty atmosphere by combining a wash with fine pen lines (Fig. 12).[19] He seldom represents clouds in his landscapes, though they do occur occasionally (Cat. No. 21). Atmosphere was also created in landscapes by drawing the horizon and the most distant trees and houses in faint, broken lines: a way of rendering what in reality can only be seen by peering intently. In the first instance this technique was a way of achieving depth, but Rembrandt's pen gave it an added atmospheric effect.

Drawings by pupils in Rembrandt's style

All the features of Rembrandt's drawings which have been briefly described here—and there are

many more besides—were imitated by pupils. This was why drawings in Rembrandt's style by pupils were previously attributed to the master. The appearance of Benesch's authoritative catalogue would seem to have stopped the process of attribution to pupils. However, the body of drawings by a number of these pupils has been further expanded by publications which have appeared since Benesch. The most spectacular expansion is the œuvre of Willem Drost; Sumowski has attributed numerous drawings to this artist, of which there are no less than sixteen in the Rijksprentenkabinet of the Rijksmuseum alone.[20] An attempt has also been made to attribute drawings to Carel Fabritius; this group can be enlarged without much difficulty by a number of drawings still regarded as Rembrandts by Benesch.[21]

Several examples of recent attributions are discussed in this catalogue. These are a small group of drawing by five of Rembrandt's pupils, namely Ferdinand Bol, Nicolaes Maes, Willem Drost, Aert de Gelder and Johannes Raven. The newly attributed drawings are preceded in all cases by a drawing which has long been ascribed to the pupil in question and whose attribution is undisputed. The new attributions have been made by various authors. While they know the drawings at first hand, they have never yet been able to study the originals side by side. The attributions discussed here appear well-founded, but not everyone will necessarily agree immediately. Our intention is that the juxtapositions may bring the hoped-for clarification.

1. Schatborn 1985.
2. Paris 1988/1989. Starcky has accepted 72 of Benesch's 109 catalogued drawings.
3. Giltaij 1988.
4. Schatborn 1989, pp. 118–20.
5. Amsterdam, Rijksprentenkabinet, Inv. No. RP-T-1983–437. Red and white chalk on yellow prepared paper. Peter Schatborn, 'Een figuurstudie met rood krijt van Pieter Lastman', *Bulletin van het Rijksmuseum* 32 (1984), pp. 25–26.
6. Munich, Graphische Sammlung; Red and white chalk, 273 × 176 mm; Benesch 5.
7. Albert Blankert, Leonard B. Slatkes *et al.* ed: *Nieuw licht op de Gouden Eeuw. Hendrik ter Brugghen en zijn tijdgenoten*, Utrecht/Brunswijk 1986/1987 (exhibition catalogue).
8. Paris, Louvre, Département des arts graphiques, Benesch 49; Paris 1988–1989, No. 1.
9. Berlin, Kupferstichkabinett SMPK; Bock-Rosenberg 1930, No. 5284; Lugt 1931, pp. 79–80; Schatborn 1989, pp. 118–19.
10. Rotterdam, Museum Boymans-van Beuningen; Benesch, no. 29; Giltaij 1988, No. 1.
11. Berlin, Kupferstichkabinett SMPK; Benesch, No. 1372; Sumowski Drawings, No. 2191-XX.
12. Groningen, Museum voor Stad en Lande; Benesch, No. 282.
13. Berlin, Kupferstichkabinett SMPK; Benesch 100 verso. On the front of the sheet there is a very freely drawn *Lamentation*.
14. Rotterdam, Museum Boymans-van Beuningen; Benesch 250; Giltaij 1988, No. 8.
15. London, British Museum; Benesch 1103.
16. Amsterdam, Rijksprentenkabinet; Benesch 890; Schatborn 1985, No. 37.
17. Berlin, Kupferstichkabinett SMPK; Bock-Rosenberg 1930, No. 1119; Benesch 876.
18. Amsterdam, Rijksprentenkabinet; Benesch 407; Schatborn 1985, No. 27.
19. *View of the Omval*, sale London, 6 July 1987, No. 16; Benesch 1321.
20. Schatborn 1985-I, pp. 100–3.
21. Schatborn 1985, Nos 61–66.

Man standing with a stick
verso: *Man seen from behind*

Black chalk, brush in white, 290 × 170 mm
Inscription: below right, part of letter *R*
Amsterdam, Rijksmuseum,
Rijksprentenkabinet

Provenance: Jacob de Vos Jbzn. (L. 1450), sale
Amsterdam, 22–24 May 1883, in lot No. 412;
acquired by the Vereniging Rembrandt in 1889
(L. 2135); Inv. No. RP-T-1889 A3172.

Literature: Henkel 1942, No. 1 and 2; Benesch
1954–1957 and 1973, No. 30; Schatborn 1985,
No. 2 (with other previous literature and
exhibitions).

1a: Rembrandt, *A standing Archer*.
Dresden, Kupferstich-Kabinett.

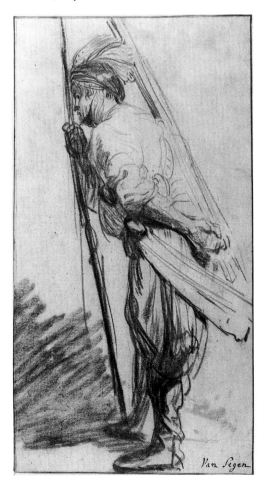

After Rembrandt had been a pupil with Jacob
van Swanenburg in Leiden and thereafter with
Pieter Lastman in Amsterdam, he set up as an
independent master in 1625 in his birthplace,
Leiden. The drawings from this early period
are mainly figure studies. Rembrandt's
ambition was to become a history painter, a
painter of biblical and mythological subjects,
and the depiction of figures was therefore of the
utmost importance. These figure studies were
made in red and/or black chalk on fairly large
sheets of paper; smaller drawings of figures
were usually done in pen and brown ink.

From the very beginning these figure studies
have an individual, robust style, which is
clearly different from the style of Lastman, who
also drew red and black chalk figures that he
used in his paintings.[1]

Rembrandt's early chalk figure studies can
be divided into groups on the basis of differing
styles. The first group, from c. 1627, consists of
three drawings in red chalk, which are
extremely sketchily and loosely executed (Fig.
1a).[2] The *Man standing with a stick* belongs to a
series of six which date from a little later and
are executed in black chalk.[3] Characteristic of
these drawings are the heavy, sometimes
angular, lines which broadly outline the forms.
In this case the profile consists of six small lines
and a dot which indicates the eye. Rembrandt
was sitting fairly close to the model when he
drew these and other figures, as we are looking
up at the man.

It was usual to begin drawings in light lines
and to elaborate with increasingly darker lines.
In the left leg of the man it can be seen how
the darker lines emphasise the outline while
simultaneously correcting the earlier ligher
lines.

Rembrandt always took the fall of light into
account. The brightly lit sections are simply
left blank. In contrast, the slightly later group
of red chalk studies are almost entirely
executed in chalk without blank areas (Cat.
No. 2).

The vertical lines beneath the belt of the
man indicate the area in shadow. Rembrandt
had apparently not determined the division
between light and dark satisfactorily at the
outset, as he painted over the three right-hand
lines with white in order to make them
invisible. These lines have now become visible
again as a result of oxidisation of the lead in the
white paint. This kind of correction, which
occurs repeatedly in Rembrandt's drawings,
indicates the importance he placed on the
precise rendering of lightfall. The most effective
method of achieving plasticity and depth was
an accurate depiction of light and dark.

The drawing of figures was, in the first

place, an exercise in learning to represent the human form realistically and it also served as preparation for the portrayal of all manner of types in paintings and etchings. Although Rembrandt usually worked from imagination or from life, the drawings could also be used as preparatory studies. One of the studies in black chalk served as a model for the figure of Peter in the etching[4] of *Peter and John healing a cripple at the Temple Gate*.[5] The other drawings in the group relate specifically to etched and painted figures which appear in his work dating from approximately the 1630s. Through practice in drawing from life, Rembrandt was also able to depict figures in a lifelike way in paintings and etchings.

The influence of the French artist Jacques Callot can be seen in these figures, and in particular from his series of prints *Les Gueux* (*The Beggars*).[6] This is especially noticeable in the shadows with parallel lines. A comparable etching of a *Man standing with a stick* (Fig. 1b)[7] from c. 1629 has more the style of a drawing. Rembrandt was one of the first artists to exploit the possibilities of the technique of etching in this manner.

Rembrandt used paper made in Italy with a watermark of a bird in a circle[8] for the *Man standing with a stick* and the other drawings of the group in black chalk. This paper must have been available in Leiden around 1630 as it was also used by his friend and fellow townsman Jan Lievens,[9] and his pupil Joris van Vliet.[10] Dated paper with this watermark appears in documents from 1629 and 1630, the same time as Rembrandt made his figure studies in black chalk. The three drawings of the group in Amsterdam all have an inscription with Rembrandt's initial at the bottom right. The chalk in which these letters are written is of a slightly different colour from that in which the drawing is made. If these inscriptions are indeed by his own hand, then Rembrandt possibly added them to the drawings at a later date.

The small sketch on the reverse of the *Man standing with a stick* perhaps represents a horseman who, however, is only partly depicted.
P.S.

1. Oxford, Ashmolean Museum; Schatborn 1981, No. 63, p. 48–49. Among the work by his teacher that Rembrandt owned, according to the inventory of 1656, was *[Een boeckie met schetsen] van Lasman met root krijt* ([A small book with sketches] by Lastman in red chalk). *Documents* 1656/12, No. 264.
2. Munich, Graphische Sammlung; Benesch, Nos. 4 and 5; Dresden, Kupferstich-Kabinett, Benesch 3.
3. Benesch 12, 30–32, 45 and 196. Schatborn 1989, p. 125–26.
4. *Man standing with outstretched arms.* Dresden, Kupferstich-Kabinett, Benesch no. 6.
5. B. 95.
6. The series *Les Gueux* appeared in 1622; J. Lieure, *Jacques Callot, Catalogue de l'Oeuvre gravé*, Paris, 1924–1929, nos. 479–503.
7. B. 162.
8. J.H. de Stoppelaar, *Het papier in de Nederlanden gedurende de Middeleeuwen, inzonderheid in Zeeland* (Paper in the Netherlands during the Middle Ages, especially in Zeeland), Middelburg 1869, pl. VIII, No. 15 (1630).
9. *Hermit in a Cave*, etching (B. 6), impressions in Rotterdam, Museum Boymans-van Beuningen and Amsterdam, Rijksprentenkabinet.
10. *St Jerome in a Cave*, etching (B. 13) dated 1631, after a painting by Rembrandt, now lost; Amsterdam, Rijksprentenkabinet.
11. Schatborn 1989.
12. Benesch 30–32.

1b: Rembrandt, *Beggar leaning on a stick*. Amsterdam, Rijksprentenkabinet.

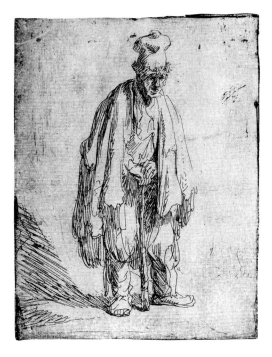

Seated old man

Red and black chalk on pale yellow prepared
paper, 233 × 160 mm
Inscription: centre below, monogram *RHL* and
1631
Paris, collection A. Delon

Provenance: J.H. Hawkins, sale London, 29 April
1850, No. 1027, W. Mitchell, London, sale
Frankfurt a/M, 7 May 1890, No. 84; Stephan
von Kuffner, Vienna; Von Kuffner family,
Zurich; sale London, 29 November 1970,
No. 16.

Literature: Benesch 1954–1957 and 1973,
No. 20 (with other previous literature and
exhibitions); J. Giltaij, 'Een onbekende schets
van Rembrandt', *De Kroniek van het Rembrandt-
huis* (1977) 1, pp. 1–9; *Corpus* II, under A66;
Jeroen Giltaij, 'The Function of Rembrandt
Drawings', *Master Drawings* (1989), vol. 27/2,
pp. 111–17.

Exhibitions: 20 ans de passion, Paris (Didier Imbert
Fine Art) 1990, No. 23.

At the end of the Leiden period and before he
went to work in Amsterdam in the early 1630s
Rembrandt drew a number of figure studies in
red chalk of an old man. This model also posed
for paintings and prints. The red chalk studies
are less linear than the figure studies in black
chalk (Cat. No. 1), which probably date from a
little earlier. The figure is now almost entirely
worked in chalk and executed with abundant
variations of light and dark. This drawing style
is characteristic of the period around 1630–
1631, during which time Rembrandt's
paintings were executed in an especially fine
manner and the etchings were conceived in
tone rather than line (Etchings Cat. No. 4).

Three of the extant figure studies of the old
man show him full-length, sitting on a chair—
originally a folding chair—which often appears
in Rembrandt's work. Rembrandt possessed
such a chair himself (Cat. No. 20).[1] In the
exhibited drawing the old man is seen
somewhat from below and from the side and he
is looking sideways.

The drawing is almost entirely executed in
red chalk. Rembrandt emphasised the outline
of the figure on the right-hand side with short
lines in black chalk and he also drew the chair
in that medium. The use of line within the
drawing is extremely varied: the figure was
first begun in fine lines, shaded with trans-
parent areas of red chalk and thereafter
elaborated with broader and longer lines. Only
the face, beard, hands and fur collar were left
blank.

The almost horizontal line beneath the chair
could indicate a higher level, a sort of low
podium which existed in the studio.[2] The foot
of the right leg rests on the ground in front of
this podium and the man is seated near a wall
on which his shadow falls.

It is rather strange that the knee of the right
leg is shown in two positions. In the higher
position only the top is visible, while the
contour of the knee below it appears to have
been erased. Traces of red chalk can be seen in
the space between the two versions of the
knee, possibly a remainder of the partly-erased
lower knee. This must then have been the
earlier version.

Rembrandt used the drawing of the old man
as a preliminary study for the figure of Jacob in
a grisaille in the Rijksmuseum, *Joseph telling his
dreams* (Fig. 2a)[3] and he appears again in a
sketch in red chalk in Rotterdam (Fig. 2b)[4]
and in an etching (Fig. 2c),[5] both of the same
subject.

The grisaille, painted on paper, is signed and
carries a date from the 1630s of which the last
figure is missing. The writing of the signature
in full indicates a date of 1633 at the earliest.[6]

2a: Rembrandt, *Joseph telling his Dreams.*
Amsterdam, Rijksmuseum.

2b: Rembrandt, *Sketch for Joseph telling his Dreams.*
Rotterdam, Museum Boymans-van Beuningen.

2c: Rembrandt, *Joseph telling his Dreams.*
Amsterdam, Rijksprentenkabinet.

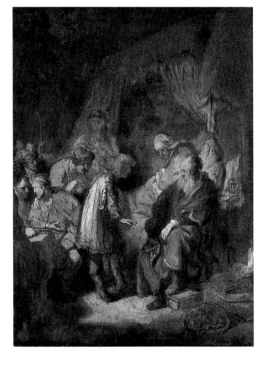

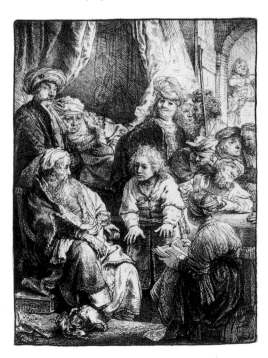

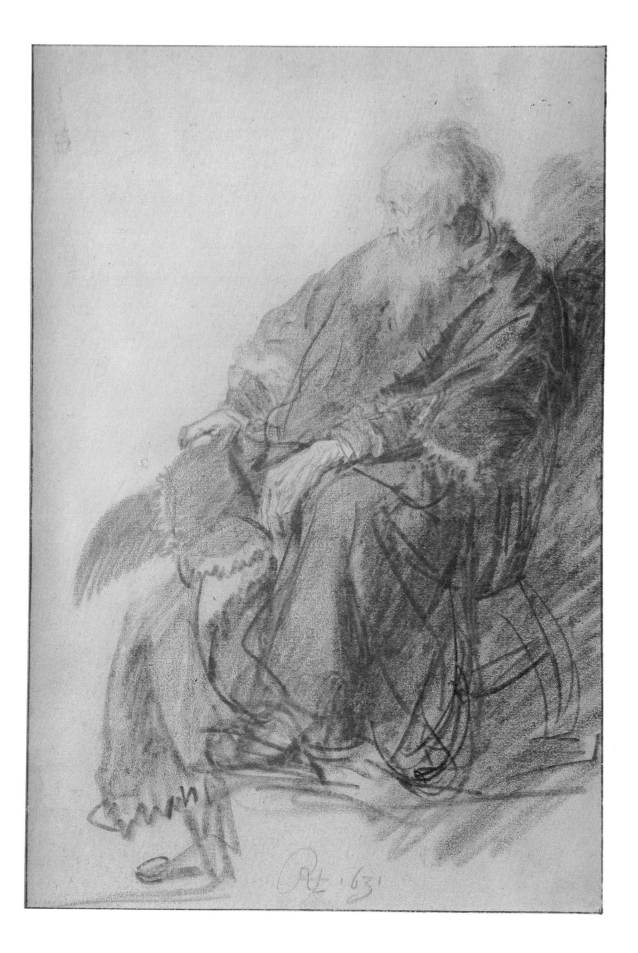

This means that the drawing dated 1631, from the Leiden period, was not made intentionally as a preliminary study, but was only adopted in the grisaille two years later. Another argument for this is the differing viewpoint: the drawn figure is seen from slightly below, as is often the case with drawings made from the life. The figure is seen from a higher viewpoint in the grisaille. Rembrandt probably reworked the drawing in order to adapt the figure to a composition with a higher viewpoint before he used it for the grisaille. This is suggested by the dark lines which have been added mainly to the lower part of the body. As a result the folds of drapery fall somewhat differently. This modification was in part adopted in the grisaille.

The height difference of the feet also posed a problem in the drawing. To solve this, the motif of a brazier was introduced into the grisaille. From a comparison of the depiction of the feet—seen from the side in the drawing and slightly more from above in the grisaille—it becomes clear that the viewpoint has been altered.

The grisaille was probably made as a design for an etching, which, however, was never realised in this form. It was only in 1638 that Rembrandt made the much smaller etching of the same subject, in which the old man appears in mirror-image. The uneven positioning of the feet was avoided in the etching by hiding them behind a step and the brazier was placed next to Jacob's chair. His leg, painted at a downward angle in the grisaille, appears a little straighter in the etching. In order to explain the two positions of the leg we could suppose that the drawing was again reworked in 1638, that Rembrandt erased the outline of the right leg and drew a new version on top of it. The position of the leg in the etching is somewhere between the two positions in the drawing.

The figure of Jacob in the sketch in Rotterdam, which was made as a preparatory study for the composition of the etching, originates in the grisaille. In the sketch, the right leg is not only drawn with one oblique line, but underneath this the higher position is perhaps already indicated with a vertical and a short horizontal line.

According to the above assumption, Rembrandt reworked the drawing of 1631 before he adopted it for the grisaille and then used it again in 1638, after he had first tried out the higher position of the knee.

Rembrandt prepared the paper with a pale yellow wash, leaving the reverse white. In this he was following Lastman's example, and Jan Lievens, also a pupil of Lastman, probably also used the same sort of paper. Rembrandt made drawings in pen and brown ink on similarly prepared paper at the end of the 1630s.
P.S.

1. Benesch 20, 40 and 41. A fourth study of the same old man, probably also originally full-length, was cut off below the knees; Benesch 37.
2. The motif of a podium also occurs in a number of paintings and etchings, see: Schatborn 1985, No. 5.
3. *Corpus* II A66.
4. Giltaij 1988, No. 13 verso.
5. B. 37.
6. In the *Corpus* (A66) this is considered to be the most likely dating.
7. Schatborn 1989, pp. 118–19.

3

Portrait of Saskia van Uylenburgh

Silverpoint on white prepared parchment, arched at the top, 185 × 107 mm
Inscription: dit is naer mijn huijsvrou geconterfeijt | do sij 21 jaer oud was den derden | dach als wij getroudt waeren | den 8 junijus 1633 (this is drawn after my wife, when she was 21 years old, the third day of our betrothal, the 8th of June 1633
Berlin, Staatliche Museen Preussischer Kulturbesitz, Kupferstichkabinett

Provenance: Jeronimus Tonneman, sale Amsterdam, 21 October 1754, Konstboek N, No. 67; A.G. Thiermann, Berlin; KdZ. 1152 (1861).

Literature: Bock-Rosenberg 1930, No. 1152, p. 230; Benesch 1954–1957 and 1973, No. 427 (with other previous literature and exhibitions); D.J. van der Meer, 'Ulenburg', *Genealogysk Jierboekje* 1971, pp. 98–99; F. Anzelewsky e.a., *Kupferstichkabinett SMPK, Kunst der Welt in der Berliner Museen*, Stuttgart/Zurich 1980, no. 33.

Exhibitions: Bilder vom Menschen in der Kunst des Abendlandes, Berlin (Nationalgalerie) 1980, pp. 280–81, No. 62.

3a: Rembrandt, *Landscape with two cottages.* Berlin, Kupferstichkabinett SMPK.

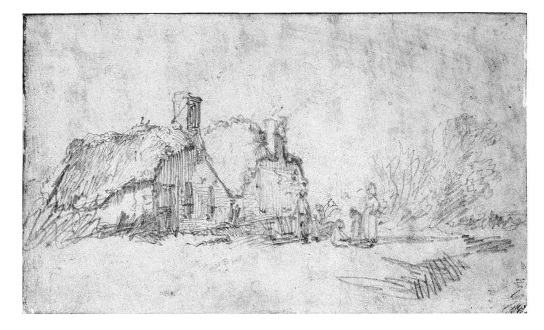

The portrait of Saskia was acquired by the museum in Berlin in 1861 from the widow of the collector A.G. Thiermann with a large collection of etchings by Rembrandt.[1] When Carel Vosmaer visited the Kupferstichkabinett shortly afterwards for his monograph on Rembrandt the drawing was catalogued as 'in the style of Rembrandt'.[2] Vosmaer recognised the likeness of Saskia and saw that Rembrandt was the creator.[3]

Saskia van Uylenburgh was born in 1612, the youngest daughter of Rombartus van Uylenburgh, government attorney and Mayor of Leeuwarden in Friesland. She was a niece of Hendrick van Uylenburgh, the art dealer with whom Rembrandt had worked since 1631. It was through him that Rembrandt became acquainted with his future wife.

Rembrandt made the drawing on costly parchment on the occasion of his engagement to Saskia on 5 June 1633. The word 'married' in the inscription means that the couple had exchanged betrothal vows.[4] The marriage took place more than a year later, on 22 June 1634.[5]

Saskia became an orphan in 1624, at the age of twelve. Thereafter she probably lived in Sint Annaparochie with her sister Hiske and her brother-in-law Gerrit van Loo, who was appointed as her guardian in 1628.[6] It is not improbable that Rembrandt travelled to Friesland to discuss the wedding with Saskia's guardian in June 1633, the date on the drawing. This would mean that the drawing was made in Friesland.[7] On 10th June 1634, when Rembrandt and Saskia's nephew Johannes Cornelis Sylvius, who signed on her behalf, signed the registry in Amsterdam, Sint Annaparochie is still given as her place of residence and this is where the marriage took place.[8]

The drawing was made in a period in which Rembrandt painted many portraits, including one of Saskia from the same year.[9] In 1633 Rembrandt made an etched portrait of the clergyman Sylvius.[10] Since the fifteenth century it was not unusual to draw portraits in silverpoint on parchment, which was first prepared with white or another colour. Immediate examples for Rembrandt were Hendrick Goltzius and Jacques de Gheyn, by whom a series of similar, mainly small, portraits are known. Rembrandt rarely used this medium. Two other parchment sheets have a drawing on both sides: on the verso of a representation of two separate small farms is landscape (Fig. 3a),[11] and on the verso of a drawing of a number of heads (Fig. 3b) is one single small farm.[12] These four drawings probably date from the same time as the portrait of Saskia. The farms which Rembrandt

drew are of a particular type found in the Gooi, in the area around Zwolle and Kampen and also in Friesland.[13]

Saskia wears a straw hat with a wide brim, decorated with flowers. Women with similar hats appear in a number of seventeenth-century representations of shepherds and shepherdesses.[14] These pastoral scenes often contain an amorous element and Rembrandt probably wanted to express this is in his betrothal portrait.[15]

The straw hat in connection with marriage also occurs in the work of Rubens of this period. In the early 1620s this Flemish artist painted Suzanna Fourment dressed as a shepherdess and with a straw hat, possibly on the occasion of her marriage to Arnold Lunden in 1622.[16] In the painting in Munich of *Rubens and Hélène Fourment in a garden*, the young bride is dressed as for gardening and also wearing a straw hat with flowers. The painting is believed to be an allegory on the marriage between Rubens and Hélène, which took place on 6 December 1630.[17]

In contrast to Suzanna Fourment and other 'shepherdesses', Saskia does not hold a shepherd's crook but a flower, perhaps a rose, an allusion to love and marriage which occurs often in literature and art.[18]

The drawn portrait of Saskia has a special place in Rembrandt's œuvre. The precision and care with which he portrayed his beloved make the drawing one of his most personal testimonies.

P.S.

3b: Rembrandt, *Model sheet*.
Rotterdam, Museum Boymans-van Beuningen.

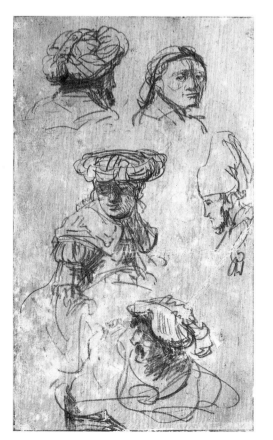

1. In the Kupferstichkabinett in Berlin is an old handwritten catalogue in which these etchings, the portrait of Saskia and three other drawings, are mentioned. This catalogue, written on paper with a watermark of 1838, is mentioned by Lugt (in L. 2434) and belonged to the English art dealer S. Woodburn (1786–1853).
2. Carel Vosmaer, *Rembrandt Harmens van Rijn, sa vie et ses œuvres*, The Hague 1868, p. 52; 'enveloppe contenant des dessins dans le goût de Rembrandt'; changed to 'un carton avec des dessins apocryphes' in the edition of 1877.
3. Peter Schatborn, 'Vosmaers magnum opus over Rembrandt', in: *De verzameling van Carel Vosmaer*, The Hague/Amsterdam 1989, ed. J.F. Heijbroek, p. 180.
4. H.F. Wijnman, 'Rembrandt en Saskia wisselen trouwbeloften', *Maandblad Amstelodamum* 56 (1969). For the details about Saskia and Rembrandt see: Broos 1981, pp. 253 ff.
5. *Documents* 1634/5. The Julian calendar was still used in Friesland in the seventeenth century. It ran ten days behind the Gregorian calendar which was used in Holland, where it was therefore 2 July on the wedding day: J.F. Jacobs, 'Notities voor een toekomstige Rembrandt-biografie', *Tableau* 8 (1986), p. 99.
6. On 14 June 1628. *Documents* Add. 1628/3. Saskia's new guardian was appointed on 20 July 1633, six weeks after the engagement, as she would come of age as a result of the forthcoming wedding. *Documents* Add. 1633/5.
7. Broos also believes that it is by no means certain that the drawing was made in Amsterdam.
8. Saskia had by then moved to Franeker, where her sister Antje had lived until her death, shortly before, on 9 November 1633.
9. Amsterdam, Rijksmuseum; *Corpus* II A75.
10. B. 266.
11. Berlin, Kupferstichkabinett SMPK, Benesch 341.
12. Rotterdam, Museum Boymans-van Beuningen, Benesch 341. A further two landscapes on parchment date from a later period, Benesch 844 and 1288; various prints of the etchings were then also printed on parchment by Rembrandt.
13. According to Boudewijn Bakker, in: Washington 1990, Intro. p. 55 and under No. 1.
14. Alison McNeil Kettering, *The Dutch Arcadia, Pastoral Art and its Audience in the Golden Age*, Montclair 1983, p. 33.
15. The first Dutch portraits in the guise of shepherds and shepherdesses were made around 1630; see Kettering 1983, p. 63 (n. 14). See also Etchings Cat. No. 17.
16. Hans Vlieghe, *Rubens Portraits of identified sitters painted in Antwerp, Corpus Rubenianum . . .* XIX, London 1987, No. 101.
17. Vlieghe 1987 (n. 16), No. 139.
18. E. de Jongh, *Portretten van Echt en Trouw, Huwelijk en gezin in de Nederlandse kunst van de zeventiende eeuw*, Zwolle, Haarlem 1986, under No. 33.

dit is naar mijn huijsvrou geconterfeijt
do sij 21 jaer oud was den derden
dach als wij getroudt waren

Rembrandt
1633

4

Self-portrait as an artist

Pen and brown ink, brown and white wash,
123 × 137 mm
Berlin, Staatliche Museen Preussischer
Kulturbesitz, Kupferstichkabinett

Provenance: Jonkheer Joh. Goll van Francken-
stein (not in the Amsterdam sale of 1 July
1833), mentioned in Cat. Woodburn 1835; Sir
Thomas Lawrence (L. 2445), London; Gallery
S. Woodburn, London, Cat. 1835, No. 72;
William Esdaile, sale London, 17 June 1840,
No. 107; Andrew Geddes, sale London, 8–14
April 1845, No. 334?; Sir Charles Robinson
(L. 1433), not in the sale, London, 7–8 May
1868; KdZ. 1553 (1880).

Literature: Bock-Rosenberg 1930, No. 1553,
p. 230; Benesch 1954–1957 and 1973, No. 432
(with other previous literature and
exhibitions).

There are not many seventeenth-century artists
who depicted themselves so often and in so
many different ways as Rembrandt. His face
already appears among the bystanders in an
early history painting of 1626.[1] In the Leiden
period Rembrandt not only made a number of
paintings of himself but also a number of
etchings which show him with various facial
expressions. Rembrandt made these in order to
depict all sorts of emotions. That self-
portraiture was exactly right for this is
apparent from a comment by Samuel van
Hoogstraten, a pupil of Rembrandt during the
1640s: 'Dezelve baet zalmen ook in 't
uitbeelden van diens hatstochten, die gy
voorhebt, bevinden, voornaemlijk voor een
spiegel om tegelijk vertooner en aenschouwer
te zijn' (the same benefit will accrue from the
depiction of the emotions which you can find
before you, namely in a mirror, where you can
be exhibiter and viewer at one and the same
time).[2] Such etchings (Cat. No. 1 and 2) were
thus made as a form of practice in the depiction
of expressions for the artist and could be used
as examples for figures in history paintings.
Moreover, they were examples for students.

Two drawn portraits from the Leiden period
(Fig. 4a)[3] were made at the same time as the
first painted and etched self-portraits. These
drawings were made as preliminary studies for
another sort of portrait, Rembrandt's first
representative etched self-portrait from 1629
(Fig. 4b).[4] The self-portraits in brown ink and
grey wash are direct precursors of the exhibited
drawing, which is in pen and brush in brown
only.

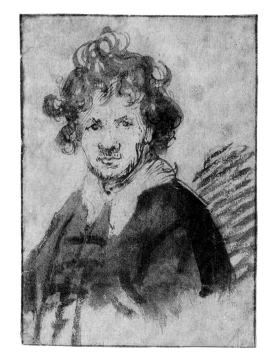

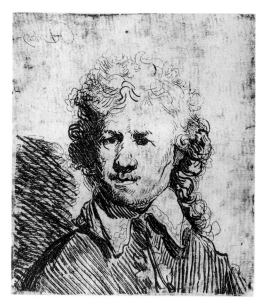

4a: Rembrandt, *Self-portrait.*
Amsterdam, Rijksprentenkabinet.

4b: Rembrandt, *Self-portrait.*
Amsterdam, Rijksprentenkabinet.

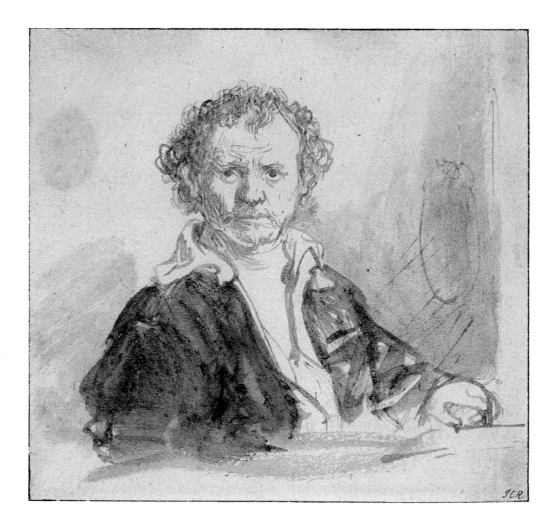

We see Rembrandt sitting at a table, his left hand on the arm of a chair. The hand in which he is holding the pen and brush is not shown. A piece of paper is perhaps lying on the table next to the sheet on which the drawing was made. In contrast to the two earlier drawings, Rembrandt wears his shirt open under his dark jacket. In all three drawings he is looking directly out at us—and himself in the mirror. His hair which was long in the early portraits is now short, the eyebrows show he is frowning slightly and the expression is serious. Rembrandt's palette is hanging on the wall. Thus the self-portrait has become that of the artist, a painter who takes his work seriously, judging by the grave expression.

During his Leiden period, Rembrandt made a small painting of himself in his studio, standing before the easel. As before, a palette hangs on the wall (Fig. 4c).[5] This painting is the first in which Rembrandt depicts himself as an artist. It probably dates from 1629, the same year as he etched his first self-portrait. It is evidence of his self-awareness as an artist.

The drawn *Self-portrait as an artist* probably dates from the beginning of the Amsterdam period, a time when Rembrandt mainly painted portraits. It had previously been supposed that

the drawing dates from the late 1620s[6] or alternatively from the mid 1640s.[7] In comparison to drawn self-portraits from the Leiden period Rembrandt seems older, but it is not easy to estimate by how much. A painted *Self-portrait* in the Louvre in Paris, dated 1633, perhaps provides the best comparison for the face and the hairgrowth, although here it is longer at the back (Fig. 4d).[8]

The style of the drawn *Self-portrait as an artist*, with its lively, sometimes sharp penlines in the face and the broad brushstrokes in parts of the clothing, is comparable to that of the drawn self-portraits made in the Leiden period. If the drawing was made in or around 1633, it would have been made at the same time as the *Portrait of Saskia* (Cat. No. 3) which was executed in silverpoint and which has a finer handling of line.[9]

We do not know for what purpose the *Self-portrait as an artist* was made. It could have been as practice or as a preparatory work, but no directly comparable painted or etched self-portrait is known from this time. Drawings of this type were also intended as examples for pupils' most of whom also drew self-portraits during their apprenticeship.[10]

P.S.

1. *Corpus* I A6.
2. Hoogstraten 1678, p. 110.
3. London, British Museum; Benesch 53. Amsterdam, Rijksprentenkabinet; Benesch 54; Schatborn 1985, No. 1.
4. B. 338.
5. Boston, Museum of Fine Arts; *Corpus* I A18.
6. Lilienfeld 1914, No. 88.
7. HdG 1906, No. 98; Valentiner II 1934, No. 1934, No. 663. Benesch dates the drawing c. 1634, Bock-Rosenberg c. 1635.
8. Paris, Musée du Louvre; *Corpus* II A71.
9. In 1634 Rembrandt drew the *Bust of an old man with clasped hands*, a figure which is reminiscent of biblical figures and saints. This drawing, in the album of the German merchant Burchard Grossman, was executed in pen and brush and shows the same combination of sharp, lively lines and broad areas of wash. Moreover, the areas of light and dark are similarly distributed over the figure. The Hague, Koninklijke Bibliotheek; Benesch 257.
10. See for example Exhib. Cat. Amsterdam 1984–1985, Nos. 3–6.

4c: Rembrandt, *Self-portrait as a Painter*. Boston, Museum of Fine Arts.

4d: Rembrandt, *Self-portrait*. Paris, Musée du Louvre.

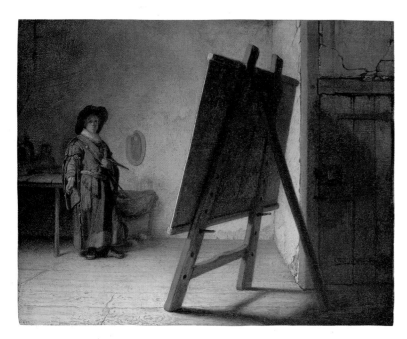

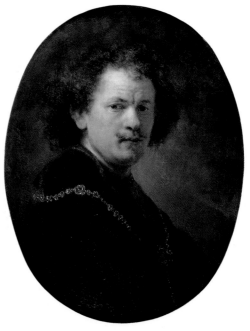

5

Christ carrying the Cross

Pen and brown ink, brown wash, mounted,
145 × 260 mm
Inscription: below left *Rembrant.*
Berlin, Staatliche Museen Preussischer
Kulturbesitz, Kupferstichkabinett

Provenance: Sir John Charles Robinson (L. 1433),
not in sale London, 7–8 May 1868; KdZ 1554
(1880).

Literature: Bock-Rosenberg 1930, No. 1554,
p. 227; Benesch 1954–57 and 1973, No. 97
(with other previous literature and
exhibitions).

Exhibitions: Amsterdam 1969, No. 40; Berlin
1970, No. 98.

Rembrandt has depicted the moment from the
Passion when Christ falls to the ground (Luke
23: 26–27). One of the soldiers behind him has
taken over the Cross to pass it on to Simon of
Cyrene. The latter stands in the left
foreground, having come in from the fields,
with a spade, from which a basket hangs, over
his shoulder. Mary has fallen backwards and a
figure, perhaps John, kneels beside her. From
behind him a woman rushes forward, her arms
outstretched. Another woman behind the cross,
jumps back startled. Between these two, we see
another head. It has recently been suggested
that the woman with outstretched arms might
be Veronica holding the cloth with the imprint
of the face of Jesus before her.[1] However,
Veronica's cloth is not clearly apparent and
the small head could also belong to a figure
situated further in the background.

Behind the soldiers is a rider on a horse,
but because the picture has been cut off at the
top at a later date, this is not immediately
apparent. The lower part of the horse's head, of
which the eyes are only just on the paper, is to
the right of the cross. Next to this the hands,
an arm and a section of the rider's cloak have
been drawn. The vertical stripes beneath the
rider represent the horse's saddlecloth.

The horizontal composition is inspired by a
print by Martin Schongauer, which Rembrandt
probably owned (Fig. 5a).[2] The placing of
Jesus under the cross and the position into

which he has fallen support the supposition that Rembrandt knew Schongauer's print. Rembrandt has replaced the soldier seen from behind, to the left of the Cross on the print, with the figure of Simon. He is not often depicted in the representational tradition and Rembrandt has added him to the scene in an original way, as a farmer with a spade and basket.[3] The man who takes over the cross and the horseman in the background appear in both works but, where Schongauer had placed a soldier with a whip in the middle foreground, Rembrandt has drawn the fallen Mary. In his composition the heads of the figures form an oval, which is even further accentuated by the direction of the various pen lines. By interpreting this story as a human drama, the drawing has become one of the most moving depictions of the suffering Jesus.

The style of the drawing is particularly sketchy, the figures are only broadly indicated, yet, in their summary treatment, almost all their movements are clear. The face of Jesus is the most highly finished and forms the central motif of the drawing, while the anxious face of the fallen Mary is also more worked out than the others. Finally Rembrandt added the figure of Simon with the brush and his shadow in the foreground forms the basis of the composition.

How a pupil used a drawing such as this as a model is apparent from a drawing in Amsterdam (Fig. 5b) of a fallen man. A woman kneels by him while an old man rushes towards him. It is not clear what the subject is, but the sheet is a kind of paraphrase of the right side of the Berlin drawing.[4]

Christ carrying the Cross is dated to the mid-1630s, when Rembrandt was occupied with the series of paintings of the Passion commissioned by Frederik Hendrik. A number of drawings from this time display the same stylistic characteristics (e.g. Cat. Nos 7, 9, 12).
P.S.

1. Information kindly supplied by Stephan Kemperdick.
2. B. 21; mentioned in the inventory of 1656 detailing Rembrandt's possessions is 'A cardboard box with prints by Hubse Marten [Schongauer], Holbeen, Hans Broesmer [Brosamer] and Israel van Ments' [Meckenem]; *Documents* 1656/12, No. 237.
3. This figure is identified by L.C.J. Frerichs, in Amsterdam 1969, No. 40.
4. Schatborn 1985, No. 88.

5a: Martin Schongauer, *The Great Ascent to Calvary.*

5b: Rembrandt, *Scene with a fallen man.* Amsterdam, Rijksprentenkabinet.

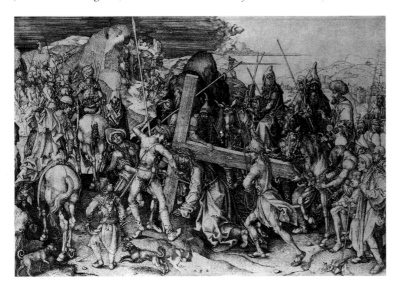

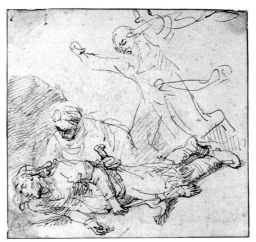

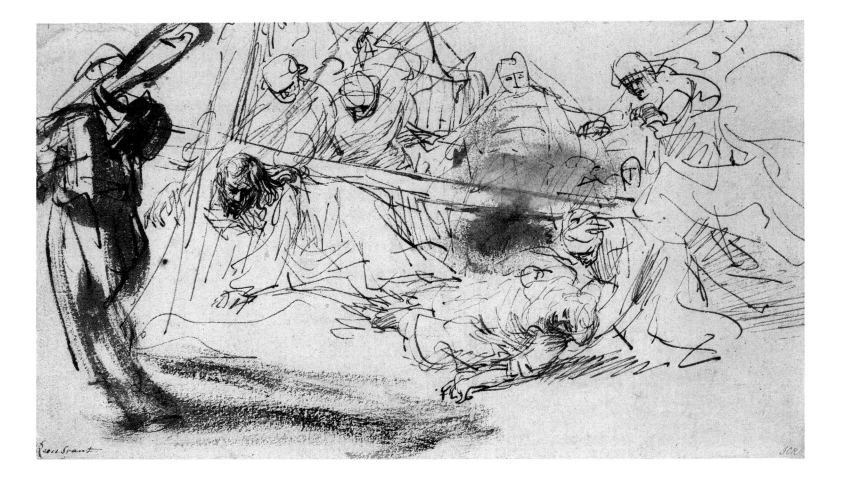

6

Christ and the Apostles on the Mount of Olives

Pen and brown ink; brown, grey, white and some green wash; black and red chalk; to the left of Christ a vertical fold; a piece of the paper cut out and the hole covered with a piece of paper glued to the back; a cut in the paper about 2 cm from the top, 357 × 478 mm
Inscription: centre right *Rembrandt f 1634*
Haarlem, Teylers Museum

Provenance: E. Valckenier-Hooft, sale Amsterdam, 31 August 1796, No. A4; Inv. No. O* 74.

Literature: Benesch 1954–1957 and 1973, No. 89; Hoekstra 1981, N.T. 2, pp. 68–69; M. Plomp, *Catalogue of the Dutch Drawings in Teylers Museum, Artists born Between 1575–1630,* to appear in 1992 (with other previous literature and exhibitions).[1]

Exhibitions: Rotterdam/Amsterdam 1956, No. 28; *Höllandische Zeichnungen der Rembrandt-Zeit,* Brussels and Hamburg 1961, No. 47; catalogue by K.G. Boon and L.C.J. Frerichs, introduction by Frits Lugt; Amsterdam 1964/1965, No. 108.

Christ and his disciples are sitting together in a circle in the darkness of the night. They are lit by the halo of Christ, who is seated above the others, holding his right hand to his chest. Nine disciples are clearly visible and the tenth has been indicated only as an initial sketch, on the left in the background. The figure with closed eyes to the left of centre can be identified as the young John and the bald, bearded figure in the background next to Christ is Peter. In the left foreground a disciple is yawning while looking out at the viewer.

The drawing was made on a large piece of paper, which has been folded down the centre. Rembrandt probably began with black chalk, as can be seen in the figure of Christ, and then added brown, grey and black wash. Thereafter he used red chalk, with which he drew over the wash in parts of the left foreground and background, including the face of the unfinished tenth disciple. Rembrandt then used black chalk again over the wash to draw the small gate behind and to the right of Christ and to sign his name and give the date. Finally, areas were enhanced with pen and dark-brown ink, including the head of the yawning man. Areas were also heightened with white, such as the profile of the disciple in the right foreground. The disciple with the turban in the centre apparently caused difficulties at first, as Rembrandt cut him out of the paper, redrew him on another piece of paper and glued it on from behind. At the top there is a cut in the paper, the presence of which cannot be explained. Up to a certain point the drawing therefore gives a clear idea of the working process.

There are a number of works by Rembrandt where the subject cannot be precisely determined in accordance with the Bible or the tradition of representation. In the case of the Haarlem drawing the question is whether it represents one particular moment. A number of varying interpretations have been suggested for the subject of the drawing.

It is true that Rembrandt sometimes depicts various moments from a story in one picture, as in the *Hundred Guilder Print* (Etchings Cat. No. 27), but such an amalgamation does not seem very plausible here.[2] It has also been suggested that the scene represents one of the miracles of Christ,[3] but there is not enough evidence for this either. A more plausible suggestion is that it represents 'The first appearance of the risen Christ' (John 20: 19–23).[4] This does take place at night but not out of doors as shown in the drawing. The presence of ten disciples does accord as Judas was then no longer alive and Thomas only appeared a few minutes later. But the two

apostles sleeping and yawning does not fit here.

It has also been suggested that the subject is 'Christ's Prophecies and Warnings' in which he is sitting on the Mount of Olives with his disciples (Matthew 24).[5] Since this scene does not take place at night, the argument is not supported.

The most recent identification is 'Christ's return to the Apostles from Gethsemane'.[6] This does take place at night, but in most representations only three of the disciples are present, according to the gospels of Matthew and Mark. In the gospel of Luke all the disciples are present when Christ discovers them asleep: 'Why sleep ye? rise and pray, lest ye enter into temptation' (Luke 22: 46).[7] With this interpretation, not only the darkness is explained, but also the sleeping John and the yawning man. Only the number of ten is actually one too few, but it is uncertain whether this should count as an argument against this identification. The gesture of the seated Christ, with his hand on his chest and heart is, however, different from the pose in other drawings of the return from Gethsemane, where Christ is shown standing with outstretched arms.[8]

As it is so difficult to pinpoint the subject, it does not seem improbable that there is an amalgamation of subjects. The drawing could then in the first instance represent 'Christ's Prophecies and Warnings' with motifs from 'Christ's Return from Gethsemane', in particular the darkness and the yawning man.

The same amalgamation was drawn by Rembrandt's pupil, Philips Koninck, and here also Christ is holding his hand to his chest (Fig. 6a).[9] Moreover, there are only ten disciples present, John is sleeping and another disciple is yawning.

Only a few of Rembrandt's drawings are so elaborately worked. There is a drawn portrait from the same year, which probably represents Willem van der Pluym and was made as an independent drawing, finished in the same media,[10] so it is not improbable that the *Christ and his Disciples* had a similar function.[11] Both works are signed and dated.

P.S.

1. Michiel Plomp was so kind as to make available his as yet unpublished catalogue text, of which use has gratefully been made.
2. Panofsky suggested that it concerns 'The calling of the first Disciples and the first Healed' (Matthew 4: 18–25) and the 'Sermon on the Mount' (Matthew 5: 1–12), in: Brussels/Hamburg 1961 (German edition).
3. Mentioned are the *Raising of Lazarus* (Van Regteren Altena, in Rotterdam/Amsterdam 1956, p. 20) and *The Healing of the epileptic Boy* (F. Wickhof, *Einige Zeichnungen Rembrandts mit biblischen Vorwürfen*, Innsbruck 1906, p. 25).
4. W. Weisbach, *Rembrandt*, Berlin-Leipzig 1926, pp. 141–42, *Corpus* III A90, p. 473.
5. Amsterdam 1964–1965 and Hoekstra 1981.
6. By Michiel Plomp, op. cit.
7. Plomp gives as an example a painting in Braunschweig by Orazio Borgianni in which eleven disciples appear.
8. Benesch 613, 940 and 941.
9. Paris, Ecole des Beaux-Arts; Benesch A53; Sumowski *Drawings*, 6, No. 1525–xx. The drawing is dated by Benesch and Sumowski to the first half of the 1640s.
10. New York, private collection; Benesch 433. I.H. van Eeghen, 'Willem Jansz. van der Pluym en Rembrandt', *Amstelodamum* 64 (1977) 1, pp. 6–13.
11. Plomp does not rule out the possibility that the drawing was begun as a design for an etching and then later changed hands as a work of art in its own right.

6a: Philips Koninck, *Christ and the Apostles*. Paris, Ecole des Beaux-Arts.

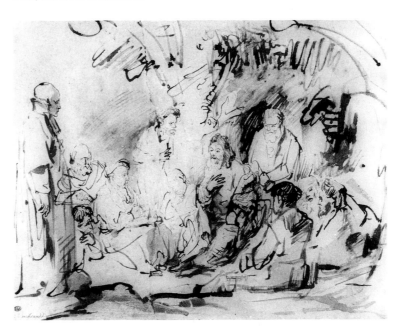

7

Sketches of figures for John the Baptist preaching

Pen and brown ink, 167 × 196 mm
Berlin, Staatliche Museen Preussischer
Kulturbesitz, Kupferstichkabinett.

Provenance: Sir Thomas Lawrence (L. 2445),
London; Samuel Woodburn, not in 1835
London Cat.; William Esdaile (L. 2617), sale
London 17 June 1840, No. 35 (to Brondgest);
KdZ 3773 (1884).

Literature: Bock-Rosenberg 1930, No. 3773,
p. 235; Benesch 1954–1957 and 1973, No. 141
(with other previous literature and
exhibitions); *Corpus* III under A 106, p. 83,
Fig. 14.

Exhibition: Berlin 1970, No., 71.

7a: Rembrandt, *St John the Baptist preaching*
(detail). Berlin, Gemäldegalerie SMPK.

7b: Rembrandt, *Sheet of studies* (recto).
Chatsworth, The Devonshire Collection.

7c: Rembrandt, *Sheet of studies* (verso).
Chatsworth, The Devonshire Collection.

The *John the Baptist preaching* (Fig. 7a), a
grisaille formerly in the collection of Jan Six
(see Cat. No. 23) and now in Berlin, is one of
Rembrandt's ambitious compositions from the
1630s.[1] This painting, like other works
executed in the same technique, is probably a
design for an etching, which was, however,
never made.

In this picture countless figures in all
manner of poses and stances are depicted
around John as he preaches. Rembrandt made
a number of preparatory drawings for the
grouping and characterisation of these figures
in approximately 1634–1635 when the initial
design of the monochrome painting had
probably already been completed.

There are two sheets of sketches with
different versions of the group of scholars in the
centre of the composition, the exhibited draw-
ing and one at Chatsworth with sketches on
both sides of the sheet (Figs. 7b and 7c).[2] On
one side two figures are conversing while a
third leans on a stick listening to them. This is
presumably the first version of this group,
which was elaborated further in the exhibited
drawing.

On the left-hand side Rembrandt drew the
same two scribes and the listening man but in
between them he placed a third figure with a
tall hat. This additional figure was also
included full-length on the lower right, while
another, separate drawing exists of just the
head.[3] The face of the same man is also drawn
on the verso of the Chatsworth sheet, cut off
below centre and partly at the edge (and
possibly above it as well). The group of three
appears again in the centre of the Berlin
drawing, but now without the listening figure.
Rembrandt tried out the heads of these figures
once more above these sketches.

The scribe seen from the side has undergone
the most interesting development: in the
Chatsworth sketch he is wearing a long cloak
and holding a stick. In the two sketches in the

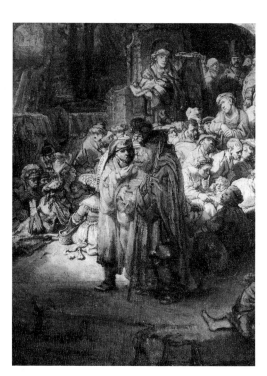

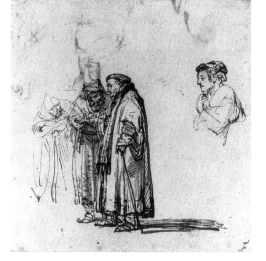

lower part of the Berlin drawing, where he is wearing the same sort of headdress as the man above left,[4] he has taken on the form of Willem Ruyters, an actor with plump cheeks and a fat stomach, who Rembrandt drew more than once (Fig. 7d).[5] In the painted version the figure is dressed in such a way that very little of his face remains visible. The actor, drawn from life, was therefore used as a type for one of the scholars, but Rembrandt eventually abandoned this idea. This illustrates the rôle played by drawings from life in a sketch created from the imagination.

A number of other sketches can be seen at the top of the Berlin drawing. The man leaning on his arms at the top right-hand side is comparable to the figure at the feet of John who is leaning on the ground. So, when Rembrandt drew this sketch the spatial structure the composition had already been determined. This may also be the case in another pen drawing in Berlin showing a group of listening figures (Fig. 7e).[6] In the painting similar figures sit and stand at the feet of John. The foliage at the top of this drawing could be compared to the foliage in the painting next to and behind John. It is true that the figures in the drawing are different from those painted, but we do encounter similar motifs. Rembrandt here especially tried to depict various ways of listening, from sceptical to sympathetic and from empathetic to uncomprehending. From the innumerable sketches we can understand a little of the way in which Rembrandt tried out different versions and built up shape in the painting, which in the end still differs from the drawings.

Two other drawings are also connected with the painting: one in Stockholm shows three studies of the figure of a negro with a plumed hat and a quiver. A similar figure lies on the ground listening to the left of centre in the painting, while another such figure stands in the right foreground.[7] Finally, there is a red chalk drawing which twice shows the figure of *John preaching* (Fig. 7f)[8] The bearing and position are roughly the same, but in the painting John's face is depicted from the side, not diagonally from the front, and with outstretched arm and fingers spread.
The exhibited drawing is a typical example of a sketch, in which Rembrandt, while drawing, sought solutions for the expression and bearing of various figures and the relationship between them, in this case during work on a particular painting, bearing its progress in mind. Such a sheet therefore had a preparatory function for Rembrandt, although the figures were not necessarily incorporated into the painting. A comparable drawing was made as an example for pupils and can be regarded as a model sheet (Cat. No. 8).

The sketchy drawing style, with its occasionally rather scratchy use of line, is in keeping with various other drawings of this period (Cat. Nos 5, 9 & 12). The dating of the painting to 1634–1635 also applies to the drawings which Rembrandt made in preparation for it. P.S.

1. Berlin, Gemäldegalerie SMPK; *Corpus* III A106.
2. Chatsworth, The Devonshire Collection; Benesch 142, recto and verso.
3. New York, Pierpont Morgan Library; Benesch 336.
4. Rembrandt wears a similar headdress in a *Self-portrait* ascribed to him in Washington, National Gallery of Art; Bredius/Gerson 39.
5. Dudok van Heel 1979–I; Albach 1979, pp. 19–21; the drawings of this actor which could have been made from the life or from memory are in London, Victoria and Albert Museum, Benesch 235; in Rouen, Musée des Beaux-Arts, Benesch, 230; Chatsworth, The Devonshire Collection, Benesch 120.
6. Berlin, Kupferstichkabinett SMPK; Benesch 140.
7. Stockholm, Nationalmuseum; Benesch A20. This drawing is inscribed on the back, possibly in Rembrandt's hand, [schi] *lderij 2-0-0/3* [Changed to] *5-0-0.*
8. London, The Princes Gate Collection, Courtauld Institute Galleries; Benesch 142A.

7d: Rembrandt, *The Actor Willem Ruyters.* London, Victoria and Albert Museum.

7e: Rembrandt, *Sketches of listening figures.* Berlin, Kupferstichkabinett SMPK.

7f: Rembrandt, *Two sketches of St John preaching.* London, Princes Gate Collection, Courtauld Institute Galleries.

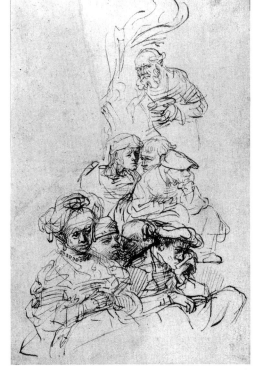

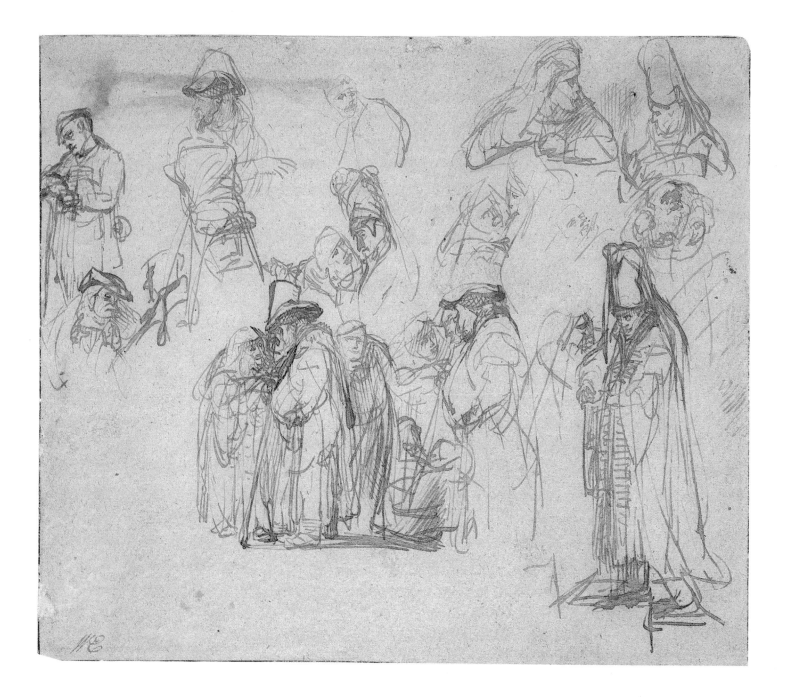

8

Model sheet with male heads and three sketches of a woman with a child

Pen and brown ink, brown wash, red chalk,
220 × 233 mm
Birmingham, The Barber Institute of Fine Arts

Provenance: R.P. Roupell (L. 2234), sale London,
12–14 July 1887, No. 1109; J.P. Heseltine
(L. 1507), London; H. Oppenheimer, London;
O.F. Oppenheimer, sale London, 17 June 1949,
No. 27.

Literature: Benesch 1954–57. No. 340; Bruyn
1983, pp. 55, 58.

Exhibitions: Amsterdam 1969, No. 37; Hamish
Miles and Paul Spencer-Longhurst, *Master
Drawings in the Barber Institute*, London (Morton
Morris & Company) 1986, No. 12 (with other
previous literature and exhibitions).

8a: Rembrandt, *Model sheet.*
Berlin, Kupferstichkabinett SMPK.

There is a difference between sheets with
sketches of various heads and figures made in
preparation for a painting or etching, and the
so-called model sheets. To the first group
belong, for example, the sketches for *The
Preaching of John the Baptist* (Cat. No. 7), where
Rembrandt appears to have experimented with
all sorts of versions of figures and groups in
order to hit upon the right shape. In contrast,
the exhibited drawing shows deliberation in the
placing of the sketches: it is not a preliminary
study. Model sheets have a less sketchy style
than sheets with sketches and are more
finished. They gave the artist the opportunity
to draw various characteristic heads and figures
on the same sheet and were intended as
examples for pupils.

Since time immemorial such sheets belonged
to model books which were at the disposal of
artists and their pupils in the studio. These
model books originally consisted of drawings,
but later there were also editions of prints, as a
result of which the examples of course achieved
a wider circulation.

Rembrandt made a number of etchings in
the tradition of such model books. In the
eighteenth century there is even a mention by
Dézalier d'Argenville of a model book by
Rembrandt, which probably consisted of
etchings of heads and figures as well as studies
of the nude.[1] We do not know for certain
whether this *livre à dessiner* of his etchings was
assembled by Rembrandt himself or by a later
collector or dealer.

The man with plumes on his headdress
wears a cloak with an ermine collar. His left
hand constitutes the centre of the sheet. The
other heads and figures have been placed in a
circle around it. At the left are two male heads,
one seen from the side and one who is looking
at us over his shoulder. To the right are three
sketches of a woman breastfeeding her child.
Two sketches show the woman with the child
in her arms, the central sketch only shows the
sleeping child against the breast. At the above
left there are two small turbaned heads. At the
bottom right Rembrandt drew a man wearing a
fur-trimmed hat who leans on a table and
seems to be listening.

This latter figure is the only one executed in
red chalk, while his features have been streng-
thened with the pen. The underside of the pen-
drawn arm of the man in the middle is
heightened with red chalk. This combination of
various media on the same sheet also occurs in
a drawing in Amsterdam of *Sketches of grieving
Marys.*[2]

The combination of exotic heads with
sketches of a woman and child does not seem
to have any particular significance. We see, for
example, similar male heads in etchings of
oriental heads, which Rembrandt made in 1635
after the example of Jan Lievens.[3] Rembrandt
also drew Saskia with a child in her arms and
the sketches on the model-sheet could be
inspired by these. In an etching of 1636 by
Rembrandt various heads of Saskia are again
combined with the head of a man wearing a
turban.[4] The variety of motifs was probably
deliberate.

Not all of these drawings have remained in
their original form. Dealers cut up some of
the sheets in order to earn more from the
individual drawings. In Rembrandt's œuvre,
we therefore come across all sorts of small
drawings, which were originally parts of larger
sheets. A drawing in Berlin consists of sketches
on small pieces of paper which have been
pasted onto a new sheet of paper to form a
whole (Fig. 8a).[5] Some pieces however are
missing, as the head of a goose in the centre
has been cut off. The exhibited drawing is, in
contrast, the finest model sheet in Rembrandt's
œuvre that has remained intact. The drawing
dates from the mid 1630s.

I.J. de Claussin (1795–1844) made a print
after Rembrandt's drawing, in which he
omitted the sketch in red chalk. However, in
the centre he added a head which derives from
another drawing.[6]

P.S.

1. Dézalier d'Argenville, *Abrégé de la vie des plus fameux
peintres . . .*, II, Paris 1745; 'son livre à dessiner est de
dix à douze feuilles'; J.A. Emmens, *Rembrandt en de regels
van de kunst*, Utrecht 1968, pp. 155–58; Bruyn 1983,
p. 57.
2. Made in 1635–1636 in preparation for *The Entombment*
in Munich; Benesch, No. 152; Schatborn 1985, No. 7.
3. B. 286–89.
4. B. 365.
5. Berlin, Kupferstichkabinett SMPK; Benesch,
No. 219.
6. Giltaij 1988, in No. 16; Benesch, No. 190.

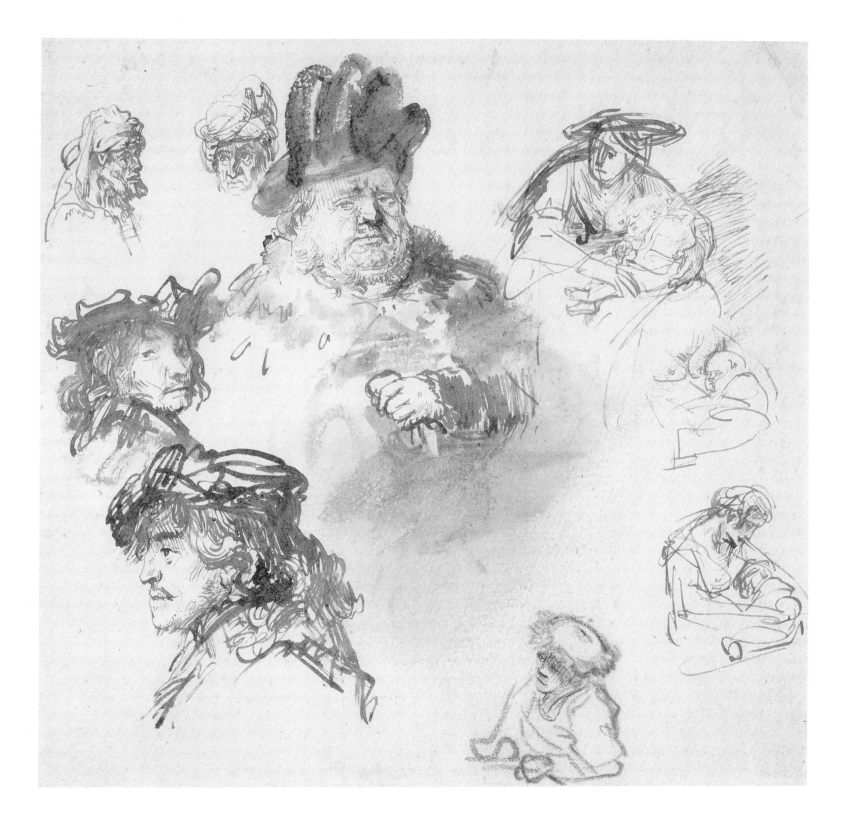

9

Woman with a Child descending a staircase

Pen and brown ink and wash, 187 × 132 mm
Inscription: bottom right, unidentified sign
New York, The Pierpont Morgan Library

Provenance: Charles Fairfax Murray, London;
John Pierpont Morgan, New York (1910);
Inv. No. I. 191.

Literature: Benesch 1954–1957 and 1973,
No. 313.

Exhibitions: New York/Cambridge 1960, No. 23;
Amsterdam 1969, No. 44; Paris/Antwerp/
London/New York 1979/1980, No. 68 (with
other previous literature and exhibitions).

One of the many subjects which Rembrandt drew is called *The Life of Women with Children* in the inventory of 1680 of Jan van de Cappelle.[1] The latter, a painter of seascapes, owned approximately 500 drawings by Rembrandt and 135 of these were representations of women and children. Although this title does not appear in the inventory of Rembrandt's own collection of 1656, the album of drawings as acquired by Van de Cappelle was probably put together by Rembrandt.[2] Drawings of women and children occupy an important place in the œuvre, especially among the drawings of the 1630s and 1640s.

The drawing of the woman descending a staircase with a child in her arms probably originates from the album of Van de Cappelle. One of the later owners added a letter (*R?*) or a sign at the lower right, which also appears on other drawings, particularly those of women and children.[3]

The young woman is wearing a small cap on her head and a cord with a tassel (or a purse?) hangs from her dress. She is shown in movement, the visible leg bent, while her dress is dragging on the stairs. The spiral staircase is certainly not depicted in the correct perspective, but it is still clearly recognisable. The young woman clasps the little boy to her, with his face touching hers.

The genesis of Rembrandt's drawings can often be read in the work itself. The fine lines were gradually supplemented by and replaced with stronger lines. The back of the boy is, as it were, expanded backwards and in comparison with the first version the legs hang more vertically. The contour of the woman's hair has been moved further out in order to obtain a better form for the head. On the other hand, the profile and the face of the child seem to have been set down correctly from the outset. Characteristic of Rembrandt is the transparent wash, through which light constantly shines and flat areas and hard contours hardly ever appear.

It is uncertain to what extent such a drawing was made from life. There is no doubt that the scene was observed, but it is likely that it was put onto paper from memory. This method of working was called 'van onthoudt' (from recollection) in the seventeenth century.[4] The similarity of the child's features with others in Rembrandt's drawings indicates that he based them on an existing model, as can be seen in the depiction of Ganymede (Cat. No. 10) and other drawings. It is clearly more likely that an existing type served as a model when he was drawing from imagination or 'from memory' rather than that he drew directly from the life.

The subject comes of course from Rembrandt's immediate surroundings. It used to be thought that Rembrandt used his wife Saskia and their children as models for his drawings, but we now know that all his children, with the exception of Titus born in 1641, only lived for a short time, and this is no longer a possibility (see Cat. No. 20).[5] However, after 1631 Rembrandt worked for a considerable time with Hendrick Uylenburgh, who became his brother-in-law in 1634. Uylenburgh had married Maria van Eyck in 1624 and by 1634 they had six children with whom Rembrandt was of course acquainted. When he married Saskia in that year these children of all ages became his nephews and nieces. They were probably an important source of inspiration for the images of the life of women and children mentioned in Van de Cappelle's inventory.[6]

The style of the drawing with its fine pen lines and transparent wash is typical of the mid-1630s. Comparable is for example the *Model sheet with heads* (Cat. No. 8).
P.S.

1. A. Bredius, 'De schilder Johannes van de Cappelle', *Oud-Holland* 10 (1892), pp. 26–40 and 133–136; Schatborn 1982, pp. 1–12.
2. In Rembrandt's inventory of 1656 these drawings are probably included among the 'sketches'. We also come across 'histories' in his inventory, which are also not mentioned individually in Rembrandt's inventory. In addition Van de Cappelle owned numerous landscapes: 277 in total.
3. Exhib. Cat. Paris, Antwerp, London & New York 1979–80, No. 68.
4. Alison McNeil Kettering, *Drawings from the Ter Borch Studio Estate*, I/II, *Catalogue of the Dutch and Flemish Drawings in the Rijksprentenkabinet, Rijksmuseum, Amsterdam*, The Hague 1988, No. H51.
5. Van Eeghen 1956.
6. Amsterdam 1984–1985, p. 8.

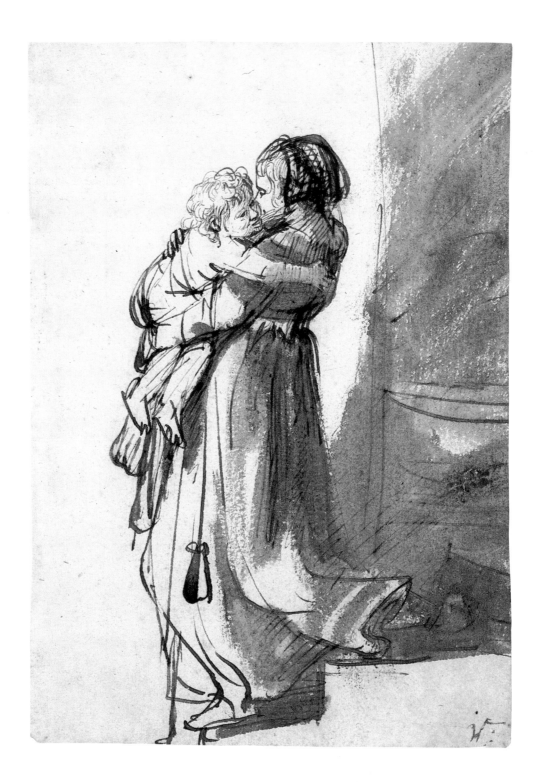

IO

The Rape of Ganymede

Pen and brown ink and wash, 183 × 160 mm
Dresden, Kupferstich-Kabinett der Staatlichen
Kunstsammlungen

Provenance: Gottfried Wagner, Leipzig (1728);
The Electors of Saxony (L. 1647), Dresden;
Inv. No. C 1357.

Literature: Benesch 1954–1957 and 1973,
No. 92 (with other previous literature
and exhibitions); Margarita Russell,
'The Iconography of Rembrandt's Rape
of Ganymede', *Simiolus* 9 (1977), 1,
pp. 5–18; *Corpus* III under A 113.

10a: Rembrandt, *The Rape of Ganymede*.
Dresden, Staatliche Kunstsammlungen.

10b: Nicolas Beatrizet after Michelangelo,
The Rape of Ganymede. Amsterdam,
Rijksprentenkabinet.

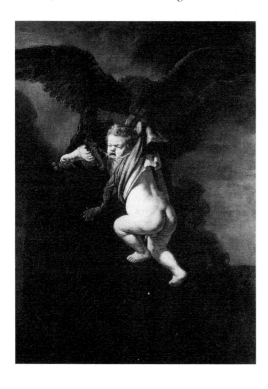

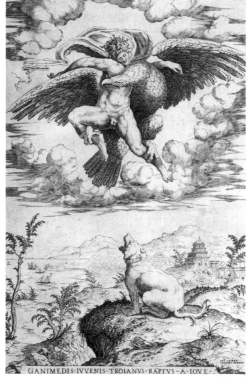

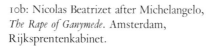

The art and literature of antiquity held a well-established place in European culture. The stories belonged to the popular repertoire of writers and artists and were widely-known in the seventeenth century. Among Rembrandt's narrative representations biblical subjects hold the most important place, but in addition to these there are a considerable number of mythological representations.

Ganymede, described in *The Iliad* as the 'divine' son of the Trojan king Tros and the most beautiful of all mortals[1] was, because of his beauty, abducted by Zeus who had taken on the form of an eagle, to become cup-bearer to the gods. In 1635 Rembrandt made a painting of this abduction (Fig. 10a).[2] The exhibited drawing is a preliminary sketch for the composition.

With wings outstretched the eagle holds the arms of the little boy in his claws and beak in such a way that the little tunic has been pulled up leaving him almost completely naked. In the lower left of the drawing the despairing parents watch their little boy disappear. These figures do not appear in the painting, but they are mentioned in Karel van Mander's *Explanation* of the much-read *Metamorphoses*. Moreover, Van Mander says that Ganymede was taken from them at an early age by death; that is, while he was still a child.[3] By depicting him as a child, Rembrandt has placed less emphasis on the erotic aspect of the story. In the drawing the child is not peeing as he is in the painting. In the latter this refers to Ganymede's transformation into the constellation Aquarius, as Van Mander relates. It is plausible to suppose that the telescope, through which Ganymede's father is looking, has a connection with this astrological aspect.[4]

The features of the child, particularly as depicted in the painting, are of a classic type, based on examples by other artists.[5] We come across the same child crying in Rembrandt's drawing which has long been known as *The naughty Child*,[6] and again as a *putto* in Rembrandt's *Danaë* from 1636.[7] A drawing which is more directly based on observation also has these classic features (Cat. No. 9).

For the composition of the drawing Rembrandt probably made use of a print by Nicolas Beatrizet, after Michelangelo (Fig. 10b) in which Ganymede is however represented as a young man and not as a child.[8] Rembrandt usually made the initial design for his composition directly onto the canvas, panel or etching plate and he very rarely drew a design for a painting. The studies which relate to paintings either work out an alteration to the first design or serve to elaborate a section of the composition. The print by Beatrizet served the

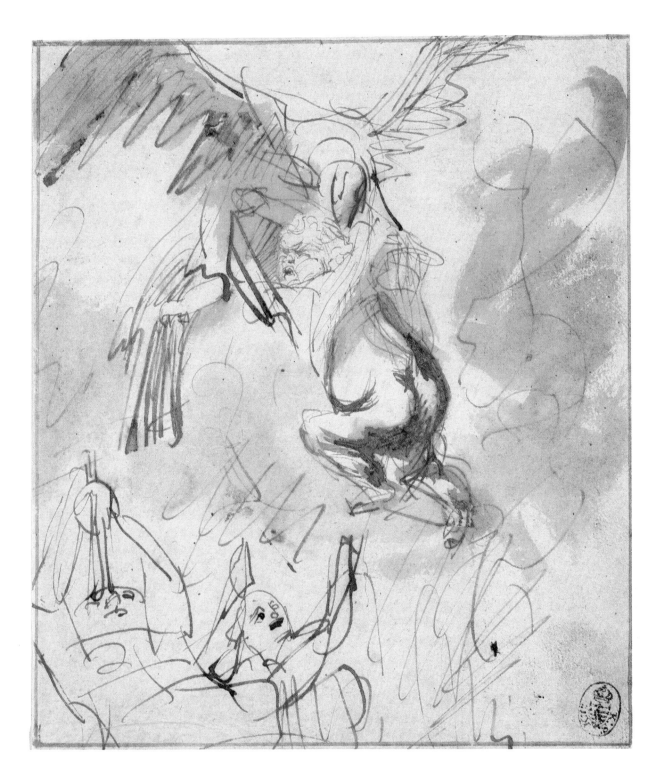

purpose of a first design and the drawing developed alterations to the print which Rembrandt then incorporated in the painting.[9] By omitting the parents in the painting he has placed all emphasis on the principal motif and thereby weakened the narrative and incidental aspects of the event in favour of the broader symbolic character. In the place where the parents were, there is now a section of a building, which does not distract the attention from the event.

The drawing is exceptionally sketchy. The classic features of the child are already visible and Rembrandt therefore did not base it on a drawing made from life.[10] There is enormous variety in the use of line: the face and figure of the child are executed with small fine lines, whereas the eagle on the whole is depicted in broad strong lines. The way in which the repeated contours of the lower half of the child are drawn shows the search for the right shape. The figures of the parents, seen from below, are rudimentarily and summarily indicated. Rembrandt indicated the background with loose zig-zag lines, whereas in the painting he depicted trees and the sky. Finally the shadow on the eagle and under the tunic of the child was added and the background was also in part lightly shaded.

This drawing style is in keeping with that of other drawings from the mid 1630s (Cat. No. 5 and 12).[11]

P.S.

1. Homer, *The Iliad*, E232.
2. Dresden, Staatliche Kunstsammlungen, Inv. No. 1558.
3. Karel van Mander, 'Uitleggingh op den Metamorfosis Pb. Ovidij Nasonis', in the *Schilderboeck*, 1604, fol. 87.
4. *Corpus* III under A113.
5. Peter Schatborn, 'Over Rembrandt en kinderen', *De Kroniek van het Rembrandthuis* 27 (1975), pp. 8–19.
6. Benesch 401.
7. J. Bruyn, 'On Rembrandt's use of Studio-Props and Model Drawings during the 1630s', *Essays in Northern European Art presented to Egbert Haverkamp-Begemann on his sixtieth birthday*, Doornspijk 1983, pp. 52–60.
8. Clark 1966, p. 15, Fig. 13.
9. The composition of an Italian print, in this case by Sisto Badalocchio after Raphael similarly provided the source for the drawing *Isaac and Rebecca Espied by Abimelech*, New York, private collection, Benesch 988, which was the basis for *The Jewish Bride* in the Rijksmuseum.
10. In another instance he did use a small drawing, *A Child frightened by a Dog*, Budapest, Szépmüvészeti Múzeum, Benesch 477 is the finished version of a study made from life in Paris, Fondation Custodia (coll. Lugt), Benesch 403 recto.
11. Particularly related is also *The Lamentation* in Berlin, Benesch 110 recto.

I I

Susanna and the Elders

Red chalk, grey wash, 235 × 364 mm

Inscriptions: below right *Rf* on the verso an inscription in Rembrandt's hand, in red chalk:; in black chalk: '*verkoft syn vaendraeger synd 15—— | en flora verhandelt—6—| fardynandus van sijn werck verhandelt | aen ander werck van sijn voorneemen | den Abraham een floorae | Leenderts floorae is verhandelt tegen 5 g'*. (sold, his standard-bearer for 15—— | a flora sold—6—| sold work by ferdynandus / another work by him / the Abraham / a flora / Leendert's flora was sold for 5 guilders).
Berlin, Staatliche Museen Preussischer Kulturbesitz, Kupferstichkabinett.

Provenance: Court Andreossy, sale Paris, 13–16 April 1864, in No. 356; Jan-François Gigoux, not in sale Paris, 6 May 1861 and 20 March 1882; Adolf von Beckerath, Berlin; KdZ 5296 (1902).

Literature: Bock-Rosenberg 1930, No. 5296, p. 224; Benesch 1954–57 and 1973, No. 448 (with other previous literature and exhibitions); Broos 1981, p. 257; Broos 1983, p. 40 and 44; Paris 1986, in No. 41, Fig. 2; *Documents*, p. 594–595.

Exhibitions: Berlin, 1970, No. 35; New York 1988, No. 30.

Susanna and the Elders has been a common biblical subject since the Middle Ages and it had not lost its popularity by the seventeenth century (Daniel 13: 15–21). The moment usually depicted is when the bathing Susanna is being spied on and blackmailed by the two old men who were, moreover, judges: they threaten that if she does not agree to have sexual relations with them they will accuse her of infidelity with someone else. Susanna refuses and is finally acquitted with the help of Daniel. Thereafter the two old men are executed.

Rembrandt's teacher, Pieter Lastman, painted the subject in 1614 (Fig. 11a),[1] and Rembrandt made a copy in red chalk, which differs in a number of details from the original. To begin with the proportion of the dimensions of the paper differ from the painting. Rembrandt's composition is wider and there is more space around the figures. This makes it all the more noticeable that one of the elders is standing nearer to Susanna in the drawing than in the painting, while stretching out his arm behind her. In this way Rembrandt has strengthened the menace that emanates from this man.[2] Other motifs have similarly been altered. The peacocks on the righthand side have been reduced in scale and the water-spewing stone sculpture and the building in the background have been enlarged. The most striking difference between Rembrandt's drawn copy and Lastman's painting is the position of Susanna's hands: Rembrandt moved the right hand, held up in shock in Lastman's painting, to her lap where the other hand rests.[3]

Susanna and the Elders is not the only copy which Rembrandt made after a painting by his teacher.[5] He made a drawing in black chalk[5] of the principal group in *The Dismissal of Hagar*.[4] The figures of Abraham, Hagar and Ishmail in this copy provided the basis for an etching and a number of drawings by Rembrandt and by his pupils.[6] Rembrandt made two other copies after Lastman, in red[7] and black chalk[8] respectively, after *Paul and Barnabas at Lystra*[9] and *Joseph distributing Corn in Egypt*.[10] These subjects were not depicted by Rembrandt himself.

Rembrandt twice depicted the bathing Susanna in paintings, once as an isolated seated figure—here only the heads of the elders are visible through the bushes—(Fig. 24a) and once standing in a larger composition of which the elders also form a part (Fig. 24b).[11] Rembrandt depicted the seated Susanna in the painting in the Mauritshuis with her right hand in her lap and the left hand at her breast in a gesture of shock and defence. The painting is dated 1636 and it is possible that the copy

drawn after Lastman predates it and served as a source of inspiration. Thus, the position of Susanna's hand in Rembrandt's painting may already have been prepared in the drawn copy.

Rembrandt made notes concerning the sale of work of pupils on the back of the drawing (Fig. 11b). There are two names, 'fardynandus', Ferdinand Bol, and 'Leendert' van Beyeren, by whom a *Flora* is sold. A *Vaandeldrager* (Standard-bearer) and a *Sacrifice of Isaac* are also mentioned. Paintings by Rembrandt of these subjects date from 1634,[12] 1635[13] and 1636.[14] From the latter year there is also a *Sacrifice of Isaac* in Munich by a pupil.[15]

If the works mentioned on the reverse of the drawing were made after Rembrandt or inspired by him, then the notes can be dated, at the earliest, to 1636. This would then be an argument for the assumption that Bol was working with Rembrandt from that year on.[16] We know of no work by Leendert van Beyeren but at a sale in 1637 he is mentioned as a '*disipel van Rembrandt*' (pupil of Rembrandt).[17]

The relationship between the drawing and the notes raises a number of questions which cannot be answered with certainty. We could assume that the notes were written at the same time that the drawing was made. A large gap in timescale does not seem likely. It is also possible that the painting by Lastman and the recorded works by pupils were sold at the same time. Moreover, as the drawn copy after Lastman precedes Rembrandt's painting dated 1636 in the Mauritshuis, the drawing could also be dated to the same year of 1636.[18]

The style of the signature *Rf* at the lower right of the drawing is fairly unusual. One of the other copies after Lastman is signed in full,[19] as are the three known copies after Leonardo's *Last Supper* from the same period.[20] Rembrandt therefore provided the composition of another artist with his own name and so his signature refers to the execution and not to the invention.

Typical of the difference between an original drawing and a copy is the uniformity of the handling of line. The genesis of a drawing, which can often be so clearly read in Rembrandt's work, is different when working after a model. Because of this the drawing has a different character from those which are made from the imagination or from life.

P.S.

1. Berlin, Gemäldegalerie SMPK, Inv. No. 1719; K. Freise, *Pieter Lastman*, Leipzig 1911, p. 48, No. 44, pp. 135 ff. and pp. 249 ff.
2. Taking note of the differences between the drawing and the painting Broos spoke of a 'critical commentary' by Rembrandt; Paris 1986, No. 41.
3. Broos pointed to the resemblance to the classical *Venus Pudica*; Paris 1986.
4. Hamburg, Kunsthalle; Inv. No. 191.
5. Vienna, Albertina; Benesch, No. 447.
6. Hamann 1936; Amsterdam 1984–1984, Nos. 68–75.
7. Bayonne, Musée Bonnat; Benesch, No. 449.
8. Vienna, Albertina; Benesch, No. 446.
9. Previously in Russia, Court Stetzki; Freise 1911, No. 88.
10. Dublin, National Gallery of Ireland; Freise 1911, No. 20.
11. The Hague, Mauritshuis; *Corpus* III A117 and Berlin, Gemäldegalerie SMPK; Bredius/Gerson, No. 516. This last painting is dated 1647, but originated in the 1630s; see Cat. No. 24.
12. *Flora*, Leningrad, Hermitage, dated 1634; *Corpus* II A93.
13. *Sacrifice of Isaac*, Leningrad, Hermitage, dated 1635; *Corpus* III A108.
14. *A Standard bearer*, Paris, private collection, dated 1636; *Corpus* III A120.
15. *Sacrifice of Isaac*, Munich, Alte Pinakothek, dated 1636; *Corpus* III, in A108.
16. In December 1635 Bol is still mentioned as painter in Dordrecht; the drawing was previously dated to between 1630 and 1637; Blankert 1982, pp. 17 and 71: after 1635.
17. *Documents* 1637/2. In the estate of his father of 7 May 1638 four copies after Rembrandt are mentioned; *Documents* 1638/5.
18. An argument against this has been advanced, that red chalk was used for the drawing and the undeciphered inscription on the verso, and black chalk for the inscriptions concerning the work of the pupils.
19. Benesch, No. 446.
20. Benesch, Nos. 443, 444 and 445, the last is dated 1635.

11a: Pieter Lastman, *Susanna and the Elders*. Berlin, Gemäldegalerie SMPK.

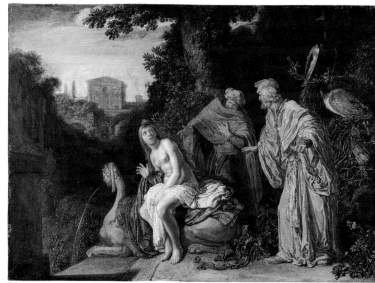

11b: Verso of Cat. No. 11.

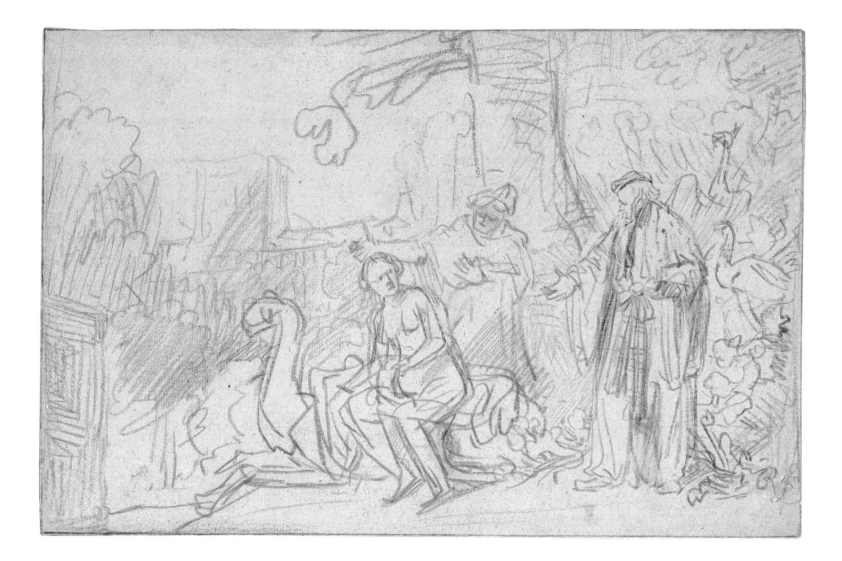

12

Seated Actor in the rôle of Capitano

Verso: *Actor in the rôle of Pantalone in Conversation.*

Pen and brown ink, brown wash; verso: pen and brown ink, 182 × 153 mm
Amsterdam, Rijksmuseum, Rijksprentenkabinet.

Provenance: Art dealer Dunthorne, London (1909); Cornelis Hofstede de Groot, sale Leipzig, 4 November 1931, No. 168; I. de Bruijn-van der Leeuw, Spiez, gift made in 1949 to the Rijksprentenkabinet, in usufruct until 28 November 1960; Inv. No. RP-T-1961-76.

Literature: Benesch 1954-57 and 1973, No. 293; Albach 1979, pp. 8-15; Schatborn 1985, No. 8 (with other previous literature and exhibitions).

Exhibition: Amsterdam 1969, No. 38.

12 verso.

12a: Jan Steen, *The Village Fair* (detail). The Hague, Mauritshuis.

When Rembrandt devised compositions of narrative subjects he employed the same techniques as a director who places his actors on stage in the *mise en scène*. Director and painter both give their own interpretation of the story. Just as with actors, Rembrandt's models were dressed up for the biblical, mythological or allegorical representation. Moreover patrons dressed themselves up as historical figures and had their portraits painted thus.

One or two actors in drawings by Rembrandt are recognisable as characters from Joost van den Vondel's *Gijsbrecht van Amstel*, a play which had its première in Amsterdam in 1638. Other drawings show players from the *Commedia dell'Arte*, such as Capitano and Pantalone: the characters on each side of the Amsterdam drawing. The actors are probably Dutch as there are no indications that Italians were acting in Amsterdam at the time that Rembrandt made the drawings.[1] He depicted quacks trying to sell their medicines in the same way as the comic characters from the *Commedia del'Arte*.

The man with the feathered hat is sitting with legs wide apart on the edge of his chair, his right hand at his side and a stick in the other hand. The long, wide cloak is draped over the back of the chair. The costume and stance characterise him as Capitano, a type which not only appears in the *Commedia dell'Arte*, but also in Bredero's *The Spanish Brabanter* of 1617, for example. Behind the Capitano hangs a cloth which was used as a simple backdrop when appearing at a fair or market. The stage was situated on an platform which explains why the scene is seen from such a low viewpoint. How such a play took place can be seen in a painting by Jan Steen (Fig. 12a),[2] among others.

A figure kneels at the left, holding a bag open for the Capitano. This bag could be the key to recognising the depicted scene. The word bag was in fact also used in the seventeenth century to denote a woman of loose morals and moreover for the female sexual organ. The open bag perhaps illustrates symbolically a scene in which the Capitano has been offered medication by a procuress. A bag also appears in Rembrandt's *Flute Player* (Etchings Cat. No. 17) where it has an erotic meaning.[3] If this interpretation is correct, the expression on the face of the Capitano could be interpreted as one of satisfaction as he listens to the proposal.

The figure of Pantalone on the verso, was drawn more often by Rembrandt. On a sheet in Groningen[4] (Fig. 12b) he is shown laughing slyly, depicted from the front and in the same

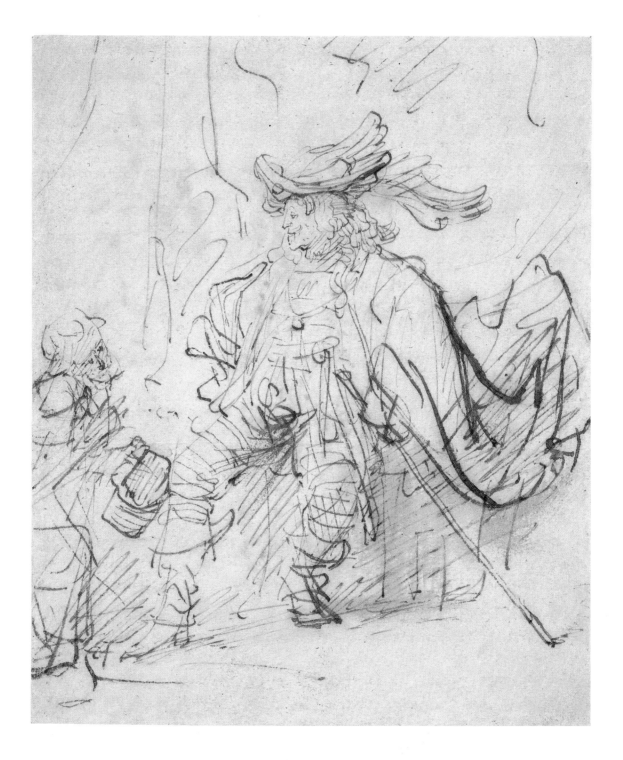

pose as in a print by the French artist Jacques Callot,[5] whereas he is seen from the side in drawings in Frankfurt[6] and Hamburg,[7] but he always displays his characteristic laughing mouth. In the Amsterdam drawing Pantalone is laughing in the direction of an unidentified man in a tall hat, who stares intently at him; only the upper half of his body is depicted. It seems that Pantalone is telling him something, all the while gesticulating, but the summarily drawn face and the stance of the other man convey incomprehension and disbelief.

It is plausible to suppose that in both drawings the figures depicted are from the same play and from the fact that Rembrandt used both sides of the paper it can be surmised that the drawing was made during the play and not in the studio.

Rembrandt's fine pen has drawn the figures in a loose and sketchy manner, whereas the faces of the Capitano and Pantelone are executed with the utmost care. Stronger accents have been added in a few places. The contours of the cloak over the back of the chair have been strengthened with a few strong lines and the space between the legs of the Capitano has also been clearly accentuated. Shadow has not only been indicated with hatching but also with the brush, particularly in the section of the chair under the Capitano's cloak.

The rhythm of the penline with its sweeping, almost scratchy, hatching is comparable to that of drawings from the mid-1630s (Cat. Nos 5, 7, 10).[8]

P.S.

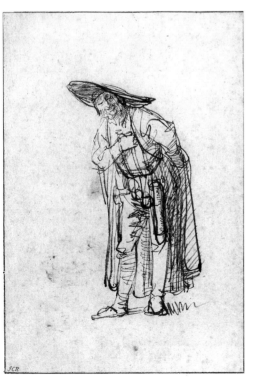

12b: Rembrandt, *Pantalone*.
Groningen, Museum voor Stad en Lande.

1. Albach 1979, p. 9.
2. Jan Steen, *The Village Fair*, The Hague, Mauritshuis. Karel Braun, *Jan Steen*, Rotterdam 1980, No. 81.
3. Alison McNeil Kettering, 'Rembrandt's Flute Player: a unique treatment of pastoral', *Simiolus* 9 (1977), 1, p. 37 and note 72.
4. Groningen, Museum voor Stad en Lande; Benesch, No. 295.
5. J. Lieure, *Jacques Callot, Catalogue de l'œuvre gravé*, No. 288.
6. Frankfurt a/M, Städelsches Kunstinstitut; Benesch, No. 297.
7. Hamburg, Kunsthalle; Benesch, No. 296.
8. The signed and dated 1635 drawing after Leonardo's *Last Supper*, Berlin, Kupferstichkabinett SMPK; Benesch, No. 445 is also comparable in style.

13

Three studies of an elephant with attendant

Black chalk, 239 × 354 mm
Vienna, Graphische Sammlung Albertina

Provenance: Archduke Albert of Saxe-Teschen (L. 174), Vienna; Inv. 8900.

Literature: Benesch 1954–57 and 1973, No. 458; L.J. Slatkes, 'Rembrandt's Elephant', *Simiolus 2* (1980), pp. 7–13.

Exhibitions: Die Rembrandt-Zeichnungen der Albertina, Vienna (Albertina) 1969–70, No. 13.

In one of Willem Goeree's manuals for artists which appeared in 1670 he gives the following advice: 'Voornamentlijk moet men sijn kans waernemen omtrent de vremdigheden, als van Leeuwen, Tygers, Beeren, Olyphanten Kameelen ende diergelijke Dieren, diemen selden onder oogen krijght, en somtjds evenwel hebben moet om in sijn Inventien toe te passen.'[1] (One should especially take the opportunity to observe the exotic, such as lions, tigers, bears, elephants, camels and such like creatures, which one rarely can set eyes on and which one sometimes must have in order to use in one's inventions). With this the author gave the reason why artists made drawings of exotic animals, although in the case of Rembrandt these were usually not used directly as preliminary studies.[2] His method of working generally meant that, having gained experience from drawing from the life, he was able to depict animals in a convincing way from his imagination.

A second drawing of an elephant, also in the Albertina in Vienna, is signed and dated 1637 (Fig. 13a).[3] Rembrandt depicted an elephant in the background of his etching of *The Fall of Man* of 1638 (Fig. 13b).[4] This elephant, in mirror-image, bears the closest resemblance to the walking elephant in the exhibited drawing, although in the etching he is carrying his trunk rather higher. The depiction of an elephant in the fall of man has a long tradition in art. In Rembrandt's etching the animal represents virtuousness as a counterbalance to the evil of the serpent.[5] A third, undated, drawing of an

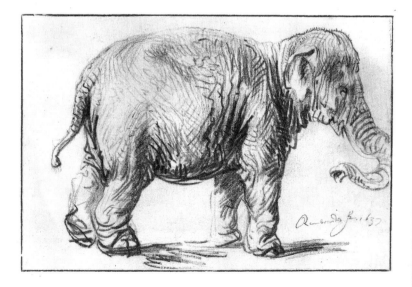

13a: Rembrandt, *Study of an Elephant.* Vienna, Albertina.

13b: Rembrandt, *The Fall of Man.* Amsterdam, Rijksprentenkabinet.

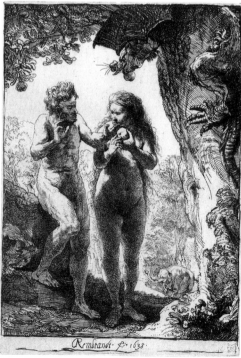

elephant is in the British Museum in London.[6] The medium which Rembrandt used for all these drawings, black chalk, is extremely effective for the characterisation of the rough skin.

The exhibited drawing is the only one which shows three studies of the same animal in various poses: lying, standing and in movement. He placed figures and heads together on a sheet in the same way.[7] The drawing of the elephant lying down is the least finished, and his rump, in so far as it is visible, is barely indicated. As in the two drawings of a single elephant, the standing elephant is seen from the side. He has just put something in his mouth with his trunk. This animal is partly shaded and rather more finished. The entirely visible elephant is stepping forward at an angle, while the attendant is perhaps guiding him with his unseen hand. The trunk has been given in two positions. The figure of the attendant has been drawn over the trunk in the lower position. This elephant is the most finished; the shadows are indicated with dark chalk lines. The hatching to the right of the animal is drawn across the man's body and the raised trunk and therefore belongs to the first version.

When an exotic animal such as this was exhibited it was obviously an exceptional event which was sometimes recorded in prints in the sixteenth and seventeenth centuries. In 1629 Wenzel Hollar depicted a ten-year-old elephant with small tusks,[8] but this image is based on a sixteenth-century print:[9] so there are instances where an older example was used as a prototype. Another print bears an inscription stating that the elephant, called Hanske, was born in Ceylon in 1630.[10] This animal died in 1655, having made many journeys through Europe. We know from many sources that this was a female elephant.[11]

Rembrandt drew the elephants from life and none of them seem to have tusks. In 1646 Herman Saftleven also made a print of an elephant without tusks and this could have been the same elephant—possibly Hanske—immortalised by Rembrandt.[12] Female Asiatic elephants do have tusks, but in contrast to those of male elephants, they are not visible, or only so with certain movements of the trunk. The walking elephant in the exhibited drawing does appear to have a tusk, but it is in the wrong place and if Rembrandt did see a tusk, then he drew it wrongly. It is clear from both of the other drawings by Rembrandt that the elephant does not have externally visible tusks. In addition, it should be noted that the tusks of the female Asiatic elephants are extremely fragile so that they appear in various lengths.

The way in which an elephant was exhibited to the public can be seen from a drawing by Jan van Goyen in the Getty Museum in Malibu.[13] Here two large, high tents are depicted and around them are standing and seated figures. Above the coach in the left foreground hangs a sign with an elephant (detail, Fig. 13c). The public could thus view the animal inside the tent and if one wanted to see the tricks the animal performed then, of course, an entry fee had to be paid. Van Goyen's drawing is dated 1653 and it is possible that it is again Hanske who is being shown to the public.

P.S.

1. Willem Goeree, *Inleydingh tot de Practijck der algemeene Schilderkonst*, Middelburg 1670, p. 121.
2. An exception is the drawing with two sketches of the head of a camel (Benesch, No. 454), of which one probably served as model for the animal in the background of *The Hundred Guilder Print* (Etchings Cat. No. 27).
3. Benesch, No. 457.
4. B. 28 (Etchings Cat. No. 11).
5. Slatkes 1980.
6. Benesch, No. 459. A fourth elephant recorded by Benesch is in the Pierpont Morgan Library, Benesch, No. 460. This is a counter-proof after a drawing probably made by one of Rembrandt's pupils.
7. For example in the etchings of heads of Saskia, B. 365, 367 and 268.
8. G. Parthey, *Wenzel Hollar*, Berlin 1853, No. 2119. Apart from the scene in the centre, there are also ten small pictures in which the elephant is performing various tricks.
9. This print by P. van Groeningen is from 1563; FM 462.
10. Slatkes 1980, fig. 2. It is improbable that this image was based on observation. It is possible that use was made of one of the elephants in the print by Hollar. This could also be the case with the anonymous print, FM 1854.
11. The details given here were provided by Prof. Dr. L. Dittrich, Zoological Gardens, Hannover, for which our special thanks.
12. Holl. 40.
13. George Goldner *et al.*, *European Drawings, I, Catalogue of the Collections*, The J. Paul Getty Museum, Malibu, 1988, No. 108.

13c: Jan van Goyen, *A Village Festival* (detail). Malibu, The J.Paul Getty Museum.

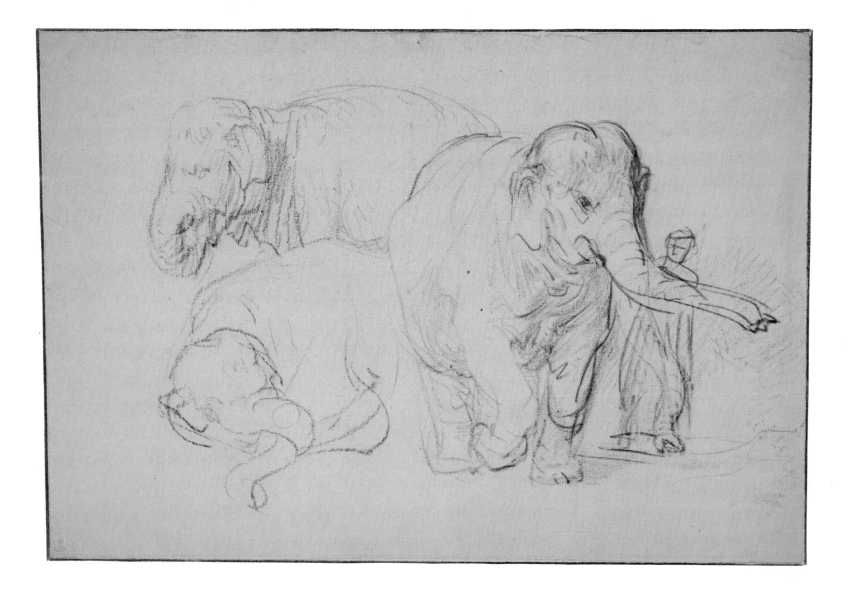

14

Two riders on horseback

Pen and brown ink, brown and white wash, red and yellow chalk, 212 × 153 mm

Inscription: on the old mount, above left *81*, on the reverse *6* and *J C Robinson/July 18 1893/from Lrd Aylesford Colln.*
New York, The Pierpoint Morgan Library

Provenance: Jonathan Richardson (L. 2184), sale London, 22 January–8 February (in fact 11 February) 1747; Thomas Hudson (L. 2432), sale London 15–26 March 1779, in lot No. 52; Henneage Finch, 5th Earl of Aylesford (L. 58), sale London, 17–18 July 1893, No. 265; Sir John Charles Robinson, sale London 12–14 May 1902, No. 355; Charles Fairfax Murray; J. Pierpont Morgan; Inv. No. I 201.

Literature: Benesch 1954–57 and 1973, No. 368; Konstam 1978, p. 27.

Exhibitions: Rotterdam/Amsterdam 1956, No. 74; New York/Cambridge 1960, No. 31; Chicago/Minneapolis/Detroit 1969; No. 112; Paris/Antwerp/London/New York 1979–1980, no. 71 (with other previous literature and exhibitions).

Four drawings which show related figures and which are executed in the same style and technique were still together in the eighteenth century in the collection of Jonathan Richardson. On one drawing are *Two negro drummers mounted on mules* (Fig. 14a),[1] and on another we see *Four negroes with wind instruments*.[2] Dutch horsemen are depicted on the other two sheets: one wears a tall hat and is seated on a horse;[3] on the other sheet there are two riders. In both drawings the horses are only summarily indicated.

It is not absolutely certain where and for what purpose Rembrandt made the four drawings. It has been suggested that he saw the horsemen when he attended the celebration of the marriage of Wolfert van Brederode and Louise Christine of Solms which took place in The Hague on 11 February 1638. On 19 February and the days following processions and competitions took place. According to an old description nobles and moors in costume were present.[4] Unfortunately, there are no other depictions of this event which could confirm this identification.

Another suggestion assumes that Rembrandt executed the four drawings in the studio and that the models were placed in front of a mirror.[5] In the New York drawing the figure behind the first would then be his mirror-image, while Rembrandt drew two different headdresses for variety. In this case the four drawings would also have been made after life.

The two horsemen are seen at an angle from the front and slightly from below. The one is wearing a tall hat, the other a flat beret with a feather. The heads have been characterised concisely in strong pen lines. The collar of the man in front has simply been indicated with a zig-zag line, while the horse has been depicted in loose pen lines and strokes of the brush.

The technique of the drawing is rather unusual as Rembrandt added red and yellow chalk to the pen and brush. This combination of materials does not often appear in his œuvre of drawings. Only the drawings after Mughal miniatures from the 1650s can serve as a comparison in this respect (see Cat. No. 37).

Both groups of drawings were formerly together in the collection of Jonathan Richardson. He may have acquired these drawings simultaneously, as they were originally sold in groups organised by subject in Rembrandt's albums.

P.S.

1. London, British Museum; Benesch, No. 365.
2. New York, collection Eugene Thaw; Benesch, No. 366.
3. London, British Museum; Benesch, No. 367.
4. I.Q. van Regteren Altena, 'Retouches aan ons Rembrandt-beeld, De Eendracht van het Land', II, *Oud Holland*, 67 (1952), pp. 60–63.
5. Konstam 1978.

14a: Rembrandt, *Two negro Drummers mounted on Mules*. London, British Museum.

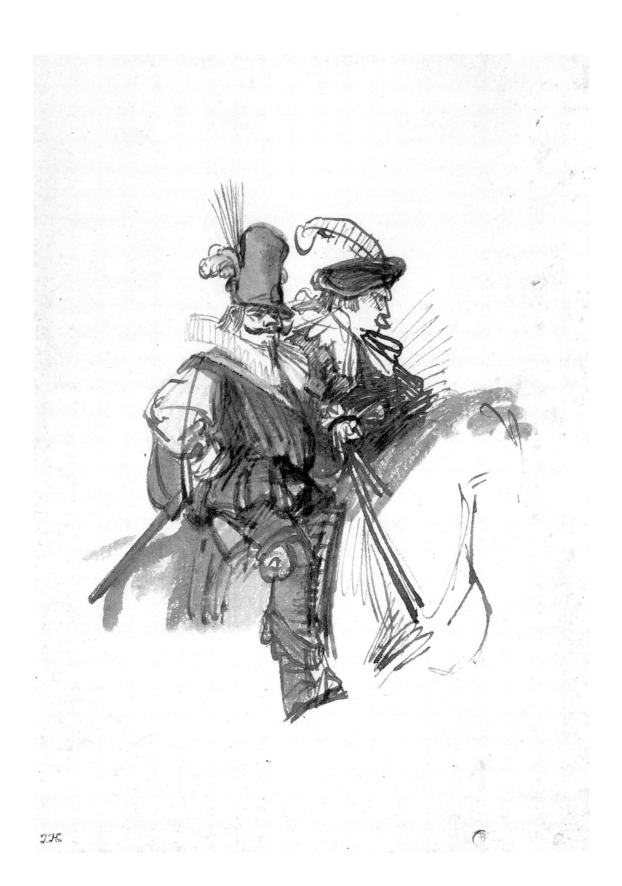

15

Two studies of a Bird of Paradise

Pen and brown ink, brown and white wash
181 × 151 mm

Inscriptions: below left *Rembrand*; above right *46*
(album Bonnat).
Paris, Musée du Louvre, Départment des arts
graphiques

Provenance: U. Price (L. 2048), sale London, 3
May 1854, No. 187; L. Bonnat, Paris (L. 1714),
presented to the Louvre in 1919; Inv. No. RF
4687.

Literature: Lugt 1933, No. 1195; Benesch 1954–
57 and 1973, No. 456.

Exhibitions: Amsterdam 1969, No. 33; Paris
1988–1989, No. 26 (with other previous
literature and exhibitions).

15a: Rembrandt, *Oriental and a Bird of Paradise.*
Paris, Musée du Louvre, Département des arts
graphiques.

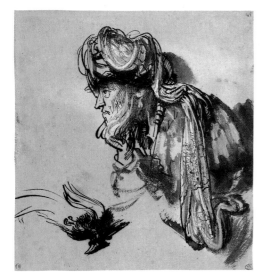

Rembrandt had a good instinct for the best
medium to use for drawing various kinds of
animals. Elephants were made in black chalk
(Cat. No. 13), lions in chalk but also in pen
and wash (Cat. No. 25). Rembrandt drew the
two birds of paradise in pen; with this medium
he could most aptly capture the characteristics
of the bird. The head and body were made in
strong lines placed very close together in some
places. The display feathers, which are usually
mistaken for a tail, are drawn in fine lines that
fan out. Rembrandt added some wash in white
in order to suggest the yellow-gold colouring of
the feathers and he achieved their full spendour
with long zig-zag lines and transparent strokes
made with a half dry brush. He added a few
fine hatching lines of shadow in order to bring
the section of feathers left white in the lower
drawing into relief.

Rembrandt drew the bird twice, in the same
way in which he filled sheets with various
figures and heads (Cat. No. 8). Such study
sheets had the function of models and were also
made in order to elaborate and complement
Rembrandt's collection of drawings and prints,
by his own hand and other masters, which
together formed a survey of the visible world.
To such a collection also belong, for example,
shells (Etchings Cat. No. 29), other natural
objects and casts from statues, creating a so-
called encyclopaedic collection, which artists
had at their disposal for their work.[1]

Among the objects mentioned in
Rembrandt's inventory of 1656 is 'een
paradijsvogel en ses wayers' (a paradise bird
and six fans) which he kept in a drawer.[2] As
can be seen in the drawing, the bird has no
legs: these were cut away in its country of
origin (New-Guinea) with the innards and
underbelly. For this reason Linnaeus had called
the bird '*Paradisia apoda*' (without legs).[3]

When Rembrandt drew another such bird,
he did give it legs (Fig. 15a).[4] He added it to a
sheet with a beautifully-finished head of an
oriental, motifs which were probably combined
because of their exotic nature. Even though the
drawing in Paris was made from a carcass, the
animal by no means gives the impression of
being dead. However, this clearly is the case in
the other drawing. There is absolutely no
indication of space around the birds—perhaps
Rembrandt had secured the bird of paradise on
a white surface—and this gives the impression
that the bird is still alive, in addition to which
the background can almost be seen as the open
air.

Birds rarely appear in the work of
Rembrandt, although we repeatedly see them
in the sky in the landscape drawings and
etchings. In a painting in the Rijksmuseum two
dead peacocks are depicted in the window next
to a girl[5] and there is a painting in Dresden,
dated 1639, in which a hunter with the features
of Rembrandt is holding up a dead bittern.[6]
In the latter case the bird has an allegorical
significance and the figure probably represents
a lover.[7] These birds were almost certainly
painted from life.

The drawing of the two birds of paradise
were made at the end of the 1630s, when
Rembrandt frequently used dark gall-nut ink
for his drawings.
P.S.

1. R. Scheller, 'Rembrandt en de Encyclopedische
kunstkamer', *Oud Holland*, 74 (1969), pp. 1–81.
2. *Documents* 1656/12, No. 280.
3. Schatborn 1977, pp. 15–16.
4. Paris, Musée du Louvre, Département des arts
graphiques; Benesch, No. 158.
5. *Corpus* III A134.
6. *Corpus* III A133.
7. E. de Jongh, 'Erotica in vogelperspectief',
Simiolus 3 (1968/1969), p. 41, n. 46.

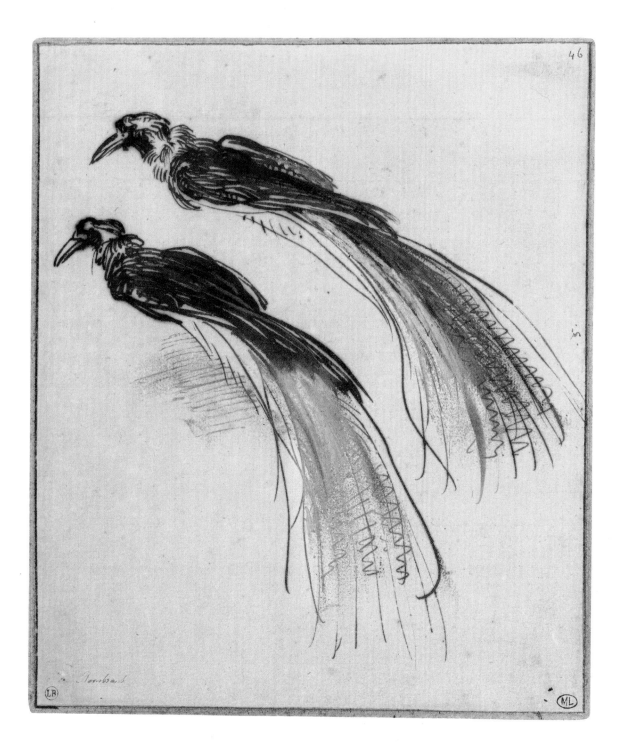

Jacob and his Sons

Pen and brown ink, brown and white wash,
the seated man on the left added on a separate
piece of paper, laid down, 176 × 230 mm
Amsterdam, Rijksmuseum,
Rijksprentenkabinet

Provenance: H. Croockewit, sale Amsterdam,
16–17 December 1874, No. 143; Berthold
Suermondt (L. 415), sale Frankfurt, 5 May
1897 and following days, No. 128; William
Pitcairn Knowles (L. 2643), sale Amsterdam,
25–26 June 1895, No. 522; acquired by the
Vereniging Rembrandt in 1901; Inv. No.
RP-T–1901 A4518.

Literature: Benesch 1954–57 and 1973, No. 541;
Schatborn 1985, No. 17 (with other previous
literature and exhibitions).

Exhibitions: Rotterdam/Amsterdam 1956, No.
90; Amsterdam 1964–1965, No. 61; Amsterdam
1969, No. 68.

Rembrandt repeatedly depicted the story of the
patriarch Jacob and his son Joseph, especially in
prints and drawings. Joseph was one of Jacob's
twelve sons, who was sold as a slave by his
jealous brothers, but eventually managed to
rise to the position of viceroy of Egypt. During
a time of famine, the brothers travelled there to
buy food. Joseph did not let them know who
he was, and imprisoned them as spies. He
demanded that they fetch the youngest brother
Benjamin, who had remained at home, while he
held Simon with him in Egypt.

When the brothers were leaving for Egypt
for the second time they begged their father to
let Benjamin accompany them. It has been
suggested that this is the scene represented in
the drawing, but this is probably not the case.[1]
Jacob is sitting in the centre on a platform
under an arch, while the young Benjamin
stands next to him holding a cup. Judah is
speaking and gesticulating while the other
brothers are listening attentively. The cup,
however, only appears later in the story. When
the brothers have set out on the return journey
from Egypt with Benjamin, and laden with
food, Joseph has secretly hidden his silver cup
in Benjamin's knapsack. When this is disco-
vered, having put his brothers to the test once
again, Joseph can no longer restrain himself and
unmasks himself as the brother they sold. After
their return to Canaan the brothers tell their
father that Joseph is still alive and that he is
viceroy of Egypt, but Jacob does not believe
them.

This moment in the story is more likely to
be the subject of the drawing. There has after
all been no previous mention of the cup in
Benjamin's hand. Moreover, the hat in
Benjamin's other hand is a sign that he has
returned from the journey.[2]

There is a second drawing of the same
subject by Rembrandt in the Louvre in Paris
(Fig. 16a) in which the scene is viewed more
from the side and in which the backs of the
figures at the left and right do not symmetri-
cally enclose the composition.[3] Here, Benjamin
does not hold a hat in his hand and there are a
greater number of brothers. A drawing in
Rotterdam shows an earlier moment in the
story, when Judah or another brother is
begging Jacob, who is in a dilemma about the
decision to let Benjamin go with them. Here,
the child stands next to his father Jacob
without cup or hat (Fig. 16b).[4]

Rembrandt's depiction of biblical stories was
in the main determined by the iconographic
tradition, the way in which predecessors and
contemporaries had depicted the subject. There
is no direct example that can be pointed to in
this tradition in the case of the Amsterdam and
Paris drawings. Rembrandt drew his
understanding of the story from the biblical
text and he particularly liked to depict the
events in which human emotions played an
important role. Consequently both drawings
concern an emotional confrontation between
the father and his sons.

Rembrandt has expressed variety in the

16a: Rembrandt, *Jacob and his Sons*. Paris, Musée
du Louvre, Département des arts graphiques.

16b: Rembrandt, *Jacob, Benjamin and an older Son*.
Rotterdam, Museum Boymans-van Beuningen.

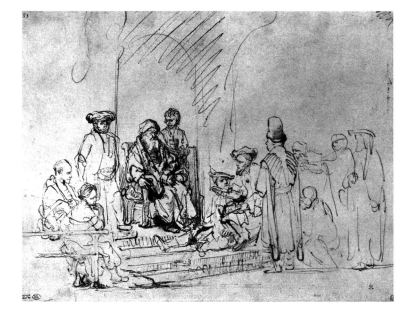

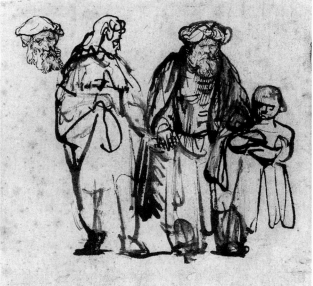

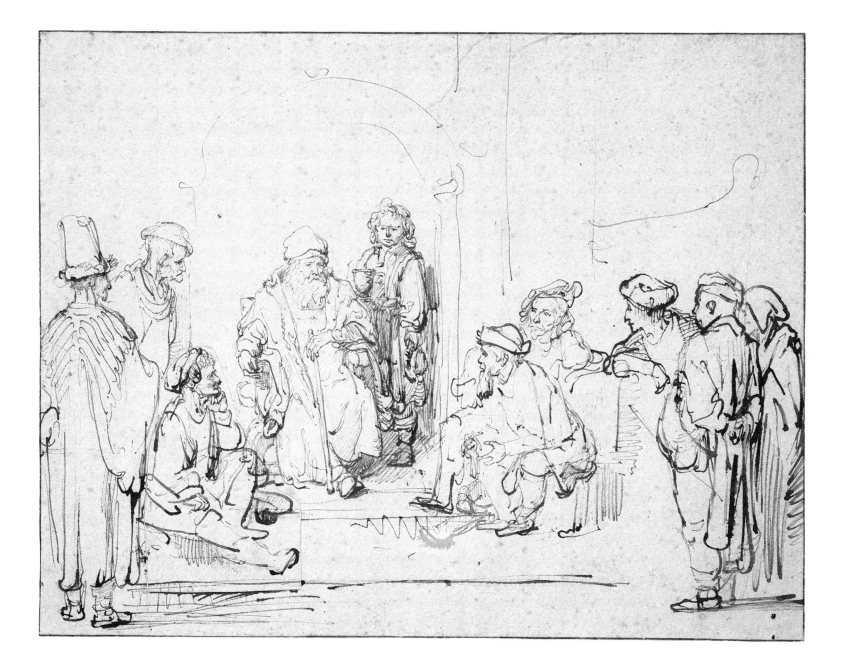

balanced composition, especially in the stances of the figures and the expressions on their faces. The seated figure to the left has been redrawn on a separate piece of paper to cover an unsuccessful version. There is also a correction in the right leg of the seated brother, which was at first stretched out. Rembrandt painted over this version in white.

The two drawings of *Jacob and his sons* are executed in the same style and date from the same period, about 1640. Rembrandt often drew different versions of the same subject. Jacob and Benjamin from the Rotterdam drawing appear again on a sheet in Stockholm, where the figure of the son has been cut off (Fig. 16c).[5] These two drawings were made later in the 1640s.[6]

P.S.

1. For the various opinions on this subject, see Schatborn 1985, No. 17 and Paris 1988–89, No. 31.
2. If it is the earlier moment that is depicted then the hat would indicate that Benjamin is prepared for a journey, which is illogical, as it is just that which Jacob still has to decide.
3. Benesch, No. 542; Paris 1988–89, No. 31.
4. Benesch, No. 190; Giltaij 1988, No. 16. as *The Dismissal of Hagar*. Luijten and Meij 1990, No. 35, as 'Biblical representation'.
5. Benesch, No. 189. Tümpel believes that the moment depicted is that in which Jacob sends his sons to Egypt the first time without Benjamin as he is afraid that something will happen to him; Christian Tümpel, 'Iconografische verklaring van de voorstelling op twee tekeningen van Rembrandt', *De Kroniek van het Rembrandthuis*, 3 (1972), pp. 67–75. The gesture of the son's hand under his father's, suggests an attempt to persuade him—of which there is however no question before the first journey. See also Luijten 1990, No. 35.
6. Benesch dates the drawings in Rotterdam and Stockholm too early, 1631–40; Giltaij approximately 1642–43, but a slightly later date, around or after the mid-1640s, is more probable; compare for example Benesch, Nos. 763 and 767. Luijten (note 4) dates the drawing to approximately 1642.

16c: Rembrandt, *Jacob and Benjamin*. Stockholm, Nationalmuseum.

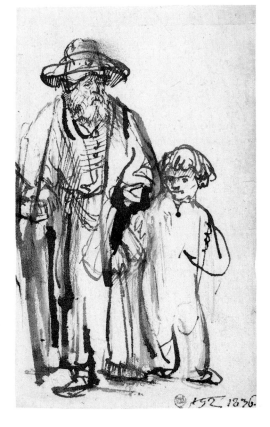

Seated old woman, with an open book on her lap

Pen and brown ink, brown wash,
126 × 110 mm
Rotterdam, Museum Boymans-van Beuningen

Provenance: J. Richardson Sr. (L. 2183); Sir
Joshua Reynolds (L. 2364); Benjamin West;
Jhr. Johan Goll van Frankenstein, sale
Amsterdam, 1 July 1833, *Kunstboek* I, No. 13;
Sir Thomas Lawrence (L. 2445); W. Esdaile (L.
2617), sale London, 17 Junes 1840, No. 62; C.S.
Bale, sale London, 1 June 1881, No. 2416; J.P.
Heseltine, sale Amsterdam, 27 May 1913, No.
16; M. Kappel, Berlin; P. Cassirer, Berlin; F.
Koenigs, Haarlem; presented to the Stichting
Museum Boymans by D.G. van Beuningen
(1940); Inv. No. R10.

Literature: Benesch 1954–57, No. 757; Giltaij
1988, No. 15 (with other previous literature
and exhibitions).

Exhibitions: Rotterdam/Amsterdam 1956, No.
84; Amsterdam 1969, No. 55.

Portraits are rare in Rembrandt's œuvre of
drawings. Apart from the self-portraits
(Cat. No. 4) and the portraits of members of
Rembrandt's family (Cat. No. 3 and 35)
there are a few preliminary studies for etched
portraits.[1] There is also one large finished
portrait drawing extant, which represents
Willem van der Pluym. This drawing hung
on the wall in the sitter's home.[2]

Around 1639 Rembrandt drew two female
portraits in the same style and technique. The
portrait of Maria Trip in the British Museum
in London (Fig. 17a)[3] gives a clue to the date,
as the drawing was made in connection with
the painting dated 1639 in the Rijksmuseum,[4]
not as a preliminary study but in preparation
for an alteration in the composition. The *Seated
old woman* is related in a number of respects to
this drawing of Maria Trip.

The woman is sitting on a chair with a low
armrest. On her lap lies an open book with two
clasps. The middle finger of the left hand has
been placed between the pages and in the right
hand she is holding her glasses between thumb
and index finger. She is wearing rather old-
fashioned clothing which indicates that she is
not so very young.

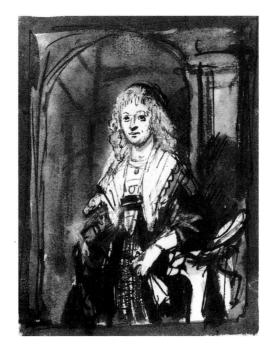

17a: Rembrandt, *Portrait of Maria Trip.*
London, British Museum.

Rembrandt started this drawing with fairly fine pen lines and then added wash with a brush which has somewhat obliterated the lines. He then took up the pen again and completed the drawing in strong lines and accents. The distribution of light and dark has been made with fewer or more transparent brushstrokes, especially in the background. The head of the woman is placed exactly on the border of the light area of the background and the dark curtain. This positioning on the border of light and dark contributes to the three-dimensional effect of the picture.

It is not known who the woman is.[5] If it were a preparatory study for a painting the sheet would be an exception in the œuvre. It is possible that the drawing, like that of Maria Trip, was a preparation for an alteration in the composition of a painting which is now lost.

The drawing gives the impression of having been made from life. This is also the case with a drawing dated 1639 of Rembrandt's sister-in-law Titia van Uylenburgh who is busy with some needlework (Fig. 17b).[6] Although this is really more of a genre-portrait and the space around her has not been indicated in much detail, this drawing is affiliated in style to the portraits of Maria Trip and the unknown woman. Lastly, this also applies to the drawing of a *Seated old man* (Fig. 17c) which, on the basis

of subject, had been attributed to Salomon Koninck, but it is so closely related in style and technique that it must be by the hand of Rembrandt.[7] It is not necessarily the case that this sheet was also drawn from life.
P.S.

1. B. 271 and Benesch, No. 758, Cornelis Claesz. Anslo; B. 285 and Benesch, Nos. 767 (Cat. No. 23) and 768, Jan Six; B. 280 and Benesch, Nos. 762, 762a nd 763, Jan Corneslisz. Sylvius.
2. New York, private collection; Benesch, No. 433. I.H. van Eeghen, 'Willem Jansz. van der Pluym and Rembrandt', *Amstelodamum* 64 (1977), 1, pp. 6–13.
3. London, British Museum; Benesch, No. 442.
4. Amsterdam, Rijksmuseum, *Corpus* III A31.
5. It has been noted that in a portrait in the National Gallery, London, there is a similarity to Magaretha de Geer, but this painting is from 1661, a date which is too late for the drawing. Gerson 1968, No. 385, pp. 130 and 503.
6. Stockholm, Nationalmuseum; Benesch, No. 441.
7. Paris, Fondation Custodia (coll. F. Lugt), inv. 4502. Amsterdam 1973, No. 56. Sumowski *Drawings*, No. 1529.

17b: Rembrandt, *Portrait of Titia van Uylenburgh*. Stockholm, Nationalmuseum.

17c: Rembrandt, *Seated old Man*. Paris, Fondation Custodia (F. Lugt Collection).

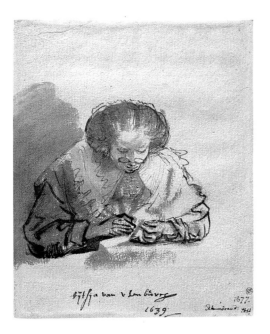

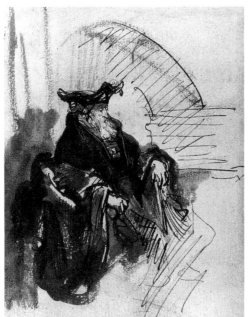

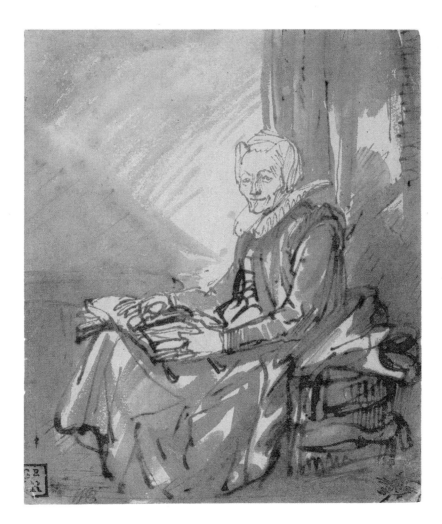

The Healing of the blind Tobit

Pen and brown ink, white wash, 210 × 177 mm
Cleveland, The Cleveland Museum of Art,
J.H. Wade Fund

Provenance: I.J. de Claussin, sale Paris, 2 December 1844, No. 53; G.J.J. van Os; N. Revil, sale Paris, 24 February 1845, No. 48 (?); Pierre Defer and Henri Dumesnil, sale Paris, 10 May 1900, No. 87; Joseph Reinach; Mme Pierre Goujon; Wildenstein & Co.; Inv. No. 69.69.

Literature: Benesch 1954–57 and 1973, No. 547 (with other previous literature and exhibitions); J.S. Held, *Rembrandt and the book of Tobit*, Northampton (Mass.) 1964, p. 17 (reprinted in *Rembrandt's Aristotle and Other Rembrandt Studies*, Princeton 1969); Louise S. Richards, 'A Rembrandt Drawing', *Bulletin of the Cleveland Museum of Art*, February 1970, pp. 68–75; *Het boek Tobias, met etsen en tekeningen van Rembrandt en zijn leerlingen*, Zeist 1987, pp. 43 and 65–66; preface by Christian Tümpel, commentary by Peter Schatborn.

Exhibitions: Seventeenth Century Dutch Drawings from American Collections, Washington (National Gallery of Art), Denver (The Denver Art Museum), Fort Worth (Kimbell Art Museum) 1977, No. 34; catalogue by Franklin Robison (with other previous exhibitions).

The story of Tobit belongs to the apocryphal books of the Old Testament. It describes the story of the old Tobit who has become blind and who is healed by his son Tobias with the help of the angel Raphael. This healing is the climax of the story and the drawing convincingly depicts the tension of the moment.

Old Tobit is seated, hands clasping the armrests of the chair. The young Tobias resting his right hand on his father's head, raises the eyelid with his thumb and performs the operation with a knife which is in his left hand.[1] Tobias's face, drawn from the side, betrays great concentration. The angel behind him is not looking at the operation but at Tobias, as if to invest him with confidence and courage. One of the angel's wings is poking out of the window and the other is stretched out behind Tobias and his mother Anna. The latter is looking with curiosity over her son's shoulder and she holds a small bowl in her hand. In the right foreground Tobias's wife Sarah stands with clasped hands, looking on. According to the story she was not present at this event, as Tobias was to fetch her only later from the gate of Nineveh where he had left her. By depicting her Rembrandt has expanded the scene to include the next moment in the story and created a link with the viewer of the drawing who is looking on in suspense, just as she is.

The faces of the figures are carefully depicted: the expression of anticipation of Tobit, whose head is bent slightly back—his mouth fallen slightly open as a result—the fixed and tense attention of Tobias, the friendly, encouraging expression of the angel and the curiosity of Anna peering through her glasses; all these facial expressions testify to Rembrandt's astonishing manner of characterisation. Sarah's eyes are not visible but the position of her head, bent slightly forward, displays her full attention for the operation.

In addition to the use of mainly fine pen lines for the contours, Rembrandt used various hatched lines, sometimes cross-hatched, to indicate shadow. The figure of the seated Tobit has thereby been brought into relief and the head of Tobias in particular has been accentuated as a result. The figure of Sarah is depicted in a slightly looser drawing style, with occasional strong strokes of the pen. Rembrandt painted over the whole of the head of the angel with white which makes him less noticeable and draws all the attention to Tobit and his son; the hand on the windowsill was also painted over with white.

The drawing in Cleveland is certainly one of the finest which Rembrandt made of the story

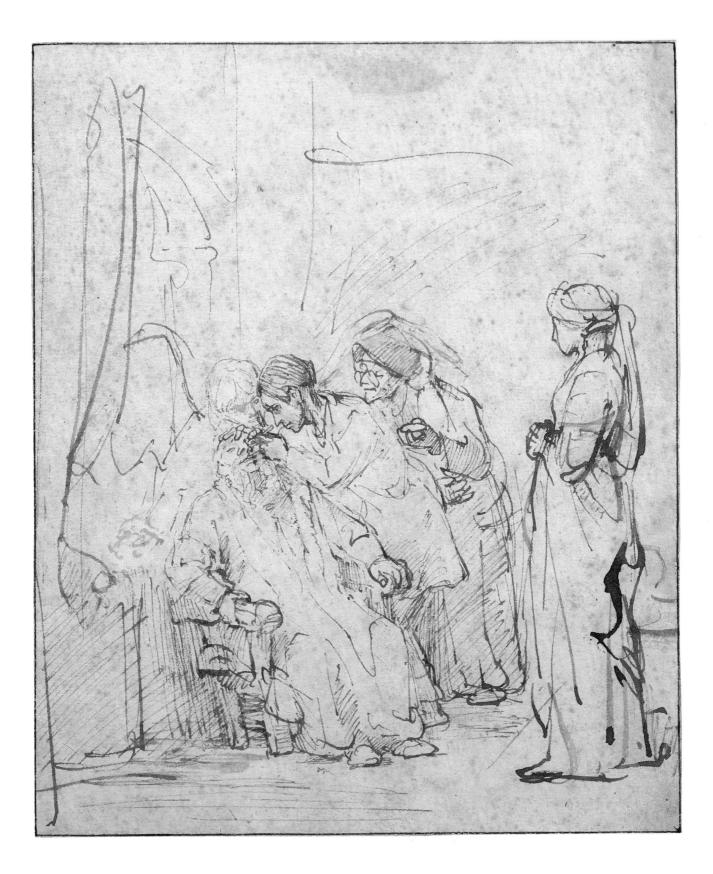

of Tobit. In the past a number of Rembrandt-esque drawings with scenes from this story have been attributed to him but most are now considered not to be by his hand. Two have recently been ascribed to Rembrandt's pupil Willem Drost (Cat. No. 46).

Rembrandt certainly owned the print by Cornelis Massys, one of a series of eight showing the story of Tobit (Fig. 18a).[2] The grouping of the figures is, in mirror-image, broadly the same, although here Anna is standing with clasped hands in the left background. There is also a man with a beard present and the bowl is held by the angel. A few other motifs have also been adopted, such as the hand of Tobias on the head of his father and Anna's hands folded together, which is Sarah's gesture in the drawing.

Rembrandt also made two etchings of scenes from the book of Tobit[3] and a painting of *The Agel leaving the house of Tobit*, dated 1637.[4] Another painting from the 1630s, *The healing of Tobit* in Stuttgart, was previously considered to be a Rembrandt but is now attributed to an unidentified pupil (Fig. 18b).[5] The group of figures seated around Tobit in the Stuttgart painting is related to the group in the drawing. It is generally dated to the first half of the 1640s, but could also have been made a little earlier.[6] The drawing could possibly have served as a source of inspiration for the painting in Stuttgart.

P.S.

1. 'Leukoma', clouding of the cornea, is translated as cataract in all translations based on the Lutheran Bible. Thus, Rembrandt has drawn the moment of the healing as if it were a cataract operation and because of this the young Tobias has a knife in his hand.
2. B. 6, Holl. 29.
3. *The Blind Tobit goes outside to meet his Son* (B. 153 of c. 1629 and B. 42 from 1651) and *The Angel departing the Family of Tobias* (B. 43 from 1641).
4. Paris, Musée du Louvre; *Corpus* III A121.
5. Stuttgart, Staatsgalerie; *Corpus* III C86. The painting only shows half of the original composition.
6. The drawing at Chatsworth, *An Actor as Bishop Gozewijn*, Benesch, No. 120, is fairly similar in style. If the actor depicted here is Willem Ruyters, drawn from life, then it must have been made before his death in 1639. Benesch dates this drawing to 1636. The drawing in Amsterdam *Joseph and his Sons* (Cat. No. 16) also displays stylistic similarity.

18a: Cornelis Massys, *The Healing of Tobit*. Amsterdam, Rijksprentenkabinet.

18b: Rembrandt pupil, *The Healing of Tobit*. Stuttgart, Staatsgalerie.

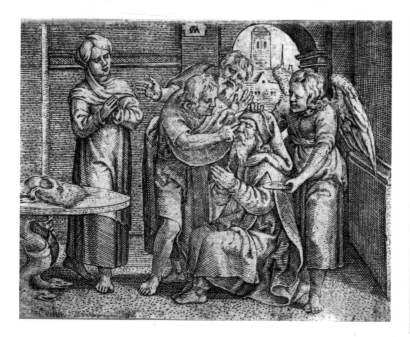

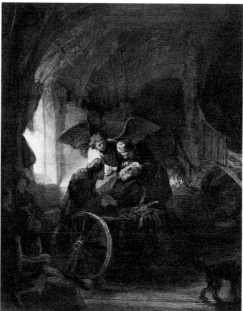

19

The Entombment, over a sketch of an executioner

Verso: *The Beheading of John the Baptist*

Pen and brown ink; a piece of paper inserted below left, 156 × 201 mm
Amsterdam, Rijksmuseum,
Rijksprentenkabinet

Provenance: Dirk Vis Blokhuyzen, sale Rotterdam, 23 October 1871, No. 500; August Sträter (L. 787), Aachen, sale Stuttgart, 10–14 May 1898, No. 1176; with Colnaghi, London (after 1900); Cornelis Hofstede de Groot, The Hague, bequest 1906, in usufruct until 14 April 1930; Inv. No. RP-T-1930–28.

Literature: Henkel 1942, No. 48; Benesch 1954–57 and 1973, No. 482; Schatborn 1985, No. 19 (with other previous literature and exhibitions).

Exhibitions: Rotterdam/Amsterdam 1956, No. 82.

Four men are carrying Christ to the grave. They have laid him in a cloth which is being held by the men in the centre. To the left is a mourning woman who is only partly visible as a new piece of paper has been inserted in the lower corner at the left. In most depictions of this subject, including Rembrandt's grisaille in Glasgow (Fig. 19a)[1] and the painting from the Passion series made for Frederik Hendrik in Munich (Fig. 19b),[2] the figure of Christ is not hidden by one of the bearers. The head of Christ is usually depicted as though he were sleeping and not hanging down with loose hair. In the drawing this emphasises the lifelessness of the body. Rembrandt has thus found a more natural and realistic solution for this subject than is to be seen in his paintings. The figures have been roughly indicated in the drawing, with the exception of the most important detail of the representation, the head of Christ.

There is a clear connection with *The Entombment* in Munich in the shape of the curtain at the left hand side. Rembrandt used this curtain as the starting point for a composition which differs from the paintings in that the figure of Christ is being carried up from the left to right.[3]

If we turn the sheet through ninety degrees

we see a head and raised hands next to it at the same height as the grave. Rembrandt has drawn his *Entombment* over this sketch which can be seen again, and more clearly, on the verso. There the figure is holding a sword in his hands and is on the point of beheading a kneeling man. These two sketches are characteristic of they way in which Rembrandt would begin a drawing, in a very faint manner which could then be elaborated and corrected with darker lines. The head of the executioner on the reverse of the sheet has already been depicted in two stages.

Both sketches are related to a *Beheading of John the Baptist* in an etching from 1640 (Fig. 19c):[4] the executioner is standing in the same position as in the sketches, in mirror-image, but the figure of John has been turned a quarter to the left. The sketch of the executioner underneath the *Entombment* looks like the same figure in a drawing in the British Museum in London and here, moreover, two other stages in the narative have been depicted, the moment before the beheading and the moment thereafter with the headless body lying on the ground (Fig. 19d).[5] A drawing in the Metropolitan Museum in New York shows the same beheading scene viewed from the side and here the head is drawn three times in the foreground (Fig. 19e).[6]

Given the similarities in these two drawings it has been suggested that models had posed in a group as in a *kamerspel* ('chamber play') as Hoogstraten called it in his *Hooge Schoole der Schilder-konst* of 1678 and that pupils together with Rembrandt had drawn the group from different angles.[7] However, the sketches of the *Beheading* on the drawing in Amsterdam do not

19: verso

19a: Rembrandt, *The Entombment of Christ*. Glasgow, Hunterian Art Gallery, University of Glasgow.

19b: Rembrandt, *The Entombment of Christ*. Munich, Alte Pinakothek.

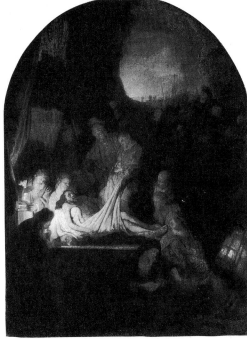

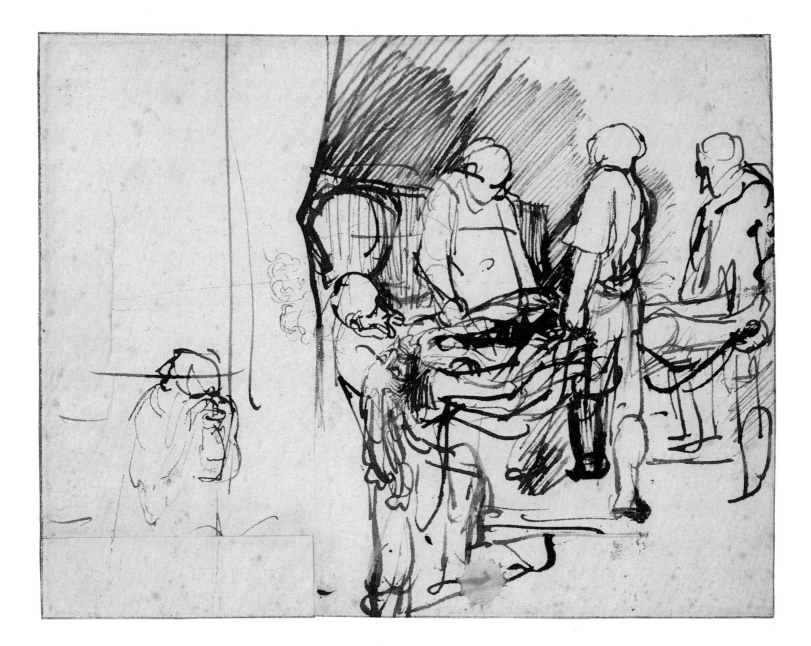

seem to be of the same group but they could of course have been inspired by them. The sketches were probably made by Rembrandt from imagination in preparation for the etching.

If the sketches for the *Beheading* were made in 1640 as preparation for the etching, then the *Entombment* cannot date from much later. The painted *Entombment* in Munich was already in February 1636 '*Ruym half gedaen*' (more than half done) as Rembrandt writes in a letter to Constantijn Huygens, secretary to the Prince.[8] In a letter of February 1639 he communicates that the painting is completed.[9] The drawing is therefore probably not a preliminary study for the painting, but is more likely to be a new, less conventional version of the subject.
P.S.

1. Glasgow, Hunterian Art gallery, University of Glasgow; *Corpus* III A105.
2. Munich, Alte Pinakothek; *Corpus* III A126.
3. The bearers with their heavy weight could be inspired by those in *The Entombment* by Raphael (Rome, Galeria Borghese), which Rembrandt could have known from a print by Peter Scalberg, as is noted by Keith Andrews in his review of Schatborn 1985, *The Burlington Magazine* 128 (1986), pp. 223–24.
4. B. 92.
5. London, British Museum; Benesch, No. 479.
6. New York, Metropolitan Museum, Lehman collection; Benesch, No. 478. This drawing is probably the work of a pupil.
7. Hoogstraten 1678, p. 192; Konstam 1978.
8. *Documents* 1936/1.
9. *Documents* 1639/1.

19c: Rembrandt, *The Beheading of St John the Baptist*. Amsterdam, Rijksprentenkabinet.

19d: Rembrandt, *Beheading of a Man*. London, British Museum.

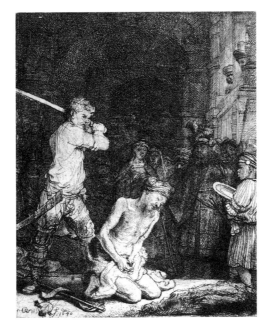

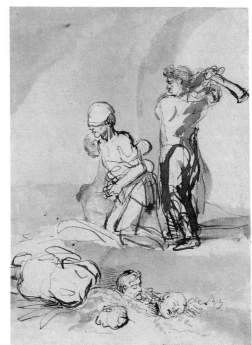

19e: Rembrandt, *Beheading of a Man*. New York, Metropolitan Museum of Art.

Interior with Saskia in bed

Pen and brown ink, brown and grey wash,
some traces of red and black chalk,
141 × 176 mm
Paris, Institut Néerlandais, Fondation Custodia
(coll. F. Lugt)

Provenance: William Esdaile, sale London, 24
June 1840, No. 1046; John Heywood Hawkins,
sale London, 29 April 1850, No. 1025;
A. Bellingham Smith, 1918; E. Parsons,
London; F. Lugt (L. 1028), acquired in 1919;
Inv. No. 266.

Literature: Benesch 1954–57 and 1973, No. 426;
Haverkamp-Begemann 1976, pp. 96–105;
Schatborn 1985, in No. 11.

Exhibitions: Amsterdam 1969, No. 58; New
York/Paris 1977–78, No. 88 (with other
previous literature and exhibitions).

20a: Rembrandt, *Model sheet with a woman lying in
bed.* Amsterdam, Rijksprentenkabinet.

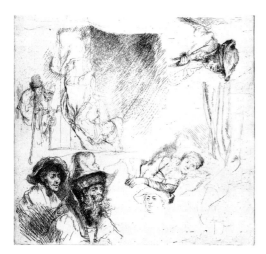

Saskia is lying sleeping in the box bed. A chair
which Rembrandt depicted in a number of
works stands by the bed (Cat. Nos 2 and 23).
At the other end of the bed a woman is seated
in the sun between the bed and the fireplace
winding lace. She has put her feet on a cushion.
The mantelpiece, carried by two herms, has a
cloth canopy. Behind the empty chair are two
doors, rounded at the top, possibly a doorway
and a cupboard door. The light falls from the
right through a window which is not visible.

This light has been extremely carefully
depicted by Rembrandt; we see for example the
shadow of the chair in front of and against the
bed, the fall of light on the blankets and the
half-darkness of the box bed which has been
executed in a number of tones. While the
woman who is absorbed in her task is placed in
the light, the shadow in which Saskia is
shrouded in the box bed suggests that she is
asleep. What is not clear however is the cause
of the shadow to the right of the scene. The
drawing has probably been cropped somewhat
here.

The drawing is not only been made in
brown ink with the pen and the brush but also
with grey, which is not so usual. Rembrandt
probably added the grey last in order to
strengthen the areas which indicate light,
where the paper is left white.

The subject of a room with a woman in bed
is unusual in the history of art, although beds
as symbols of amorous relations are frequently
depicted in interiors in the seventeenth
century. In Rembrandt's endeavour to record
in drawings the visible world in all its shapes
and forms he encompassed the bedroom. In the
choice of such scenes Rembrandt could have
had similar subjects in mind which he could
use in paintings and etchings.

There is a certain connection with, for
example, an etching such as *Le Lit à la française*
of 1646, in which a pair of lovers are depicted
in bed.[1] Here there is also a door or niche with
a rounded top to the left of the bed. More
closely connected to the drawings is the
etching with two sketches of a woman in bed.
These were possibly made from life, with
Saskia as model and etched directly onto the
plate (Fig. 20a).[2] There are also biblical
representations which take place in a bedroom
such as *The raising of Jairus's Daughter* (Cat.
No. 36).

The drawing of the room with the sleeping
Saskia is of course also a genre sence, which
gives us a glimpse of the daily reality of
Rembrandt's life. He drew his wife in bed a
couple of times, once from close up[3] and
another time in a bedroom with a cradle (Fig.
20b).[4] This indicates that here Saskia is an

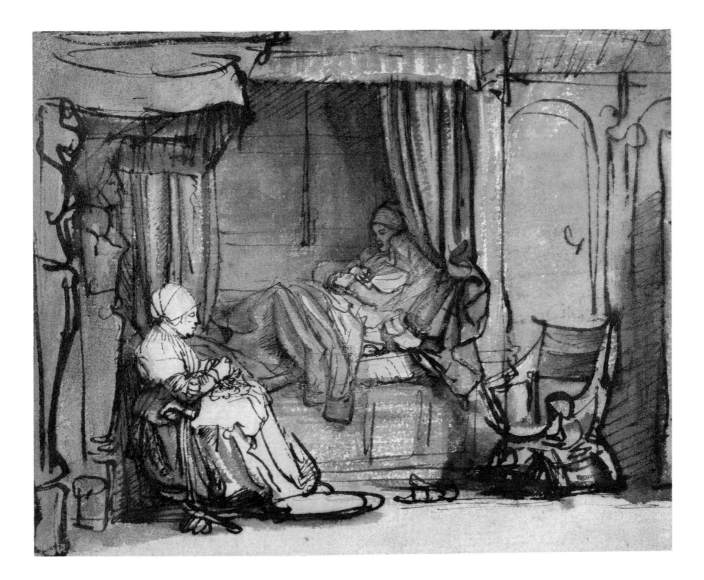

expectant mother, which could also be the case in the drawing in the Lugt collection.

The two drawings show different interiors and therefore were probably not made in the same house. We can determine in which houses these rooms were situated by a combination of the birth dates of the four children of Rembrandt and Saskia and what is known of the various addresses where they lived.[5]

Three of Rembrandt and Saskia's children died young. Only the last child, Titus, reached adulthood. Rumbartus was baptised on 15 December 1635 and was born in the house 'naest den pensijonaris Boereel, nieuwe doelstraat' (next to the Pensionary Boereel, Nieuwe Doelenstraat).[6] On the basis of style in both drawings this date would be too early for the rooms to have been in this house.[7] Cornelia was baptised on 22 July 1638 and was born in the house 'op de Binnen Amstel, 'thuijs is genaemt die Suijkerbackerrij' (on the Binnen Amstel, the house is named the Sugar-bakery).[8] The second Cornelia was baptised on 29 July 1640 and she must have been born in the house on the Breestraat, now the Rembrandthuis, which Rembrandt had bought on 5 January 1639.[9] Titus, who was baptised on 22 September 1641, must also have been born in that house.[10]

The drawing in the Lugt collection represents a later stylistic phase than the one in Amsterdam. So it is likely that this shows a room in the house on the Breestraat and that the Amsterdam drawing shows one in the house on the Binnen Amstel. The cradle was for the nursing of the first Cornelia. In the drawing in the Lugt collection—if the supposition is correct—Saskia is expecting either the second Cornelia or Titus. The Amsterdam drawing could therefore be dated to July 1638 and the drawing in the Lugt collection to before July 1640 or September 1641. Saskia died on 14 July 1642, less than a year after the birth of Titus.[11]

P.S.

1. B. 186.
2. B. 269.
3. Dresden, Kupferstich-Kabinett, Benesch, No. 255; Groningen, Museum voor Stad en Lande, Benesch, No. 282; Oxford, Ashmolean Museum, Benesch, No. 281a; London, British Museum, Benesch, No. 281; in a sketch in red chalk, Saskia is holding a child in her arms: London, Courtauld Institute Galleries, The Princes Gate Collection, Benesch, No. 280a.
4. Amsterdam, Rijksprentenkabinet; Benesch, No. 404.
5. See Schatborn 1985, No. 11.
6. This address is mentioned by Rembrandt in a letter to Huygens from February 1636; *Documents* 1636/1. Rumbartus had already been buried on the 15th of this month; *Documents* 1636/3. I.H. van Eeghen, 'De kinderen van Rembrandt en Saskia', *Maandblad Amstelodamum* 35 (1956), pp. 144–46.
7. Rumbartus is depicted with Saskia on a drawing in Rotterdam; Benesch, No. 228; Schatborn 1975.
8. Rembrandt gives this address on 17 December 1637 and 12 January 1639; *Documents* 1637/7 and 1639/2. Cornelia was buried as early as 13 August 1638; *Documents* 1638/9.
9. She was buried on 12 August of that year; *Documents* 1640/6.
10. *Documents* 1641/4.
11. *Documents* 1642/3 and 1642/4.

20b: Rembrandt, *Interior with Saskia in bed*. Amsterdam, Rijksprentenkabinet.

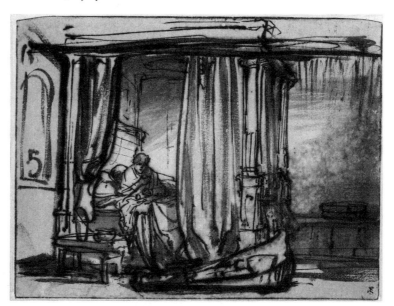

The Windmill on the Bulwark Het Blauwhoofd

Pen and brown ink, brown wash, mounted,
118 × 200 mm

Inscription: below left *RH 5*, in the hand of
Richard Houlditch; on the reverse, on the old
mount *1736*, the date of Houlditch's
acquisition.
Paris, Institut Néerlandais, Fondation Custodia
(coll. F. Lugt).

Provenance: Richard Houlditch, 1736 (L. 2214),
sale London, 14 February 1760, No. 50 or 71;
Viscountess Churchill, later Mrs Isham, sale
London, 29 April 1937, No. 97; F. Lugt
(L. 1028); Inv. 5174.

Literature: Benesch 1954–57 and 1973, No.
1333; Haverkamp Begemann 1976, p. 361;
Giltaij 1988, in No. 20, ill. a; Washington 1990,
in No. 10, Fig. 1.

Exhibitions: Brussels/Rotterdam/Paris/Bern 1968/
1969, No. 116; Amsterdam 1969, No. 96; Paris
1974, No. 79; Leningrad/Moscow/Kiev 1974,
No. 87; New York/Paris 1977–1978, No. 91.

To the west of Amsterdam, near the IJ, there
was a bulwark called Het Blauwhoofd. On most
bulwarks there were mills such as this little
smockmill, of which the upper part revolves in
such a way that the sails face into the wind.
On a drawing of the same place by Roelant
Roghman we see the sails in a different position
(Fig. 21a).[1] Roghman sat on the left of the
road, drawing the IJ with the palings in front of
the harbour, whereas Rembrandt was seated on
the right of the road. He placed the mill in the
centre of the sheet. To the left he drew the
cannons with their barrels sighted in the
direction of the water, where a section of the
palings can also be seen. To the right are trees
at the bottom of the incline. The same trees
are also just visible on Roghman's sheet. Next
to these trees part of a wooden building can be
seen behind the houses on the Zoutkeetsgracht.
A rope-yard was situated here.[2]

 After Rembrandt had drawn the mill, the
houses, the cannons and the trees in pen, he
elaborated the drawing with the brush. The
brown wash has been applied in rich contrasts,
creating strong shadows. The light which
comes from the east, and from the right, falls
low on the bulwark, as shown by the long
shadow of the house on the lower section of the
embankment. This indicates that Rembrandt
made the drawing with its quiet mood in the
early morning. Rembrandt drew the mill and
houses from closer up in a drawing in Rotter-
dam (Fig. 21b).[3] Here we also see the other
side of the IJ with the gallows-field on a
peninsula, De Volewijk.[4] Boats are lying in the
water behind the mill. The house standing
separate from the mill and from the other two
houses which we see in Roghman's drawing,

21a: Roelant Roghman, *Mill on the Bulwark Het
Blauwhoofd*. Amsterdam, Gemeente Archief.

does not appear in Rembrandt's drawing. Rembrandt made another drawing of a view of Het Blauwhoofd from a bulwark situated further to the west (Fig. 21c).[5] Here the other side of the IJ can also be seen, as well as the trees at the bottom of the embankment situated to the right.

The Windmill on Het Blauwhoofd in the Lugt collection has been variously dated, 1645–50[6] and c. 1654.[7] The drawing of *The Montelbaen Tower* in the Rembrandthuis provides a clue for an earlier dating, to the mid 1640s.[8] Here we see how the trees have been drawn in a comparable manner with the pen and brush and that the handling of lines has the same variation of accents. On basis of topographical details this drawing can be dated to 1645–46.

P.S.

1. Amsterdam, Gemeente Archief. W. Th. Kloek, *De kasteeltekeningen van Roelant Roghman*, Alphen aan de Rijn, II, 1990, pp. 20–21. Kloek dates the drawing to the second half of the 1640s.
2. This is apparent from the depiction of the bulwark on the map of Amsterdam by Balthaar Florisz.
3. Rotterdam Museum Boymans-van Beuningen; Benesch, No. 813 (c. 1641); Giltaij 1988, No. 20 (c. 1652); Washington 1990, No. 10 (c. 1640–41).
4. Giltaij, following Bakker and Hofman, believes that it is the Nes, a peninsula lying further to the west, which is depicted, and not the Volewijck.
5. Vienna, Albertina; Benesch, No. 1280 (c. 1652); Washington 1990, No. 61 (c. 1645–49).
6. Cat. New York/Paris 1977–78, No. 91.
7. Benesch, No. 1233.
8. Amsterdam, Museum The Rembrandthuis; Benesch, No. 1309 (c. 1652–53); Washington 1990, No. 49 (c. 1648–50): Lugt 1920, p. 51 (before 1644); Schatborn 1990, p. 37 (1645–46).

21b: Rembrandt, *Mill on the Bulwark Het Blauwhoofd*. Rotterdam, Museum Boymans-van Beuningen.

21c: Rembrandt, *View over the IJ with the Bulwark Het Blauwhoofd*. Vienna, Albertina.

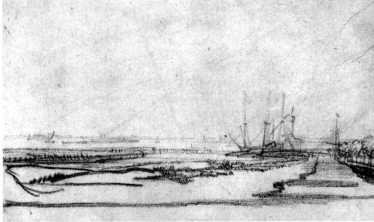

22

A ditch with overhanging bushes

Black chalk, 145 × 115 mm
Wroclaw, Library of the Ossolinski Institute of
the Polish Academy of Arts and Sciences

Provenance: Prince Hendryk Lubomirski; Lvov,
Lubomirski Museum; Inv. No. 8728.

Literature: Benesch 1954–57 and 1973, No. 817;
White 1969, pp. 204–5.

Exhibitions: Washington 1990, No. 58 (with
other previous literature).

Rembrandt usually drew his landscapes with
the pen and brush, but he used black chalk for
a number of cityscapes and small landscapes.
These may have belonged to 'Een boeckie vol
gesichten geteeckent van Rembrant' (a book
with views drawn by Rembrandt), which is
mentioned in Rembrandt's inventory of 1656.[1]

When Rembrandt worked out of doors, he
sometimes drew in the neighbourhood of his
own house, in the city centre or at the
fortifications on the edge of the city (Fig. 21c).
At other times he went out of town, drawing
in the area surrounding Amsterdam, along the
river Amstel or in the polders. His sketches,
made carefully but not in detail, are a direct
representation of what he saw. He often
recorded recognisable places but he sometimes
also drew a piece of nature or open countryside
(Fig. 22a).[2]

During one of his walks Rembrandt depicted
a rather unusual subject. He was standing on a
small bridge which can just be seen at the
bottom of the drawing. To the right of the
small sheet a section of a wooden gate is
visible, which gives access to a farmyard or the
garden of a house. A tree to which a plank of
wood has been attached is standing to the left.
We look from the centre of the drawing over
the ditch into the distance, where a windmill is
situated. Bushes which are reflected in the
water hang over the timbering of the river
bank. Only the bare branches of the trees
behind these bushes are visible. Above this
Rembrandt has drawn a number of zig-zag
lines, in order to fill this rather empty area of
paper somewhat. The tree on the left has also
only been finished up to a certain point and the
top is indicated with a single line. The foliage
of the central bush is the most elaborately
worked, with sharp chalk. The bushes and
trees in the further distance through which the
light shimmers, have been indicated with fine
chalk lines.

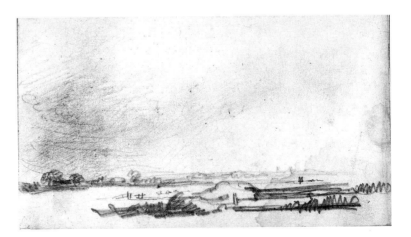

22a: Rembrandt, *Polder landscape.*
Vienna, Albertina.

84

The drawing could have been made anywhere in the environs of Amsterdam, as almost all the houses in the polder land were divided from the road by a ditch, over which there was a bridge. Richer country houses and farms, for example those along the Amstel and the Vecht, had an access gate at this bridge, which is frequently seen in other landscapes by Rembrandt. The partly visible wooden gate has a roof, which also appears in the drawing of the *View of the Amsteldijk near Trompenburg* (Fig. 22b).[3] Here there is also a low gate, a plank leaning against two palings, which, just as the plank against the tree, marks out the path to the bridge.

The subject and the composition of the landscape—the drawing has probably been cropped a little on all sides—is very unusual for a seventeenth-century representation, and not only in Rembrandt's œuvre. However, he drew more than one such view. In 1645 he made an etching of *A Boathouse under the trees*[4] and although he did not use the drawing as a preliminary study the subject is similarly

unusual. (Fig. 22c). Here the branches also fade out into nothingness and here also a plank is attached to a tree, on which in this case Rembrandt has placed his signature and the date 1645. In this way motifs from real life were adopted in new compositions. There is not really a comparable predecessor for the composition of this etching, as there is for most of the landscape compositions.[5]

It seems obvious that the chalk drawing dates from 1645, the date of the etching. Rembrandt's dated etchings of landscapes were made between 1641 and 1652 and most landscape drawings are dated to approximately the second half of the 1640s, in a few cases on grounds of topographical details.[6]

P.S.

1. *Documents* 1656/12, No. 259.
2. Vienna, Albertina; Benesch, No. 812a.
3. Chatsworth, The Devonshire Collection; Benesch, No. 1219.
4. B. 231.
5. Amsterdam 1983–I, No. 64.
6. An exception is the *View of the Nieuwezijds Voorburgwal*, Benesch, No. 819; Schatborn 1985, No. 50, which must have been drawn in or after 1657.

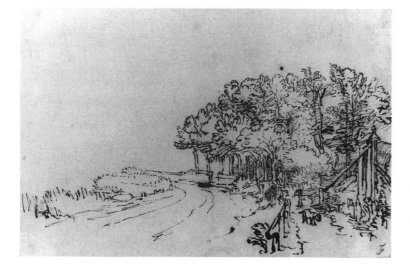

22b: Rembrandt, *View of the Amsteldijk near the Trompenburg Estate*. Chatsworth, The Devonshire collection.

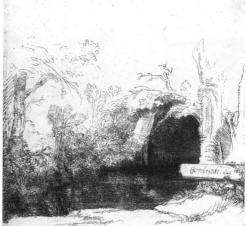

22c: Rembrandt, *A Boathouse among trees*. Amsterdam, Rijksprentenkabinet.

23

Portrait of Jan Six at a window

Pen and brown ink, brown and white wash, 220 × 177 mm; a piece added below. Amsterdam, Six collection

Provenance: Richard Cosway (L. 629), sale London, 14 February 1822, No. 503; Jean Gisbert Baron Verstolk van Soelen, sale Amsterdam, 22 March 1847, Livre B, No. 36.

Literature: Benesch 1954–57 and 1973, No. 767 (with other previous literature and exhibitions); Clara Bille, 'Rembrandt and burgomaster Jan Six', *Apollo* 85 (1967), pp. 260–65; J. Six, 'Jan Six aan het venster', *De Kroniek van het Rembrandthuis* 23 (1969) 2, pp. 34–52; Broos 1981, in No. 13.

Exhibitions: Rotterdam/Amsterdam, 1956, No. 27a; Amsterdam (Museum het Rembrandthuis) 1969, A (see Six 1969).

Rembrandt made two drawings in preparation for the etched portrait of Jan Six (Etchings Cat. No. 23; here Fig. 23a), firstly a pen drawing which gives the subject in broad outline and then a precise preparatory drawing in chalk. In the first drawing, which is exhibited here, Six stands leaning against the sill of an open window, his arm on a section of the cloak which is lying on the table behind him.[1] Six looks straight ahead and past the artist. He is wearing a short jacket from which a collar is peeping out at the top. A fairly large not clearly recognisable object is lying on the table.[2] A dog is jumping up at Six. A table covered with a cloth is standing in front of the window and in the left foreground stands a chair which we have seen in a number of Rembrandt's works (Cat. Nos 2 and 20). The presence of this chair might indicate that this drawing was made in Rembrandt's home. Through the window we see the contours of a building.

Rembrandt executed the drawing with the reed pen using fine and broad lines. Six's face has been indicated with only a few lines with white dots left blank for the eyes. Numerous hatchings in various directions divide the light and dark areas and shadows have also been added with the brush. Rembrandt made a few alterations during the making of the drawing, for example in the position of the feet and legs. The dog too, has achieved its shape after a lot of scratching. Various lines were painted over with white body colour and in this way areas were corrected.

This drawing of Jan Six has an exceptionally spontaneous character, in contrast to the second preparatory drawing in black chalk which is also in the Six collection (Fig. 23b). Both drawings have been corrected with white.[3] Besides having taken more care with the drawing, Rembrandt also altered it considerably. As this etching was commissioned by Six, he probably suggested the alterations himself.

Six's first rather nonchalant pose has been replaced by a more formal one. He has been made smaller in relation to the picture space and is standing reading against the windowsill with his legs in an elegant position; Six's cloak is draped behind him. The chair, now of simpler design, has been moved to the other side. The piece of clothing on it was replaced in the etching with a pile of books. A painting with a curtain in front of it now hangs on the wall. The composition has been closed off on the left in a fairly traditional manner with a curtain. All the signs are that Six, poet, collector and later burgomaster, wanted himself immortalised as an erudite man.

23a: Rembrandt, *Portrait of Jan Six*. Amsterdam, Rijksprentenkabinet.

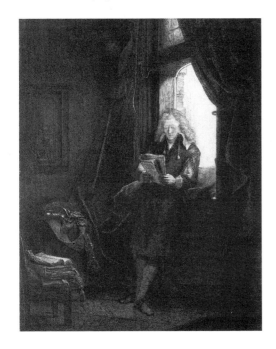

23b: Rembrandt, *Portrait of Jan Six reading by the window*. Amsterdam, Six collection.

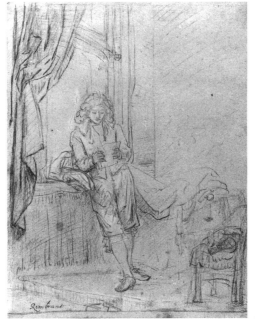

Before Rembrandt made this second version he had drawn the new position of Six's head and upper body in black chalk on the back of a drawing of a family of beggars (Fig. 23c).[4] This small sketch is clearly an experiment, possibly made to show Six how it would look. The hat which Six is wearing was omitted from the second sketch. In the etching, his hat is hanging next to the window.

The lines in the second draft have been indented with a sharp instrument, after Rembrandt had blackened the back of the paper. There are only a few preparatory drawings extant which show the entire composition and the two drawings are the only ones made for one and the same etching. Other indented drawings have similarly all been executed in chalk. On the other hand a few preparatory drawings for etchings which are not indented have been made in pen (Cat. No. 25).

The etching of Jan Six is dated 1647 and the drawings are therefore a good example of Rembrandt's style in that year. The small sketch of Six and the drawing of a family of beggars on the reverse are also a clue to the dating of a group of sketches in black chalk, of figures as well as landscapes (Cat. No. 22).

A few works and documents bear witness to the relationship between Jan Six and Rembrandt. Six was born in 1618 and Rembrandt had known him at least since the portrait of 1647. Rembrandt etched a frontispiece, *The Marriage of Jason and Creusa* in 1648 for Six's tragedy *Medea*.[5] In 1652, when Rembrandt made the two drawings in the Pandora album (Cat. No. 31A and B), he concluded two deals with Six on 5 October concerning the sale of paintings; one was in connection with a *Portrait of Saskia*,[6] the other a *Simon in the Temple* and a *Preaching of John the Baptist*.[7] In the following year Six lent Rembrandt a thousand guilders which he used in part as repayment on his house,[8] for which reason he probably also sold the above mentioned paintings to Six in 1652. Lastly, in 1654, Rembrandt painted the *Portrait of Jan Six* which is still in the Six collection.[9]

The Six family had made their fortune in the silk and cloth industry and after the death of his mother Anna Wijmer in 1645 Jan could live on his inheritance and devote himself entirely to literature and art. He had enjoyed a good education, had attented the Latin school in Amsterdam and the university in Leiden. As conclusion to his studies he made a trip to Italy around 1640. In 1655 he married Margaretha Tulp. He took up the public office of burgomaster of Amsterdam in 1691. By the time of his death in 1700 the collection acquired by Six included Dutch and Italian paintings, antique statues, drawings, prints and books.[10]

P.S.

1. Six suggested that his ancestor is holding a rabbit in his left hand; J. Six, 'Rembrandt's voorbereiding van de etsen van Jan Six en Abraham Francen', *Onze Kunst* (1908), p. 54.
2. Interpreted by Six as a birdcage 1969; Broos 1981.
3. Benesch, No. 768.
4. Amsterdam, Historical Museum; Benesch, No. 749; Broos 1981, No. 13.
5. B. 112.
6. *Documents* 1652/7.
7. Documented in a contract of 13 September 1658, when this and the first agreement were annulled; *Documents*, 1658/18.
8. This debt was taken over by Lodewijk van Ludick in 1657. *Documents* 1657/3.
9. Bredius/Gerson, No. 276.
10. The sale catalogue of 6 April 1702 is in the archive of the Six family.

23c: Rembrandt, *Portrait of Jan Six*. Amsterdam, Historisch Museum.

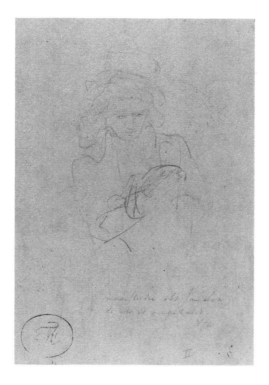

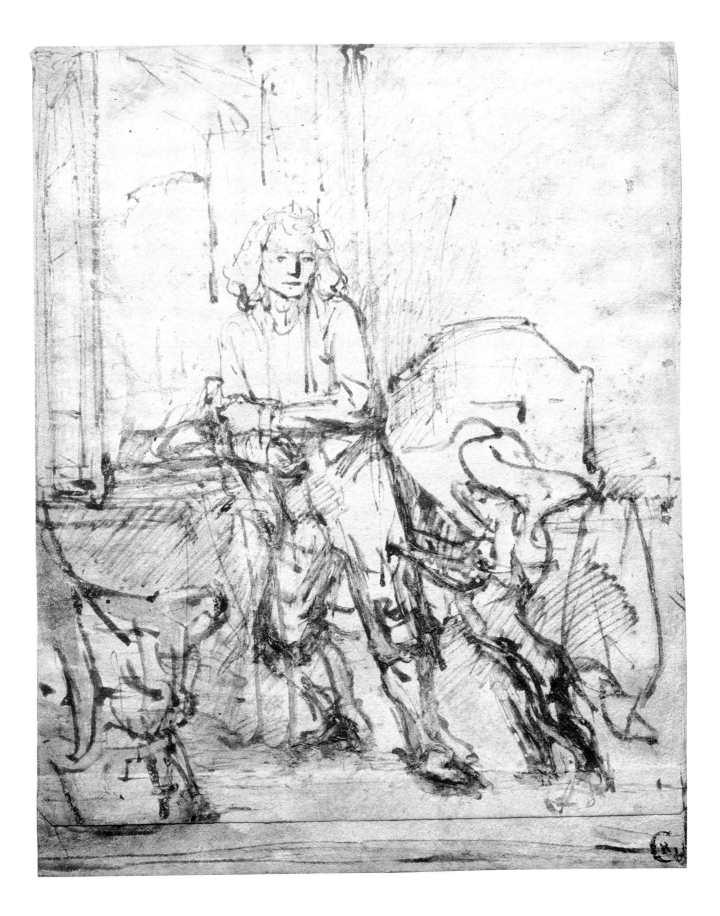

24

Seated female nude, as Susanna

Black chalk, white wash, 203 × 164 mm
Berlin, Staatliche Museen Preussischer
Kulturbesitz, Kupferstichkabinett

Provenance: Count Andreossy, sale Paris, 13–16
April 1864, No. 384; Jean François Gigoux
(L. 1164), sale Paris, 20 March 1882, No. 413;
KdZ. No. 5264 (1902).

Literature: Bock-Rosenberg 1930, No. 5264,
p. 224; Benesch 1954–57 and 1973, No. 590
(with other previous literature).

Exhibition: Berlin 1970, No. 37.

24a: Rembrandt, *Susanna at the Bath*. The Hague,
Mauritshuis.

24b: Rembrandt, *Susanna and the Elders* (detail).
Berlin, Gemäldegalerie SMPK.

Life drawing formed part of the training for the apprentice artist. This exercise was useful at a later date when nude figures were depicted in biblical and mythological scenes. Rembrandt used studies of the nude in this way for the first time in two etchings dating from the beginning of the 1630s. It is uncertain whether they date from the Leiden period or were made in Amsterdam, where Rembrandt settled to work in the early 1630s.[1] A preliminary study, made in black chalk for one of these etchings, *Diana seated by the water*, is still extant, the earliest drawn nude that we know of by Rembrandt.[2]

In the later 1630s Rembrandt drew a few female nudes,[3] and in the mid-1640s boys stood as models. While the pupils drew these, Rembrandt made various etchings, which in turn served as models for pupils (Etchings Cat. No. 21).[4] A few drawings of nudes from the later period were executed in pen and these were also made with his pupils (Cat. No. 38 and 49).

The half-naked woman sits on a chair with a small back rest. She is holding her left arm up to her just visible breast and her right arm is resting on a tabletop, the edge of which is clasped by her hand. The woman has turned her head partly towards us with a startled expression. Given this pose, it is likely that the model is depicted in the role of the biblical Susanna, at the moment when she is surprised, while bathing, by the two elders. Rembrandt painted a bathing Susanna in 1636 (Fig. 24a)[5] and probably earlier in that year, he drew the copy of Pieter Lastman's painting of the same subject (Cat. No. 11). Finally, there is Rembrandt's larger painted version in Berlin dated 1647 (Fig. 24b).[6]

The question is whether a connection can be established between the exhibited drawing and either of the above mentioned paintings. In considering this we should take note of the fact that under the visible version of the 1647 painting, there is a much earlier one, which is known from a drawing by a pupil (Fig. 24c).[7] The painted Susanna of 1636 and the model in the drawing are both depicted seated, but the position of the head and hands differs considerably. In the painting, Susanna's head is placed nearer her shoulders and the body is, moreover, seen from the side.

There are also differences in Susanna's pose in the first and second versions of the Berlin painting. Judging from the drawn copy of the first version, the position of Susanna's head and shoulders was a compromise between the painting of 1636 and the second version. More of her right shoulder is seen in the final version than in the earlier one, and in addition,

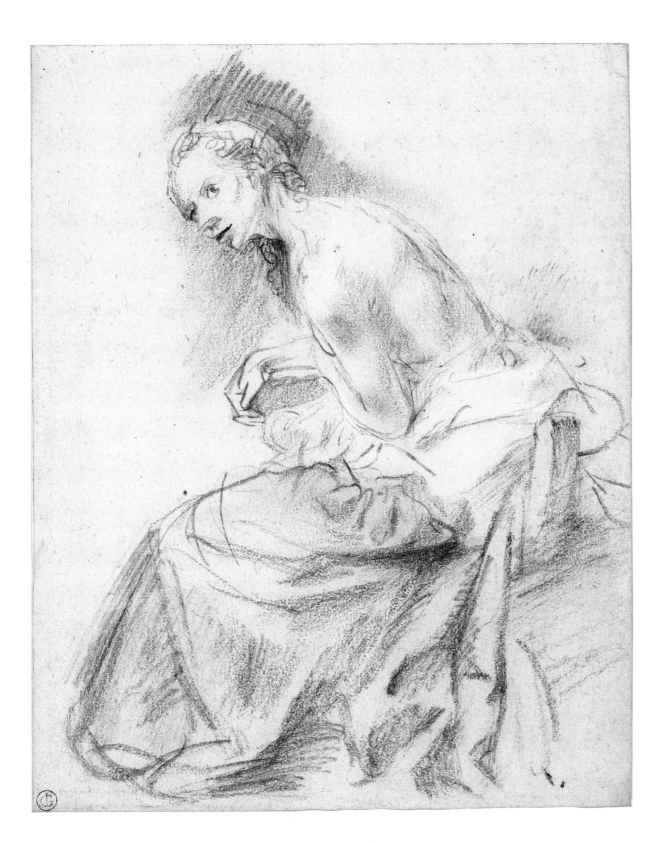

Susanna's breast was initially covered by her arm.[8]

The pose of the earliest Susanna therefore seems to be the starting point for the first version of the Berlin painting. In the position of the head, neck and upper body, the drawing bears the most resemblance to the visible second version of the Berlin painting. Both the modelling and the areas of shadow of the drawing accord with this last version. Rembrandt thus made the drawing in preparation for the alteration of the pose. The drawing had previously also been considered to be a study for this painting and dated to the same year of 1647.[9]

Rembrandt used black chalk more often at that time. With it he drew a number of small figures and groups, landscapes in and around Amsterdam (Cat. No. 22), and one of the two preparatory drawings for the etching of *Jan Six*, which is also dated 1647 (Fig. 23b). This drawing displays the greatest similarity in style. The black chalk has been subtly applied in various gradations, particularly in the hatched areas, and strong accents have been placed here and there. The chalk drawings from the 1630s are done in a broader style and are less varied in tone. It is characteristic of Rembrandt's method of working that he made the drawing in preparation for alterations while the work was in progress.

There is also a drawing of one of the elders, the one standing behind Susanna in the Berlin painting (Fig. 24d).[10] This sheet was made in gallnut ink on light yellow prepared paper. On basis of this characteristic technique, it can be assumed that the drawing was made towards the end of the 1630s.[11] It is clear from the pose of the man that the composition of the picture had already been determined: the line through the left hand of the elder indicates the contour of Susanna's back and the diagonal line at the lower right marks out the position of the cloak, which, in the painting, is lying on a wall. So, the first version of the painting probably also dates from the last quarter of the 1630s.

P.S.

1. It concerns an etching of a *Seated female nude* (B. 198) and a *Nude Diana* (B. 201), both with the monogram *RHL*, which Rembrandt used during 1632 and not thereafter. If the two etchings were made during the Amsterdam period—in Uylenburgh's 'Academy' where Rembrandt was working, there was probably greater opportunity to work from the nude than in Leiden—then they must be dated to the end of 1631 or beginning of 1632.

2. London, British Museum; Benesch, No. 21.

3. In red chalk a *Standing female nude as Eve*, Malibu, The J. Paul Getty Museum, Benesch, No. 137; and in black chalk a *Seated female nude*, Rotterdam, Museum Boymans-van Beuningen, Benesch, No. 376. Both drawings are dated to c. 1637.

4. B. 193, 194 and 196.

5. The Hague, Mauritshuis; *Corpus* III A117. Paris 1986, No. 41.

6. Berlin, Gemäldegalerie SMPK; Bredius/Gerson, No. 516.

7. Budapest, Szépmüvészeti Múzeum, Sumoski *Drawings*, No. 823–x, as Barent Fabritius. He was probably working with Rembrandt in the second half of the 1640s and the sheet is dated to 1646. Hans Kauffmann, 'Rembrandts Berliner Susanna', *Jahrbuch der Preussischen Kunstsammlungen*, 45 (1924), p. 72–80.

8. From an x-ray of the figure of Susanna it appears that the head and shoulders were placed close together intentionally. Kauffmann dates the first version to c. 1635; Kauffman 1924, p. 80; Bruyn 1983, p. 54, n. 13, dates the first version of the painting to about 1636.

9. By Kauffmann 1924. Hofstede de Groot is the only one to date the painting earlier, 1635–37; HdG 1906, No. 46.

10. Melbourne, National Gallery of Victoria; Benesch, No. 157. John Gregory, Irena Zdanowicz, *Rembrandt in the collections of the National Gallery of Victoria*, Melbourne 1988, p. 117.

11. Dated examples of the same technique and style are Benesch, Nos. 161 (1638), 168 (1638) and 442 (1639).

24c: Barent Fabritius, *Susanna and the Elders*. Budapest, Szépmüvészeti Múzeum.

24d: Rembrandt, *One of the Elders*. Melbourne, National Gallery of Victoria.

25

Jerome reading in a landscape

Pen and brown ink, brown and white wash,
260 × 204 mm
Hamburg, Kunsthalle, Kupferstichkabinett

Provenance: E.G. Harzen, Hamburg (1863);
Inv. No. 22414.

Literature: Benesch 1953–57 and 1973, No. 886;
White 1969, pp. 220–21.

Exhibitions: Rotterdam/Amsterdam 1956, No.
185; Amsterdam 1969, No. 105; Milan 1970,
No. 23; Washington 1990, No. 42 (with other
previous literature and exhibitions).

25a: Rembrandt, *Christ in the Garden of Gethsemane.*
Hamburg, Kunsthalle, Kupferstichkabinett.

25b: Rembrandt, *St Jerome in an Italian Landscape.*
Amsterdam, Rijksprentenkabinet.

Preliminary drawings for etchings are rare, but
there are two such sheets in the Kunsthalle in
Hamburg,[1] *Christ in Gethsemane*[2] (Fig. 25a) and
Jerome reading in a Landscape. Both are drawn in
pen, with wash added with the brush and
corrected with white body colour. The
representation of *Christ in Gethsemane* had been
made smaller in the etching and the group of
Christ with the angel has not been depicted in
mirror-image.[3] On the other hand, the etching
of *Jerome in a Landscape* has the same dimensions
as the drawing, while the composition—in
mirror-image—is more or less similar (Fig.
25b; Etchings Cat. No. 31).

The saint sits reading in the shadow of a
truncated tree, while the lion, his companion,
stands watch. A church, a tower and one or
two houses are situated in the hilly landscape.
A brook runs under a bridge and down into the
foreground. Rembrandt sketched the scene in
very broad outline but, as usual, he took
deliberate account of the fall of light. This can
be seen, for example, from the illuminated side
of the tree, which has been very finely drawn,
while the side in shadow has been depicted
darker. Rembrandt indicated shadow in fine
hatched lines on the hind leg of the lion and he
corrected parts of his head and paws in white
body colour. He also made the saint's hat
smaller and lines in the landscape were
obscured with white paint.

Rembrandt decided to change the division of
light and dark when he transferred the compo-
sition to the copper plate. The foreground, the
saint and the lion's rump, in shadow in the
drawing, have been placed in the light in the
etching. All sorts of details were also added—

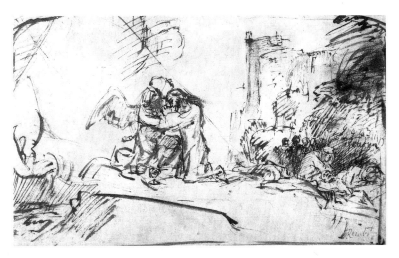

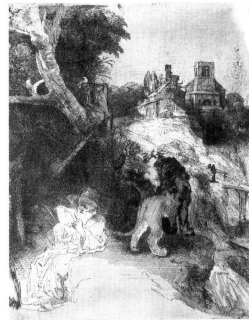

figures on the bridge, a bird in the truncated tree—and the composition was changed to the extent that Jerome's hut is substituted for the view to the right of the lopped tree. Rembrandt drew a tower with a truncated spire on the hill and a lower lying building with a chimney. The buildings were completed in a different way in the etching and the tower has no spire at all.

Rembrandt was influenced by Italian examples.[4] He had seen the print by Cornelis Cort, after Titian, of the same subject dated 1565; here a hilly landscape also forms the background.[5] The buildings are inspired by sixteenth-century Venetian prints, although there is no direct example to indicate this.[6] However, the tower and the houses in particular contain elements which are reminiscent of Dutch buildings drawn by Rembrandt.

Rembrandt drew the lion from memory, relying on the experience he had gained in drawing animals after life (Cat. No. 26). But here a model also played a part, which he also used for the drawing of *Daniel in the Lions' Den* (Fig. 26b).[7] In the latter, he adopted the lion entering the composition from the right, from a print by Willem de Leeuw after a painting by Rubens of the same subject.[8] The pose of the lion on the left hand side on the same print could have been the point of departure for Jerome's lion. The invention has therefore come about through a combination of motifs observed from nature and from examples by other masters.

The drawing and the etching are usually dated to the first half of the 1650s, but a slightly earlier dating, on grounds of similarity in style to *Daniel in the Lions' Den*, has also been suggested; the latter can be dated 1649 or before.[9] The etching of *Christ in Gethsemane* bears a date in the 1650s of which the last digit is not visible. A dating of the three drawings to about 1650 seems therefore likely, although it must be remembered that the prints were not necessarily executed at the same time. The drawing of *Daniel in the Lions' Den* could, like the two drawings in Hamburg, have been made as a preliminary sketch for an etching, although in this case the etching was never executed.

The lively, broad pen-lines, which also occur in the drawing for the etching of Jan Six (Cat. No. 23), are characteristic of the late 1640s. In the early 1650s Rembrandt's handling of line becomes tighter and less fluid. The drawings of 1652 in the Pandora album are examples of this (Cat. No. 31).

P.S.

1. P. Schatborn, 'Tekeningen van Rembrandt in verband met zijn etsen', *De Kroniek van het Rembrandthuis*, 38 (1986) 1, pp. 7–38.
2. Benesch, No. 899.
3. B. 75.
4. Clark 1966, p. 117–121.
5. J.C.L. Bierens de Haan, *L'Œuvre gravé de Cornelis Cort*, The Hague, 1948, No. 134.
6. In the literature Campagnola is particularly mentioned as a source of inspiration.
7. Amsterdam, Rijksprentenkabinet; Benesch, No. 887.
8. Schatborn 1985, No. 24, Fig. 24c.
9. See Schatborn 1985, under No. 24 and Washington 1990, No. 42, where the drawing is dated to c. 1649–1650 and the etching to c. 1650.

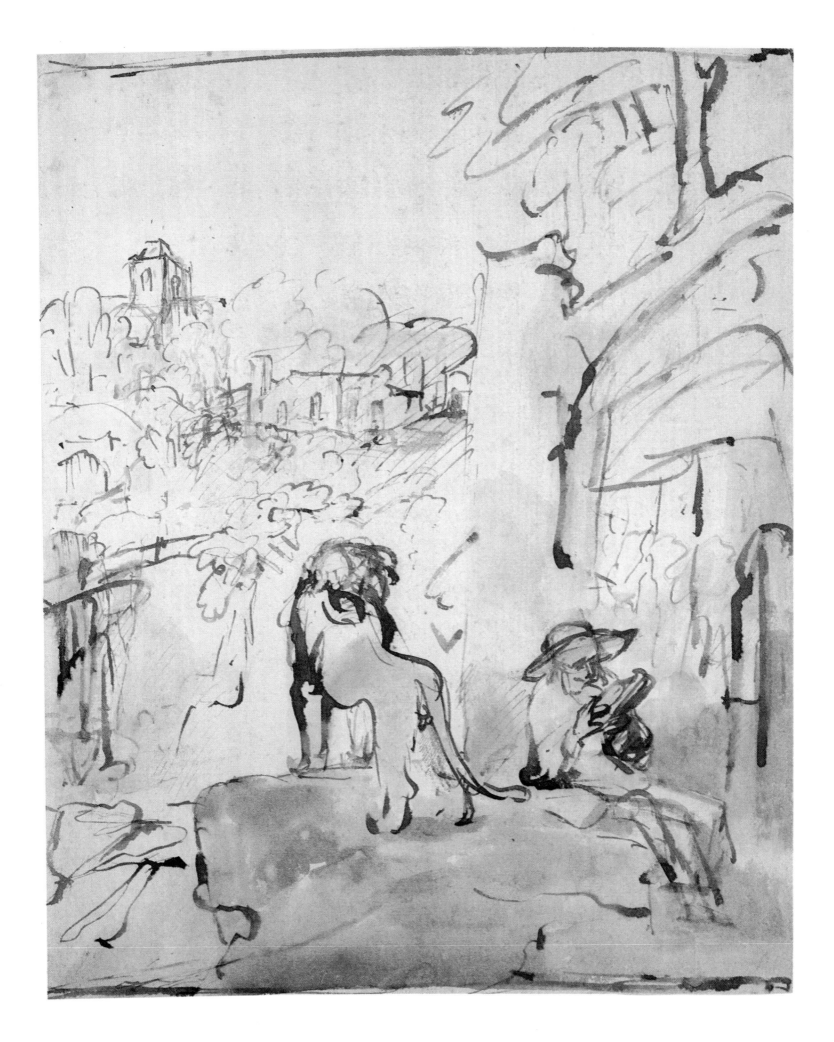

26

Lion lying down

Pen and brown ink, brown wash, 138 × 204 mm

Inscription: below right *Rembrandt fec.*, above left *52* (Bonnat album); verso *van rembdt na 't leven, f 10 gld.* (by Rembrandt, made from life, 10 guilders).
Paris, Musée du Louvre, Département des arts graphiques.

Provenance: H. Reveley (L. 1356), sale London, 21 April 1884, No. 157; R.P. Roupell, sale London, 12 July 1887, No. 1078; L. Bonnat (L. 1714), presented to the Louvre in 1919 (L. 1886); Inv. No. RF 4721.

Literature: Lugt 1933, No. 1119; Benesch 1954–57 and 1973, No. 1214.

Exhibitions: Paris 1988–1989, No. 43 (with other previous literature and exhibitions).

Rembrandt has depicted the distrustful looking lion exceptionally strikingly. It looks as if the drawing was quickly set down, but as usual, it was done with great care. He has, for example, left the area beneath the dark pupils white to give the animal its watchful gaze. Shadow has been indicated in the face with small strokes, whereas the mane has been made in rich contrasts of transparent wash, which gives it its rough character. Rembrandt drew the body in varying pen lines, while the supple skin was indicated with loose strokes. The forepaws have not been elaborated and the foreground is barely indicated. Finally, there are hatched lines on the left, made with a half dry pen, putting the massive head into relief.

The Berber lions which Rembrandt and his pupils drew came from North Africa and were imported by the East India Company.[1] Rembrandt's drawings of lions are not preliminary studies. He made such drawings for practice, in order to depict these animals, from memory, in biblical and other representations and as models and a source of inspiration for his pupils. Thus Rembrandt had no difficulty in depicting the lion from memory, concisely but accurately, in for example the preparatory drawing (Cat. No. 25) and the etching of *St Jerome in a Landscape* (Etchings Cat. No. 31).

The drawings of lions formed part of the art book or album, which are mentioned in Rembrandt's inventory of 1656 as *beesten nae 't leven* (animals made from life).[2] Rembrandt's lions were not only popular with his pupils but also later on. In 1729 a *Recueil de Lions* (album of lions) by Bernard Picart appeared which included 18 prints after drawings of lions (Fig. 26a).[3] Perhaps these were made after the same drawings mentioned some years before in the catalogue of the well-known art dealer Jan Pietersz. Zomer.[4] Although a fair number of drawings of lions accredited to Rembrandt appear in sale catalogues in the later eighteenth century, it is notable that only a few sheets are now considered to be by his hand.[5]

The drawing in the Louvre was made, like the others, in pen and brush towards the end of the 1640s. These studies probably predate Rembrandt's drawing of *Daniel in the Lions' Den* in Amsterdam (Fig. 26b).[6] Rembrandt's pupil, Constantijn van Renesse, similarly made a drawing of this subject which is dated 1649.[7] It is probable that Rembrandt's drawing served as a model and a source of inspiration for his pupil.

From the prices written in an old hand on the back of a number of drawings of lions, it is clear that they were already changing hands in the seventeenth or early eighteenth centuries. On the reverse of the exhibited drawing is written that it was sold for ten guilders. An inscription on the Rotterdam drawing gives the information that it costs six guilders and on one of the Amsterdam drawings is written that *5 stux leuwen* (five lions) were sold for three guilders.
P.S.

1. Schatborn 1977, p. 25.
2. *Documents* 1656/12, No. 249.
3. Schatborn 1982, p. 25–28. The Paris drawing is reproduced in the album as No. 11.
4. Schatborn 1982, pp. 21–24.
5. Two in the British Museum in London are made in black chalk; Benesch, Nos. 774 and 775. Those in Amsterdam and Rotterdam in pen and brush; Benesch Nos. 1215 and 1216; Schatborn 1985, Nos. 53 and 54; Benesch, No. 1211; Giltaij 1988, No. 23.
6. Benesch, No. 887; Schatborn 1985, No. 24.
7. Rotterdam, Museum Boymans-van Beuningen; Sumowski *Drawings*, No. 2145; Giltaij 1988, No. 130.

26a: Bernard Picart, *Recueil de Lions*, No. 11. Amsterdam, Rijksprentenkabinet.

26b: Rembrandt, *Daniel in the Lions' Den*. Amsterdam, Rijksprentenkabinet.

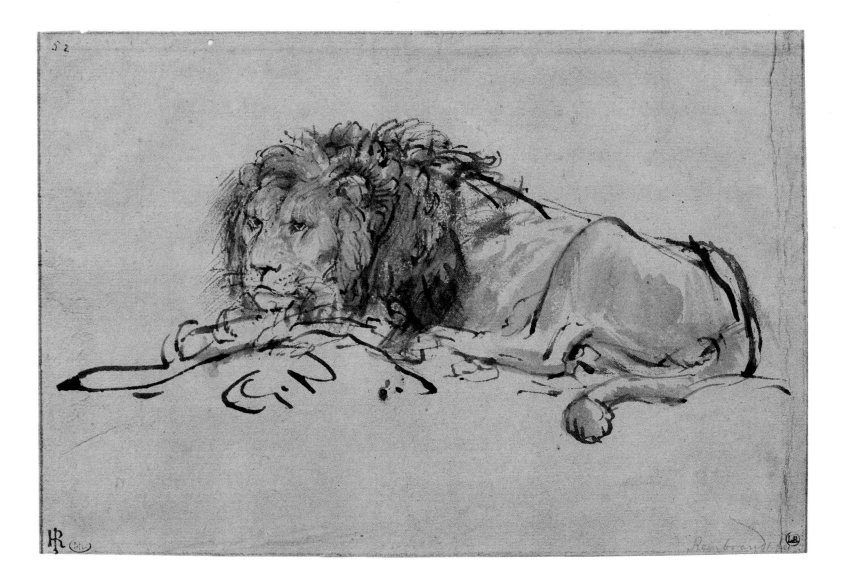

27

Farm with dovecote

Pen and brown ink, brown and white wash,
129 × 200 mm
Private collection

Provenance: Unidentified Dutch collection
(L. 2942/43); N.A. Flinck, Rotterdam (L. 959);
William Cavendish, 1st Duke of Devonshire
(1723); The Duke of Devonshire and the
Chatsworth Settlement, sale London, 6 July
1987, No. 14.

Literature: Benesch 1954–57 and 1973,
No. 1233.

Exhibitions: Amsterdam 1969, No. 87;
Washington 1990, No. 14 (with other previous
literature and exhibitions).

When Rembrandt went out to draw the
landscape, he often chose one of the many
farms in the polderland as his subject. A large,
stately farm, extended to a sort of country
house, can be seen in the exhibited drawing.
The building has two roofs and a side wing
with a large dovecote attached. A barn stands
to the right of the house and a haystack behind
the fence. Cows stand and lie in the field. The
house is divided from the road by trees which
obscure the front of the house. To the left,
grass ruffled by the wind grows on a dike
which stretches into the distance. Here, small
houses can be seen. Nearer by, a figure is
seated in the shadow of the house, leaning
against the dike, possibly a pupil drawing the
landscape further away. In the distance we see
a second small figure. Behind the houses the
sea has been indicated with a horizontal line.

Rembrandt's pen has depicted the sun-
drenched landscape in a variety of lines,
through which no linear pattern has emerged.
The areas intentionally left open represent the
sunlight in the landscape. The light brown
wash not only indicates the areas of shadow
but has also been used to depict one or two
branches which hang over the road. The
horizon of the sea has similarly been indicated
in light brown ink with the tip of the brush.
Between the trees and the horizon there was a
dot which Rembrandt covered with white.

Rembrandt probably made the drawing on
the Diemerdijk which ran eastwards along the
mouth of the IJ and the Zuiderzee.[1] It is known
that he made drawings and etchings with his
pupils there. The houses in the distance could
represent the inns situated on the bend of the
dike, where he drew the *View over the* IJ (Cat.
No. 28). We do not know of this particular
type of farm from other drawings. *The farm with
dovecote* was made in around 1650, the period in
which Rembrandt drew many landscapes.

The paper at the top of the drawing is
rounded, a form which also occurs in etchings
and paintings. At the top right we see two
marks, which were written by an unidentified
seventeenth-century Dutch collector. Similar
marks occur on drawings—particularly
landscapes—and some etchings by Rembrandt,
as well as on drawings by other artists.[2] Two
landscapes were acquired from the unidentified
collector by Nicolaes Anthonie Flinck, whose
mark is on the bottom right of the drawing.
He was the son of Rembrandt's pupil and
collaborator Govert Flinck. A large part of his
collection was acquired by the Duke of
Devonshire in 1723.[3] After having remained
together in the possession of the dukes for
centuries, a number of the drawings were
recently auctioned. Among them were twelve
landscapes by Rembrandt.[4]

P.S.

1. According to B. Bakker the farm is characteristic of
the Amstelland; Washington 1990, No. 14, p. 102.
2. Schatborn 1981–I, p. 17.
3. See also Schatborn 1982, pp. 16–21.
4. Sale London, 3 July 1984 and 6 July 1987.

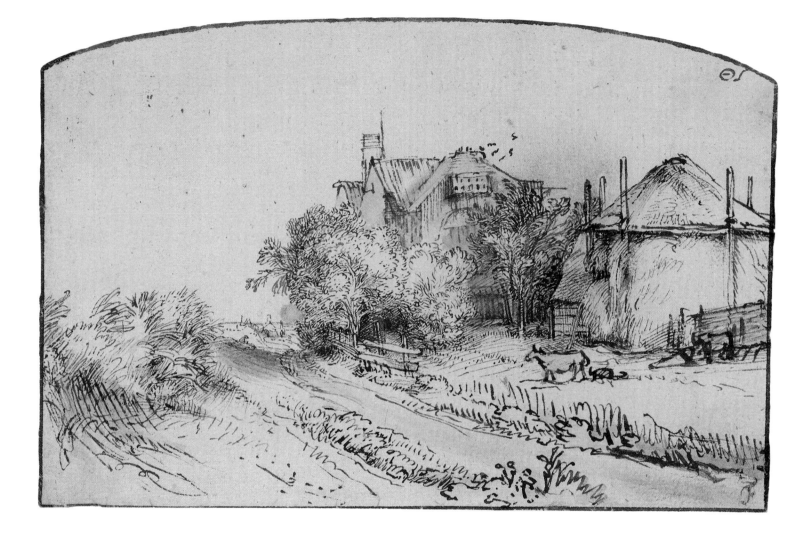

28

View over the IJ *near Amsterdam*

Pen and brown ink, some body colour,
cartridge paper, 76 × 244 mm
Chatsworth, The Duke of Devonshire and the
Trustees of the Chatsworth Settlement

Provenance: N.A. Flinck, Rotterdam (L. 959);
William Cavendish, 1st Duke of Devonshire
(1723); Inv. 1030

Literature: Lugt 1920, p. 143; Benesch 1954–57
and 1973, No. 1239.

Exhibitions: Amsterdam 1969, No. 84; London
1969, No. 91.

This long view over the IJ was drawn from the Anthonisdijk or Diemerdijk, which stretched from Amsterdam eastwards along the mouth of the IJ and the Zuiderzee. On the other side of the water, in the centre, lies the village of Schellingwou, to the left in the distance is the tower of Nieuwendam and to the right, further inland, the tower of Ransdorp.[1]

When Rembrandt made the drawing, he was sitting at a bend of the Diemerdijk, where a few inns were situated. To the left he saw the piece of land which jutted out into the IJ from outside the dike. In the right foreground is the oak facing which starts from here and runs along the dike.[2] Rembrandt was therefore drawing from where the facing began, with a view over the land lying outside the dike.

The dike with paling facing also appears in the foreground of a drawing in Rotterdam, (Fig. 28a),[3] also a view of Schellingwou.[4] In addition it shows part of a dike with two tall beacons in the IJ. This is probably the *nieuw ghemaakte dyck* (newly made dike), which also appears on a print by Roelant Roghman and

where the holes can be seen which were breached in the Diemerdijk on 5 March 1651 (Fig. 28b, detail).[5] In the centre, behind the hole in the dike, are inns; this is the spot where Rembrandt sat to make the drawing. In Roghman's print we clearly see the dike with wooden facing to the right of the inns; to the left of the inns is the *nieuw ghemaakte dyck*, marked with *C*.

In a drawing of an *Interior with a man drawing* in Paris (Fig. 28c)[6] we see through the window the same view of Schellingwou as that in the Rotterdam drawing. Rembrandt possibly made this together with the pupil depicted in the Paris drawing, while they were sitting in one of the inns with a view over the new dike to Schellingwou. Therefore, the drawings in Paris and Rotterdam were made shortly after the breach of the dike in 1651. The exhibited landscape must have been made before this. The date of these drawings can be established and precisely specified by means of the topographical details.[7]

Broad compositions with a town or village

28a: Rembrandt, *View over the* IJ. Rotterdam, Museum Boymans-van Beuningen.

28b: Roelant Roghman, *The Bursting of the Dam at Diemen* (detail). Amsterdam, Rijksprentenkabinet.

28c: Rembrandt, *Interior with a Man drawing and a View over the* IJ. Paris, Musée du Louvre, Département des arts graphiques.

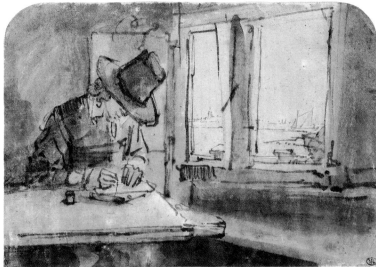

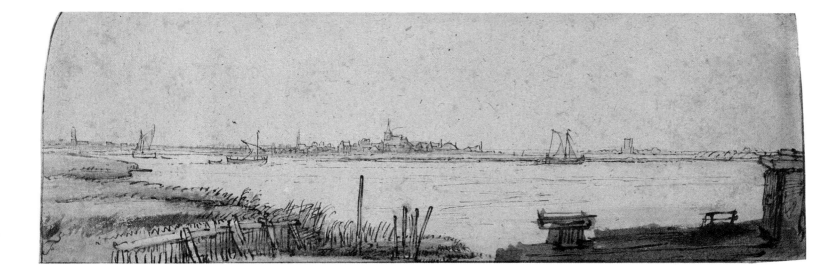

on the horizon originally appeared in atlasses and as marginal decoration on maps and plans of towns. In the seventeenth century these town profiles were also drawn as independent works, made into prints and, especially towards the end of the century, also painted. Rembrandt made an etching of the *View of Amsterdam* from a point at the start of the Diemerdijk (Fig. 28d).[8]

Rembrandt used greyish cartridge paper for the drawing. As a result the landscape has acquired a quiet atmosphere. The drawing was originally rounded at the top, but a piece has been cut off there at a later date.

P.S.

1. Identified by F. Lugt 1920, p. 143.
2. To the east behind the dike is a small lake, the Nieuwe Diep, which was created as a result of a breach in the dike in 1420.
3. Rotterdam, Museum Boymans-van Beuningen; Benesch, No. 1358 (c. 1655–1656); Giltaij 1988, No. 26 (1650–1653).
4. There is a tall roof to the left of the church tower in this drawing which is not in the Chatsworth drawing.
5. Amsterdam, Rijksprentenkabinet; FM 2017, Holl. 39. The print is made up of various representations and also shows a second breach in the Diemerdijk near Houtewael, which is nearer to the town.
6. Paris, Louvre, Département des arts graphiques; Benesch, No. 1172 (c. 1655); Lugt 1933, No. 1152 (1650–1653); Paris 1988–1989, No. 65 (1653–1656). Lugt 1933, No. 1152 (1650–1653); Paris 1988–1989, No. 65 (1653–1656). Lugt believed that Jan Six was depicted here, writing in his country house IJmond, which was situated near 'Jaaphannes', further along the wooden faced dike; Lugt 1920, p. 144. Looking in the direction of Schellingwou from this point, the new dike is not visible.
7. Benesch dates the Chatsworth drawing to 1650–1651; the catalogue of the exhibition in 1969 in Amsterdam to 1649–1650.
8. B. 210, usually dated to the beginning of the 1640s.

28d: Rembrandt, *View of Amsterdam*. Amsterdam, Rijksprentenkabinet.

29

The Rhine-gate at Rhenen

Brown ink, pen and brush, 119 × 175 mm
Chatsworth, The Duke of Devonshire and the
Trustees of the Chatsworth Settlement

Provenance: N.A. Flinck, Rotterdam (L. 959);
William Cavendish, 1st Duke of Devonshire
(1723); Inv. 1043.

Literature: Lugt 1920, p. 161–162; Benesch
1954–57 and 1973, No. 1301; Schatborn 1990,
p. 33.

Exhibitions: Chicago 1969, No. 126; London
1969, No. 95; Washington 1990, No. 52 (with
other previous literature and exhibitions).

Rembrandt and Hendrickje Stoffels probably
made a trip to the east of the country in 1649.
She was born in Bredevoort, not far from the
German border, in 1626. From a recently
discovered document it has become known that
she attended a baptism there in 1649 (see Cat.
No. 35).[1]

On their journey Rembrandt drew the
medieval city gates of Rhenen, a town on the
Rhine.[2] Like many other artists, Rembrandt
had a preference for old buildings. The
medieval city gates of Rhenen were probably
considered to be radically different from the
then 'modern' buildings of the Renaissance and
Baroque. The old buildings not only
symbolised transience, but were possibly also
seen as relics of an indefinable past where the
stories from the Bible and antiquity took place.
Rembrandt's drawings of old gateways,
fortifications and towers can be considered to
be preparatory studies for the buildings which
he depicted in the background of historical
representations. These buildings, drawn from
memory, are directly comparable to the old
buildings drawn after life.

Rhenen was greatly loved by artists; the
town appears in many drawings, etchings and
paintings by various seventeenth-century
artists. The drawing of the city side of the
Rhine-gate focuses on the gate-house, which
Rembrandt made the most highly finished part
of the drawing. We see the opening in the
inner gate, the massive square tower and, to
the right, the two towers of the outer gate.
From this, a bend in the road led to the exit
from the town on the Rhine.

The medieval building has a weathered
character which has been depicted with fine,
lively lines. Rembrandt has indicated the
darkness beneath the vault in the entrance of
the gate with strong lines, while light shines in
the area behind it between the inner and the
outer gate. We also see one or two figures on
the road here. The wall of the house to the
right of the gate has been left blank to indicate
the fall of light, by which Rembrandt has
created a strong contrast with the dark
entrance.

The style in which the buildings to the left
of the gate have been depicted in turn contrasts
with the detailed drawing style of the gate-
house. Here, the houses are drawn sketchily in
a free rhythm of loose lines with here and there
hatchings and areas of shadow. Two children
are sitting playing in the street in front of the
houses. Rembrandt's personal style manifests
itself particularly well in the alternation of
precision and sketchiness, combined with the
varied contrasts of light and shade.

A second view of the Rhine-gate at Rhenen,

from a slightly different viewpoint (Fig. 29a),[3] is more uniformly drawn and with less variety. The buildings to the left of the entrance to the gate are also dissimilar, but the underpass is especially different; instead of the play between light and dark in the gateway of the exhibited drawing, there is a fairly black hole in the Paris drawing, as if the entrance is closed. The light falls from different angles in the drawings; Lugt therefore noted that one drawing was made in the morning and the other in the afternoon.[4]

How to explain the differences between the two drawings? Was the Paris drawing made at another, for example later, time or was it made in the studio after the example of the exhibited drawing? Did Rembrandt work in different styles within the same period, with the Paris drawing being particularly influenced by Venetian drawings?[5] As Rembrandt often went out drawing with his pupils it is possible the work is by two hands. No doubt has ever been cast on the authorship of the Paris drawing; however, it remains to be seen whether there really is no cause for this. In the assessment it should be remembered that the grey wash was added later.

In the literature it has in the past been suggested that Rembrandt visited Rhenen twice and drew the city gate on both occasions. That could be an explanation for the differences between the drawings.[6] The drawing at Chatsworth would then have been made in 1649 and the Paris one at the beginning of the 1650s. It remains curious, though, that the buildings to the left of the gate are different in both drawings.

Related to the drawings of Rhenen are the views of *The Montelbaen Tower* and the *Tower of Swijgh Utrecht*, both are sections of the medieval walls of Amsterdam, the first from 1645–1646 (see Cat. No. 21) and the second from the beginning of the 1650s.[7]

P.S.

1. Henk Ruessink, 'Hendrikje Stoffels, jonge dochter van Bredevoort', *De Kroniek van het Rembrandthuis* 1 (1989), pp. 19–24. J.R. Voûte, 'Rembrandt's reis naar Bredevoort', *De Kroniek van het Rembrandthuis* (1990) 1–2, p. 40.
2. *The West Gate:* Haarlem, Teylers Museum, Benesch, No. 826; London, British Museum, Benesch, No. 1304; *The East Gate:* Bayonne, Musée Bonnat Benesch, No. 825; The drawing in Amsterdam, Rijksprentenkabinet, Benesch, No. 828 (Schatborn 1985, No. 111) is probably a copy and the representation is possibly a gate in Amersfoort (Fléhite [1982] 1, p. 6), where Rembrandt also made a drawing of the Singel, Paris, Louvre, Benesch, No. 824.
3. Paris, Louvre, Département des arts graphiques; Benesch, No. 1300.
4. Lugt 1920, p. 161.
5. This influence has been noticed in his work since 1650. The various possibilities are discussed by Schneider in Exh. Cat. Washington 1990, No. 52.
6. Lugt mentioned one journey which he dates to between 1650 and 1660; Lugt 1920, p. 156. Benesch believed that Rembrandt made two journeys, in c. 1648 and in 1652–53.
7. Amsterdam, Rijksprentenkabinet, Benesch, No. 1334; Schatborn 1985, No. 34.

29a: Rembrandt, *The Rhine-gate at Rhenen.* Paris, Musée du Louvre, Département des arts graphiques.

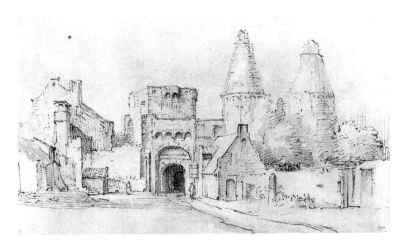

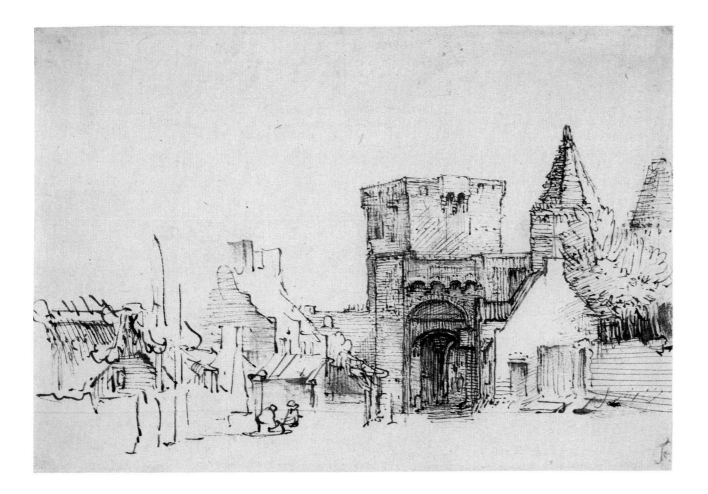

30

The bend in the river Amstel at Kostverloren

Pen and brown ink, brown and white wash, on cartridge paper, 136 × 247 mm, a piece of paper added to the right.
Chatsworth, The Duke of Devonshire and the Trustees of the Chatsworth Settlement

Provenance: N.A. Flinck, Rotterdam (L. 959); William Cavendish, 1st Duke of Devonshire (1723); inv. 1021.

Literature: Lugt 1920, p. 112; Benesch 1954–57 and 1973, No. 1265; I.H. van Eeghen, 'Rembrandt aan de Amstel', *Genootschap Amstelodamum*, Amsterdam 1969, Fig. IV; S. Slive, 'The manor Kostverloren: vicissitudes of a seventeenth-century Dutch Landscape Motif', *The Age of Rembrandt: Studies in Seventeenth Century Dutch Painting, Papers in Art History from the Pennsylvania State University*. Vol. III, 1988, pp. 132–68.

Exhibitions: Rotterdam/Amsterdam 1956, No. 150; Washington 1990, No. 67 (with other previous literature and exhibitions).

Rembrandt's landscapes followed in the footsteps of those artists who, at the beginning of the seventeenth century, first chose to depict the Dutch landscape.[1] Thus there are numerous similarities between Rembrandt's compsotions and those of Esaias and Jan van de Velde and Willem Buytewech.

Accurate observation of reality forms the basis of Rembrandt's depiction of landscape, although it has been suggested, probably wrongly, that he made a drawing such as this one in the studio.[2] On the left, the horizon has been depicted with one or two small dots and lines in order to indicate the distance; the trees in the right foreground have been depicted more boldly, thus creating depth in the composition.

Rembrandt created shadow with the brush: in and under the trees, in the reflection on the water, in the dark tree to the right and its shadow on the bank of the dike. In contrast the farm, the road and the path by the water along which two riders are making their way, have been placed in the light. By leaving the left foreground open—where the river bank ends, indicated by two lines—the perspective along the river from right to left has been strengthened. Rembrandt covered these lines over with white. The representation is a lyrical evocation of the Dutch landscape, in which the light and the atmosphere, also helped by the tinted paper, have been arrestingly captured.

The tower of the castle Kostverloren emerges above the trees in the centre of the landscape. This makes the location recognisable as the place by the Amstel where the café Het Kalfje is still to be found. The house has a long history and was depicted by a number of artists, including Jacob van Ruisdael and one of the Beerstratens (Fig. 30a).[3] This drawing

30a: Anthonie Beerstraten, *View of the Manor House Kostverloren and the Amstel.* Amsterdam, Rijksprentenkabinet.

shows the house in its surroundings. To the right stands a small house which appears behind the boats in the shadow of the trees in Rembrandt's drawing.

The house appears in the background of Rembrandt's etching of 1641, *Farm with haystack*,[4] but his drawings are later.[5] The most comparable drawing is now in the British Museum (Fig. 30b).[6] It was made from a position further along the bend of the river. In the foreground here we see a large hole with fencing around it. In the distance we see the other side of the river and a house.

Tradition has it that the house burnt down in 1650 and Rembrandt drew it in this ruined condition from the south west (Fig. 30c). The drawing must date from before 1658, the year in which the house was demolished and rebuilt.[7] The other drawings probably all date from before the fire, at the end of the 1640s.
P.S.

1. See for example the catalogue of the exhibition *Landschappen van Rembrandt en zijn voorlopers* (Landscapes by Rembrandt and his predecessors), Amsterdam (Museum het Rembrandthuis) 1983.
2. Schneider (in Exh. Cat. Washington 1990, No. 67) suggests that the drawing in Chatsworth was made in the studio with a drawing in the British Museum, Benesch, No. 1269, as model, which however is probably not by Rembrandt, but perhaps by his pupil Willem Drost; see Schatborn 1990.
3. Amsterdam, Rijksprentenkabinet, Inv. No. RP-T–1988 A1558.
4. B. 225.
5. Benesch, Nos. 1266 (c. 1651–52), 1268 (c. 1651–52), 1270 (c. 1652) and a drawing in Dresden, Kupferstich-Kabinett, which has not been included by Benesch. Schneider (Washington 1990, No. 67) rightly dates the drawing to 1649–1650.
6. London, British Museum; Benesch. No. 1269.
7. Chicago, The Art Instutute; Benesch, No. 1270 (c. 1652).

30b: Rembrandt, *The Bend of the Amstel near Kostverloren*. London, British Museum.

30c: Rembrandt, *The Manor House Kostverloren*. Chicago, The Art Institute.

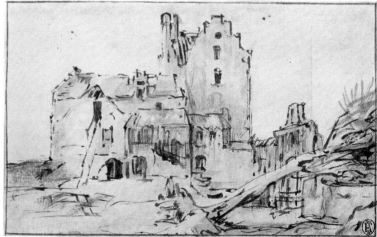

31

(A) *Homer reciting verses*

Pen and brown ink, 265 × 190 mm

Inscription: centre below *Rembrandt aen Joanus Six. 1652.*
Amsterdam, Six Collection.

(B) *Minerva in her study*

Pen and brown ink, brown and white wash, 190 × 140 mm

Inscription: centre below *Rembrandt f 1652*

Provenance: Jan Six, Amsterdam.

Literature: Benesch 1953–57 and 1973, No. 913 and 914 (with other previous literature); Dora and Erwin Panofsky, *Pandora's Box*, Bollingen series LII, New York 1956, p. 68 and 77; E. Haverkamp-Begemann, 'Rembrandt's so-called portrait of Anna Wijmer as Minerva', *Studies in Western Art, Acts of the twentieth International Congress of the History of Art*, Princeton 1963, pp. 59–65; Clark 1966, p. 166 and 184; Clara Bille, 'Rembrandt and burgomaster Jan Six', *Apollo* (1967), pp. 260–65; George Möller, *Het album Pandora van Jan Six (1618–1700)* 1983 (doctoral thesis).

Exhibitions: Rotterdam/Amsterdam 1956, No. 185a; Amsterdam 1969, No. 109, both times *Homer reciting verses*.

Among the best documented drawings, moreover in optimum condition, are two which form part of an album which has been in the possession of the descendants of Jan Six since it was made. It has a small folio format, is bound in a parchment cover and consists of 170 leaves, of which a fair number have been left blank. Jan Six must have made use of the album between 1647 and 1686. *Pandora 1651*[1] is written in black ink in decorative letters on the cover.

Pandora was created by Hephaistos and was given life by Pallas Athene (or Prometheus) and all the gods had given her gifts of distinguishing characteristics, and other presents.[2] In Six's album there are written and drawn 'gifts' to him from friends and well-known figures.

The friendship-album, *album amicorum*, was developed in the second half of the sixteenth century in the circles of usually well-to-do students who collected memories of famous

contemporaries and friends in their albums on their journeys visiting the universities of Europe. These were a sign of erudition and status, and a memory of friendship.[3]

Rembrandt contributed three times to an *album amicorum*. Apart from that for Jan Six, he drew an *Old man with clasped hands*[4] in 1634 for Burchard Grossman and in 1661 he drew a *Simon in the Temple*[5] for Jacobus Heyblocq. The drawings in the Pandora album are of classical subjects. The representation of *Homer reciting verses* is on fol. 40 and *Minerva in her study* appears two pages later. The choice of these subjects was of course determined by Six's interest in antiquity; they may even have been suggested by him. But we also find classical subjects in Rembrandt's œuvre and Rembrandt, like Six, possessed antique statues or casts made after them among them a head of Homer.[6] The drawing of *Homer reciting verses* bears the inscription *Rembrandt aen Joanus Six. 1652.*

The representation of Homer is inspired by Raphael's famous fresco *Parnassus* in the Vatican in Rome. Six had first-hand knowledge of it and both Rembrandt and Six probably owned Marcantonio Raimondi's print after it (Fig. 31a).[7] Rembrandt's substitution of a dignified upright pose for Raphael's elegantly posed Homer is characteristic. Various other motifs have been borrowed from Raphael's *Parnassus*:

the groundplan with figures placed on a lower plane in the right foreground and the men seated to the left and right of Homer, one of whom is writing down the words of the poet. The facial expressions in Rembrandt's drawing display in particular his capacity for simplifed characterisation.

The second drawing in the album, *Minerva in her study*, which has never been exhibited, is of a very different nature. The goddess is seated with her back to the window writing in a room draped with curtains. Her pen is just visible above the book lying on a book-rest. A cloth has been spread over the work table which is on a raised level. Minerva's shield with the Medusa head hangs on the wall to the right, above it her helmet and next to it a lance. In the foreground is a cast-iron stove with a bust and the end of the curtain has been draped over this.[8] We also come across a stove and bust draped with a cloth in Rembrandt's etching *An artist drawing from a model* (Fig. 31b, detail).[9]

In contrast to *Homer reciting verses* the character of this drawing is above all determined by the wash applied with the brush. Rembrandt made the white paper, as seen in the window, the strongest light-source. White paint has been used in various places, in order to lighten areas such as to the left behind the pedestal and to cover dark ink in other

areas; the wash is continually varied and transparent.

In this respect the drawing of *Rembrandt's studio with a model* of 1652 (Cat. No. 33) is most closely related. Here the window is also the source of light, which Rembrandt used to depict an equally atmospheric interior. Whereas this drawing was made after life, the *Minerva in her study* was made from imagination,[10] although some of the motifs were determined by the reality of Rembrandt's time; the table with the cloth and book-rest, the leaded window and the stove with the bust are all contemporary motifs. The shield and the lance, Minerva's attributes, come from representational tradition, while the raised curtain is a theatrical motif especially popular in portraiture and which gave the scene or the sitter a certain allure. Such a curtain was also included in the second preparatory drawing for the portrait of Jan Six. The Leiden artist Pieter Couwenhorn drew a similarly draped interior with Minerva in the *album amicorum* of Petrus Scriverius (Fig. 31c).[11]

The Roman Minerva was goddess of wisdom, science and the arts. The Medusa head, the head with the snakes, cut off by Perseus, and which turned all who regarded it to stone, adorned her shield. Rembrandt painted Minerva twice in the 1630s, once in an interior and another time depicting her larger

31a: Marcantonio Raimondi after Raphael, *The Assembly of the Gods on Mount Parnassus.* Amsterdam, Rijksprentenkabinet.

31d: Barent Fabritius, *The Sacrifice of Iphigenia.* Besançon, Musée des Beaux-Arts et d'Archéologie.

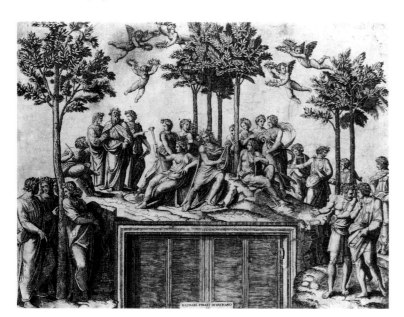

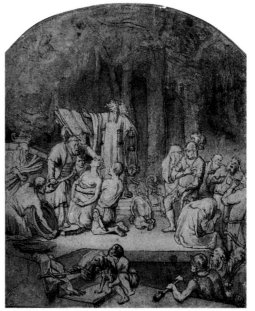

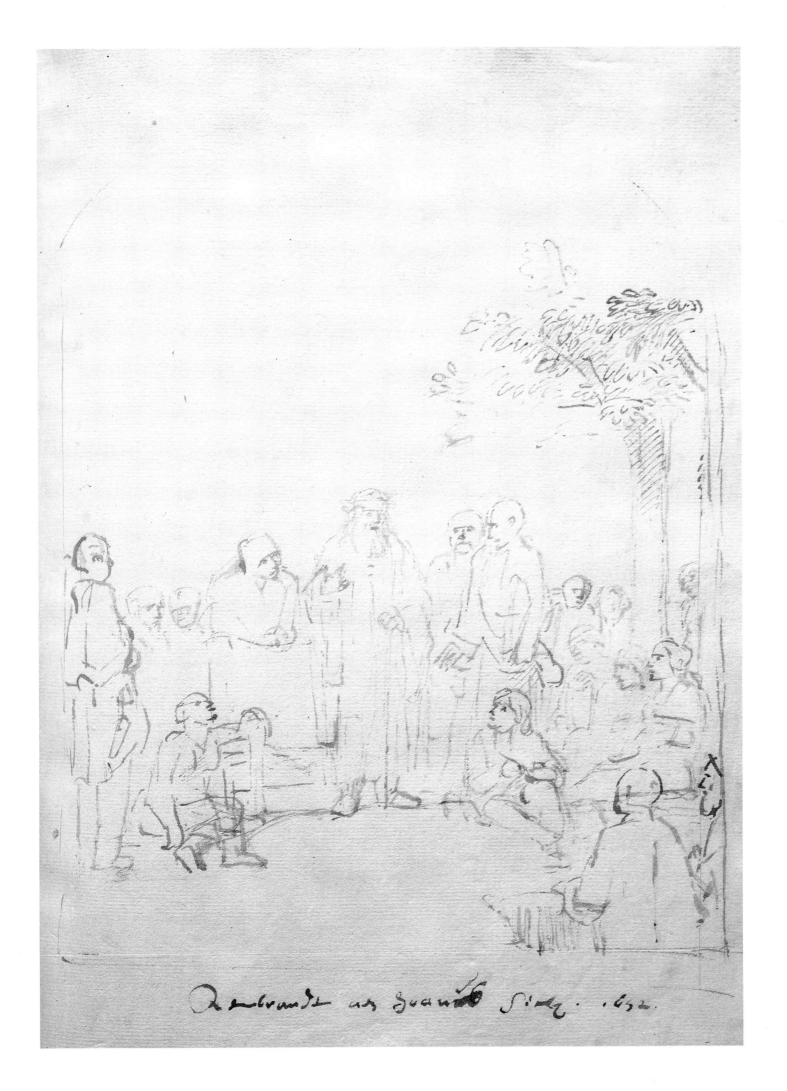

Rembrandt as Gaudis Study. 1652.

in the picture area.[12] In both paintings she is seated at a table with books, with the shield with the Medusa head hanging on the wall.

The drawings must also have been admired by Rembrandt's pupils. There is, for example, a depiction of *The Sacrifice of Iphigeneia* by Barent Fabritius, inspired by Rembrandt's *Homer* (Fig. 31d).[13]

Rembrandt's drawings in the album are the point of departure for the dating of other, undated sheets. Moreover, they enable us to see important aspects of Rembrandt's draughtsmanship at its best: his treatment of classical subjects, his concise method of characterisation with the pen and his atmospheric handling of light and dark with the brush.

P.S.

1. For earlier uses of Pandora as a title, see: Panofsky 1956, pp. 68–69.
2. She is particularly known for opening a box, from which all manner of evil was spread throughout the world.
3. K. Thomassen et al., *Alba Amicorum*, Maarssen/The Hague 1990.
4. The Hague, Royal Library; Benesch, No. 257.
5. The Hague, Royal Library; Benesch, No. 1057.
6. *Documents* 1656/12, No. 163; in addition Rembrandt possessed a bust of Aristotle and one of Socrates, together with heads of Roman emperors. He depicted the head of Homer in 1653 in his painting *Aristotle with the bust of Homer*, New York, Metropolitan Museum of Art; Bredius/Gerson 1935/1969, No. 478. Rembrandt depicted Homer as poet in a painting in The Hague, Mauritshuis; Bredius/Gerson 1935/1969, No. 483; De Vries 1978, No. XII.
7. B. 247. This probably belonged to one of the albums with prints after Raphael; *Documents* 1656/12, No. 196, 205, 206, 214.
8. The stove was identified by drs. R.J. Baarsen.
9. B. 192 (Etchings Cat. No. 15).
10. It has been incorrectly suggested that Anna Wijmer, the mother of Six, is depicted here in the guise of the goddess; see: Haverkamp-Begemann 1963.
11. The drawing is dated 1635. Thomassen 1990, No. 36 (n. 3). Victor Freijser et al., *Leven en Leren op Hofwijck*, Delft 1988, p. 49.
12. Berlin, Gemäldegalerie SMPK, *Corpus* I A38, which is dated to 1631 and Tokyo, private collection, *Corpus* III A114, dated 1635. Rembrandt painted a number of scenes with classical female figures in the beginning of the Amsterdam period: in 1633 a painting which is usually called *Bellona*, but could more appropriately be called Pallas Athene or Minerva on basis of the shield with the Medusa head (*Corpus*, II A70), in 1634 *Flora* (*Corpus*, II A93) and *Sophonisba* (*Corpus*, II A94), in 1635 another *Flora* (*Corpus*, III A112).
13. Besançon, Musée des Beaux-Arts; Sumowski *Drawings*. No. 834-x (1650–1655). Fabritius's drawing was therefore made in or after 1652.

31b: Rembrandt, *The Artist drawing a nude Model* (detail). Amsterdam, Rijksprentenkabinet.

31c: Pieter Couwenhorn, *Minerva in her Study*, *Album amicorum van Petrus Scriverius*. The Hague, Koninklijke Bibliotheek.

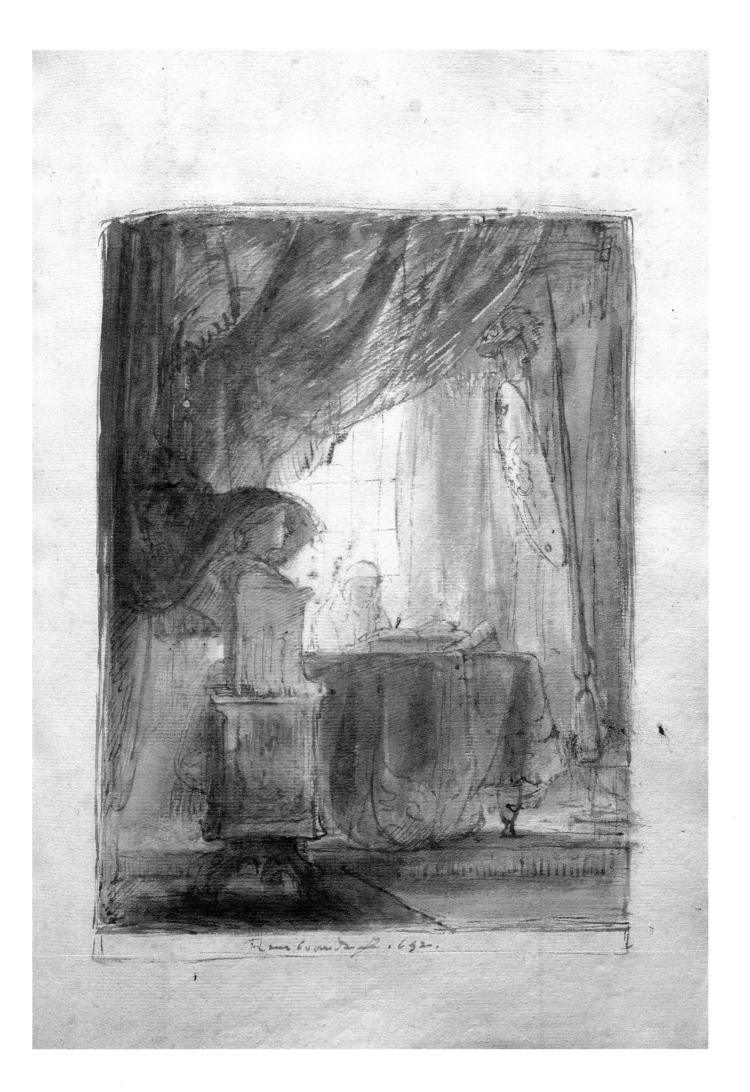

32

The Angel appearing to Hagar and Ishmael in the wilderness

Pen and brown ink, white wash, 182 × 252 mm

Inscription: above left *Gen:21.4.17.*
Hamburg, Kunsthalle, Kupferstichkabinett

Provenance: E.G. Harzen, Hamburg (1863);
Inv. No. 22411.

Literature: Benesch 1953–57 and 1973, No. 904;
H.v.d. Waal, Hagar in de woestijn door
Rembrandt en zijn school, *Nederlands Kunst-
historisch Jaarboek* I (1947), pp. 144–59;
Hoekstra 1983, p. 27.

When Sara, at an advanced age, gave birth to a
son, Isaac, she forced Abraham to send away
his second wife Hagar and her son Ishmael
(Genesis 21: 9–21). Hagar and Ishmael, with
bread and a water bottle, roamed the wilder-
ness of Beersheba. When the water was
finished, she laid the child under a bush and sat
at some distance from him in order to spare
herself the sight of his death, and cried. But an
angel came, showed her a well and told her
that she need not be afraid. God would make a
great nation of Ishmael as well as Isaac.

In Rembrandt's drawing the angel has
descended and with his right hand touches
Hagar, who is sitting wringing her hands. He
points with his other hand in the direction of a
well.[1] Ishmael is lying sleeping peacefully in the
left background. In the foreground the empty
water bottle has toppled over.

The drawing has a simple and direct
eloquence. The sheet is for the greater part left
blank and the forms of the figures and motifs
are loosely indicated with pen-lines in varying
degrees. By emphasising the important
elements of the representation and limiting the
elaboration of the drawing, the story emerges
in concentrated form.

That Ishmael is sleeping is suggested by his
closed eyes and particularly by the heaviness of
his head which has fallen sideways. The contact
between the angel and Hagar is shown by the
angel's precisely depicted index finger, which is
touching her. The pointing finger of the other
hand, of which the other fingers are in a relaxed
position, is strongly accentuated. The angel's
determination is as clearly drawn in a few lines
as the despair on Hagar's face. Her rescue is
indicated by the protective gesture of the
angel's outstretched arms, precisely in the
centre of which Hagar's head is drawn.

Rembrandt had originally given the angel a
larger wing which he painted over with white,
but the lines have become visible again as a
result of the oxidisation of the lead white. Lines
depicting Ishmael have also been painted over
with white.

The story of Hagar was especially popular
with Rembrandt and his pupils (see Cat. No.
41), and a number of drawings and an etching
take the Old Testament story as their subject,
and in particular Abraham's dismissal of Hagar
and Ishmael.[2] *Hagar and Ishmael in the wilderness*
was depicted by Rembrandt's teacher Pieter
Lastman in a drawing from 1600[3] and in 1621
in a painting.[4] Here, Hagar is shown less
despairing and the angel is higher in the air and
further away from her; the angel's outstretched
arms have much less expressive power in this
version of the subject.

Rembrandt made the drawing at the begin-
ning of the 1650s. It belongs to a group of
drawings which all depict moments from the
Bible in a concise and evocative manner. None
of these drawings are preliminary studies or
designs.

P.S.

1. It is possible that Rembrandt has drawn the well to
the right of Hagar.
2. Hamann 1936. The etching B. 30 is dated 1637.
3. New Haven, Yale University Art Gallery, Inv.
1961.64.6; Sacramento 1974, No. 6.
4. Kurt Bauch, 'Entwurf und Komposition bei Pieter
Lastman', *Münchner Jahrbuch der bildenden Kunst*,
N.F. 6 (1955), p. 216, Fig. 5.

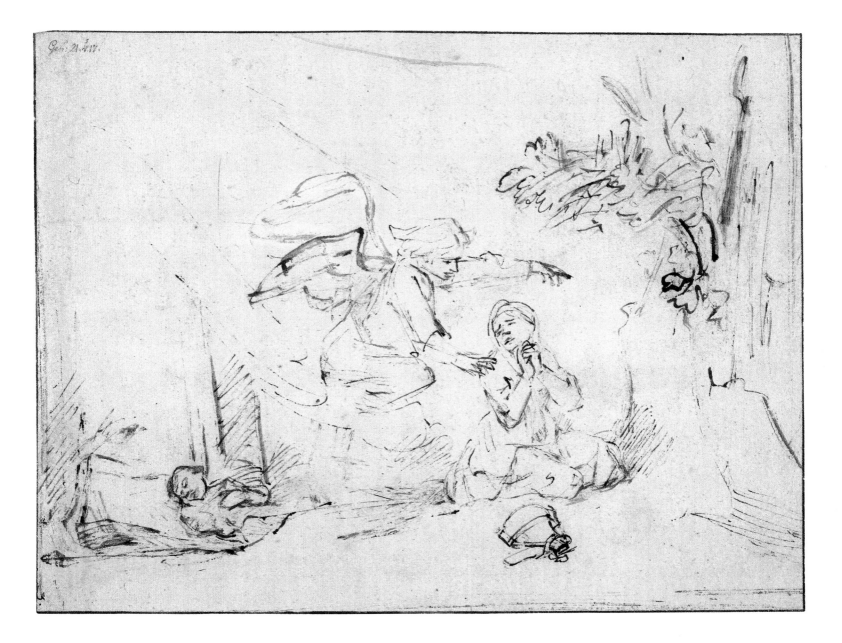

33
Rembrandt's studio with a model

Pen and brown ink, brown and white wash,
205 × 190 mm
Oxford, The Ashmolean Museum

Provenance: London, E.V. Utterson (L. 909);
London, Chambers Hall (L. 551).

Literature: K.T. Parker, *Catalogue of the collection of drawings in the Ashmolean Museum*, I, Oxford 1938, No. 192; Benesch 1954–57 and 1973, No. 1161 (with other previous literature and exhibitions); Schatborn 1981, No. 83.

Exhibitions: Amsterdam 1969, No. 119; Amsterdam 1987, No. 25.

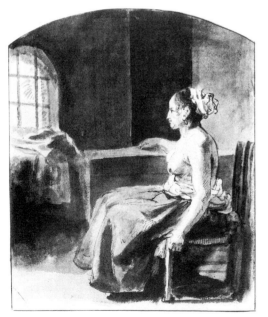

The studio, in which a half-dressed model is seated, is lit from an upper window. The shutters of the lower windows are closed and the cloth above the window, with which the light can be tempered, has been raised. To the left we see Rembrandt's easel with a painting on it and on the stool in front of it lies what could be his painting smock. Beneath the window is a table upon which a book-rest can be seen, on which the etching plate was laid or which was used for drawing. Next to it is a cradle with a hood and a coverlet. Behind the cradle lie a few more things, a shelf is fastened to the wall and another to the wall next to it. A sculpted head is beneath the tall mantelpiece, and there is another stool under the table.

Only the window and the lit areas of the model are not in shadow, while in the rest of the scene Rembrandt has depicted the divisions of light and dark in all possible gradations of tone with the brush. In this way he created space and atmosphere. Some areas have been rubbed with the finger or a dry brush and in some places white paint has been added.

The woman in the studio had perhaps been breastfeeding her child when Rembrandt drew the interior. She is wearing a small cap and is clasping the seat of the chair with her left hand. There is a second drawing of this model, which shows her in the same pose, but seen more from the side (Fig. 33a). It could have been made by a pupil, perhaps Abraham van Dyck, who would then have been drawing to the left of Rembrandt.[1]

It is not improbable that the figure depicted is Rembrandt's wife, Hendrickje Stoffels, feeding her daughter Cornelia, who was Rembrandt's third child to be named after his mother. Cornelia was baptised in the Oude Kerk on 30 October 1654.[2] If this supposition is correct, the drawing was made in that year or slightly later, in the house which is now known as the Rembrandthuis. Hendrickje was already living there in 1649.[3] When she became pregnant out of wedlock in 1654, she was summoned by the church council no less than three times. She eventually appeared on 23 July and was 'ernstelijck bestraft, tot boetvaardicheijt vermaent en van de taffel des Heeren afgehouden' (severely reprimanded, admonished to be repentant and barred from communion).[4]

Hendrickje named Titus as her heir in the event that Cornelia should die before him.[5] Hendrickje and Saskia's son helped Rembrandt in various ways in the later years of his life. They must have had a good relationship as they set up together as art-dealers on his behalf from 1658 onwards.[6] However, Hendrickje and Titus both died before Rembrandt: she was buried in the Westerkerk on 24 July 1663[7] and Titus on 7 September 1668.[8]

Both the suggested identification and the drawing style with its fine pen-lines and graded wash indicate a date after the 1640s. The most comparable drawing is that of Minerva in the Pandora album of 1652 in the Six Collection (Cat. No. 31).

P.S.

1. London, Speelman Collection (1973); Benesch, No. 1161a. Benesch believes that the drawing has been heavily reworked but that the substance is by Rembrandt. Sumowski (1961, p. 21) does not. The attribution to Van Dyck is based especially on a comparison with a monogrammed drawing in Bremen; Sumowski *Drawings*, No. 572. If the attribution and the dating of the exhibited drawing are correct, it means that Van Dyck was still with Rembrandt in 1654. His earliest known paintings are from 1655; Sumowsk 1983, Nos. 357 and 388.
2. *Documents* 1654/18.
3. *Documents* 1654/4.
4. *Documents* 1654/11, 12, 14, 15.
5. *Documents* 1661/6.
6. *Documents* 1660/20.
7. *Documents* 1663/4.
8. *Documents* 1668/8.

33a: Rembrandt, *A seated Woman*. London, E. Speelman Collection (1973).

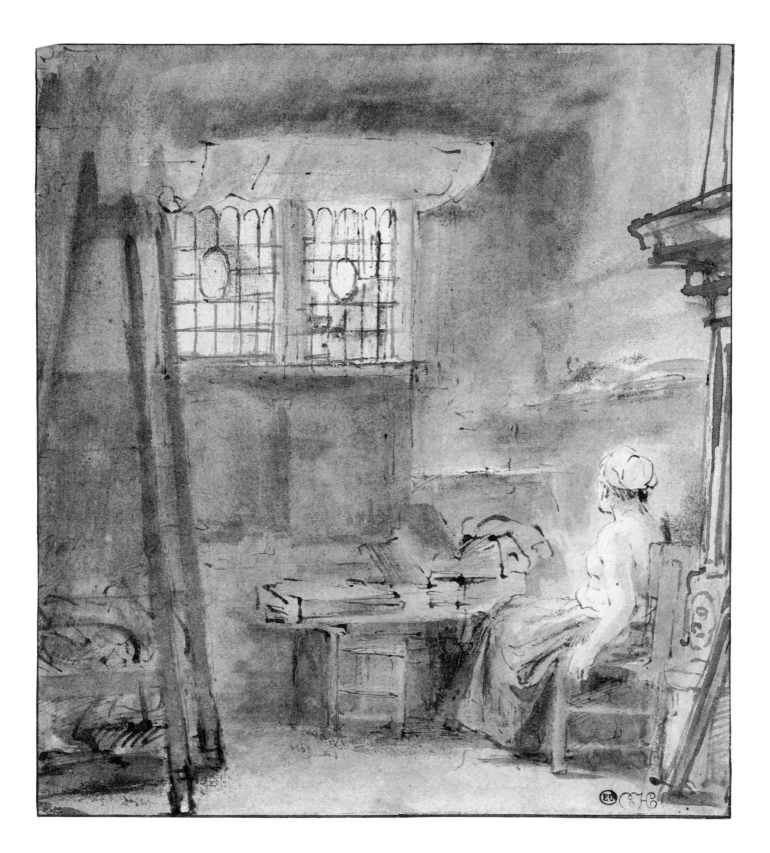

34

The Washing of the feet

Pen and brown ink, 157 × 221 mm
Amsterdam, Rijksmuseum,
Rijksprentenkabinet

Provenance: Jacob de Vos Jbzn., sale Amsterdam,
22–24 May 1883, in lot No. 424 with 14
drawings; in 1889 acquired by the Vereniging
Rembrandt (L. 2135); Inv. No. RP-T-1889
A2049.

Literature: Benesch 1954–57 and 1973, No. 931;
Schatborn 1985, No. 25 (with other previous
literature and exhibitions); Robinson 1988,
pp. 584–85.

Exhibitions: Rotterdam/Amsterdam 1956,
No. 214; Amsterdam 1964–65, No. 107;
Amsterdam 1969, No. 113; Amsterdam 1983,
No. 78.

Christ crouches amid the apostles and is
washing the feet of Peter over a round bowl.
Peter initially protested against Jesus washing
his feet, but when he understood that he would
otherwise not become his associate, his feet too
were cleaned. Peter sits on the edge of his
chair, his hands supported by the ends of the
arm-rests and, with head outstretched, he looks
on attentively. His bearing reveals something
of the initial disbelief and the wonderment
with which he undergoes the washing. The
other apostles, of whom only three are
depicted, look on. Jesus does not kneel, as is
usual in this representation, but crouches: a
more natural than respectable pose. Rembrandt
has restricted himself to the depiction of the
figures, and space is only indicated by a curtain
drawn with one line.

The drawing shows the extent to which
Rembrandt employed abstraction and
idiosyncrasy to express human emotions.
The drawing style is particularly evocative
and details are barely given. There are strong
contrasts between the extremely thinly drawn
lines, almost without ink, and those made with
a full pen. The lines which depict the curtain
and the legs of the figure beneath it show the
edges of the half-empty reed pen. In other
places the full pen has drawn broader lines,
by which the figure beneath the curtain in
particular has acquired a strong presence.
The faces have been reduced to their
elementary forms, but they clearly display the
attention with which the apostles witness the
event. The dark lines of the leg and the back of
Jesus were superimposed upon the initially
fainter lines of the sketch, in order to clarify
and improve upon the form.

A painting of *The washing of the feet* by
Rembrandt is mentioned twice in the
seventeenth century, once in the inventory of
Abraham Jacobz. Graeven of 1660,[1] and another
in that of Harmen Beckers of 1680; in the later
it concerns a *graeutie*, a grisaille.[2]

There is a drawing of the same subject in
the British Museum in London, which
Rembrandt made at the beginning of the 1630s
(Fig. 34a).[3] Here Jesus is kneeling, while Peter
is seen from the front, and a greater number of
apostles are depicted. When he drew the figure
of Peter in the Amsterdam drawing,
Rembrandt may have had in mind the apostle
seated to the left with outstretched head. The
composition of the London drawing broadly
reflects that of Rembrandt's most ambitious
painting from the Leiden period, *Judas repentant*
of 1629.[4] Both here and in the London drawing
the main characters of the story occupy the
whole composition, whereas in the Amsterdam
drawing the figure of Peter stands out alone

against the background. Christ's central
position has been given emphasis by the fact
that everyone else looks at him. Rembrandt
repeatedly depicted the same subject and he
has achieved a greater simplicity and intensity
in the years which separate the two drawings.

The Amsterdam drawing is generally dated
to the 1650s, especially on grounds of the
rather firm way, in broad lines, in which the
apostles on the right-hand side have been
indicated. Other areas display the lively
drawing style with richer contrasts of the
1640s, a date which has also been suggested,[5]
but preference should perhaps be given to a
later dating.

Although the drawing is now considered to
be a particularly characteristic example of the
manner in which Rembrandt depicted a
moment from the life of Jesus, it was acquired
in 1883 from the collection of Jacob de Vos
Jbzn. in a lot of 14 as 'School of Rembrandt',
and listed in the inventory as such. Shortly
afterwards, however, it was published as by
Rembrandt.[6]
P.S.

1. *Documents* 1660/3.
2. A. Bredius, 'Rembrandtiana', *Oud Holland* 28 (1910),
p. 198. In Chicago there is a painting of *The washing of
the feet* previously attributed to Rembrandt, see:
Chicago 1969, No. 81 and Sumowski 1983, No. 1921, as
School of Rembrandt.
3. London, British Museum; Benesch, No. 182. The
drawing could just be dated to the Leiden period.
4. *Corpus* I A15.
5. For the dating by various authors see: Schatborn
1985, No. 25. Robinson (1988) suggests c. 1650 as a
possible dating.
6. F. Lippmann and C. Hofstede de Groot, *Original
Drawings by Rembrandt*, I–IV, Berlin/The Hague
1888–1911; II, No. 21 (1900).

34a: Rembrandt, *The Washing of the Feet*.
London, British Museum.

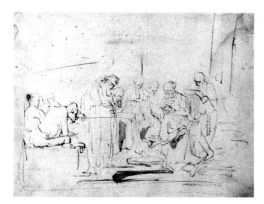

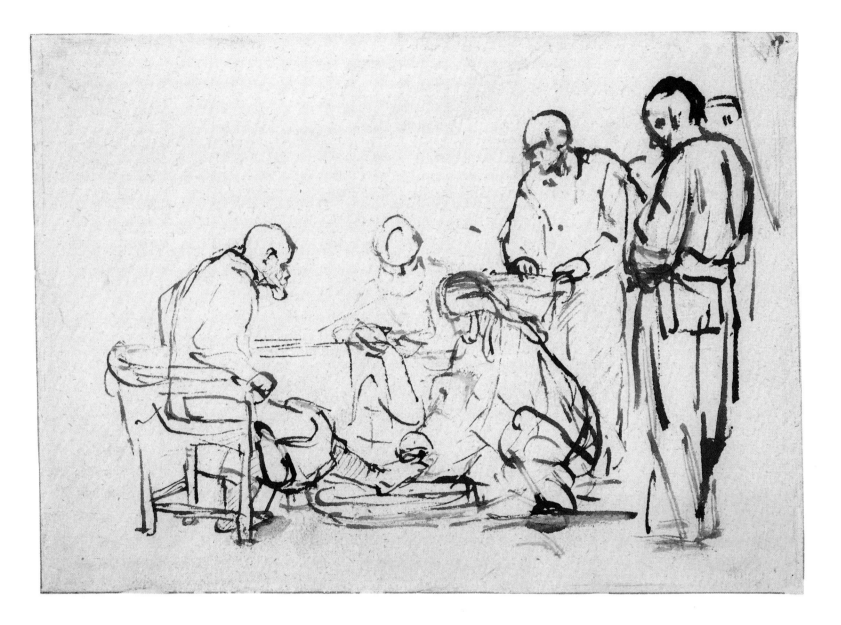

35

Hendrickje Stoffels seated in a window

Pen and brown ink, brown and white wash,
162 × 174 mm

Inscription: below right in the hand of Frederik
Sparre *1883*
Stockholm, Nationalmuseum

Provenance: Pierre Crozat, sale Paris, 10 April–13
May 1741, in lot 869 or 873; Carl Gustaf
Tessin, Paris/Stockholm; Kungliga Biblioteket,
Stockholm; Kungl. Museum, Stockholm
(L. 1638); Inv. No. 2084/1863.

Literature: Kruse 1920, IV, No. 3; Benesch
1953–57 and 1973, No. 1101.

Exhibitions: Rotterdam/Amsterdam 1956,
No. 230; New York/Boston/Chicago 1969,
No. 65 (with other previous literature and
exhibitions).

Some drawings in Rembrandt's œuvre are
executed in an exceptionally broad style and
the exhibited sheet is one of the finest examples
of this. The girl is depicted in the window
with broad strokes of the reed-pen. Her arm
rests on the window-sill, she wears a cloth over
her head and she is sitting with closed eyes in
the sun; behind her, the room is shrouded in
semi-darkness.

Despite the sketchy nature of the drawing,
it is founded on careful observation and well-
considered execution. The lines are of varying
strength and the white paper indicates the
light fall. The shadow in the background is
given with transparent brushstrokes.

Rembrandt had a predilection for depicting
figures in a window or doorway. He also drew
his first wife Saskia in an open window.
Although there is of course a considerable
difference in the drawing style, the drawing in
Rotterdam is characterised by the same
directness, precision and effective lighting
(Introduction, Fig. 8);[1] the later drawing has a
much more painterly character.

A window frame frames the figure, as it
were. Moreover, a window suggests depth and
creates distance between the outside and the
inside. Rembrandt often depicted scenes in a
doorway for the same reasons, particularly
those which include an arrival or leave-taking.
Implied movement in space and time is
expressed in such scenes, a typical aspect of
Baroque art. It is probably Rembrandt's future
wife Hendrickje Stoffels who is represented in
the exhibited drawing (see. Cat. No. 33). Her
presence in Amsterdam is first indicated on 15
June 1649.[2] In that year she appeared as a

witness when a settlement was agreed upon
with Geertje Dircks, the woman who lived in
the house with Rembrandt and who, among
other things, looked after Titus. She wanted to
conclude a favourable agreement before she left
the house.

There is a second drawing of Hendrickje in
the window in Stockholm (Fig. 35a). Both
sheets come from the collection of Pierre Crozat
and were auctioned in Paris in 1741. They were
acquired, along with more than a hundred
drawings said to be by Rembrandt, by the
Swedish ambassador in Paris, Carl Gustaf
Tessin. The catalogue of the Crozat sale is by
the dealer and collector Jean-Pierre Mariette,
who wrote the number 217 at the bottom of
the smallest of the two drawings. The other
drawing does not have such a number. The
area of paper on which the number was written
was probably cut off by a collector or dealer; it
is very apparent that both drawings have been
cropped on all sides.

A third drawing of Hendrickje, where she is
shown sleeping, is in the British Museum in
London (Introduction Fig. 1).[3] The three
drawings are dated to the mid 1650s.
Hendrickje is depicted bathing in a painting of
1655. (Fig. 35b).[4] The broad brush-strokes with
which Hendrickje's white shift is painted, are
directly comparable to the broad strokes of the
reed-pen and brush in the drawings.
P.S.

1. Rotterdam, Museum Boymans-van Beuningen;
Benesch, No. 250; Giltaij 1988, No. 8.
2. *Documents* in No. 1649/4.
3. London, British Museum; Benesch, No. 1103.
4. London, National Gallery; Bredius/Gerson, No. 437.

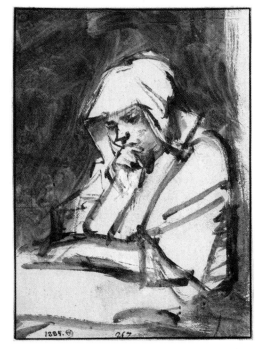

35a: Rembrandt, *Hendrickje in the window*.
Stockholm, Nationalmuseum.

35b: Rembrandt, *Hendrickje bathing*.
London, National Gallery.

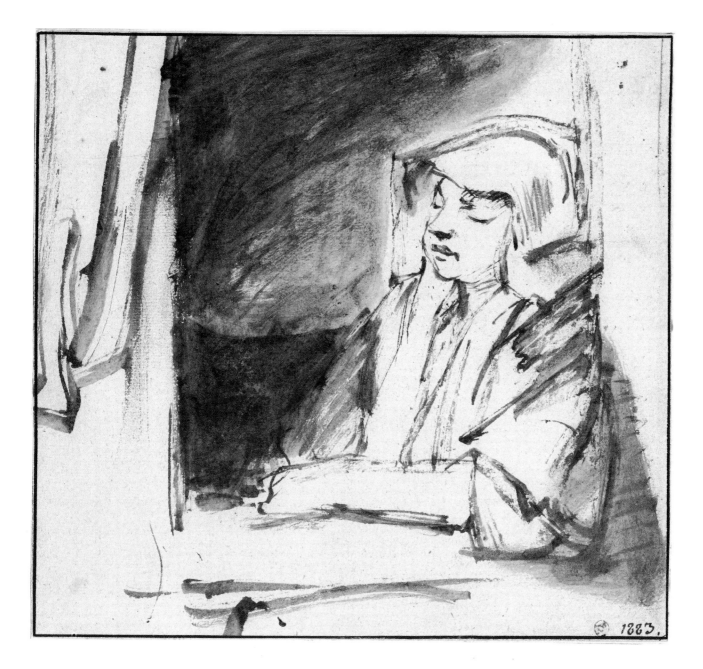

The raising of Jairus's daughter

Pen and brown ink, brown and white wash, laid down, 198 × 198 mm
Berlin, Staatliche Museen Preussischer Kulturbesitz, Kupferstichkabinett

Provenance: Sir F. Seymour Haden, London (L. 1227?), not in the sale of 15 June 1891; A. von Beckerath, Berlin; Berlin, KdZ 8508 (1902).

Literature: Bock-Rosenberg 1930, No. 8508; Lugt 1931, p. 58; Benesch 1954–57 and 1973, No. 1064 (with other previous literature and exhibitions); Hoekstra 1981, N.T.2, p. 24–25.

Exhibition: Berlin 1970, No. 75.

One of the miracles performed by Jesus is the healing of the daughter of Jairus, the ruler of the synagogue. He had fallen at Jesus's feet and begged him to cure his ailing daughter. Then came the message that she had died. Jesus entered the house of the ruler with the apostles Peter, James and his brother John, and sent the crowd away. He took the child's hand and said: get up. She immediately stood up and was cured (Mark 5: 21–43).

Jesus stands in the middle of the representation, and, rather than taking hold of the child's hand as is related in the biblical text, raises his own hand. With this, Rembrandt has made it clear that a miracle is taking place. We encounter the same gesture in an etching of 1642, *The raising of Lazarus*.[1] The mother is kneeling with hands folded at the foot of the bed. Behind her we see Peter, bald, bearded and, like the woman, with hands folded; James and his brother, the young beardless John, are also standing there. Finally, the Jairus's face is partly visible behind Jesus's raised hand and the curtain.

Jairus's twelve-year-old daughter lies on the bed resting against large pillows, her arms stretched out beside her body. Her legs, partly covered with a blanket, indicate recent movement, a first sign of her regained life. Also noticeable is a certain tension in the muscles of her neck, by which Rembrandt has indicated that, any moment now, she will be able to lift her head. The bed is placed diagonally to the picture plane. Curtains hang to the left and right of the head of the bed and a curtain also closes off the scene to the right. By this means the performance of the miracle has acquired privacy.

The drawing has been created in a specially evocative drawing style. There is great diversity in the handling of line, from the broad lines drawn with the pen pressed flat, depicting the curtain to the left and superimposed upon previously drawn areas of the picture, to the hatchings on the sleeve of Jesus's cloak made with an almost dry pen. The shadow in the background has been made by rubbing with the finger, and the dark lines have been covered over with white, particularly in the headcloth of the mother.

The emotions expresed are clear despite the imprecise description of the figures: Jesus directs his concentrated gaze on the sick child, James and Peter look on attentively and full of expectation, while the angled position of the head of the young John expresses amazement. It seems that the head of Jairus behind the curtain in the background was added at a later stage. His face appears to express astonishment and respect. This small head has been given an

important place in the composition behind the raised hand of Jesus, the cause of his wonder.

Painted and etched representations with a bed as the central motif occur a few times in Rembrandt's œuvre and these compositions are always enclosed by curtains. There are drawings of this rarely depicted subject from the beginning of the Amsterdam period, but it is not certain whether they are by Rembrandt.[2] This drawing is usually dated to the second half of the 1650s.

P.S.

1. B. 72.
2. Benesch, Nos. 61 and 62, Whereabouts of both unknown. Moreover, there is a related, fairly rough pen sketch in the same style and probably also from the 1630s; Amsterdam, Rijksprentenkabinet; Schatborn 1985, No. 84.

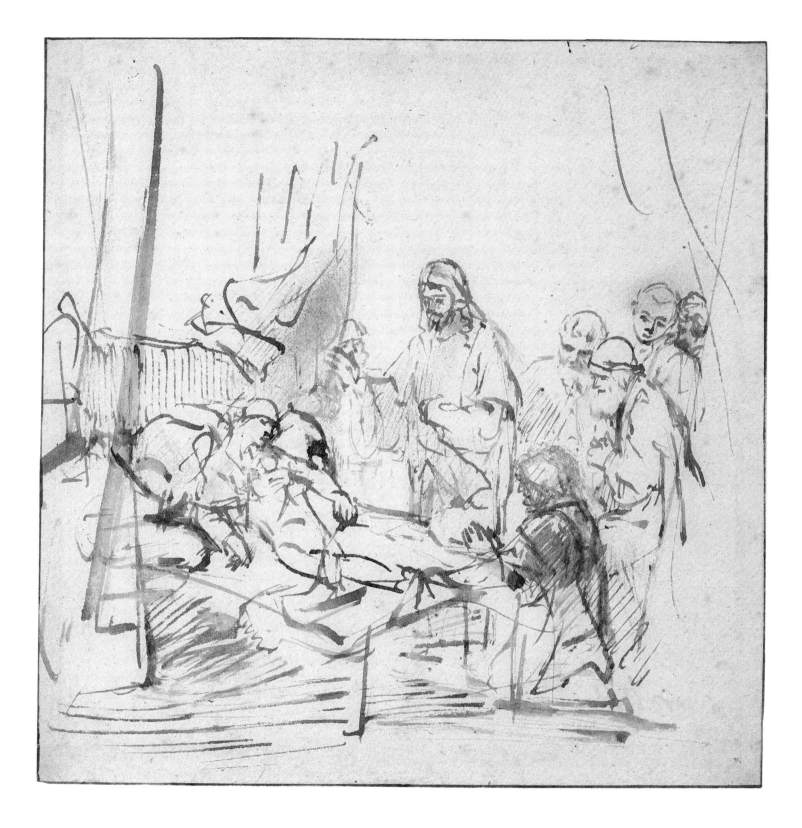

37
Shah Jahan and one of his sons

Pen and brown ink, brown wash, on light-brown oriental paper, 94 × 86 mm

Inscriptions: verso, on the lining *N: 29/Bought at Hudsons sale/A:O:1779*; in the centre *autograph of Lord Selsey, at whol . . . in 1872 many years after his death his books and drawings were sold at Sotheby's in London by the representatives of the widow and her sons, Purchased by me from that sale RPR.*
Amsterdam, Rijksmuseum, Rijksprentenkabinet

Provenance: Richard Houlditch (L. 2214), London; Jonathan Richardson Sr. (L. 2184), sale London, 22 January–8 February (in fact 11 February) 1747, in lot No. 70; Thomas Hudson (L. 2432), sale London, 12–14 February 1779, No. 29; Lord Selsey, sale London, 20 June 1872, in lot No. 2635; Robert Prioleau Roupell (L. 2234), sale London, 12–14 July 1887, No. 1101; John Postle Heseltine (L. 1507), London; Henry Oppenheimer, sale London, 10–14 July 1936, No. 288; I. de Bruijn-van der Leeuw, Spiez, presented to the Rijksprentenkabinet, in usufruct until 28 November 1960; Inv. No. RP-T-–83.

Literature: Benesch 1954–57 and 1973, No. 1196; B.P.J. Broos, 'Rembrandts Indische miniaturen', *Spiegel Historiael* 15 (1980), pp. 210–18; P. Lunsingh Scheurleer, 'Mogol-miniaturen door Rembrandt nagetekend', *De Kroniek van het Rembrandthuis* (1980) 1, pp. 10–40; Schatborn 1985, No. 59 (with other previous literature and exhibitions).

Exhibition: Amsterdam 1969, No. 121.

Some of the most remarkable drawings in Rembrandt's œuvre are the copies he made after Indian Mughal miniatures. They are not the only copies by his hand, but they do form the largest group—23 in all.[1] In the inventory of Rembrandt's possessions of 1656 an album is mentioned with 'curieuse minijateur teeckeningen' (curious miniature drawings)[2] and these are usually considered to be the Mughal miniatures which Rembrandt used as models.[3] Almost one hundred years later 'A book of Indian drawings by Rembrandt, 25 in

number' is mentioned in the sale catalogue of Jonathan Richardson Sr., and most of the drawings now known carry his collector's mark. The exhibited drawing was previously in the collection of Richard Houlditch (died 1736), whose mark is below that of Richardson.

Almost all these drawings are portraits of Shah Jahangir (ruler from 1605 to 1628) and Shah Jahan (ruler from 1628 to 1658) and courtiers from the years 1635–1650. In most drawings we see one or two figures depicted full-length, but there are also some with a rider,[4] one of a group of seated scribes[5] and one of emperor Timur, considered to be the progenitor of the dynasty, surrounded by his followers and courtiers.[6] In addition there are one or two small half-length portraits, two of an Indian woman[7] and two of Shah Jahan, the latter two in the Rijksprentenkabinet in Amsterdam.[8] In general such portraits have no background representations. In Rembrandt's drawings the backgrounds usually consist of shadow only.

In the exhibited drawing we see the Shah behind a balustrade, with a rug hanging over it. Standing close next to him we see his son.[9] The Shah is depicted in profile, with jewels on his turban, around his neck, in his ear and around his arm. He is also holding a ring or bracelet in his left hand. The boy, seen diagonally from the front, also wears a turban and has laid his small hand on the balustrade. It is uncertain which of the sons is depicted.

It is not known precisely which miniatures Rembrandt made use of, although there are a number of related miniatures in the so-called *Millionenzimmer* in the Schönbrunn palace outside Vienna.[10] We cannot point to any direct model for the Amsterdam drawing. There are various types of miniatures in which the Shah is depicted with one or more of his sons; in addition more of this type of portrait exist, showing the shah behind a balustrade with a rug.

Many Mughal miniatures are brightly coloured with the brush; others are well-nigh monochrome. Rembrandt remained relatively faithful to his own drawing style and used pen and brush, in contrast to the Indian miniaturist. He added some colour—red and yellow—to some of the drawings. He used a particularly fine pen and in his characteristic way applied wash with the brush in many gradations. What is exceptional about these drawings is that they are not literal imitations, neither in technique, nor in style. With Rembrandt's experience in drawing from life, he was able to give them a more natural appearance, as if they were drawn from real life.[11]

There is an etching by Rembrandt, *Abraham entertaining the angels*,[12] dated 1656, which, in the figures and composition, clearly show the influence of comparable Mughal miniatures. Rembrandt's compositions after Indian miniatures are usually dated to that year, the year in which the inventory was also compiled. These drawings are not individually mentioned in it and nor are the other copies which he made after Lastman (Cat. No. 11) and Leonardo, among others.

Rembrandt was still using the same fine pen in the 1660s.[13] The style of the miniatures perhaps also determined the drawing style of Aert de Gelder, Rembrandt's pupil at that time. This influence is clearly expressed in his drawing of *A group of Orientals* (Cat. No. 47).
P.S.

1. Benesch has included 21, Nos. 1187–1194, 1194A, 1195–1206. One drawing not mentioned by Benesch was in a French private collection (mentioned in New York 1979–1980, at No. 75) and another is in the collection of Mrs Christian Aall in New York (Robinson 1988, Fig. 4a), the drawing of a *Young Woman standing with a flower* in Stockholm (Benesch, No. 450) could also belong to this group (Lunsingh Scheurleer 1980, pp. 17–18). Finally, two drawings were previously in Weimar, on which Rembrandt had written *oostindisch poppetje* (East Indian figure) (HdG 1906, Nos. 541–42).
2. *Documents* 1956/12, No. 203.
3. Lunsingh Scheurleer (1980, p. 15) does not really consider this probable, as such miniatures in the seventeenth century were usually called 'Mogolse', 'Suratse' or 'Oost-Idiaanse' miniatures.
4. Paris, Musée du Louvre, Département des arts graphiques; Benesch, Nos. 1197, Paris 1988/1989, No. 67 and London, British Museum; Benesch, No. 1205.
5. London, British Museum; Benesch, No. 1187.
6. Paris, Musée du Louvre, Départment des arts graphiques; Benesch, No. 1188; Paris 1988/1989, No. 68.
7. Rotterdam, Museum Boymans-van Beuningen; Benesch, No. 1206, Giltaij 1988, No. 31 and New York, collection Mrs Christian Aall, not in Benesch (see note 1).
8. Amsterdam, Rijksprentenkabinet; Benesch, Nos. 1195 and 1196; Schatborn 1985, Nos. 58 and 59.
9. Broos (1980) believed that the child was added to the Mughal portrait of the Shah by Rembrandt.
10. Established by H. Glück; J. Strzychowski and H. Glück, *Asiatische Miniaturenmalerei*, Klagenfurt 1933.
11. New York/Cambridge 1960, at No. 63; Broos 1980, p. 212.
12. B. 29.
13. Examples of this are *Isaac and Rebecca being spied on by Abimelech*, New York, private collection, Benesch, No. 988; *Elsje Christaens hanging on the gallows*, New York, The Metropolitan Museum of Art, The H.O. Havemeyer Bequest, Benesch, No. 1105 and The Lehman Collection, Benesch, No. 1106.

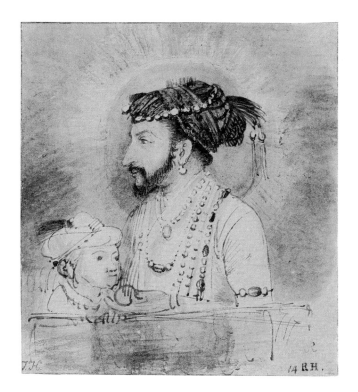

38

Seated female nude

Pen and brown ink, brown and white wash,
211 × 174 mm
Chicago, The Art Institute, The Clarence
Buckingham Collection

Provenance: L. Corot, Nîmes (L. 1718);
A. Strölin, Paris/Lausanne; Inv. No. 1953. 38.

Literature: Benesch 1953–57 and 1973,
No. 1122; Schatborn 1981, No. 84 and p. 56;
Schatborn 1987, pp. 307–20; Giltaij 1988,
at No. 185.

Exhibitions: Rotterdam and Amsterdam 1956,
No. 237; New York and Cambridge 1960,
No. 74; Chicago, Minneapolis and Detroit 1969,
No. 137; Washington, Denver and Fort Worth
1977, No. 40; Amsterdam and Washington
1981–82, No. 84.

38a: Aert de Gelder, *Seated female Nude*
(Cat.No. 49).
Rotterdam, Museum Boymans-van Beuningen.

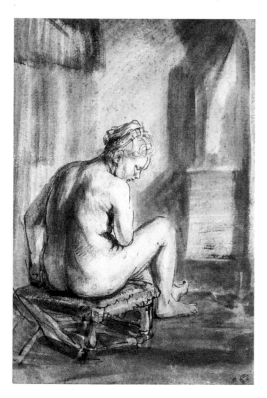

Rembrandt drew nudes from life at various times (see Cat. No. 24). Most of the late studies of models were originally attributed to Rembrandt himself, but from a comparison with drawings by pupils from that time, in particular Aert de Gelder (Cat. No. 49) and Johannes Raven (Cat. No. 51), it seems likely that they made drawings alongside Rembrandt and in his style.

Rembrandt drew the *Seated female nude* while Aert de Gelder depicted the model in the same pose from a different angle (Cat. No. 49; Fig. 38a). A comparison of the two drawings gives a clear insight into the way in which the pupil assimilated Rembrandt's drawing style, without equalling his master.

The drawings are extremely similar at first sight: almost analogous positioning in the picture plane, the use of the same ink, an imprecise descriptive pen-line and the continuous transparent wash with the brush. One of the most important differences is the rendering of light. Here, it is also one of Rembrandt's most noticeable distinguishing characteristics. It is only a consistent depiction of light and dark which gives the figure plasticity, suggests texture and creates space.

In the drawing in Chicago the light comes from a high window to the left, falling onto the model and the ground next to her, where Rembrandt has left the paper white. The parts of the figure nearest the light have been left open but in the areas further back and in those where shadow falls Rembrandt has applied wash with the brush, on the whole in subtle gradations and sometimes with strong accents. The precision with which he did this—and it is greater than appears at first sight—has given the figure three-dimensional form.

The pen-lines give the impression of being sketchy. The contours are here and there interrupted and apart from the lines which describe the form, there are other lines which have a corrective function. For example, within the outline of the buttock there are a few lines which do not describe anything and only serve the purpose of making the area appear smaller. The long diagonal through the calf of the left leg similarly creates no form, but improves the impression which the leg makes as a whole. The contour of the right shoulder is primarily defined with the brush; the outline of the other shoulder is made up of various lines, which together give the impression of the correct form. All these peculiarities of draughtsmanship are characteristic of Rembrandt's aim to present a convincing representation of the figure as a whole.

The brush-strokes in the background have various directions and tones, so that space and atmosphere are created by an abstract pattern, without any clear form. The woman is probably sitting near a wall, onto which her shadow falls, indicated by short vertical strokes. In the drawing by Aert de Gelder (Cat. No. 49) we see that the model sits by a stove, which also appears in one of Rembrandt's etchings.[1] From a written source it appears that artists, from approximately the middle of the century, had the opportunity to draw collectively from a model and Rembrandt's pupil Samuel van Hoogstraten, in his *Academy* of 1678, also mentions 'Teyckenschoolen of Academien' (Drawing schools or academies) where nude models sat 'in de warme stooven' (by the warm stoves).[2] Perhaps Rembrandt and Aert de Gelder drew the same model at such a session, and Rembrandt's drawing must have simultaneously served as a model for Aert de Gelder.

It is uncertain precisely when this took place. De Gelder, who was born in 1645 in Dordrecht, was first a pupil of Samuel Hoogstraten in that town, probably towards the end of the 1650s, and thereafter followed in the footsteps of his first master and studied under Rembrandt. The nudes were probably made around 1660 or shortly after. Rembrandt similarly made a life-drawing with another pupil from a later time, Johannes Raven. Drawings showing the same model in the same pose by these two artists are also extant (see Cat. Nos. 50 & 51).

P.S.

1. B. 197.
2. Hoogstraten 1678, p. 294.

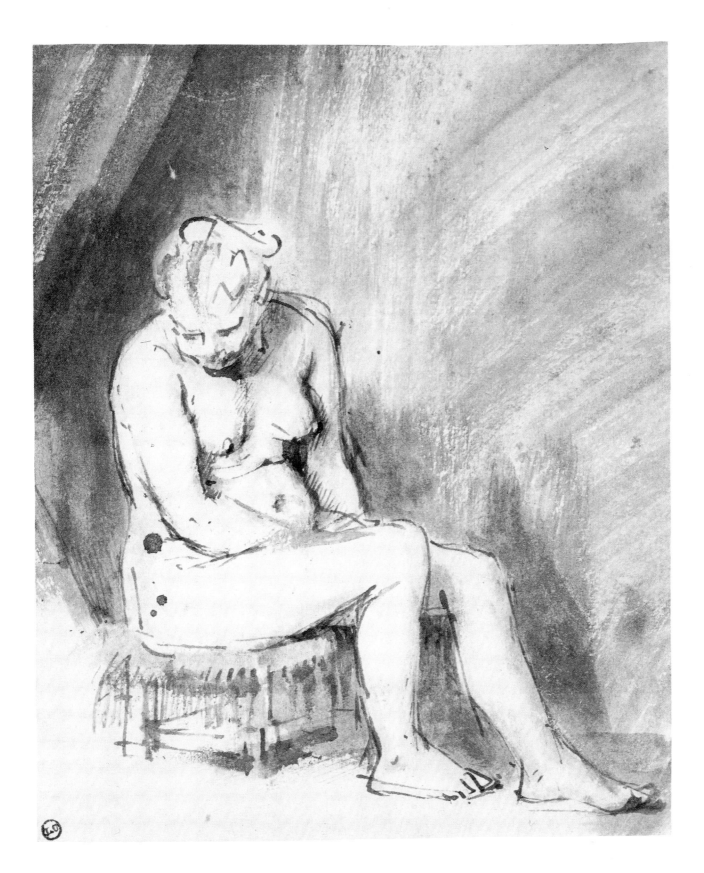

The conspiracy of the Batavians under Claudius Civilis

Pen and brown ink, brown and white wash, 196 × 180 mm

Inscription: below left *5070* (old Inv. No.); verso: partial text of a funeral ticket of Rebecca de Vos, 25 October 1661 Munich, Staatliche Graphische Sammlung

Provenance: Elector Carl Theodor of the Palatinate (L. 620), Mannheim (1758).

Literature: Benesch 1954–57 and 1973, No. 1061; C. Müller Hofstede, HdG 409. 'Eine Nachlese zu den Münchener Civilis-Zeichnungen', *Konsthistorisk Tidskrift* 25 (1956), pp. 42–55; B. Haak, 'De nachtelijke samenzwering van Claudius Civilis in het Schakerbos op de Rembrandttentoonstelling te Amsterdam', *Antiek* 4 (1969), 3, pp. 136–48; C. Müller Hofstede, 'Zur Genesis des Claudius Civilis-Bildes', *Neue Beiträge zur Rembrandt-Forschung*, Berlin 1973, pp. 12–30 (Discussion pp. 41–43); W. Wegner, *Die Niederländischen Handzeichnungen des 15.–18. Jahrhunderts. Kataloge der Staatlichen Graphischen Sammlung München*, I, Berlin 1973, No. 1097 (with other previous literature). J. van Tatenhoven and P. Schatborn, Review of Wegner 1973, *Oud Holland*, 92 (1978), p. 134; Carl Nordenfalk, *The Batavian's Oath of Allegiance, Rembrandt's only Monumental Painting*, Stockholm 1982.

Exhibitions: Stockholm 1956, No. 56; Rotterdam/Amsterdam 1956, No. 249; Amsterdam 1969, No. 135; *Zeichnungen aus der Sammlung des Kurfürsten Carl Theodor*, Munich (Staatliche Graphische Sammlung) 1983–84, No. 75.

The composition sketch shows *The conspiracy of the Batavians under Claudius Civilis*, which Rembrandt painted for one of the arched spaces of the gallery which ran on all sides of the interior of the new town-hall on the Dam in Amsterdam. The extant central section of the painting, which was about 5.5 meters high and broad in its original state, is now in the Nationalmuseum in Stockholm (Fig. 39a).

The subject is derived from Tacitus who describes how, under the leadership of Claudius Civilis, the Batavians revolted against the Roman oppressors in A.D. 69.[1] This subject was chosen as decoration for the town-hall because of its parallel with the revolt of the Dutch against Spanish rule, which ended in 1648.

The drawing shows Civilis and his supporters congregated in a place—Tacitus mentions a grotto—in the Schakerbos, under the pretence of sharing a meal.[2] When the lateness of the hour and the alcohol had warmed their spirits, Civilis began to speak of the honour and glory of his people and the injustice that was being done to them; after this they swore a confederacy against the Romans and 'barbaarse rituelen' (barbarous rituals) followed.

The commission for eight paintings with subjects from the revolt of the Batavians and four scenes from Jewish and Roman history, went to Rembrandt's pupil Govert Flinck in 1659, but he died shortly afterwards on 2 February 1660. On 13 January 1661 Jan Lievens and Jacob Jordaens were commissioned to do one painting each, but none of the sources mention the commission given to Rembrandt.[3]

Rembrandt made his drawing on the back of a still partially legible funeral ticket, on the

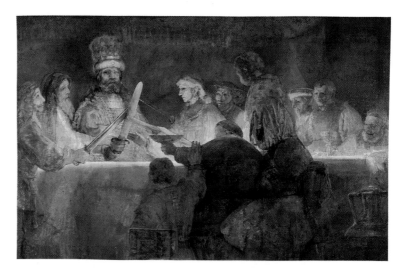

39a: Rembrandt, *The Batavians' Oath of Allegiance*. Stockholm, Nationalmuseum.

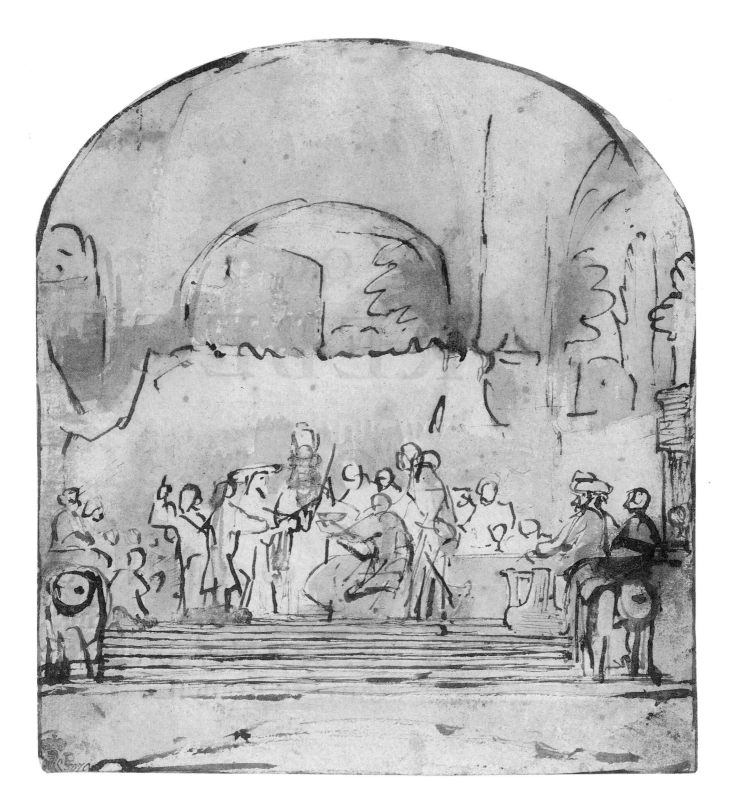

missing part of which is written the date 25 October 1661.[4] According to the description of the town-hall by Fokkens, the foreword of which is dated 21 July 1662, Rembrandt's painting was already hanging in position.[5] This is confirmed by a contract of 28 August of that same year, in which there is also mention of *verschildering* (repainting): apparently something in the painting had to be changed.[6] The painting was eventually taken away and in 1662 the commission went to Juriaen Ovens, who finished the incomplete version of the same subject by Flinck, before the end of the year.[7] The painting still hangs in the *galerij* (gallery) around the courtyards and the reception room of the former town-hall (Fig. 39b).

The drawing depicts a large space with semi-circular arches, behind which a building and trees can be seen. Steps, flanked on the left and right by stone lions, lead to a platform on which a wide table is standing. Around this the conspirators are sitting and standing, Civilis to the left of the table with his sword raised diagonally forwards in the air. Behind the table the scene is closed off by a large curtain hanging over a stick.

The scene is drawn in an extraordinarily concise manner, which makes the care with which Rembrandt went to work all the more noticeable. Alterations within the drawing can be seen, of which one or two are visible in the x-ray of the painting. Civilis's hat was made taller, and his sword shortened. The sword held by the man to the right of Civilis—a diagonal lines in the drawing—was replaced by an outstretched arm, the hand of which is touching Civilis's sword. Rembrandt first drew the head of the man standing in front of the table in an upright position and then again with his head leaning to the left, and it is in this pose that he appears in the painting. The man seated in front of the table, holding a drinking bowl in his outstretched hand, was drawn in two positions. The lower position was adopted for the painting and is indicated in darker lines in the drawing which makes it recognisable as the second version. The flat hat of the man next to Civilis was omitted in the painting; a head cloth took its place. Some of these changes created more space around Civilis and thus drew the attention to him.

There are, however, further differences between the drawing and the painting in Stockholm. After the removal of the painting from the town-hall, Rembrandt probably adapted the remaining section of the composition to the new format. But it is uncertain which alterations were made then and which had already been made. It is

apparent from the drawing that Civilis was at first standing full-length next to the table, which is shown considerably higher in the painting than in the drawing. After the table had been lengthened at the left, Rembrandt painted a boy with a shield and with raised hand in the foreground. He, as it were, replaces the man with raised hand to the left of the table in the drawing, who disappeared when the scene was reduced in size in the painting.

In the x-ray a head of an old man seated behind the table can be seen in the place of the man standing in front of the table.[8] As he does not appear in the drawing and the standing man does, the drawing can be considered to be a second design, made in preparation for the alteration in the composition, and not a preliminary study.[9] Rembrandt would then already have begun the painting before 25 October 1661.[10]

There are another four drawings with the same subject, three of which are also in Munich.[11] These are indistinctly and more coarsely drawn. Previously ascribed to Rembrandt, these and many others from the collection of the elector, can now no longer stand the test of criticism. The greater part of the Rembrandtesque drawings in Munich were made by pupils and followers. A fourth compositional drawing, in Edinburgh, has also been connected with Rembrandt's painting, but in this case too, attribution to Rembrandt is unlikely.[12]

P.S.

1. *Historiae* (IV 13–15).
2. Under No. 17 in the sale of 10 August 1734 in Amsterdam, the painting appears as '. . . de samensweering der oude Batavieren, in 't Heilig of Schaker Bos, door Claudius Civilis de voornaamste edelen op een gastmaal nodigt' (the conspiracy of the old Batavians, in the Holy or Schaker wood, where Claudius had invited the principal nobles to a meal).
3. Pieter Scheltema, 'Belooningen aan schilders voor het maken van schilderijen op het stadhuis . . ., *Amstel's Oudheid*, I (1855), p. 134.
4. I.H. van Eeghen, 'Rembrandt's Claudius Civilis and the Funeral Ticket', *Konsthistorisk Tidskrift*, 25 (1956), pp. 55–57.
5. M. Fokkens, *Beschrijvinge der wijdt vermaarde koop-Stadt Amstelredam*, Amsterdam 1662, p. 159.
6. *Documents* 1662/6. In this is stated that regarding ''t stuck schilderije op 't stadhuys gelevert' (the painting delivered to the town-hall), Lodewijk van Ludick 'sal genieten' (will receive) one fourth of what Rembrandt has earned and will further earn 'by verschildering' . . . (in repainting).
7. Harry Schmidt, *Jürgen Ovens, sein Leben und seine Werke*, Kiel 1922, p. 86–87: on 2 January 1663 a sum of 48 guilders is mentioned for the 'opmaken van een schets van Govert Flinq . . .' (finishing of a sketch by Govert Flinck).
8. Nordenfalk 1982, p. 33, ill.
9. If we consider the drawing to be a first draft then the seated man can only be explained as an alternative solution, which was not used. Nordenfalk 1982, pp. 32–35.
10. Haak also believes that the drawing was made while work was in progress, as it is too small and sketchy to be a compositional design. Haak 1969.
11. Benesch, Nos. 1058–1061.
12. E. Haverkamp-Begemann, 'Eine unbekannte Vorzeichnung zum Claudius Civilis', *Neue Beiträge zur Rembrandt-Forschung*, Berlin 1973, pp. 31–43.

39b: The South Gallery in the former Town Hall.

One of the Staalmeesters
Jacob van Loon

Pen and brown ink, brown and white wash;
on accounting paper; lines, 195 × 160 mm
Amsterdam, Rijksmuseum,
Rijksprentenkabinet

Provenance: H. Behmer, Weimar;
H. Ph. Gerritsen, The Hague, presented by
him to the Rijksprentenkabinet; Inv. No.
RP-T-1896 A3172.

Literature: Benesch 1954–57 and 1973, No.
1179; Schatborn 1985, No. 56; Giltaij 1988, in
No. 36; Luijten and Meij 1990, in No. 36 (with
other previous literature and exhibitions);
Martin Royalton-Kisch, 'Rembrandt's sketches
for his paintings', *Master Drawings* 27 (1989) 2,
pp. 142–44.

Exhibitions: Rotterdam/Amsterdam 1956,
No. 256; Amsterdam 1969, No. 136.

As *The Nightwatch* of 1642 is the highpoint
among Dutch militia pieces,[1] so *The Staalmeesters*
(Fig. 40a) of twenty years later is the
masterpiece among the paintings of governors.
There are three drawings extant for this
painting of 1662. The exhibited drawing shows
Jacob van Loon, who in the painting is seated
on the left-hand side of the table. The second
drawing is in Rotterdam and shows Volkert
Jansz., who is standing next to him (Fig. 40b).[2]

40a: Rembrandt, *The 'Staalmeesters'*.
Amsterdam, Rijksmuseum.

Rembrandt has depicted the figures in the third drawing, in Berlin, in the left-hand section of the painting (Fig. 40c).[3] Part of a hat can be seen on the right-hand side of this sheet, where the drawing has been cut, and the drawing probably showed the composition in its entirety.

It is not absolutely clear what role the drawings played in the creation of the painting. Rembrandt did not usually make direct preliminary studies for paintings. Drawings which are nevertheless related to them, were usually made when he was planning to make an alteration in the composition. When Rembrandt made the drawings of the individual figures, the composition as a whole had already been made. This is apparent from the fact that, in the Rotterdam drawing, the space in the lower left corner is left open for Jacob van Loon's chair. Volkert Jansz. is standing upright in the drawing and it is clear from the x-ray that this was also the case in the first painted version of this figure. Rembrandt has made him lean forward slightly in the final version, as if here were preparing to stand up or sit down. By depicting one figure in movement, an original motif rarely occurring in a group portrait, Rembrandt has eliminated the static character.[4] It is clear that the drawings of the group of Staalmeesters and that of Volkert Jansz. were made before the latter's pose was altered.

Van Loon is wearing a stiff collar in the painting, and is seated on a chair which appears on other occasions in Rembrandt's work (Cat. No. 2, 20, 23). He is wearing a simpler collar in the drawing and is sitting on a straight-backed chair with straight legs. In the drawing a section of the projecting wall can be seen behind Volkert Jansz. This area has been moved to the right in the painting, and in the Berlin drawing the background has yet again been rearranged.

The figure of the messenger, Frans Hendriksz. Bel, was initially not included in the Berlin drawing, that is, if he did not occupy the area that has been cut off. A very rough sketch of his head was added to the drawing, in the position he was to take in the final version of the painting.[5]

The drawings of Van Loon and Jansz. were made on accounting paper, which, in the exhibited drawing, is only evident from the reverse. Rembrandt also used this paper for one of his nudes, which is, moreover, drawn in the same colour ink.[6]

The Rotterdam and Berlin drawings are made with broad, rough lines of the reed-pen; the one in Amsterdam with fine lines for the face and hands. Wash has been applied in the background in a painterly manner. The white highlights were originally clearer, but they are still fairly bright in the overall scene.

From the most sketchy depiction of the figures in the Berlin drawing it appears that Rembrandt was mainly concerned with discovering the best composition. The paper was even damaged while he was working on it and maybe this accounts for the section cut off at the right. By working in a chiefly functional manner, Rembrandt developed a style which is now considered to be expressive. The broad pen-lines and brush-strokes in the drawings of *The Staalmeesters* have their parallel in the evocative handling of brush of the late paintings.

P.S.

1. *Corpus* III A146.
2. Rotterdam, Museum Boymans-van Beuningen; Benesch, No. 1180; Giltaij, No. 36; Luijten and Meij 1990, No. 36.
3. Berlin, Kupferstichkabinett SMPK; Bock-Rosenberg, No. 5270; Benesch, No. 1178.
4. A. van Schendel, 'De schimmen van de Staalmeesters', *Oud Holland* 71 (1956), pp. 1–23.
5. Van Schendel 1956, p. 14 (n. 4), sees this as a sculpted head, a part of the fireplace.
6. Amsterdam, Rijksprentenkabinet; Benesch, No. 1142; Schatborn 1985, No. 55.

40b: Rembrandt, *One of the Staalmeesters, Volkert Jansz.* Rotterdam, Boymans-van Beuningen.

40c: Rembrandt, *Three Staalmeesters*. Berlin, Kupferstichkabinett SMPK.

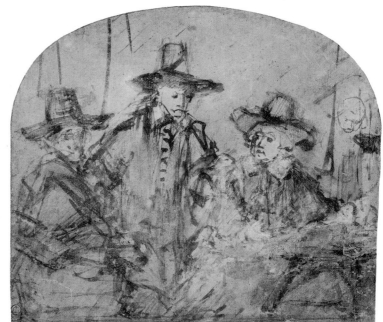

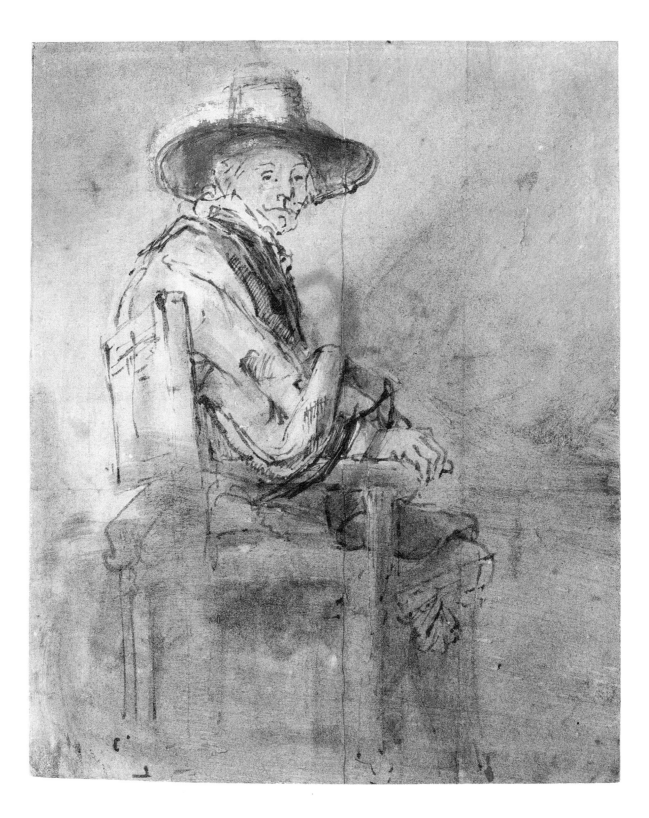

41

FERDINAND BOL

*Hagar at the well
on the way to Shur*

Pen and brown ink, brown wash,
182 × 232 mm

Inscription: below right *R ft*
Amsterdam: Rijksmuseum,
Rijksprentenkabinet

Provenance: Jan Pieter Graaf van Suchtelen
(L. 2332), St Petersburg, not in the Paris sale,
4 June 1862; Remy van Haanen, Vienna;
H. Lang Larisch, Munich (1900); Cornelis
Hofstede de Groot, The Hague, gift of 1906,
in usufruct until 14 April 1930; Inv. No.
RP-T-1930–27.

Literature: Henkel 1942, No. 1; Sumowski
Drawings 1979, No. 89 (with other previous
literature and exhibitions); Albert Blankert,
Ferdinand Bol, Doornspijk 1982, in Cat. 1; B.P.J.
Broos, Review of Sumowski Drawings 1–4, *Oud
Holland* 98 (1984), p. 180 and N. 114; Giltaij
1988, in No. 43; Sumowski 1983, in No. 89.

41a: Ferdinand Bol, *Hagar in the Desert.*
Gdánsk, Muzeum Pomorskie.

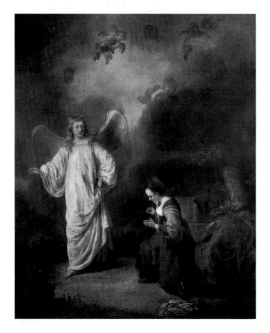

As Sara could give him no children, Abraham
took the servant Hagar to serve him as wife.
When she became pregnant, the jealous Sara
forced her to leave the house. On the way to
Shur, near a spring of water, an angel appeared
who encouraged Hagar to return, and to serve
Sara again. The angel told her that she would
bear a child whose name would be Ishmael
(Genesis 16: 1–16).

The angel has appeared from out of a cloud
and, gesticulating, addresses the kneeling
Hagar. Her amazement is expressed by her
arms and by her hands which are somewhat
outstretched. A water bottle and Hagar's cloak
lie next to her.

Bol has drawn the figures in fairly even lines
and applied only one or two strong accents.
The hatching on the wing and on the inside of
the angel's robe have also been finely drawn;
however, broader lines have been placed in the
right background. The figures are lightly
shaded with the brush, as are the trees.
The foreground and Hagar's cloak are depicted
with darker brushstrokes.

The drawing has been ascribed to
Rembrandt in the past. The inscription *R ft*
was added by a later owner in order to make
this attribution plausible.[1] The sheet was
recognised as by the hand of Bol in 1924.[2]

There is a clear relationship with a painting
of upright format in Gdánsk (Fig. 41a),[3] where
the composition is almost the same. Here,
Hagar is shown more in profile and the angel
holds up a section of his robe; in addition,
angels are hovering in the sky. Bol often
borrowed motifs from the work of Rembrandt;
the angels were probably inspired by
Rembrandt's etching of *The Annunciation* from
1634.[4]

The style of the drawing is based on the one
by Rembrandt from the mid 1630s. But Bol
draws the forms a little more precisely and less
evocatively. The painting is dated to
approximately 1650[5] and the drawing to the
end of the 1630s.[6] The drawing is therefore not
a direct preliminary study. Ferdinand Bol was
born in Dordrecht in 1616. After an apprentice-
ship with an Utrecht master, he went to study
with Rembrandt in Amsterdam. Notes made
by Rembrandt on the reverse of a drawing after
a painting by Lastman, *Susanna and the Elders*
(Cat. No. 11, Fig. 11b), indicate that he sold
work by Bol. If the dating of this drawing to
1636 is correct, then it was made in the year
that he came to Rembrandt; he is mentioned
as still being in Dordrecht in 1635.

The relationship between Rembrandt and
Bol is not wholly clear. We do not know of
works by Bol dating from the second half of the
1630s. Bol was probably one of those pupils
who, after a traditional apprenticeship, took
further training from Rembrandt and
simultaneously had a share in the work
produced by the studio.[7] The earliest dated
and signed work by Bol is from as late as
1641;[8] a few other paintings are attributed to
him and dated to approximately 1640.[9]
Although a number of drawings can be con)-
sidered to be preliminary studies for paintings
(and etchings), the precise relationship
between Bol's drawings and paintings is
not clear. Bol could have made use of an earlier
drawing around 1650 for the exhibited drawing.

All in all, there is reason enough to consider
the exhibited drawing as characteristic of Bol's
work. On the basis of the style of Rembrandt's
drawings, which it reflects, a dating to the
second half of the 1630s is the most probable.
P.S.

1. Broos reads here part of the name of Bol; Broos 1984,
p. 180.
2. L. Münz, 'Federzeichnungen von Rembrandt und
F. Bol', *Belvedere* 5 (1924), 27, pp. 106–12.
3. Blankert 1982, Cat. 1; Sumowski 1983, No. 89.
4. B. 44 (Etchings Cat. No. 9).
5. By Blankert 1982.
6. T. Gerszi, 'Etudes sur les dessins des élèves de
Rembrandt', *Bulletin du Musée Hongrois des Beaux-Arts*
(1971), 36, p. 105 and n. 46; W.R. Valentiner, 'Notes on
old and modern drawings. Drawings by Bol', *The Art
Quarterly*, 20 (1957) 1, pp. 54. 56.
7. Thus J. Bruyn in his review of Sumowski 1983,
I *Oud Holland* 98 (1984), pp. 151–52.
8. *The Sacrifice of Gideon*, Utrecht, Rijksmuseum Het
Catharijneconvent; Blankert 1982, No. 11; Sumowski
1983, No. 79.
9. Sumowski considers *The liberation of Peter* in the Baaij
collection at Schoten and the corresponding drawing as
early works of c. 1640 (Sumowski 1983, No. 78;
Sumowski Drawings, No. 87). Blankert doubts this
attribution (Blankert 1982, No. D4). Two other
drawings are also dated by Sumowski to the same
period (Sumowski 1983, Nos. 132 and 159); Bruyn
1984 (n. 7), pp. 151–52.

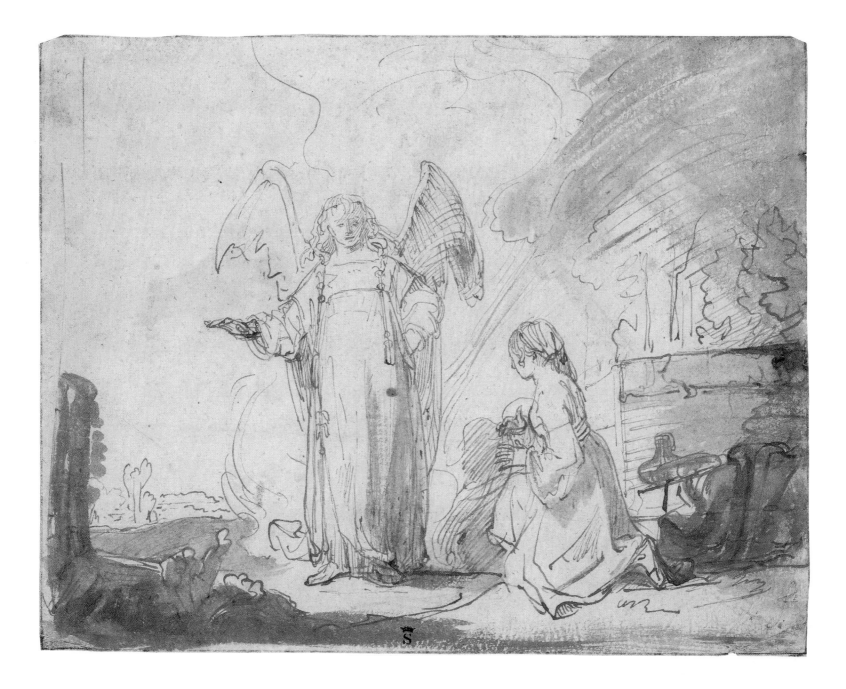

FERDINAND BOL

Vertumnus and Pomona

Pen and brown ink, grey and white wash,
170 × 152 mm; with upper corners rounded
Rotterdam, Museum Boymans-van Beuningen

Provenance: Earl of Dalhousie (L. 717a); Franz
Koenigs (L. 1023a), Haarlem (1923); presented
by D.G. van Beuningen to the Stichting
Museum Boymans (1940); Inv. No. R. 44.

Literature: Benesch 1954–57 and 1973, No. 165;
Giltaij 1988, No. 43 (with other previous
literature and exhibitions).

Exhibition: Amsterdam 1969, No. 59.

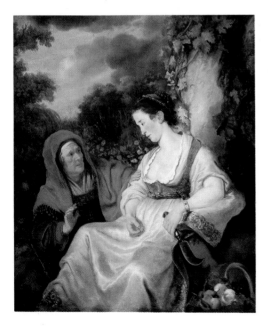

42a: Ferdinand Bol, *Vertumnus and Pomona*.
Cincinnati, Cincinnati Art Museum.

In Benesch's catalogue and in the previous
literature, this drawing had always been
considered to be by Rembrandt. Benesch dated
it to approximately 1638, Valentiner to approx-
imately 1645.[1] In the exhibition in Amsterdam
in 1969 it hung among characteristic drawings
by Rembrandt and it was then that doubt was
cast on its authenticity.[2] It was first attributed
to Bol in the 1988 catalogue of the Rotterdam
drawings by Jeroen Giltaij, an attribution based
on a comparison with the drawing of *Hagar at
the well on the way to Shur* (Cat. No. 41.)

Bol depicted mythological scenes more often
than Rembrandt and three paintings have
Vertumnus and Pomona as their subject (Fig.
42a).[3] However, the drawing is not a
preliminary study for one of these paintings,
just as the Amsterdam drawing is not a prelim-
inary study, although it was used as a model
for a painting (Cat. No. 41).

It is related in Ovid's *Metamorphoses* how
the nymph Pomona kept all admirers at bay by
means of a fence around her garden. But
the god Vertumnus managed to approach her
in the guise of an old woman and to
recommend himself as a candidate. When he
revealed himself in his true shape, Pomona
declared herself won over.

We see Vertumnus holding forth while
Pomona, with a garland around her head and
hands folded in her lap, listens attentively.
Vertumnus's stick is lying across his knee.
According to Van Mander in his *Uitlegginge en
singhevende verclaringe* of the *Metamorphoses* from
1604, this motif is 'het steunstocsken der
traecheijt' (the crutch of sluggishness) which
he must relinguish 'met alle vrouwlijck wesen'
(with all female characteristics) in order to
achieve virtue, by which is meant Pomona.[4]
The garden in which they are sitting is not
indicated, unlike in the three paintings by Bol.

There are important similarities with the
Amsterdam drawing by Bol (Cat. No. 41).
There are not many contrasts within the
figures, who are drawn with equally even, light
pen-lines. Here and there are one or two
accents, for example in the hands of the angel
and those of Vertumnus. The relationship
between the lines and the areas left blank is
also fairly consistent. The wash differs in colour
but is applied in a similar manner: some light
shadows are to be seen on the figures, while the
background is more broadly and transparently
shaded. The stronger wash in the foreground of
the Amsterdam drawing is comparable to the
shadow to the right of Vertumnus. The figures
have been placed in between the darker and
lighter wash in both drawings. So, in their
execution, the Amsterdam and the Rotterdam
drawings display all sorts of similarities.

This also applies to the faces of the angel and
Pomona, both depicted by half ovals and both
having similar facial expressions, including a
straight mouth and areas left blank for the
eyes.

Just as with the Amsterdam drawing, a
dating to the second half of the 1630s is the
most probable.
P.S.

1. Valentiner II, 1934, No. 614.
2. Haverkamp-Begemann 1971, p. 88.
3. Blankert 1982, Cat. 36, 37 and 38; Sumowski 1983,
No. 84.
4. Amsterdam 1969.

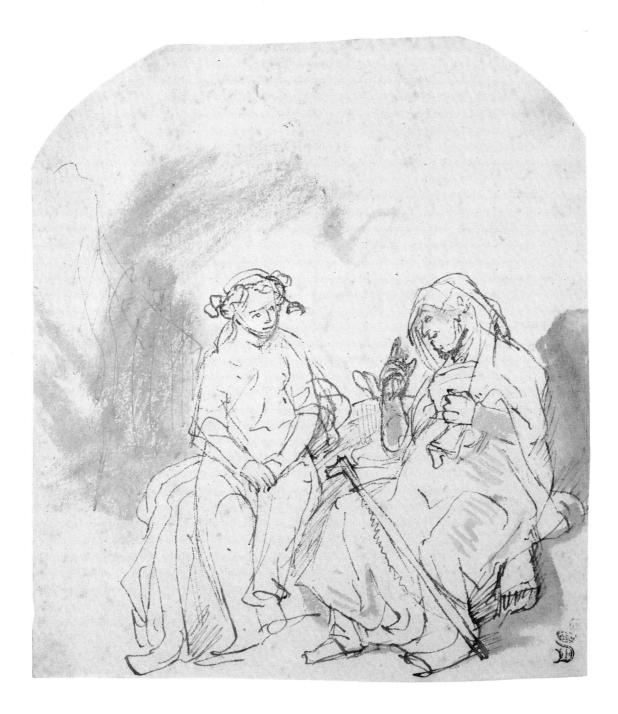

43

NICOLAES MAES

Absalom hanging from an oak

Pen and brown ink, brown wash,
209 × 323 mm
Amsterdam, Rijksmuseum,
Rijksprentenkabinet

Provence: From an album of drawings, mainly
by Matthijs Balen; Inv. No. RP-T-1957–161.

Literature: Sumowski *Drawings*, pp. 4259–60
and No. 1923–x (with previous literature).

Nicolaes Maes was born in Dordrecht in 1634.
Around 1650 he was a pupil of Rembrandt in
Amsterdam. His first independent work is a
signed painting from 1653.[1] In addition to some
early works with biblical subjects, he chiefly
painted interior genre scenes in the 1650s.
From then on and until his death in 1693, he
worked as a portrait painter in Amsterdam,
where he went to live in 1673.

Maes made innumerable drawings as
preliminary studies for paintings.[2]

However, one group of sheets with biblical
representations had a different function and was
made as practice in forming compositions, in
the depiction of events and the resulting
expressions.[3] In this, Maes was following in the
footsteps of his teacher. The drawings from this
group are dated to the mid 1650s;[4] some are
variations on scenes by Rembrandt.

The exhibited drawing, and a second one
showing a different moment from the story of
Absalom (Fig. 43a),[5] originate from an album
acquired by the Rijksprentenkabinet in 1957.
It mainly consists of drawings by Maes's later
fellow-townsman, Matthijs Balen (1684–1766).[6]
The thirteen drawings by Maes at the back of
the album, were probably acquired by Balen
from the artist or his heirs *en bloc*. Having
remained in the album until 1957, the drawings
are in excellent condition.

The moment depicted is that when David's
son Absalom, during the battle with his father,
is caught by his long hair in the branches of a
tree and kept hanging there (I Samuel 18: 9).
The army is in the left background and closer
by, a man stands behind a tree. He will relate
the incident to Joab, David's general, who was
subsequently to kill Absolaom with three
arrows. This moment is depicted in the other
drawing from the album (Fig. 43a).

The attribution to Maes rests, among other
things, on the similarity between this sheet and

other historical scenes from the same group,
including a drawing of a *Rumblepotplayer at the
entrance of a house*.[7] There is a painting of this
scene by Maes in Dordrecht.[8]

Absalom hanging from an oak is fluently drawn
with a lively pen. The composition was first
roughly indicated in fine lines (as can still be
seen in the left background) and then elabora-
ted with looser pen-lines, here and there with
a half dry pen. Thereafter Maes strengthened
contours with the brush and added shadow.

We come across this loose drawing style, in
which a few details have been more precisely
given, in drawings by Rembrandt from the
time that Maes was his pupil. An example is
the compositional design of *Jerome reading in
a landscape* (Cat. No. 25), which is dated to
approximately 1650.[9]

P.S.

1. *The Dismissal of Hagar*, New York, Metropolitan
Museum; Sumowski 1983, No. 1315.
2. William W. Robinson, 'Nicolaes Maes as a
Draughtsman', *Master Drawings* 27 (1989) 2,
pp. 146–62.
3. William W. Robinson, 'Rembrandt's sketches of
historical subjects', *Drawings Defined*, New York 1987,
pp. 241–57.
4. Sumowski *Drawings*, p. 4260.
5. Amsterdam, Rijksprentenkabinet; Sumowski
Drawings, No. 1924–x.
6. Inv. Nos. RP-T-1957–9 up to and including 152.
7. Sumowski *Drawings*, No. 1768.
8. Sumowski 1983, No. 1360.
9. Other examples are *Christ in the Garden of Gethsemane*
and *Daniel in the Lions' Den* (Fig. 25a and 26b); Benesch,
Nos. 899 and 887.

43a: Nicolaes Maes, *Joab killing Absalom*.
Amsterdam, Rijksprentenkabinet.

44

NICOLAES MAES

Panoramic view from a hill

Pen and brown ink, brown, grey and orange-brown wash, 145 × 196 mm
Amsterdam, Rijksmuseum, Rijksprentenkabinet

Provenance: W.N. Lantseer, sale Amsterdam, 22 April 1884, No. 392; W. Pitcairn Knowles (L. 2643), sale Amsterdam, 25 June 1895, No. 527; Inv. No. RP-T 1899 A4334a.

Literature: Henkel 1942, No. 76, as Rembrandt; Benesch 1954–57 and 1973, No. 829, as Rembrandt; Sumowski *Drawings*, No. 1956a–x, as Maes (with other previous literature and exhibitions).

As early as 1900, Woldemar von Seidlitz doubted the attribution of the drawing to Rembrandt.[1] Even so, various authors still considered it to be by his hand, although mention was made that its somewhat unusual character was caused by later additions.[2] Formerly, attributions had been made to a number of other artists, among them, Jan Ruisscher, Aert Gelder and Roelant Roghman,[3] but Benesch considered the landscape to be by Rembrandt. Finally, Sumowski proposed that the work be included in the œuvre of Maes and then in the group to which *Absalom hanging from an oak* also belongs (Cat. No. 43).

Between the verge of the road which bends off to the right and a higher part of the hill on the left of the drawing, we see a panoramic view. The plane and the foreground are lit, whereas the high verge and the edge of the hill are in shadow; a part of the foreground, at the lower edge of the drawing, is also in shadow.

In the initial design the plane is depicted in fine horizontal pen-lines, comparable to the background of *Absalom hanging from an oak*. The road and the verge were also drawn with the pen in the first draft, afterwards elborated with the brush. The relationship between the pen and the brush is the same in both drawings. The brush renders form—such as the plants in the foreground—as well as shadow. Shadow has been lightly indicated with the brush on the tree to the right of Absalom, the surface of the bark depicted in darker strokes later. Maes did something

similar in the shadowing of the verge, where the growth was suggested with darker brushstrokes over a lighter wash, which Maes had first allowed to dry. Numerous light brushstrokes depict the foliage above Absalom, and the sunlit verge on the right of the landscape was rendered in the same way. The forms of the leaves and the branches are similarly comparable: the branch to the left of Absalom has, in its design and in the relationship of pen and brush, the same character as the high bush to the right of the landscape. Also characteristic are the zig-zag and looped lines with which the contours of the foliage are indicated. In both drawings contours have been strengthened here and there with the brush.

The colour of the ink is the same in both drawings. To the left of the landscape grey and lighter brown wash has also been added. The use of the brush with grey ink in a drawing made with the pen and brush in brown occurs also, and to a much stronger degree, in a drawing similary attributed by Sumowski to Maes of a *View of Ravenstein* (Fig. 44a).[4] Maes also drew one or two views of his birthplace, Dordrecht, where he worked until 1673.[5] On the basis of these topographical drawings it can be assumed that the *Panorama from a hill* was also made directly from nature. Previously, when Rembrandt's name was attached to the drawing, it was proposed that it must have depicted an area in Gelderland, near Rhenen.[6] We know that Maes did travel in that direction from a drawing of a *View of the Belvedere in Nijmegen*.[7]

The attribution of landscapes to Maes is based on a drawing of a *Landscape with trees along a road*[8] on the reverse of a characteristic sketch of figures from a representation of *Christ blesses the children* in Lille.[9]

P.S.

1. Woldemar von Seidlitz, review of Lippmann and Hofstede de Groot, I–II, 'Zeichnungen von Rembrandt Harmensz van Rijn', *Repertorium für Kunstwissenschaft* 23 (1900), p. 489.
2. According to Benesch, the zig-zag line in the left foreground and the blue-grey and brown of the small hill above it are later additions.
3. For these attributions, see: Sumowski *Drawings*, No. 1956a–x.
4. Amsterdam, Rijksprentenkabinet; Sumowski *Drawings*, No. 1902–x. This combination of materials also appears in another landscape by Maes, *A village street*, in Cambridge; Sumowski *Drawings*, No. 1903–x.
5. *View of Dordrecht*, Amsterdam, Stichting P. & N. de Boer; Sumowski *Drawings*, No. 1900–x and Cambridge, Fogg Art Museum; William W. Robinson, 'Nicolaes Maes as a draughtsman', *Master Drawings* (1989), p. 159, ill. 36.
6. Lugt 1920, p. 162.
7. *View of the Belvedere in Nijmegen*, Berlin, Kupferstich-kabinett SMPK; Sumowski *Drawings*, No. 1899a–x.
8. Lille, Musée des Beaux-Arts; Sumowski *Drawings*, No. 1763.
9. Lille, Musée des Beaux-Arts; Sumowski *Drawings*, No. 1761.

44a: Nicolaes Maes, *View of Ravenstein*. Amsterdam, Rijksprentenkabinet.

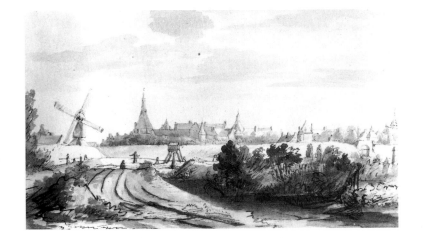

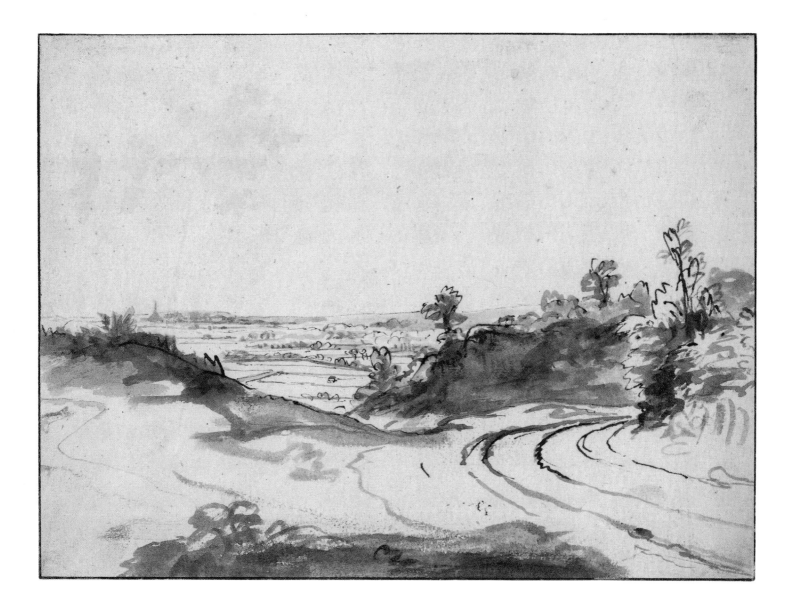

45

WILLEM DROST

Ruth and Naomi

Pen and brown ink, brown and white wash,
187 × 235 mm
Bremen, Kunsthalle

Provenance: L. Franklyn, London;
Inv. No. 54/437.

Literature: Benesch 1954–57 and 1973, No.
C100; D. Pont, 'De composites Ruth en Naomi
te Bremen en Oxford. Toeschrijving aan
Willem Drost', *Oud Holland* 75 (1960), pp. 205–
21; Sumowski *Drawings*, No. 546 (with other
previous literature and exhibitions); Sumowski
1983, in No. 311.

Exhibitions: Leiden 1956, No. 112, as Eeckhout;
Bremen 1964, No. 50, as Drost.

Willem Drost was studying with Rembrandt in
around 1650. His earliest work is a *Self-portrait*
etching of 1652 (Fig. 45a).[1] He travelled to
Italy in the second half of the 1650s and he was
certainly back in 1663.[2] Drost's painted and
drawn œuvre has increased considerably over
the years and this growth will probably
continue.[3]

The exhibited drawing was wrongly consid-
ered by Benesch to be a copy. Pont attributed
it to Willem Drost in 1958[4] and also related it
to the painting of the same subject in Oxford
(Fig. 45b). Both attributions are generally
accepted.

The draughtsman has depicted a moment
from the book of Ruth. After Naomi and her
two daughters-in-law from Moab were
widowed, Naomi wanted to return to her
country of birth, Judea. One of her daughters-
in-law, Ruth, went with her to Bethlehem.
In the drawing we see Ruth and Naomi,
accompanied by a dog, in a hilly landscape with
a high bridge and a town in the background.

The fairly even lines are characteristic of
Drost's drawing style. Also extremely typical
are the many and various hatchings, placed
close together and further apart in several
directions all over the scene. In Naomi's skirt
they have merged to form shadows, a handling
of line which occurs more often in other
drawings by Drost. The hatchings which are
intended to create shadow do not always
produce depth and plasticity, but give the
drawing a rather linear character. The figures
do not stand out strongly against the
background, although it is evident that the
light falls from the left. Naomi's features are
succinctly depicted, the eyebrows with one

continuous curved line and the open mouth
with two short lines.

The overall impression of the sheet is
mainly determined by the even pattern of lines.
As a result the atmosphere is not especially
perceptible. This is not so in the painting.
There, the figures are strongly lit against a
dark background, creating a theatrical effect.
In contrast to the drawing, the painting is
upright in format and the figures are standing
in the centre of the composition.[5] Their dress
is also given in more detail. Only a bridge is
to be seen in the dark background.

A good comparison of the drawing style can
be found in Drost's etched self-portrait of 1652.
The style of drawing, with many hatchings,
appears to be derived up to a certain point
from etchings by Rembrandt of that time.
The painting and the drawing are dated to the
beginning of the 1650s.[6]

On the basis of the convincing attribution
of the drawing and the painting to Drost, the
former has become the point of departure for
the attribution of another drawing to this
pupil, which was, until recently, still
considered to be a Rembrandt (Cat. No. 46).
P.S.

1. Holl. 1.
2. There is a painting dated 1663 of a portrait of
Hillegonda van Beuningen in a Dutch private
collection; Sumowski 1983, No. 342.
3. Of the drawings in the Rijksprentenkabinet, sixteen
were attributed to Drost; Schatborn 1985–I, pp. 100–3.
4. D. Pont, *Barent Fabritius*, 1624–1673, Utrecht 1958
(diss.), p. 129, in No. 4.
5. Bruyn concludes, on the basis of the format of the
drawing, that the painting has been cut down (Bruyn
1984, p. 154). However Drost may deliberately have
chosen a composition with figures placed large in the
picture plane.
6. Pont dates both works to 1652–1653, Sumowski
approximately 1651.

45a: Willem Drost, *Self-portrait of the Artist
drawing*. Amsterdam, Rijksprentenkabinet.

45b: Willem Drost, *Ruth and Naomi*. Oxford,
Ashmolean Museum.

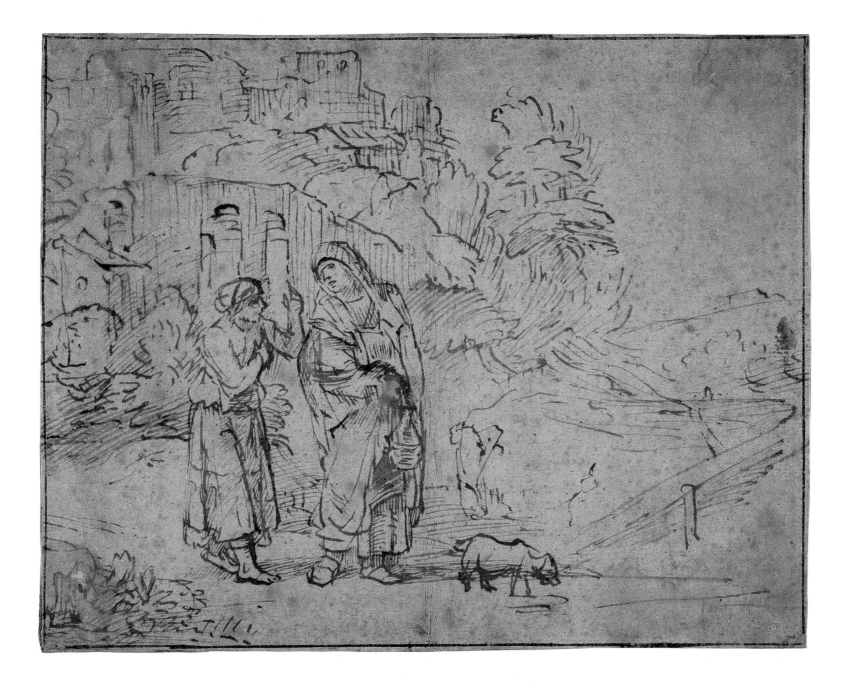

46

WILLEM DROST

The Angel departing from the family of Tobit

Pen and brown ink, 193 × 245 mm

Inscription: verso:
Purchased in 1783 at Mr. Forster's Sale
New York, The Pierpont Morgan Library

Provenance: J. Richardson Sr. (L. 2184), sale London, 22 Jan.–8 Feb. 1747 (old calendar 1746), possible No. 68 or in No. 43, 64 or 66 (?); Ingham Foster; H. Reveley, sale London, 21 April 1884, no. 154; Sir J.C. Robinson; C. Fairfax Murray; J. Pierpont Morgan, New York (1910); Inv. No. IF. 197.

Literature: C. Fairfax Murray, Vol. I, 1905, No. 197; Benesch 1954–57 and 1973, No. 893, as Rembrandt.

Exhibition: New York/Cambridge 1960, No. 70 (with other previous literature and exhibitions).

The scene depicted is the departure of the angel from the house of the family of Tobit, after Tobit's blindness had been healed by his son Tobias (see Cat. No. 18). Until recently, the drawing was always considered to be a work by Rembrandt.[1]

The drawing style looks very much like that of Willem Drost, expressed in *Ruth and Naomi* (Cat. No. 45), and other drawings. Here too the numerous hatchings are the most characteristic feature. In the doorway and on the wall to the left the lines have merged, as occurs to a lesser degree on the skirt of Naomi, and more often in other drawings by Drost. The draughtsman has also rubbed areas with his finger, which Rembrandt also used to do. The figures lack a degree of plasticity and this is partly due to the predominant linear pattern. The fall of light has also been fairly flatly interpreted.

The composition is roughly similar to Rembrandt's etching of 1641 of the same subject (Fig. 46a). In his own characteristic style, the pupil has made a variation on Rembrandt's composition. In Rembrandt's etching, which is of course more elaborate than the drawing, the light is particularly effectively rendered and the figures are much less flat, a result of the contrast between the light areas and those which are strongly shaded. In the

etching, only half of the angel who is flying away can be seen and the pupil has not adopted this original motif.

Drost's drawing can be compared to drawings by Rembrandt from the beginning of the 1650s. Although a number of Rembrandt's drawings have similar stylistic characteristics, there is in his work a different relationship between the various elements which constitute the drawing, for example, the hatching is not so prominent. There are also numerous hatchings in a drawing in the Louvre of *Christ among the Doctors* (Fig. 46b),[2] but these are more varied and in some places they clearly contribute to the creation of depth. While a secondary figure, such as the man standing above Jesus, is very lightly drawn, other figures—the man in the left foreground and the central figures—are strongly accentuated. This also creates variation and strengthens the suggestion of depth. It is also notable for example, that the small figure of Jesus is not covered with hatchings but is left white, standing out from the hatchings around him. The pupil uses the master's method but applies it in a less refined and less effective manner.

Although some variation in the lines and hatchings in the drawing of *The Departure of the Angel* is perceptible, the individual figures are not very clearly demarcated. There is a

46a: Rembrandt, *The Angel departing from the Family of Tobit*. Amsterdam, Rijksprentenkabinet.

46b: Rembrandt, *Christ among the Doctors.* Paris, Musée du Louvre, Département des arts graphiques.

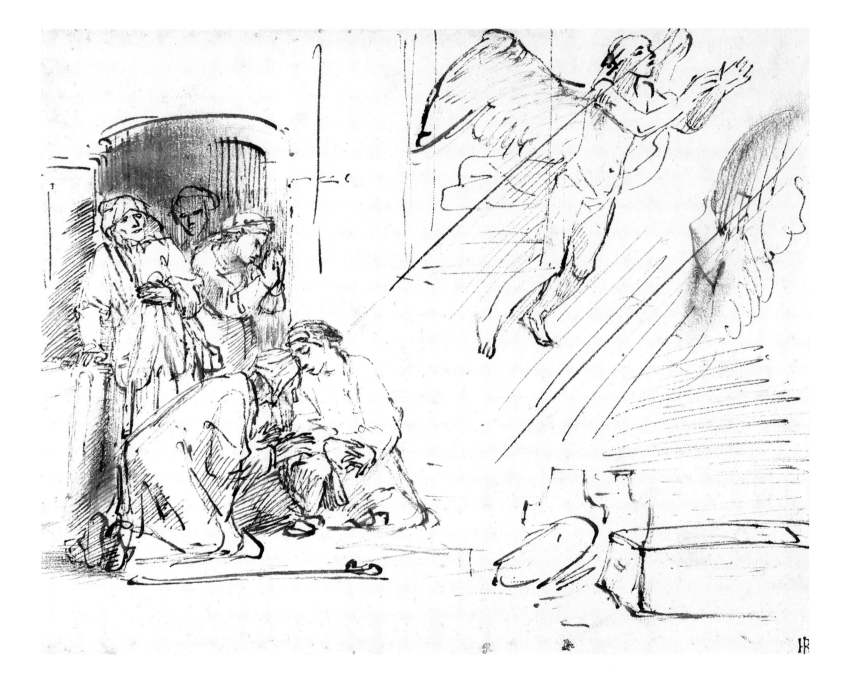

similarity with *Ruth and Naomi* in the way the faces are depicted. The mouth, in which some white is visible between the lips, and a profile with a dark eye occur on both drawings. The sketchily depicted hands are also fairly comparable.

An attribution of the New York drawing to Drost seems plausible and this can be confirmed by a comparison with other drawings attributed to Drost by Sumowski and others.

There is a drawing by another pupil, Constantijn van Renesse, which is closely related to Rembrandt's etching and especially to Drost's composition (Fig. 46c).[3] Renesse was not a regular pupil, but probably had occasional lessons from Rembrandt. On these occasions Rembrandt corrected drawings made by Renesse, including the sheet with *The departure of the angel*.[4] He must also have had Drost's drawing at his disposal in Rembrandt's studio at the beginning of the 1650s.[5] It is possible that Drost was not only a pupil but also a co-worker for some time, at least in the time before his earliest dated etching of 1652. So, Renesse not only used Rembrandt as his model, but in this case, Drost too.

P.S.

1. William W. Robinson kindly informed me that he believed the drawing to be by the hand of Drost.
2. Paris, Musée du Louvre, Département des arts graphiques; Benesch, No. 885; Paris 1988–1989, No. 50.
3. Vienna, Albertina; Benesch, No. 1373; Sumowski *Drawings*, No. 2189–xx.
4. Benesch assumed that the drawing by Renesse, corrected by Rembrandt, was the point of departure for his drawing in New York. Sumowski dates both sheets to the beginning of the 1650s.
5. According to an inscription on a drawing in Rotterdam, Renesse visited Rembrandt for the second time on 1 October 1649; Sumowski *Drawings*, No. 2145. He must have made another visit to Rembrandt at the beginning of the 1650s; Sumowski *Drawings*, p. 4911.

46c: Constantijn van Renesse, *The Angel departing from the Family of Tobit*. Vienna, Albertina.

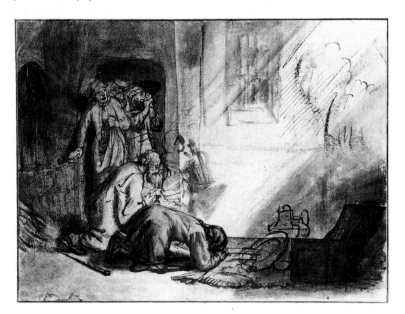

47

AERT DE GELDER

A group of Orientals

Pen and brown ink, white wash, 151 × 195 mm
London, private collection

Provenance: London, Parsons & Sons Gallery
(inventory list 1923, No. 190, as Rembrandt);
Basle, C. de Burlet; Munich, Herbert List; sale
Berlin, 11 May 1964, No. 252, as Rembrandt
School.

Literature: Sumowski *Drawings*, No. 1052
(with other previous literature and
exhibitions); Sumowski 1983, at No. 724.

Exhibitions: Chicago, Minneapolis & Detroit
1969–1970, No. 181.

In 1934 this sketch, showing a discussion
between a group of Orientals, was related to a
painting by Aert de Gelder now in the
Mauritshuis in The Hague (Fig. 47a).[1] In the
painting a scene showing Peter and John
healing a cripple at the Temple-gate is depicted
in the right background; in the left foreground
is a group of Orientals, similar in arrangement
and stance to the drawing (Fig. 47b). The man
in the centre background and the head drawn
between the three figures talking together are
omitted in the painting; other Orientals were
added to the scene. More variation in the
clothing was introduced in the execution of the
painting. In particular the fairly similar turbans
were replaced by all manner of richly decorated
head gear.

The style of the drawing is in some respects
comparable to the painting. The dark accents
in the painted figures also occur in the draw-
ing, although not in the same places. Similar,
too, is the manner in which the eyes are
depicted with dark dots.

It is therefore probable that the drawing
played a part in the making of the painting
dated 1679. Such a relationship is rare in the
œuvre of Aert de Gelder. There is moreover
the problem of whether the drawing and the
painting date from the same period. The style
of the drawing, made with a fine pen, reflects
that of a number of late drawings by Rem-
brandt.[2] De Gelder's sheet could therefore
presumably be dated to the time of his
apprenticeship with Rembrandt or after it, in
the early 1660s.

Aert de Gelder was born in Dordrecht in
1645. There, he was first a pupil of Samuel van
Hoogstraten, who had worked with Rembrandt
in the 1640s. So de Gelder had already become

47a: Aert de Gelder, *The Temple Entrance*.
The Hague, Mauritshuis.

47b: Detail from 47a.

acquainted with Rembrandt's drawing style during his apprenticeship with Hoogstraten.[3]

Striking characteristics of the exhibited drawing are the loose, occasionally short, jaunty lines and the darker covering strokes of the pen, which somewhat randomly accentuate the forms. Improvements were also made with these dark lines in the face of the man standing in the left foreground, for example. Characteristic, too, are the groups of hatchings suggesting shadow. These hatchings consist of lines drawn closely together which end in a loop; on the back of the man in the left foreground a group of such lines ends in a short zig-zag line. Such hatchings also occur in de Gelder's paintings and are achieved by scratching with the end of the brush in the still-wet paint. He has probably also rubbed the hatchings with his finger, a technique which de Gelder had learnt from Rembrandt. In this way shadow could be finely rendered. The contours are emphatically indicated with single lines and not as 'een omtrek, die als een swarten draet daer om loopt' (as an outline, which surrounds it like a black thread), as de Gelder's first teacher, Samuel van Hoogstraten describes it in his *Hooge Schoole der Schilder-konst* of 1678.[4] Most of the hands are not visible, whereas the eyes are drawn with rather differing uneven black marks and a single line, or one or two uneven lines indicates the mouths. The right hand of the second Oriental is depicted without any indication of the fingers, as if the man is wearing a glove; a thumb and two fingers of the other hand are visible.

A couple of drawings by de Gelder have the same loose style, including the *Self-portrait while drawing* (Fig. 47c).[5] A drawing which has been attributed to de Gelder for some time, *Jacob being shown Joseph's blood-stained coat* (Fig. 47d),[6] has a tighter handling of line, but the same relation between the lines, hatchings and shadows.

The drawing of the group of Orientals and the sheets directly related to it are the point of departure for the attribution to de Gelder of other drawings (Cat. No. 48 and 49).
P.S.

1. Valentiner II 1934, p. XXXIV; Sumowski 1983, No. 724.
2. The copies after Indian miniatures, dated to the second half of the 1650s, are an example of this (Cat. No. 37). This also applies to the sketch of *Isaac and Rebecca spied on by Abimelech*, which was used for *The Jewish Bride*, dated 16 . . ., Benesch, No. 988, and to the two drawings of *Elsje Christiaens hanging from the gallows* from 1664, Benesch No. 1105 and 1106.
3. Schatborn 1985, pp. 105–6.
4. Hoogstraten 1678, p. 28.
5. Amsterdam, Rijksprentenkabinet, Inv. No. RP-T-1975–56.
6. Chicago, The Art Institute; Benesch, No. A83. The attribution is by W. Valentiner, (II 1934, p. XXXIV).

47c: Aert de Gelder, *Self-portrait of the Artist drawing*. Amsterdam, Rijksprentenkabinet.

47d: Aert de Gelder, *Jacob being shown Joseph's blood-stained Coat*. Chicago, The Art Institute.

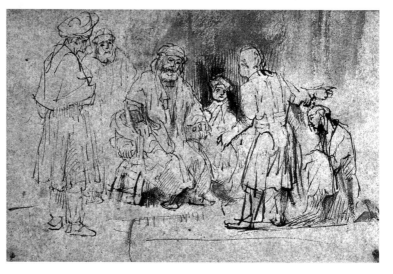

48

AERT DE GELDER

Seated female nude on a bed

Pen and brown ink, brown and white wash,
on brownish paper, 142 × 176 mm

Inscription: verso: latin text
Dresden, Kupferstich-Kabinett der Staatlichen
Kunstsammlungen

Provenance: Dresden, The Electors of Saxony
(L. 1647), acquired before 1756; Inv. No.
C1344.

Literature: Benesch 1954–57 and 1973,
No. 1109, as Rembrandt; Schatborn 1987,
as Aert de Gelder.

A young girl is seated on a bed, leaning with
her left elbow on a pillow, her right arm
resting on the cloth covering her legs. She is
looking to the right. At the lower right a
section of the bed on which she is sitting is
indicated.

This study from a model had always been
considered to be by Rembrandt until an
attribution to Rembrandt's pupil Aert de
Gelder was suggested.[1] The attribution is
based on a comparison with *A group of Orientals*,
and one or two other related drawings
considered to belong to the same group (Cat.
47, Fig. 47c & 47d). All these drawings were
executed with a fine pen. The figure of the
seated girl has been built up with shorter and
longer lines of varying thickness. The less
important lines, such as those indicating the
folds of the cloth, were made with very fine
strokes, sometimes with an almost dry pen.
The three-dimensional effect of the figure is in
the main the result of the fine hatching on the
underarm and the right hand, the wash applied
with the brush between the back and the
pillow and the hatching in the background. We
encounter comparable vertical hatching in the
background of *Jacob being shown Joseph's blood-
stained coat* (Fig. 47d). There, wash was added
with the brush, in the same way as it was
added to the left of the body on the bed, and
on the pillow, in the study of the model. The
hair of the model is transparent, depicted in
part with half-dry strokes, or rubbed with the
finger. Although the *Self-portrait* and *A group of
Orientals* are made with numerous loose, wavy
lines, there are far fewer of these in the
drawing of the nude model. Here, the lines are
tighter, as is the case in *Jacob being shown
Joseph's blood-stained coat.*

The plasticity of the seated nude is not
particularly well suggested, and this also
applies to the figures in the other drawings.
The lines create a fairly fine pattern, the
liveliest in *A group of Orientals*. Yet one can see
the same relationship between the individual
lines. Loose, fine lines are alternated with
stronger lines and accents. The darker lines do
not appear to have a clear relation to the fall of
light in the drawings, thus causing the lack of
plasticity. Just as in the drawing of the nude,
depth has been created in particular by the
hatching, placed here and there between and on
the figures.

The nude study and the self-portrait were
made from a model, with the artist drawing
what he saw. The two sketches were made
from imagination. The nude is one of a number
of late model studies considered by Benesch in
his catalogue of the œuvre to be by Rem-
brandt. Benesch divided them into one or two

groups which he dated to the mid 1650s and
the beginning of the 1660s. A number of the
approximately thirty drawings are in the
Graphische Sammlung in Munich. Most of
these are considered by critics of Benesch to
be imitations or the work of a follower. Of the
remainder, a few had already been questioned
and one group was attributed to Johannes
Raven (Cat. No. 51).

It is possible that it was Aert de Gelder who
was responsible for some of these late nudes in
Rembrandt's style. This pupil lived until 1727
and he may have continued until late in life to
draw from the model more or less in the style
of his teacher, although there are no clues to
such an attribution in his painted œuvre.
P.S.

1. Schatborn 1987.

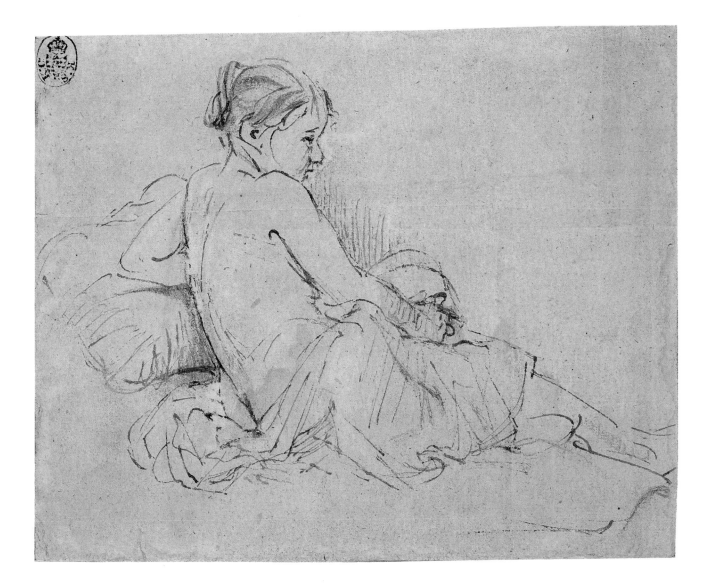

49

AERT DE GELDER

Seated female nude in front of a stove

Verso: *Head and shoulders of a seated female nude*

Pen and brown ink, brown wash,
292 × 195 mm

Inscription: verso: *12 Rembrandt, 41.*
Rotterdam, Museum Boymans-van Beuningen

Provenance: Baron R. Portalis (L. 2232), sale
Paris, 2 February 1911, in No. 174 (as School
of Rembrandt); E. Rodrigues, Paris (L. 897);
F. Koenigs (L. 1023a). presented to the
Stichting Museum Boymans by D.G. van
Beuningen (1940); Inv. No. R1.

Literature: Benesch 1954–57 and 1973,
No. 1121, as Rembrandt; Schatborn 1987,
as Aert de Gelder; Giltaij 1988, No. 185, as
Anonymous.

Exhibition: Rotterdam 1988, No. 185 (Giltaij
1988).

49: verso

The nude model is seated on a low stool with her back to the draughtsman. In the background a stove provides the required heat for the nude model. We know of this type of stove from an etching by Rembrandt, *Seated nude by a stove*,[1] and from a written source we know that artists and pupils drew from the life 'bij de warme stooven' (by the warm stoves) (see Cat. No. 38).

The drawing, together with the *Seated female nude* (Cat. No. 48), belongs to a fairly large group of nudes, which until recently were considered to be the work of Rembrandt. While the exhibited drawing is ascribed to an unknown pupil of Rembrandt in the catalogue of the drawings in Rotterdam, an attribution to Rembrandt's pupil Aert de Gelder is also suggested.

This attribution is in the first instance based on a comparison with a drawing by Rembrandt of the same model (Cat. No. 38). He made this study simultaneously with the pupil, but from a different angle. Although the drawings display similar characteristics, there are considerable differences, although these are not immediately evident. In any event, the study by the pupil is strongly influenced by Rembrandt.

It is more likely that two artists were simultaneously working from the same model, than that one artist drew the same model twice in the same pose, although this is of course not to be ruled out. There is, moreover, a comparable example of the master working with another pupil, Johannes Raven (Cat. No. 51).

Rembrandt and his pupil used the same materials. The most important difference can be seen in the depiction of light. Whereas Rembrandt leaves the foreground open, his pupil fills it with brushstrokes, which create the impression of an uneven floor. The pupil has rendered the shadow underneath the stool rather disproportionately, although he was presumably trying to depict it accurately with, among other things, brushstrokes along the spindles; he also tried to draw the stool itself with the same accuracy in pen, but in his attempt to work fluently he has produced a rather rickety looking piece of furniture. The stool drawn by Rembrandt seems to be of simpler construction; this is because he has depicted no details and abstracted the forms to a certain degree. As a result—and with far fewer pen-lines—a much sturdier piece of furniture has been created, which is also spatially more convincing. Rembrandt has achieved this by depicting light in half of the area under the stool, by strongly accentuating the left leg and allowing the right to dissolve

in shadow. The pupil lacks such refinement.

The fall of light on the body also reveals such differences. Although the pupil is not completely unsuccessful, the brushstrokes are less evocative. In some places they have a fairly descriptive character: they follow the contours of the shoulder, thigh and calf, and the outline of the stomach and shoulderblade. Furthermore the backbone is indicated with one uninterrupted brushstroke between the other areas of wash. The pupil also depicted the background with brushstrokes which are as transparent as Rembrandt's, but contribute less to the suggestion of space around the figure than his abstract pattern of lines. The background appears to be divided into various sections, while the repetition of brushstrokes on the left actually creates a rather flat impression. The darkest shadow made by the pupil on the model's back has become just too much of an independent shape, as the edges of the shadow do not suggest the dispersal of light with enough precision.

The most notable difference in the use of the pen can be seen in the depiction of the head-dress. Rembrandt only needed a few lines and a little wash to evoke the plasticity of the form. The pupil has depicted the cap in a rather messy way with various lines in pen and brush. The crumpled-looking headdress moreover does not form such a natural entity with the head as it does in the Rembrandt drawing.

The pupil has drawn a zig-zag hatching in pen on the lower back, a somewhat isolated element and a stylistic characteristic of Aert de Gelder, appearing repeatedly in a number of drawings attributed to him (Cat. No. 47 and 48). Just as in the Rembrandt, the face of the woman is indicated with the pen and touches of the brush. But here too, the method has created rather isolated forms.

The pupil started the drawing on the reverse of the sheet. Here, we see the head and part of the back, drawn in pen only. The lines create a fragmented impression, which cannot only be explained by the omission of the wash. The pupil apparently did not think this drawing successful, which is why he turned the paper over and started again on the other side. The ear of the woman is depicted in a rather idiosyncratic manner on the recto of the sheet, by means of a few lines forming a circle in which a dark dot has been placed. We come across a similarly typical characteristic in the *Seated female nude* (Cat. No. 48). This drawing was attributed to Aert de Gelder because of the similarity in style with *A group of Orientals* (Cat. No. 47) and directly related sheets.

The Rotterdam drawing is closer to Rembrandt than the other, particularly the

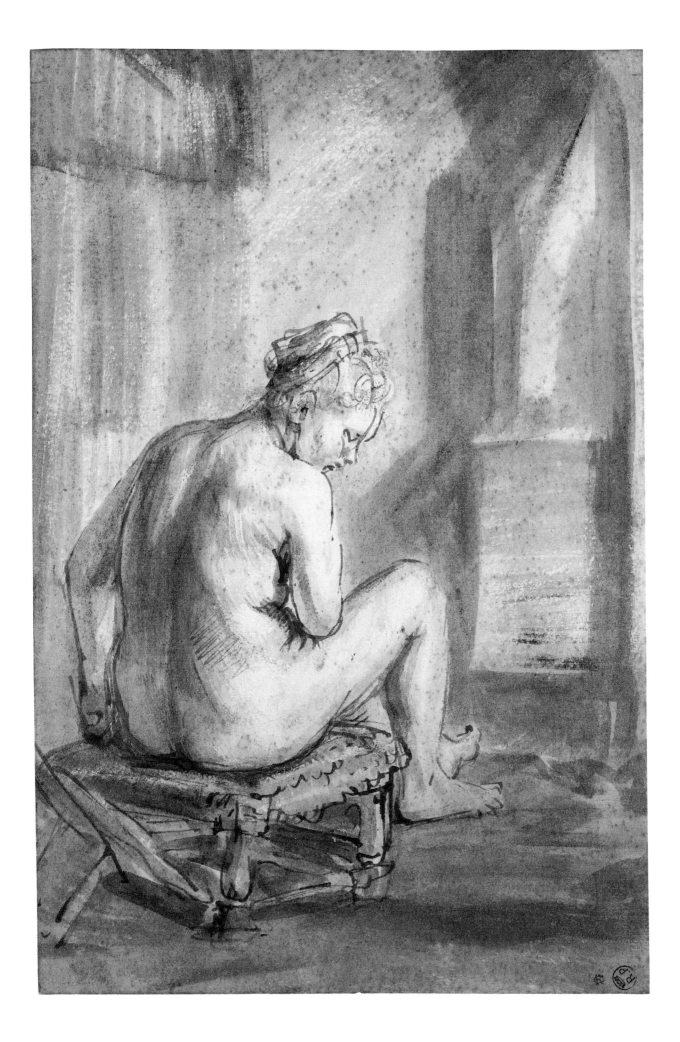

depiction of the profile on both sides of the drawing is similar to that of the *Seated female nude*. The composition of the face, the dark dot which indicates the eye and the method of shading with transparent strokes or marks, as in the neck of the woman on the back of the Rotterdam drawing, are comparable. The relation between the loose pen-lines depicting the hair and the wash through it is particularly close. The fingers of the hands of the nude seated on the bed and the visible finger of the nude by the stove are depicted with fairly similar, looped lines. The short hatchings on the stomach of the woman by the stove appear in larger scale on other drawings. Only the germ of the characteristics of de Gelder's style is to be found in the Rotterdam drawing. However, after establishing that the drawing is not by Rembrandt, it provides sufficient evidence to support the attribution to Aert de Gelder.

P.S.

1. B. 197.

50

JOHANNES RAVEN

Seated half-nude boy with clasped hands

Pen and brown ink, brown and white wash, 198 × 160 mm

Inscription: below right old Inv. No. 4912; verso: *Johannes de Jonge Raven*
Munich, Staatliche Graphische Sammlung

Provenance: Mannheim, Elector Carl Theodor of the Palatinate; Inv. No. 1567.

Literature: Wegner 1973, No. 851; Sumowski *Drawings*, No. 2141 (with other previous literature); Schatborn 1985, under No. 69; Schatborn 1987, p. 313.

Exhibitions: Wolfgang Wegner, *Rembrandt und sein Kreis*, Munich 1966–1967, No. 117.

We know of Johannes Raven as a draughtsman by his signature on the reverse of the exhibited drawing (Fig. 50a).[1] He is mentioned in 1659 as a twenty-five year old painter in Amsterdam and he died in 1662.

Raven was probably a pupil of Rembrandt for a while and, together with him, made life-drawings (see Cat. No. 51). His drawing style betrays influence from Rembrandt's late drawings of the female nude. Two of Rembrandt's nudes are in Chicago (Cat. No. 38) and Amsterdam (Fig. 51b) respectively.

Raven drew the boy seated with clasped hands in scratchy, fairly carelessly placed pen-lines, with double and sometimes overlapping contours, closely placed together accents of short lines and here and there darker and broader accents. Some shadows are indicated by zig-zag hatchings. With the brush, Raven also added light shadows on the body and darker shadows in broad strokes along or very near to the outline of the figure and the cloak. The drawing was then probably completed in pen, with which Raven added new accents over the brushwork. The shadow in the background is, just as in the figure and the cloak, built up of layers of varying thickness. Especially in the hands and face we can see how Raven's fairly scratchy pen has unevenly and with occasional sharp accents, drawn the forms. The strokes of the brush along or next to the contours are also characteristic of Raven's drawing style.

A drawing of a *Seated boy holding a rope* was also attributed to Raven by Sumowski.[2] A group of nudes, which was considered by Benesch to be the work of Rembrandt, is now similarly attributed to Raven (Cat. No. 51).

P.S.

1. The drawing bearing Raven's name was published by Wolfgang Wegner in *Oud Holland* 69 (1954), pp. 236–38.
2. Basle, Kunstmuseum, Kupferstichkabinett; Sumowski *Drawings*, No. 2142-x. Henkel 1942, p. 100, under No. 1; this author attributed the drawing to Renesse. The drawing style could also be compared to that of Abraham van Dyck.

50a: verso of Cat. No. 50.

51

JOHANNES RAVEN

Seated female nude

Pen and black ink, brown and grey wash, 291 × 155 mm

Inscriptions: verso: . . . *im Lanore valle Las Cases* (?); below left *No 1025, Sammlung Gsell, 230, Rembrandt*; below right *A No 610* Amsterdam, Rijksmuseum, Rijksprentenkabinet

Provenance: Joseph Daniel Böhm, sale Vienna, 4 December 1865, No. 1388; F.J. Gsell, sale Vienna, 14 March 1872, No. 610; Max Freiherr von Heyl zu Herrnsheim, Darmstadt, sale Stuttgart, 25 May 1903, No. 251; Cornelis Hofstede de Groot, The Hague, gift of 1906, in usufruct until 14 April 1930; Inv. No. RP-T-1930-57.

Literature: Benesch 1954–57 and 1973, No. 1146, as Rembrandt; Schatborn 1985, No. 69, attributed to Johannes Raven (with other previous literature and exhibitions); Schatborn 1987, p. 313, as Johannes Raven.

The group of late drawings of female nudes, to which the exhibited drawing belongs, is notable for the use of sharp pen-lines, loose hatching and extensive use of wash.[1] Always considered to be by Rembrandt, it was suggested in 1969 that only the dark wash was later added by another hand, but that otherwise the drawing was by Rembrandt.[2] In 1985 an attribution to Johannes Raven the younger was suggested for this group, a pupil by whom one documented drawing is extant (Cat. No. 50).

The seated female nude's arms are raised and she holds a cord in both hands. She is sitting on a chair covered with a cloth. The drawing is executed with various materials: initially drawn in almost black ink with the pen and then extensively elaborated with the brush in brown and grey. The contours are partly drawn with loose, sloping lines and partly with short lines; the features are depicted in the same manner. Loose and fine hatching has been applied on and around the figure. The brush has retraced the contours, and shadows have also been added to the face with the brush. The folds of the cloth have been indicated in various widths of brushstroke and the area behind the figure has been fairly evenly shadowed. Lighter shadows in grey were added to the figure and a section of the paper to the left of the figure was also covered with grey.

A drawing belonging to the same group, in London (Fig. 51a),[3] was made when Rembrandt simultaneously drew the same model from a different viewpoint (Fig. 51b).[4] The pen-lines of the London drawing are clearly derived from those of Rembrandt, but the wash displays great similarity to the exhibited sheet. Here the pupil has borrowed the loose hatching over the body from Rembrandt's drawing. But he did not adopt Rembrandt's characteristic use of transparent wash.

The most notable similarity between the exhibited drawing and the nude study by Raven (Cat. No. 50) is the way in which the wash has been applied with the brush. This is most apparent in the depiction of the clothing, where the brushstrokes follow the contours. In both cases loose hatchings have been added with the pen next to or through them. The structure of the pen lines also shows affinity, to be seen in the outlines as well as in the accents placed here and there. The feet were depicted in a similar manner, while the same scratchy lines appear in the faces.

There are also, of course, differences. In the Amsterdam drawing the pupil has allowed himself greater liberties than with the study of the male nude. The latter has a slightly more reserved character and is executed with greater precision. The drawing of the seated woman

51a: Johannes Raven, *Seated female Nude.* London, British Museum.

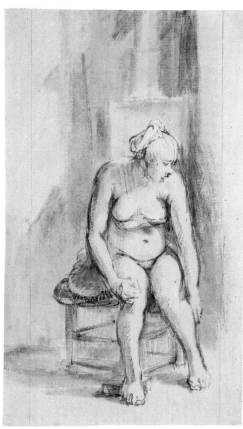

51b: Rembrandt, *Seated female Nude.* Amsterdam, Rijksprentenkabinet.

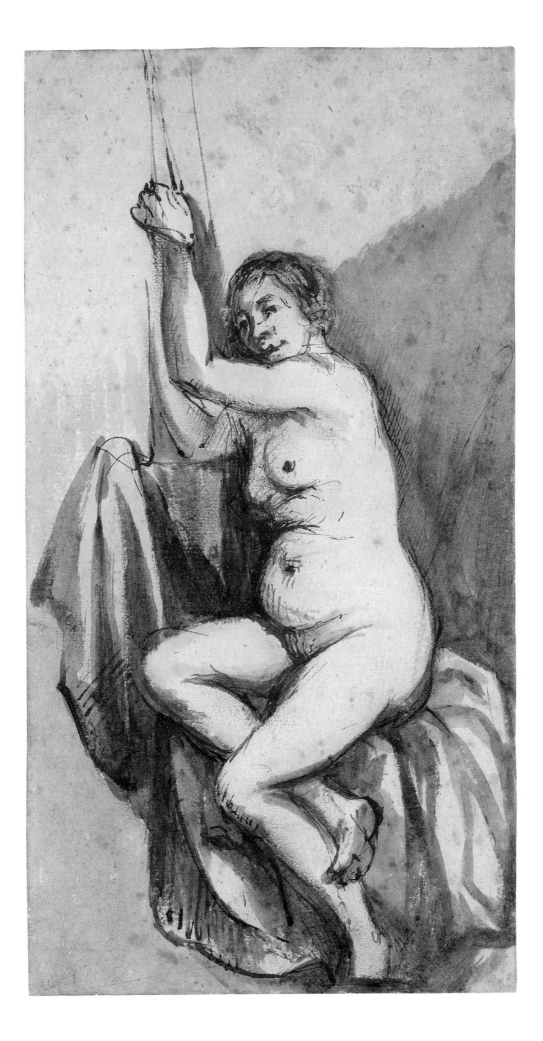

was made when Raven was still in contact with Rembrandt and the *Seated boy with clasped hands* was presumably made when he was an independent artist, in 1659 or later.

The drawing style of pupils often betrays a certain ambivalence: the pupil wants to depict the forms as well as possible, but is at the same time stimulated by Rembrandt's example to take a certain amount of liberty and to work freely; as this fluency is not developed from personal experience, the pupil sometimes aspires too high.

There is a drawing in the British Museum from the group of five female nudes,[5] possibly made when Rembrandt etched his *Woman with the arrow*, although the right arm is depicted in differing positions in the etching and the drawing.[6]

It is unlikely that the pen-drawing is by Rembrandt himself and that the wash was added later by another hand, as has been suggested. The pen-drawing itself is too far removed from Rembrandt's characteristic style, as we know it from both the drawing in Chicago (Cat. No. 38) and that in Amsterdam (Fig. 51b). Raven's pen is more careless and the forms have less plasticity. The precision with which Rembrandt drew the head with the cap and the face of the woman in the above mentioned drawings is utterly lacking with Raven; this is also the case with Aert de Gelder (Cat. No. 49).

However, it should not be ruled out that Raven himself later elaborated his drawings with the brush, but it is difficult to draw a dividing line between this later application of wash and the original drawing.

P.S.

1. London, British Museum, Benesch, Nos. 1143, 1145 and 1147; Rotterdam, Museum Boymans-van Beuningen, Benesch, No. 1144, Giltaij 1988, No. 186, as by an unknown pupil.
2. Haverkamp-Begemann in White 1969, p. 187, No. 19.
3. London, British Museum; Benesch, No. 1143.
4. Amsterdam, Rijksprentenkabinet; Benesch, No. 1142; Schatborn 1985, No. 55.
5. London, British Museum; Benesch, No. 1147.
6. B. 202.

Etchings

The exhibition of Rembrandt's Etchings was originally planned and selected by Hans Mielke and Peter Schatborn in 1988/89. The authors have been responsible for its development since 1990.

In Berlin and Amsterdam the exhibited etchings are from the respective collections (the Kupferstichkabinett SMPK and the Rijksprentenkabinet). In London the exhibited etchings are from the collection of the British Museum. In the catalogue inventory numbers are given in brackets and * indicates the example which is illustrated.

The authors are particularly grateful to Jan Kelch, Hans Mielke, Martin Royalton-Kisch and Peter Schatborn for their stimulating suggestions.

Holm Bevers and Barbara Welzel

Rembrandt as an Etcher
Holm Bevers

1: Rembrandt, *Portrait of his mother*. Amsterdam, Rijksprentenkabinet.

'I have seen a number of his printed works which have appeared in these parts; they are very beautiful, engraved in good taste and in a good manner . . . I frankly consider him to be a great virtuoso.'[1] So wrote in 1660 the Italian baroque painter Guercino to the Sicilian aristocrat and connoisseur Don Antonio Ruffo, whose collection contained a number of works by Rembrandt. The fame of the Dutch artist was not just confined to his native land, but was already well established in large parts of Europe, principally because of his prints.[2] In his book on the history of prints published in 1662, the English author John Evelyn praised the 'incomparable Reinbrand, whose Etchings and gravings are of a particular spirit.'[3] Rembrandt's etchings had already become collectable during his own lifetime. Michel de Marolles, whose large and important graphic collection formed the nucleus of the Bibliothèque Nationale in Paris, lists 224 entries under Rembrandt's name in his catalogue of 1666.[4] Even today, the fascination of collecting etchings by Rembrandt, especially rare impressions and states, has lost none of its mystique. Equally, his style awoke the interest of contemporary artists, and was copied by Giovanni Benedetto Castiglione (1609–1665) among others. Entire generations of artists in the eighteenth and nineteenth centuries worked in Rembrandt's manner. Even prints by Pablo Picasso contain numerous references to his etchings.

Rembrandt produced prints from about 1628 to 1661, that is from his juvenile beginnings in Leiden to his late years in Amsterdam. For unknown reasons he appears to have abandoned etching after 1661, as the only known work after this date is a portrait (B. 264) from 1665.

The earliest *catalogue raisonné* was compiled by Edmé Gersaint in 1751, and followed by Adam Bartsch's in 1797. These two authors constructed an œuvre of 341 and 375 works respectively, using his signed and dated prints as the comparative basis against which unmarked works could be stylistically evaluated. The classification system devised by Bartsch, which groups and numbers prints thematically, has successfully withstood the test of time. The number of etchings presently accepted as being by Rembrandt has shrunk to around 290, with many of those attributed to him by Gersaint and Bartsch now given to pupils or followers.

A cursory study of the prints shows that they cover a wide variety of subjects. In his paintings, Rembrandt confined himself principally to the two areas most highly regarded at that time: portraiture and illustrative themes taken from the Bible, mythology and history. For his etchings, however, he expanded his repertoire to include subjects which in seventeenth-century Dutch art were usually executed by specialists. In addition to the above-mentioned, Rembrandt turned his attention to genre, landscape, nudes, miscellaneous sketches and studies as well as allegories and still-life. The combination of his thematic diversity and his mastery of the various techniques enabled him to achieve an unrivalled intensity of artistic expression.

Known since about 1430, the medium of engraving was chiefly used in the seventeenth century for reproductive prints, that is the reproduction of paintings by professional engravers. Etching is a younger invention; some of the earliest examples were made by Dürer during the second decade of the sixteenth century. In the course of the next century, the status of etching rose to a par with that of engraving, with etchings being highly prized by collectors and artists alike. It was first and foremost the medium of the painter-etcher, that is of those artists who actually etched their own inventions. In his 1645 treatise on printmaking, the French engraver and author Abraham de Bosse recommended that etched lines be made to look like engraved ones, as these have a precise, sharp-edged appearance and produce a clearly definable structure. Rembrandt took the opposite approach: he used the needle as if it were a paintbrush, and in doing so became the first artist to maximise the aesthetic possibilities of the medium.

The soft layer of wax covering the copper plate allows the artist to draw flowing lines of diverse strength to mould his forms. Rembrandt obtained the nuances of tone used to create light by multiple biting of the plate or using acids of varying intensity. He only occasionally used the burin—the engraver's principal tool—to optimise the effectivness of hatching. Of far greater importance was drypoint, a technique which involved scratching the line directly in the metal surface with a special needle—almost like using pen on paper. The action pushes the displaced metal to the side and creates the so-called 'burr', which is coated when the plate is inked, and produces an impression with black velvety lines. The first artist to employ this technique was the Master of the Housebook, who was active in the region of the middle Rhine during the late fifteenth century. But it was Rembrandt who became the greatest exponent of drypoint by fully integrating its specific characteristics into his pictorial concept, either on its own, or in conjunction with etching. With the

exception of the landscape etchings of Hercules Seghers, no other artist experimented with printing techniques to the extent Rembrandt did. He created a very fine, powdery tone, probably by using sulphur to bite the metal, which produced an effect similar to that obtained by aquatint—a technique first tried by Jan van de Velde IV in Amsterdam during the 1650s.[5] Impressions from a plate with a porous ground are characterised by fine gradations of tone and appear as if washed. Two of the finest examples of Rembrandt's application of this technique, which he in fact rarely used, are his portrait of *Jan Cornelius Sylvius* (Cat. No. 22) and *The landscape with the three trees* (Cat. No. 19).[6]

Rembrandt was not a trained engraver but a painter, and so it is hardly surprising to find that he favoured techniques which matched his artistic inclination. For him, etching and drypoint were not subordinate mediums suitable only for reproductive exercises, rather they represented a means of achieving new heights of personal expression. While his prints were, for the most part, stylistically, iconographically and compositionally independent of his painting, they were, nevertheless, accorded equal status.

Little is known about Rembrandt's beginnings as an etcher. The two earliest dated prints are from 1628 and show Rembrandt's elderly mother (B. 352, 354). But the twenty-two year-old artist was already an accomplished and talented etcher. All the specific characteristics of his manner are evident. The lines of *The Artist's Mother* (Fig. 1) are airy and sketch-like, light and shadow are indicated not only by hatching of varying thickness, but also by lines which have been bitten to different depths. Rembrandt's attention to physiognomic detail may have been inspired by the miniature portraits engraved and drawn by Dutch Mannerists such as Jacques de Gheyn or Hendrick Goltzius. However, no prints are known which could have been of immediate importance for the development of Rembrandt's etching technique. Neither of his teachers, Jacob Isaacz. van Swanenburgh in Leiden nor Pieter Lastman in Amsterdam, can have taught Rembrandt the art of etching; indeed, Lastman did not etch at all. The question of Rembrandt's beginnings is related to the evaluation of two etchings which are usually categorised in the literature as representing the first works of the young artist, from the years 1625/26. *The Circumcision of Christ* (S. 398; Fig. 2) and *The Rest on the Flight into Egypt* (B. 59; Fig. 3) are both executed in a somewhat schematic and uncertain manner, and although the former bears the signature *Rembrant fecit*, its

authenticity is by no means certain.[7] *The Rest on the Flight into Egypt* is related, but not stylistically identical. Its quick, sketchy lines and the frequent use of zig-zag are features of a group of early etchings by Jan Lievens, who was also active in Leiden between 1625 and 1631.[8] His etching of *St John the Evangelist* (Fig. 4) bears the name of Jan Pietersz. Berendrecht, a publisher in Haarlem, whose address also appears on *The Circumcision* attributed to Rembrandt. While the conceptual approach of both artists shows the influence of their teacher Lastman, their graphic style does not.[9] Moreover, their manner of etching cannot be connected directly to the generation of important Dutch etchers, such as Esaias and Jan van der Velde and Willem Buytewech, who were active during the first three decades of the seventeenth century. A possible source of inspiration may have been the etchings of Moses van Uyttenbroeck and Jan Pynas;[10] equally Gerrit Pietersz. Sweelinck, the first important Dutch painter-etcher and Lastman's teacher, may have played a role.[11] Related to *The Rest on the Flight into Egypt* is a small group of etchings (B. 9 & 54) which are considered to be by Rembrandt from c. 1626/27. However, Rembrandt as an etcher is only really tangible with the appearance in 1628 of his first dated prints.

Towards the end of his stay in Leiden and for a period after he moved to Amsterdam in 1631, Rembrandt produced a number of small self-portraits (Cat. Nos. 1 & 2), portraits of old men, possibly including his own father, as well as some of his aged mother (Cat. No. 4). All of these served as studies of the 'affetti' and physiognomy of the elderly. Around 1629/30 he captured beggars and other street dwellers in small genre illustrations (Cat. No. 3), for which he was thematically and technically motivated by the etchings of beggars by the French artist Jacques Callot. A group of etchings showing heads and beggars executed around 1631 in a coarse and schematic style was previously accepted, by Bartsch among others, as original; they can, however, now be attributed to pupils, including Jan Joris van Vliet.[12] In addition to portraits and genre scenes, Rembrandt now turned his attention to an object which was to fascinate him for the rest of his life: the bible. Instead of following the tradition of producing a complete cycle to illustrate his chosen subject, he usually confined himself to a single print. The majority of those produced around 1630 are small many-figured scenes, conceived in a painterly fashion (B. 48, 51, 66); indeed, images such as *The Circumcision of Christ* (B. 48; Fig. 5) are more or less translations of his earlier history paintings into miniature-scale

etchings.[13] Rembrandt constructed his figures and the other elements of his composition by means of a complex system of lines of varying density and bitten depth.

As well as his role as a painter-etcher in the early 1630s Rembrandt turned to reproductive prints. His model was undoubtedly Rubens, who sought to publicise his compositions by having them reproduced in Antwerp by engravers who remained under his constant supervision. In 1631 Jan Joris van Vliet, then active in Leiden, etched four designs which name Rembrandt as the *inventor*; one of the paintings which served as a model is still in existence.[14] After Rembrandt moved to Amsterdam in 1631 Van Vliet continued to work for him; he reproduced some studies of heads in addition to his more famous etchings of Rembrandt's two large baroque compositions, *The Descent from the Cross* (B. 81; Fig. 6) of 1633 after the panel from the cycle of the Passion painted for Frederik Hendrik (Munich, Alte Pinakothek), and the *Ecce Homo* (B. 77; cf. Cat. No. 38) of 1635–1636 after a grisaille specially painted for this purpose (London, The National Gallery).[15] Both etchings were at one time believed to be by Rembrandt, but he probably made only the final corrections to the plates before the prints—with his name and privilege—were placed on the market. Other grisaille paintings from the 1630s may have been intended to serve as models for prints which were never made.[16] As it was, Rembrandt made little use of the possibilities of reproductive prints, and by 1636 had abandoned them altogether—in contrast to Rubens for whom they constituted a successful and profitable section of his business. Apparently Rembrandt's standing as a painter-etcher was such that he felt he could devote himself exclusively to this activity, especially as he knew public opinion judged etching to be artistically equal to reproductive prints.[17] Furthermore, there may also have been the problem of finding suitable engravers and publishers—essential for anyone wishing to compete with the outstanding quality of the prints leaving Rubens's studio.[18]

The majority of Rembrandt's own etchings from the early 1630s illustrate genre and biblical themes. In his principal religious etching of this period, *The Annunciation to the Shepherds* of 1634 (Cat. No. 9), Rembrandt's dramatic rendering of light and dark paves the way for his future achievements. Despite the acclaim he received as a portraitist during his first years in Amsterdam, Rembrandt etched only a few portraits (B. 266, 269). A distinctive group of prints from the middle of the 1630s are his etched sheets of sketches (Cat. No. 5 & 12), and Rembrandt

2: Rembrandt, *The Circumcision*.
Amsterdam, Rijksprentenkabinet.

3: Rembrandt, *The Rest on the Flight into Egypt*.
Amsterdam, Rijksprentenkabinet.

4: Jan Lievens, *St John the Evangelist*.
Amsterdam, Rijksprentenkabinet.

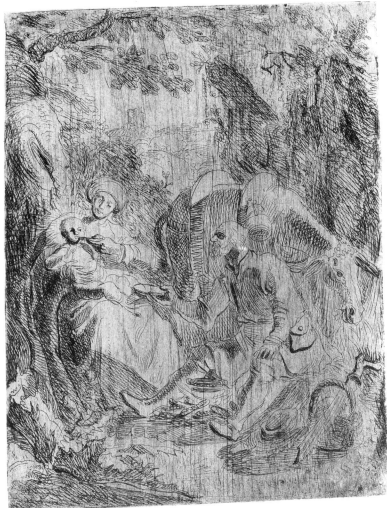

appears to have been the first to render as a print an artistic process which belongs to the medium of drawing.

Towards the end of the 1630s, possibly from 1637, Rembrandt developed a more spontaneous and freer approach, and on occasions simply delineates his figures. From 1639 he used the medium of drypoint with increasing frequency, particularly to accentuate contours, and indeed entire sections, by means of dark velvety lines. Rembrandt must have realised that he could not achieve a sufficiently dramatic and painterly effect when rendering light and dark by relying solely on bitten lines of varying depth. The first two etchings to be reworked using drypoint were his wonderful rendering of *The Death of the Virgin* (Cat. No. 14) of 1639 and *The Presentation in the Temple* (B. 49), probably from the same year.

The Death of the Virgin reflects Rembrandt's preoccupation with Dürer's woodcut cycle devoted to the Life of Mary. Rembrandt's study of the works of other artists must be seen as a continuous and varied dialogue. His own enormous collection of paintings, sculpture, medallions and numerous albums containing drawings and prints by predecessors and contemporaries provided a constant source of inspiration.[19] *Imitatio* was not considered a sign of an artist's inability to invent, rather it demonstrated the breadth of his erudition and education. Artists should attempt not only to compete with famous models but also to surpass them.[20] Rembrandt had detailed knowledge of his artistic heritage, especially the history of graphic art. The fact that he filed his own prints among the works of those artists he most admired testifies to his awareness of his own role within the historical development. His collection was undoubtedly a status symbol intended to document his affiliation to the social class of 'gentlemen *virtuosi*'.[21]

The contents of the *kunst boecken* show Rembrandt to be a collector with encyclopaedic taste and the eye of a connoisseur; he was as interested in quality as in variety and completeness. Thanks to the inventory of 1656 we are well-informed about the contents and arrangement of his collection.[22] He possessed folders of prints of the great Italian renaissance and baroque artists: engravings and etchings by Andrea Mantegna, the Carracci, Guido Reni and Jusepe de Ribera; woodcuts after designs by Titian and three *kostelijcke boecken* devoted entirely to prints after Raphael. In addition, Rembrandt owned albums containing works by the most important earlier and contemporary Netherlandish and German artists: engravings and woodcuts by Martin Schongauer, Lucas Cranach, Albrecht Dürer and Lucas van Leyden; prints after Pieter Bruegel and Marten van Heemskerck; engravings by his famous Dutch predecessor, Hendrick Goltzius; reproductive prints after Rubens, Jacob Jordaens and Anthony van Dyck; not to mention works by his own contemporaries and pupils, such as Jan Lievens and Ferdinand Bol.

The works he used as models served very different purposes. Beyond providing inspiration for compositions (Cat. No. 8, 10, 24, 40), they offered Rembrandt the opportunity of engaging in artistic *paragone*: his *Ecce Homo*, for example, is related to the famous engraving by Lucas van Leyden, which Rembrandt had acquired for a large sum of money (Cat. No. 38). It was not unusual for him to integrate into his compositions individual elements or figures 'borrowed' or adapted from other artists, as in the case of a putto from Raphael's *Triumph of Galatea* whom Rembrandt changed into an ordinary boy (Cat. No. 10). Rembrandt studied the printing technique of Andrea Mantegna, especially his manner of hatching (Cat. No. 36 & 37). The initial idea for his famous *Self-portrait leaning on a stone sill*, in which he portrayed himself as a true *gentiluomo* (Cat. No. 13), came from Raphael's portrait of *Baldassare Castiglione*, which Rembrandt copied in 1639, and Titian's so-called *Ariosto*.

It is difficult to characterise the stylistic tendencies of the 1640s. Simple, quiet forms abound. More emphasis is placed on the contours of the figures, while at the same time a reduction in their vitality and movement can be observed. Moreover, frequent changes in style occur. For example, *Abraham and Isaac* (B. 34) and *The Rest on the Flight into Egypt* (B. 57) are both from 1645 (Figs. 7–8), yet the former could be described as 'painterly' in style, while the latter is more 'linear'. To a certain degree, the subject matter influenced Rembrandt's choice of etching technique. His portraits (Cat. No. 16) are more in line with the systematic parallel- and cross-hatching of engravings, while the sketchy manner of his landscapes is not unlike that of his landscape drawings (Cat. No. 20). In other words, the artist approached these two particular themes in a very different manner.

Around 1646–47 Rembrandt made a number of portraits, most of which were probably commissioned, of friends and public figures in Amsterdam. In the most important of these, the portrait of 'Jan Six' from 1647 (Cat. No. 23), Rembrandt favoured a dense, dark structure, broken only by a few bright areas to highlight and define the sitter's features. In no other etched

5: Rembrandt, *The Circumcision*. Amsterdam, Rijksprentenkabinet.

6: Rembrandt, *The Descent from the Cross*, Amsterdam, Rijksprentenkabinet.

7: Rembrandt, *Abraham and Isaac*.
Amsterdam, Rijksprentenkabinet.

8: Rembrandt, *The Rest on the Flight into Egypt*.
Berlin, Kupferstichkabinett SMPK.

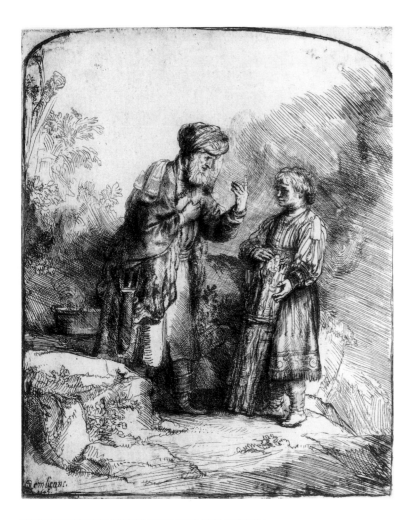

portrait did he come as close to giving his print the appearance of a mezzotint. This can hardly have been a coincidence, but rather the result of Rembrandt constantly exploiting all the means at his disposal to achieve optimum tonality. The technique of mezzotint was discovered during the 1640s; it involves first roughening the entire plate and then scraping down the 'burr' created by this process in proportion to the lightness of tone required.[23] The 'painted' appearance of the superb *Hundred Guilder Print* (Cat. No. 27) of 1647 is the result of the combined use of different techniques and lines; here Rembrandt employed his entire stylistic repertoire in one work.

Although Rembrandt painted comparatively few landscapes, they play an important role in his etched œuvre. In his paintings of the late 1630s and early 1640s he made ample use of heroic compositions with mountains and dramatic lighting, but for his prints—and drawings—he turned to the low, flat countryside of his native soil. It was also during these years that he produced a number of prints of male nudes, which, among other things, may have served as models for his pupils to improve their drawing skills (Cat. No. 21).

Around 1650 a radical change occurred in Rembrandt's graphic work. The individual, block-like elements of his compositions are organised into a clearly definable arrangement of receding parallel layers. His attitude to the actual line also changed considerably: in place of finely moulded forms, he now favours regular oblique lines of parallel hatching which cut across the different elements. Rembrandt may have adapted this hatching system from the engravings of such artists as Andrea Mantegna. These lines are especially prevalent in his biblical themes which, around the middle of the 1650s, were frequently conceived as cycles (Cat. No. 36 & 37). In Rembrandt's landscape etchings of 1650–1652 drypoint plays an increasingly important role (Cat. No. 28), as is evident from the velvet tonality of early impressions of the first state of the *Landscape with three cottages* (Cat. No. 32). The same applies to his portraits from the middle of the 1650s (B. 274, 275), with the exception of the 'sketchy' *Portrait of Clement de Jonghe* (Cat. No. 30). Rembrandt's triumphant masterpieces of the 1650s are the two large religious illustrations, *The Three Crosses* of 1653 (Cat. No. 35) and the *Ecce Homo* of 1655 (Cat. No. 38). Both are done in drypoint—although other techniques are evident in the former—and apparently without using bitten lines to provide a rough guide. The soft, velvety tonality of the drypoint burr is

particularly effective in the *Ecce Homo*, especially in the early impressions of the first state printed on Japanese paper (Fig. 9).

The 1650s can be termed Rembrandt's 'experimental phase', with the actual process of printing assuming an even greater importance. Either by leaving the ink on the plate, or by wiping it so that only a film of ink remains, Rembrandt achieved a surface tone somewhat like a wash. This not only affected the actual appearance of the impression, but had the further advantage of making each impression unique. The effect created by surface tone is comparable with that produced by monotype, or single print. This technique, invented by Giovanni Benedetto Castiglione in the 1640s, requires the artist to draw his design directly in the inked plate before running it through the press. Understandably, scratched or bitten lines play no part in this process. The most extreme example of Rembrandt employing surface tone can be seen in *The Three Crosses* (Cat. No. 35): in the first, second and fourth states the crucified figure of Christ is bathed in light, otherwise he is submerged with his fellow suffers in a uniformly dark surface tone.[24] Moreover, Rembrandt consciously used the condition of the plate to create surface texture by retaining the scratches and stains which occur when the plate is wiped or incorrectly bitten. The sky of many of his landscapes, including *The Goldweigher's Field*, *St Jerome* and the *Landscape with the three cottages* (Cats. Nos 28, 31 & 32 respectively), is marked by such irregularities.

The type of paper used played an ever increasing role for the overall appearance of the impression. In addition to the common white hand-made paper of Europe, Rembrandt used paper from the Far East which was imported through the port of Amsterdam. Paper from Japan and China was luxurious and expensive, thin and absorbent, and its ivory-yellow or light grey tone produced a warm, soft effect. Such paper was particularly well-suited as it softened the otherwise hard contrast between bitten and scratched lines, as the impressions of *The Landscape with the Goldweigher's Field* (Cat. No. 28) exemplify. The majority of the first and second state impressions of the *Hundred Guilder Print* (Cat. No. 27) owe at least part of their atmospheric effect to having been printed on Japanese or Chinese paper. Far Eastern paper was also used for quite a large number of impressions of the *Ecce Homo* (Cat. No. 38). Not quite so common are prints on thick, grey oatmeal (cartridge) paper, which also produces an interesting surface texture. Rembrandt sometimes used vellum (Cat. No. 35), but this was expensive and not very suitable as it

10: Rembrandt, *Portrait of a bald man.*
Amsterdam, Rijksprentenkabinet.

11: Rembrandt, *Portrait of a bald man.*
Amsterdam, Rijksprentenkabinet.

soaked up a lot of colour, made lines appear fuzzy and, because it tended to run, produced almost completely black areas.

An important aspect of Rembrandt's graphic art is his reworking of his plates. In the beginning, such changes were frequently just corrections to unimportant details, as in *The Artist's Mother* (Cat. No. 4) and *The Fall of Man* (Cat. No. 11). It is unfortunately not always possible to establish—and the existing catalogues are not very precise—the role of the different states of a plate in the evolution of a design. To take the example of first-state impressions: is one dealing with a finished design even when alterations follow, or with a trial proof; that is, an impression taken by the artist from the unfinished plate so that he can establish whether further work is required? Obvious mistakes and the number of extant impressions could in a number of cases help clarify the problem.[25] Only two impressions of the first state of *The Annunciation to the Shepherds* (Cat. No. 9) exist, and both of these are trial proofs. The first state of the *Self-portrait drawing at a window* (Cat. No. 25) could be a trial proof, even though a relatively large number of impressions exist. The case of *The Pancake Woman* (Cat. No. 10) is more complex: the two known impressions of the first state show the principal figure unfinished, yet both are signed and dated—a fact which could understandably be interpreted as confirmation that Rembrandt had completed his work on the plate. This may indeed have been the situation, and only after a number of impressions had been made did he reconsider the result and return to the plate—an approach which is also evident in other prints.

From 1647/50, or the start of Rembrandt's 'experimental phase', a more radical reworking of his plates involving changes to the original design can be observed (Cat. No. 35, 38). The most drastic alteration in the history of prints was made by Rembrandt to his two large illustrations of the Passion from the middle of the 1650s. The fourth state of *The Three Crosses* (Cat. No. 35) differs from the preceeding ones to such an extent that one can speak of a new pictorial variation which condenses and dramatises the original composition. Less far reaching are the alterations to the plate of the *Ecce Homo* (Cat. No. 38).[26]

No other artist in the history of print-making reworked his plates as frequently as Rembrandt. Rare states were highly prized by collectors from the start. Rembrandt himself possessed a number of 'proefdrukken' or trial proofs of engravings after Rubens and Jacob Jordaens.[27] The famous collection amassed from about 1670 by Jan

Pietersz. Zomer (1641–1724) contained, according to the catalogue published in 1720, all of Rembrandt's etchings in different states.[28] At that time, connoisseurs collected prints according to the quality of the impressions and the paper, as well as for their rarity. Arnold Houbraken, discussing Rembrandt in his *Groote Schouburgh* (1718), wrote: 'This manner [of producing different states] brought him great fame and not a small profit; especially his art of making slight changes and unimportant additions to his prints so that they be sold anew. Indeed, the tendency at this time was such that no one could call himself a connoisseur who did not possess Juno with and without a crown, Joseph with a light and dark face, and others of the same kind'.[29] Basically, he sees in the frequent reworking of the plates a good business sense. It is, however, wrong to imagine that pure market-strategy lay behind Rembrandt's working methods and artistic intentions.[30] Houbraken's story is not unlike those recorded by other writers on art, such as Gersaint's tale of Rembrandt fabricating the auction of his estate for financial gain: they all belong to the myth that Rembrandt was avaricious.[31] But Houbraken's text does contain a grain of truth, for at the same time as connoisseurs awoke to the desirability of such prints as visual documentation of the intellectual creative process it became interesting for artists to produce so many different states; Rembrandt, it could be said, both created and satisfied the demand.

The fact that alterations to the plates could play an important role in the evolution of a design indicates that Rembrandt may have frequently drawn his composition directly in the thin layer of ground covering the plate without first making preparatory studies; in exceptional cases he may have even scratched the design directly into the plate itself.[32] This may also account for the presence in some etchings of parts of older and abandoned designs which Rembrandt did not bother to burnish out—possibly because bizarre 'capricci' appealed to him. Such prints include the *Landscape with three trees* (Cat. No. 19) and *The Virgin and Child in the clouds* (B. 61). The latter shows an upside-down head at Mary's feet which may possibly have been the Virgin's face in an earlier version.[33] Rembrandt also employed a method commonly used by engravers, including Hendrick Goltzius, which involved using a 'sketch' on the plate as the basis for the composition. The few extant trial proofs, such as those for *The Annunciation to the Shepherds* (Cat. No. 9) and the *Portrait of a bald-headed man* from

1630 (B. 292), give valuable insights into this process. The first state (Fig. 10) of the latter shows the finished head of the old man, but with the bust only lightly sketched; the second (Fig. 11) shows the bust completely etched-in.

When changes were to be made to an existing plate, Rembrandt frequently tested his ideas on an earlier impression rather than make an extra preparatory sketch. However, he did not always use these corrections. He added his body in black chalk on the second and fourth states of his early *Self-Portrait* of 1631 (B. 7; in London and Paris respectively; Fig. 12), but only in the fifth state did he actually etch it. Rembrandt made corrections on six different impressions of the first state of his *Self-portrait leaning on a stone sill* before finally deciding which was the most suitable for the second state (Cat. No. 13). Comparable alterations can also be seen in the complex evolution of the *Raising of Lazarus* (Cat. No. 7), while corrections on the counterproofs of the portraits of *Jan Cornelisz. Sylvius* (B. 266; London) and *Jan Lutma* (B. 276; Amsterdam) indicate that they may also have served the same purpose.

Although preparatory drawings by Rembrandt for etchings are rare, the extant examples are sufficient in number to permit us to establish their function within the creative process: they served as preparatory sketches for individual features as well as for entire compositions, as studies for single figures and groups, as complete designs and, finally, as an actual model—the latter two naturally in reverse to the etching itself.[34] In many cases Rembrandt probably first sketched a rough outline of the composition, although few such drawings have survived. A sketch in red chalk for the small etching of 1638 showing *Joseph telling his Dreams* (B. 37; Drawings Cat. No. 2) is known.[35] Individual studies of figures were made before or during work on the copperplate. On a sheet of drawings in Leiden, Rembrandt experimented with the pose of Adam and Eve for the etching of *The Fall of Man* (Cat. No. 11), and studies of figures and groups for the *Hundred Guilder Print* have also survived. One can assume that such studies also existed for equally complicated, many-figured compositions such as the *Ecce Homo* (Cat. No. 38) and *The Three Crosses* (Cat. No. 35).

More frequent are pen and wash studies. The principal features of the compositions for *Jan Cornelisz. Sylvius* (Cat. No. 22) and *St Jerome* (Cat. No. 31) were established in such studies, although the finished etchings show minor changes. Only four drawings have survived which were used to transfer the design directly onto the copper-plate. They are drawn in black or red

chalk, and include one for each of the portraits of *The Preacher Cornelis Claesz. Anslo* (Cat. No. 16) and *Jan Six* (Cat. No. 23). The numerous studies for the latter show the care taken by Rembrandt in the preparation of this portrait, but this is an exception.

We know almost nothing about the distribution of Rembrandt's etchings. For a short period during the 1620s he may have been employed, together with Jan Lievens, by the Haarlem publisher Johannes Pietersz. Berendrecht (cf. p. 160). During the early 1630s Rembrandt appears to have attempted to establish a commercial publishing company for reproductive prints modelled on the system devised by Rubens in Antwerp (p. 163). Hendrick Uylenburch, an influential art dealer in Amsterdam and a relative of Rembrandt's wife, Saskia, was involved in the enterprise as he is named as publisher on the third state of *The Descent from the Cross* (B. 81).[36] However, they soon disbanded their association. As all other etchings omit any mention of a publisher,[37] it seems possible that Rembrandt printed them in his own studio; he may even have been responsible for their distribution. Such an assumption is supported by the high standard of the impressions and the frequent reworking of the plates. It seems probable that the majority of Rembrandt's plates were still in his studio during his last years, even though they are not listed in the inventory of 1656.[38] Nevertheless, one cannot exclude the possibility that outside publishers were recruited. Documents relating to a legal battle show that in 1637 Rembrandt sold the plate of *Abraham casting out Hagar and Ishmael* (B. 30) to the Portuguese painter Samuel d'Orta, then a resident of Amsterdam. This transaction probably gave d'Orta the right to make further impressions.[39] If d'Orta was also active as a publisher—as the sale of the plate to him indicates[40]—then the inference is that Rembrandt may have frequently sold plates after he had made a number of impressions for his own use. This is supported by the legal dispute which reveals that Rembrandt was accused of making too many impressions for himself, contrary to his agreement with d'Orta. In individual cases the plates may have passed to the person who commissioned the etching, particularly if it involved a portrait (Cat. No. 23).

Only much later does a publisher again enter the scene. It is unclear whether Rembrandt actually worked for Clement de Jonghe (Cat. No. 30). It was probably only after Rembrandt was declared insolvent in 1656 that De Jonghe acquired seventy-four of his plates. Although he

did not add his own name, de Jonghe, who died in 1677, continued to have impressions made from them, even after Rembrandt's death in 1669. These plates, which included *The Fall of Man* (Cat. No. 11), *The Pancake Woman* (Cat. No. 12), *The Hurdy-Gurdy Player and his Family receiving Alms* (Cat. No. 26) and *Faust* (Cat. No. 33), are listed in the 1679 inventory of de Jonghe's estate.[41] They span the different phases of Rembrandt's career, and show that impressions from older works could always be produced if there was a demand. In the eighteenth century, and indeed up to 1906, impressions were made from a number of the extant plates, many of which had been reworked since Rembrandt's day to enliven worn-out areas.[42]

The original number of impressions published in an edition is a matter for conjecture. An estimate can be gauged from the extant impressions, even after taking into account that a number have been lost over the centuries and that not all surviving examples from a plate are known. An etched plate can only produce a certain number of high-quality impressions because the process of printing wears down the etched lines, making them more indistinct with every impression. Approximately one hundred excellent impressions could have been obtained from one of Rembrandt's plates. However, this number sank drastically if drypoint was used because the burr is much more fragile. From such plates Rembrandt may have acquired fifteen to twenty really excellent impressions; a number which is consistant with existing examples. The velvet tonality so characteristic of the technique diminishes with every impression made over and above this number. Unfortunately, it is difficult to tell, especially when the plates have not been reworked by a later hand, whether it was Rembrandt or later owners who produced impressions of poor quality. Light could be shed on this problem by examining the watermarks, as well as by placing greater importance on the actual quality of extant impressions. Moreover, research in the archives in Amsterdam into publishers who might have worked together with Rembrandt could also prove to be rewarding.

When Rembrandt died in 1669 his etchings were to be found in all the famous print collections. The importance of his graphic work was never questioned, even by those late seventeenth- and eighteenth-century classicists who criticised his apparent disregard for the 'rules' of art. In his book on graphic art published in Florence in 1686 Baldinucci praised Rembrandt's 'highly bizarre technique, which he invented for etching and

12: Rembrandt, *Self portrait*.
London, British Museum.

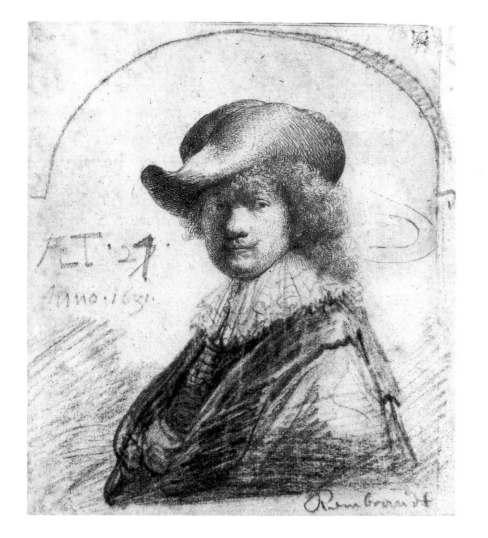

which was his alone, being neither used by others nor seen elsewhere. This he achieved by using lines of varying lengths and irregular strokes, and without outlines, to create a strong *chiaroscuro* of painterly appearance'.[43] Baldinucci emphasised the free and easy manner of Rembrandt's etchings, and it is this which separates them from the systematised appearance of reproductive prints and ensured they maintained an exemplary position until well into the nineteenth century. Of course Rembrandt was not the only artist in the seventeenth century to work in this manner, but he was the only one to apply it so significantly and in such extremes.

The important exhibitions on Rembrandt in Rotterdam and in Amsterdam in 1956 and again in Amsterdam in 1969 completely ignored his etchings. Unfortunately this has not been rectified in recent years, although Rembrandt's paintings and drawings continue to be the subject of much discussion. Such neglect may be the result of an increased interest in the more easily definable reproductive prints which distract attention from Rembrandt's very different 'bizarre' style. Our view of Rembrandt as a painter and draughtsman has been changed both by the work of the Rembrandt Research Project and the publication of numerous catalogues devoted to his drawings.[44] Moreover, because considerable attention has been paid to paintings and drawings by Rembrandt's pupils and followers,[45] it has been possible to make a clearer distinction between these and autograph works by the master. This in turn has furthered our knowledge of studio practice and the method of working favoured by Rembrandt. Unfortunately, his prints have not yet been subjected to a comparable study. The aim of such a study should be twofold: on the one hand, technical aspects relating to questions on states and trial-proofs, the number of impressions which made up an edition as well as the watermarks must be examined, and on the other, a more detailed analysis of the themes and function of Rembrandt's etchings must be undertaken.

1. '. . . perche io ho veduto diverse sue Opere in stampa comparse in queste nostre parti, le quali sono riuscite molto belle, intagliato di buon gusto e fatte di buona maniera . . . et io ingenuamente lo stimo per un gran virtuoso.' Cf. W. Strauss and M. van der Meulen, with the assistance of S. Dudok van Heel and P.J.M de Baar. *The Rembrandt Documents*, (hereafter cited as *Documents*), 1979, p. 457, No. 1660/7.

2. Slive 1953, pp. 27 ff.

3. Cf. *Documents* 1979, p. 519, No. 1662/16.

4. *Documents* 1979, p. 565, No. 1666/7.

5. Cf. e.g. Holl. 1 (*Portrait of Christina of Sweden*) and Holl. 2 (*Portrait of Oliver Cromwell*).

6. Boston 1980–81, p. XXIII and pp. 150 ff., Cat. No. 97.

7. *The Circumcision*, which Gersaint (1751, G. 48) first recognised as entirely autograph, is generally considered to be Rembrandt's earliest etching. However, Hind (1912, No. +388) rejected the sheet. Under no circumstance should the inscription *Rembrant fecit* be taken as absolute proof as this was only added in the second state.

8. B. and Holl. 4, 10; cf. Amsterdam 1988–89, pp. 22 ff.

9. Only a small pen drawing by Lastman from 1613 (Paris, Fondation Custodia) shows comparable lines; cf. Amsterdam 1988–89, pp. 5 ff.; Schatborn 1990, pp. 120 ff., Fig. 5.

10. Bauch 1960, pp. 103 ff.

11. Slatkes 1974, p. 252. On Gerrit Pietersz., see Boston 1980–81, pp. 18 ff.; Holl. 1–6.

12. Among others: B. 6, 175, 298, 314, 337; cf. Hind 1912, pp. 24 ff.

13. This can be seen, for example, from a comparison between the paintings of *Judas returning the Thirty Pieces of Silver* (Corpus A15) and *The Presentation in the Temple* (Corpus A34).

14. It is the *Old Woman reading* (B. 18) after the painting in the Rijksmuseum, Amsterdam (*Corpus A37*); cf. Cat. No. 4, Fig. 4a. The etching is reversed. The other etchings are B. 1, 12 and 13; cf. Bruyn 1982, pp. 35 ff.

15. *Corpus A65 & A89*; Hind 1912, pp. 28 ff; Royalton-Kisch 1984.

16. *Joseph telling his Dreams*, Rijksmuseum, Amsterdam (*Corpus A66*); *John the Baptist preaching*, Gemäldegalerie SMPK, Berlin (*Corpus A106*); cf. Paintings Cat. No. 20.

17. Robinson 1980–81, p. XLIV.

18. The extent to which other etchings, which are generally accepted as by Rembrandt, could in fact be reproductive works by pupils has not as yet been explained satisfactorily, and cannot be dealt with here; some scholars consider the following to fall into that category: *The Good Samaritan* from 1633 (B. 90) and *Jan Uytenbogaert weighing Gold* from 1639 (B. 281). The hatching in the upper part of the etching of *The Artist drawing from a model* (Cat. No. 15) could be by a pupil. See for example, Haden 1877, pp. 34 ff.; Hind 1912, pp. 28 ff.; Royalton-Kisch 1984.

19. Scheller 1969.

20. Cf. Amsterdam 1985–86, pp. 4 ff.

21. Scheller 1969, pp. 128 ff.

22. *Urkunden*, pp. 200 ff., No. 169; *Documents* 1979, pp. 367 ff. No. 1656/12.

23. Cf. Boston 1980–81, pp. XXXIII ff.

24. See the detailed description in London 1969, pp. 18 ff., No. X; Boston/New York 1969–70, pp. 86 ff., No. XIII; Amsterdam 1981, pp. 41 ff.

25. Pure trial-proofs are B. 8 I, 44 I, 77 I (van Vliet), 222 I, 281 I, 292 I, 340 I and II, 354 I.

26. On this cf. Boston/New York 1969–70, pp. 101 ff., No. XIV.

27. *Urkunden*, p. 203, no. 169; *Documents*, p. 375, No. 1656/12; Robinson 1980–81, p. XLIII.

28. Robinson 1980–81, p. XL.

29. 'Dit doen bragt hem grooten roem en niet min voordeel by: inzonderheid ook het kunsje van lichte verandering, of kleine en geringe byvoegzelen, die hy aan zyne printjes maakte, waar door dezelve andermaal op nieuw verkogt werden. Ja de drift was in dien tyd zoo groot dat zulke luiden, die het Junootje met en zonder 't kroontje, 't Josephje met het wit en bruine troonitje en diergelyke meer, niet hadden.' Houbraken 1718, p. 271. Significantly, Houbraken follows this with a discussion of Rembrandt's pupils and the income they generated.

30. Alpers 1989, pp. 242 ff.

31. Gersaint 1751, pp. XXVIII–XXIX; Kris/Kurz 1980, p. 145.

32. See B. 107, 192 and 222 for sketches in drypoint. On B. 192, cf. Cat. No. 15.

33. Cf. Campbell 1980, pp. 10 ff.

34. Cf. Schatborn 1986, pp. 1 ff.

35. See Giltaij 1990.

36. In the fourth state the address was changed to that of Justus Danckers, who worked in Amsterdam during the 1680s.

37. An exception is the fifth state of *The Three Crosses* (Cat. No. 35); it bears the address of Frans Carelse.

38. Strauss 1983, pp. 261 ff.

39. *Documents*, p. 145, 1637/7; Amsterdam 1987–88, pp. 78 ff., nos. 55–56.

40. Plates sometimes found their way into the hands of other artists. A case in point is that of a plate by Hercules Seghers which was in Rembrandt's possession and which he transformed from a rendering of *Tobias and the Angel* into *The Flight into Egypt* (B. 56); cf. White 1969, pp. 218 ff.

41. De Hoop Scheffer/Boon 1971, pp. 2 ff.

42. A number of De Jonghe's plates were acquired by the Amsterdam collector Pieter de Haan (1723–1766), and later by the French amateur-engraver Claude-Henri Watelet. He owned 81 plates obtained from different sources. These plates were then bought by the French dealer Pierre François Basan, who had new impressions made for his *Recueil*, which was published between 1789 and 1797. The plates, which were in use until 1906, are now in the Museum of Raleigh, North Carolina. Cf. Hind 1912, pp. 16 ff., note 2; White 1969, Vol. 1, pp. 11, 19; De Hoop Scheffer/Boon 1971, pp. 2 ff.

43. '. . . fu una bizzarrissima maniera, ch'egli s'inventò, d'intagliare in rame all'aqua forte, ancor questa tutta Sua propria; ne più usato da altri, ne più Veduta, cioè, con certi freghi, e freghetti, e tratti irregolari, e senza dintorno, facendo però risultare dal tutto un chiaro scuro profonda, e di gran forza, ed un gusto pittoresco . . .'; *Urkunden*, pp. 419 ff, No. 360, § 13.

44. Of particular importance are the catalogues of Rembrandt's drawings in Amsterdam and Rotterdam; cf. Schatborn 1985 and Giltaij 1988 respectively. The catalogue of the collection in London by Martin Royalton-Kisch will be published to coincide with the opening of the exhibition in the British Museum. Hans Mielke is preparing the catalogue of the drawings in Berlin.

45. Cf. Sumowski, *Drawings*.

I

Self-portrait in a cap, open mouthed

Etching and burin, 51 × 46 mm; one state
Signed: *RHL 1630.*
B./Holl. 320; H. 32; White pp. 108–9

Berlin: I (36–16)*
Amsterdam: I (O.B. 697)
London: I (1973 U. 769)

Rembrandt, lips parted and eyes open wide, fixes the viewer with his stare. A harsh light from the upper left plays across his face, casting the underside of his cap, forehead and left cheek into deep shadow. The left shoulder across which Rembrandt looks towards the viewer is only cursorily indicated, and the turn of his head increased the impression of spontaneity. The image suggests a 'snapshot' of a face captured in a moment of alarm. In the very small scale of the etching the figure is pushed close to the picture plane thus enhancing its presence.

This print belongs to a group of physiognomic studies. Their varying sizes suggest, however, that the group was not conceived as a series. Rembrandt used his own face as the model from which to observe and record various emotions (Fig. 1a; Cat. No. 2). Even though no preparatory drawing for this etching has survived, other prints in this group were based on drawings.[1] The intention nonetheless, is to give an impression of uninhibited spontaneity, as if the etching had been produced while the artist was looking at his own reflection in a mirror. It is primarily through the nature of the strokes used that this effect is achieved: passages of shadow are not established by even hatching but rather with seemingly arbitrary, unsystematic lines.

Karel van Mander, in his didactic verse treatise of 1604, expressly recommended that painters should study the representation of the passions:

'Gheen Mensch soo standvastich / die mach verwinnen
Soo gantschlijck zijn ghemoedt en swack gheneghen /
Of d'Affecten en passien van binnen
En beroeren hem wel zijn hert' en sinnen /
Dat d'uytwendighe leden mede pleghen /

En laten door een merckelijk beweghen /
Soo in ghestalten / ghedaenten / oft wercken /
Bewijselijcke litteyckenen mercken.
[. . .]
Dees affecten / zijn niet soor gaer en lichte
T'exprimeren / als sy wel zijn te loven /
Eerst met de leden van den aenghesichte /
Thien oft wat meer van diverschen ghesichte /
Als / een voorhooft twee ooghen en daer boven
Twee wijnbrouwen / en daer onder verschoven
Twee wanghen / oock tusschen neus ende kinne
Een twee-lipte mondt / met datter is inne'.[2]

(No man is so steadfast as to be able to master his emotions and weaknesses completely, or to reach a point where the stirrings of passion do not touch his heart and his mind. The visible parts of the body work in concert so that either through a clear movement of the whole figure, or in the face or through the gestures, one can make out clear signs of that which is felt within [. . .] These passions are not at all so easy to represent as they are claimed to be, and this is above all the case with the various parts of the face; for here we find ten or more different aspects, such as the forehead, two eyes and above them two eyebrows, and squeezed in beneath them two cheeks, and between the nose and the chin a mouth with two lips and all that is inside them.)

Rembrandt studied such emotions in his own face. His intention was evidently to achieve an authentic representation of his own facial expressions. Samuel van Hoogstraten, a pupil of Rembrandt, wrote in 1678: 'Dezelve baet zalmen ook in't uitbeelden van diens hartstochten, die gy voorhebt, bevinden, voornaemlijk vor een spiegel om tegelijk vertooner en aenschouwer te zijn'.[3] (The same benefit can also be derived from the depiction of your own passions, at best in front of a mirror, where you are simultaneously both, the repres: er and the represented.)

The purpose of this exercise seems to have been not only to record the artist's own face and its expressions, but also to assemble a repertoire of emotions for use in the composition of history paintings. Even the earliest among Rembrandt's painted self-portraits seem intended as models for various facial expressions and effects of *chiaroscuro*.[4] Rembrandt's face occurs, for example, among the figures in *The stoning of Saint Stephen* in Lyon[5] and in the unidentified historical scene in Leiden.[6] Even the protagonist in *Samson threathing his Father-in-law* (Berlin),[7] a painting from the Amsterdam period, has a physiognomy similar to that of the artist, where it conveys rage through its frowning brow,

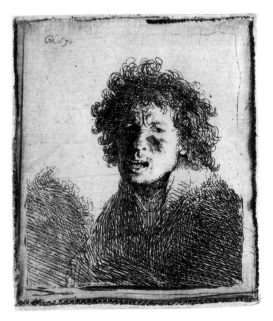

1a: Rembrandt, *Self-portrait.*
Berlin, Kupferstichkabinett SMPK.

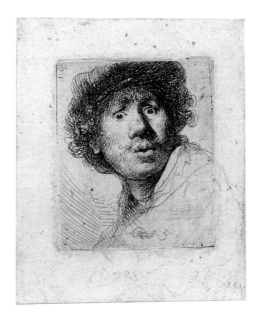

squinting eyes and open, cursing mouth. As this work is clearly not intended to allude to events in Rembrandt's own life, it is a persuasive example of the artist's attempt for an authentic and not merely formulaic rendering of emotion. Rembrandt's early etchings, clearly intended for sale, are the first record of his study of passions from the live model.

The etching exists in one state only. The earliest impressions, for example in London, reveal uneven plate edges, which were later smoothed down.[8] Although the plate was almost entirely bitten, in some areas further work was added in burin.[9] Rembrandt seems, for example, to have strengthened and made more precise the shadows on the left cheek and on the neck through the subsequent addition of several lines.[10]

B.W.

1. Amsterdam, Benesch 54; Schatborn 1985, No. 1 is possibly a preparatory drawing for B. 338; see also the drawing Benesch 53 in London.
2. Karel van Mander (1916), pp. 134–37.
3. Hoogstraten 1678, p. 110.
4. Amsterdam (*Corpus* A14); The Hague (*Corpus* A21); Munich (*Corpus* A19). See Bruyn 1983, pp. 57–58 and Raupp 1984, pp. 250–55.
5. *Corpus* A1.
6. *Corpus* A6.
7. *Corpus* A109.
8. Münz (11) refers to two states.
9. Not described in Hollstein.
10. The Berlin proof shows slight additions in black chalk, probably by a later hand, that extend the torso beyond the plate mark and add background shadow at the right.

2

Self-portrait, frowning

Etching, I: 75 × 75 mm; from II: 72 × 60 mm; 4 states (3 according to Hollstein)
Signed and dated: (in I only): *RHL. 1630*
B./Holl. 10; H. 30; White p. 108

Berlin: IIa (6–16)*
Amsterdam: I (O.B. 20)
London: I (1925–6–15–23); II (1843–6–7–5); III (1973 U. 765)

'Op 't voorhooft (welck de Heidensche
 geslachten
Genius toewijdden) segg' ick / behoeven
Wy te letten / nadien 't eenighe achten
De Siel-wroeger / en 't aenschijn der
 gedachten /
Iae 't Boeck des herten / om lesen en proeven
Des menschen gemoet: want kreucken en
 groeven
Daer bewijsen / dat in ons is verborgen
Eenen bedroefden geest / benout / vol sorgen.
Ia 't voorhooft gelijckt wel de lucht en 't
 weder /
Daer somtijts veel droeve wolcken in waeyen /
Als 't hert is belast met swaerheyt t'onvreder'.[1]

(It is my view that we should pay attention to the forehead which, according to the Ancients, was the seat of genius and which some held to be able to reveal the secrets of the soul, and to be the visage of thought and even the book of the heart, in which human passions could be detected and tested: for its folds and dimples show that within us is hidden a distressed and troubled spirit. Indeed, at times when the heart is burdened with melancholy and discord, the forehead resembles the turbulent air crowded with dark clouds.)[1]

This etched self-portrait with an angry expression also dates from 1630 (see Cat. No. 1). Presenting himself half-length, Rembrandt again uses the turned head looking across the left shoulder to establish both spatial depth and spontaneity. The tousled hair and heavily shaded torso add force to the figure's scowling expression, while the frontally-viewed head provides a certain monumentality. Characteristic here is the harsh and steeply slanted light that contrasts brightest illumination with deepest shadow. The shading makes the face appear asymmetric and so reiterates, with the nervous and wilful use of line, an impression of grim defensiveness. The zig-zag outlines of the fur coat are typical of work from Rembrandt's Leiden period.

No preparatory drawings have survived, as is the case with Cat. No. 1. The etching, however, is known in several states which document the work-process. In addition to those cited in the literature, there is a state (IIa) in Berlin not previously described. After Rembrandt had reduced the size of the plate to print state II, he added a second shoulder outline and a broader collar, as an experiment, in state IIa. In state III, both of these correction have been removed. While in state I, apparently by mistake, several white patches remain,[2] in state II these are filled in and state IIa was produced after this correction.

B.W.

1. Karel van Mander (1916), p. 147.
2. Not described in Hollstein.

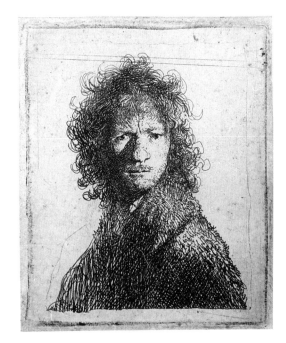

3

Beggar with a wooden leg (The Peg-leg)

Etching, I: 114 × 66 mm; II: 112 × 66 mm;
2 states. c. 1630
B./Holl. 179; H. 12

Berlin: I (266–16)
Amsterdam: I (O. B. 419)*
London: II (1973 U. 743)

3a: Rembrandt, *Seated Beggar*.
Berlin, Kupferstichkabinett SMPK.

3b: Jacques Callot, *The Beggar with the wooden leg*.
Berlin, Kupferstichkabinett SMPK.

During his Leiden period, between about 1628 and 1631, Rembrandt was especially preoccupied with the subject of the beggar. His numerous beggar etchings are usually small in scale and show the subjects as isolated figures with no precise indication of setting.[1] These etchings seem to be intended as individual sheets, not as part of a series of the kind that was usual in the traditional depiction of beggars.

The Peg-leg shows an old man, dressed in rags, with a wooden leg and a pair of crutches; his left arm is in a sling. His bristly face lies in shadow and its details are difficult to distinguish: his eyes appear to lie in deep hollows, his mouth is open as if shouting. To judge by its style and etching technique, the print dates from about 1630, from the same time as the *Seated Beggar* dated 1630 (Fig. 3a), which it also matches in size and use of line and which was perhaps conceived as a pendant to *The Peg-leg*.[2] In both the style and the subject of this work, the young Rembrandt was inspired by Jacques Callot's famous beggar series *Les Gueux* (1621–22; Fig. 3b).[3] The influence of Callot, recognised by Gersaint in 1751,[4] is clear in the treatment of light and the contrast between bright and heavily-shaded areas, and also in the use of line—in particular the use of long, vertical strokes to model the figure. The same stylistic characteristics are to be found in Rembrandt's chalk studies of standing male figures from about 1629–30 (see Drawings Cat. No. 1).

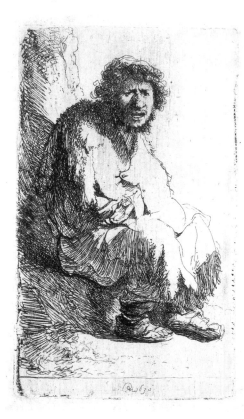

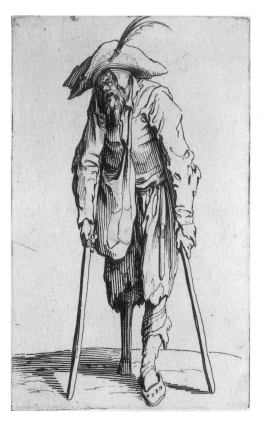

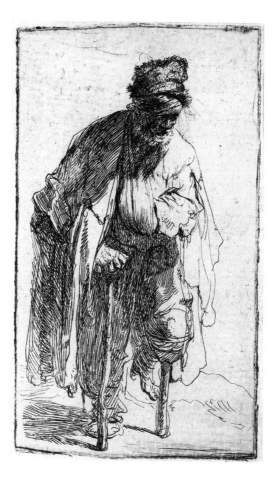

Images of beggars may be traced back to medieval examples; in late fifteenth- and sixteenth-century German and Netherlandish prints the subject is frequently treated in a complete series of images. The prevailing attitude of scorn and condemnation of the poverty that beggars brought upon themselves persisted into the seventeenth century. Thus, the ragged figures in the etched beggar series of Jan Joris van Vliet (1632)— who was a member of Rembrandt's Leiden circle—were presented as caricatures, open to ridicule and disparagement.[5] Like Rembrandt, Van Vliet included in his series a beggar with crutches and a wooden leg (Fig. 3c). Scholars have responded in various ways to the question of how far Rembrandt's early etchings are to be understood in this sense, i.e. with a moralising and derisive attitude towards beggars.[6]

Rembrandt's *Peg-leg* shows a bogus cripple. He has tied on a wooden leg to arouse pity: his own leg has not been amputated but only bent back. This motif is to be found in Sebastian Brant's *Narrenschiff* (Ship of Fools) (1494).[7] A satirical inscription on a print after Pieter Breughel (about 1560), showing a whole group of beggars, censures bogus cripples that only go begging out of laziness.[8] In his *Zede-printen* (descriptions of Customs) (1623–24) Rembrandt's friend Constantijn Huygens casts scorn on beggars who, among other lazy tricks, try to arouse pity by displaying their peg-legs and crutches: 'Then he points to his peg-leg, then he beats on the ground with his crutches and, out of pity, you reach for your purse.'[9]

It is probable that Rembrandt's contemporaries would have received his own beggar images such as *The Peg-leg* in essentially the same spirit. It appears, however, that Rembrandt's interest in beggars and vagabonds was determined by the fascination that these figures had exerted on him at the start of his career. They offered him a chance to study emotions in a way comparable to his etched self-portraits of the same period (Cat. No. 1 & 2). Etchings such as the *Peg-leg* and the *Seated Beggar* employ the same method of using gestures and facial expression to record the sort of states of mood that Constantin Huygens had so greatly admired in the figure of Judas in Rembrandt's painting *Judas returning the Pieces of Silver* (1629).[10] Both Rembrandt's beggar images seem to embody the feeling of despair and anger, conveyed in the open-mouthed shriek. The moralistically devaluing tendency of contemporary beggar series is subordinate in Rembrandt's images to a sober depiction of revealed emotion. His attitude towards beggars seems to be imbued with the Lutheran idea that 'We are beggars on earth (as Christ

Himself was)'.[11] It is surely significant that Rembrandt twice etched the scene of *Peter and John healing the Cripple at the Doors of the Temple*, in about 1629 and in 1659.[12] Here the concern with beggars is united with another subject often treated by the artist: the Prodigal Son. Both of these stress the inherently sinful nature of man, insisting that man is destined to sin and then to be forgiven.[13]

The two states of *The Peg-leg* differ only in their size; in state II the plate has been slightly reduced.

H.B.

1. B. 138, 150, 160, 162–167, 171, 173–175, 179, 183; on this, see also Bauch 1960, pp. 152 ff. In the case of the etchings and the drawings it is not always clear whether real beggars or, rather, merely simple people from the poorest class are shown; see Schatborn 1985, p. 10, Cat. Nos 2–4.
2. B. 174. The *Seated Beggar* has mostly been interpreted as a self-portrait, but it is by no means certain that this is correct; see, most recently, Held 1984, pp. 32–33.
3. Lieure 1924, Nos. 479–503.
4. Gersaint 1751, p. 143, No. 172.
5. B. 73–82, especially B.74.
6. Stratton, for example, stresses the satirical, moralising intention of the early beggar images (Stratton 1986). Held and Baldwin, on the other hand, conclude that Rembrandt had a positive view of beggars: Held believes that the sympathetic presentation of beggars is above all to be understood as a motif adopted for personal and psychological reasons (Held 1984), while Baldwin interprets the sympathetic treatment of the subject in Rembrandt's work in a religious light as a parable of man who, following Christ, is a beggar on earth (Baldwin 1985).
7. See Braunschweig 1978, p. 134.
8. Holl. 34.
9. Huygens 1623–24, p. 212. 'Dan maent hij met een stomp, dan slaet hij met twee krucken,
En doet medoogentheit den neck ter borse bucken'.
10. Tümpel 1977, p. 33; Baldwin 1985, p. 122.
11. Baldwin 1985.
12. B. 95, 94.
13. On this point, see Held 1984.

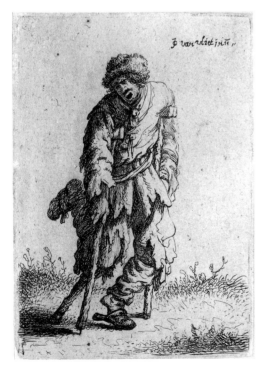

3c: Jan Joris van Vliet, *The Beggar with the wooden leg*. Berlin, Kupferstichkabinett SMPK.

4

The Artist's Mother

Etching, 149 × 131 mm; 3 states
Signed: *RHL. f*; c. 1631
B./Holl. 343; H. 52; White, p. 112

Berlin: II (426–16)
Amsterdam: II (62–116)*
London: II (1973 U. 786)

There is no documentary evidence that this
print really shows Rembrandt's mother.
In Clement de Jonghe's inventory the print
is cited with this title,[1] and the fact that the
same old woman appears in several etchings
(e.g. Introduction, Fig. 1) and paintings seems
to prove this identification.[2] Just as
Rembrandt's early etched self-portraits were a
means of capturing the expression of mood (see
Cat. 1 & 2), Rembrandt's mother was a model
from which the young artist might study the
physiognomy and form of old women.
This seems to be the only explanation for the
reproduction of a 'role portrait' in the form of
a print. Gerard Dou, who from 1628 to 1631
worked in Rembrandt's studio, also used his
teacher's mother as a model, and in 1631 Jan
Joris van Vliet published a print after
Rembrandt's *Reading Prophetess* which has his
mother's facial features (Fig. 4a).[3]

Neeltgen Willemsdochter van Zuytbroeck, a
baker's daughter, had nine children, the eighth

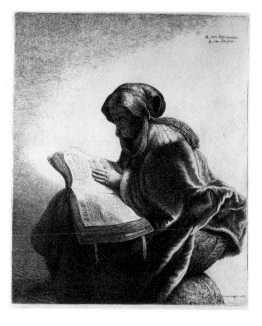

4a: Jan Joris van Vliet, *Reading Prophetess*.
Berlin, Kupferstichkabinett SMPK.

of these being Rembrandt; she died in 1640. Rembrandt shows the old woman in half-figure turned to the right, with folded hands, sitting in a chair that is drawn up to a table. Her head-dress, her fur-trimmed cape, her wrinkled face, and folded hands are painstakingly recorded. Rembrandt's mother appears again in a comparable manner, though without the table, in the 1631 etching B. 348, and the similarity between the two works suggests that they were made at the same date. Two small head studies, however, show a much closer view of Rembrandt's mother.[4] Her portrait in the chair seems more distanced, as Rembrandt here employed the half-length presentation frequently used for official portraits in the seventeenth century. In spite of a certain distance, the calm, introspective image of the artist's mother conveys the young man's respect for the old, and for their noble air of resignation, in a way which may be compared to Dürer's chalk portrait of his aged mother.[5]

A copper engraving by Hendrick Goltzius showing an older woman—perhaps his step-mother, Agathe Scholiers—in a comparable pose at a table might have been the model for Rembrandt (Fig. 4b).[6]

Rembrandt's plate seems to have been etched in two workings, the first showing the mother and, after that, the table; for the outlines of her skirt are still visible beneath the hatched lines of the table. The three states differ from each other only slightly: in the thickness of the hatching on the left below the artist's monogram. In the example of state II in Amsterdam, grey pen additions in Rembrandt's hand are to be seen on the foremost corner of the arm of the chair below the sitter's arm.

H.B.

1. *Urkunden*, No. 346, item 10; 'Rembrandt's moeder'; De Hoop Scheffer/Boon 1971, pp. 6, 14.
2. Etchings B. 343–44, 348, 351–52 and 354 (Introduction, Fig. 1); paintings Bredius/Gerson 63–71. *Corpus* A27, A32, A37.
3. On Dou, see Sumowski 1983, Vol. I, pp. 525 ff., No. 245 (Amsterdam, Rijksmuseum), No. 253 (Berlin, Gemäldegalerie SMPK). The model for Van Vliet's etching is in the Rijksmuseum, Amsterdam; *Corpus* A37; B. 18.
4. B. 351–52.
5. Anzelewsky/Mielke 1984, pp. 82–83, No. 79.
6. B. 210; Holl. 225.

4b: Hendrik Goltzius, *Portrait of an old woman.* Berlin, Kupferstichkabinett SMPK.

Damnosa quid non imminuit dies:
Ætas parentum peior auis, tulit
Nos nequiores: mox daturos
Progeniem vitfiorem.

5

Sheet of sketches with a self-portrait

Etching, I: 101 × 114 mm; II: 100 × 105 mm;
2 states; c. 1631
B./Holl. 363; H. 90

Berlin: II (485–16)
Amsterdam: I (O.B. 764)*
London: I (1848–9–4–187)

Etched sheets of sketches with individual figures and heads are a special case among Rembrandt's prints.[1] One of the earliest examples of this type shows studies of the figures and heads of old men and beggars as well as a portrait of the artist. The figures are distributed across the sheet as if there were no connection between them, facing various directions; Rembrandt's portrait, viewed in a mirror and thus shown frontally, is towards the top right corner. The passages left blank which cut into the dark hair and the shaded eye area show that the head was originally intended to be covered by a broad-brimmed hat.[2] The similarity between this print and another etched self-portrait of 1631 suggests that the sheet of studies was made in the same year (Introduction, Fig. 12).[3]

The impression of a freely executed sheet with sketches from life comes not only from the fragmentary and dissimilar figures, but also from the extensive scratching and experimental strokes and—in state I—the large acid spots, which seem to be traces of unskillful, speedy work on the plate. Studies after whole figures and parts of the body were a traditional method of practice for the draughtsman. They served not only for the preparation of a particular scene, but could also be used as occasion demanded, in the tradition of pattern books for a variety of compositions. A fine, albeit rare, example of this type from among Rembrandt's drawings is the *Sheet with nine studies of heads and figures* in Birmingham (see Drawings Cat. No. 8).[4]

Engraved or etched scenes with detailed studies of this type were to be found in drawing instruction manuals from the baroque period; budding artists carried out their first exercises in drawing by following these examples.[5] However, in contrast to Rembrandt's etching, which brings together disparate motifs

as if by chance, engraved model sheets in instruction manuals usually show similar figures or motifs in various arrangements—the same head, for example, seen from various angles. It is possible that Rembrandt had intended a number of etchings made in the 1630s and 1640s—*The Walking Frame* (see Cat. No. 21), *The Artist drawing from the Model* (see Cat. No. 15), as well as study sheets with heads (see Cat. No. 12)—for a drawing instruction manual.[6] It seems improbable, however, that the young artist had already conceived this plan at the beginning of the 1630s.

Rembrandt's etched sheets of studies should, rather, be seen in terms of the tradition of drawn study sheets, in which an apparently chance collection of disparate figures and motifs was intentional. Jacques de Gheyn, with whose work Rembrandt was familiar, produced drawings of this kind which have survived: these seek to emulate the appeal of sheets of studies or sketches made from life, and this itself becomes the real 'subject' of such works.[7] Rembrandt's etched study sheets were not intended as pattern book models for pupils or workshop assistants; they reproduce, rather, a type of drawing that was highly valued by both art critics and collectors in the seventeenth century as *crabbelinge* or *griffonnement*.[8] That this was the aim here is indicated not only by the carefully contrived grouping of the subjects, but also by the introduction of the irregular, black-printed plate edges as a type of frame for the whole. Nor do the impurities in the plate, such as the experimental strokes, appear to have come about by chance. In a similar way, in a sheet of studies in Rotterdam (Museum Boymans-van Beunigen), Jacques de Gheyn introduced experimental pen lines into his composition, that are apparently not roughly scribbled but deliberately placed (Fig. 5a).[9] Rembrandt's collection of bizarre ideas—which, like the beggars, preoccupied him at the start of the 1630s—must have been carried out as independent works of art for collectors of such *capricci*.

In state II the plate was somewhat reduced in size, and the spots of acid, for example above the artist's head, were erased.

H.B.

1. B. 363, 365–370.
2. This is also revealed in a small drawing dated 1630, in the Louvre, Paris, showing the artist's portrait in a mirror image of the self-portrait in B. 363; see Lugt 1933, p. 18, No. 1149, Plate xxxiii; Bauch 1960, Plate 261, note 132. Bauch classified the drawing as a reversed model for the head on the sheet of studies. Today the attribution to Rembrandt is no longer accepted; and the sheet was not included in the Paris 1988–89 catalogue.
3. B. 7.
4. Benesch 340.
5. Bolten 1985; Dickel 1987.
6. Emmens 1968, pp. 157 ff.; Bruyn 1983, pp. 57 ff.
7. Van Regteren Altena 1935, pp. 46 ff.; Bruyn 1983, p. 55.
8. Held 1963, p. 89. Both terms signify a rough sketch, scrawl or scribble.
9. Van Regteren Altena 1983, Vol. II, No. 772, Vol. III, Plate 359.

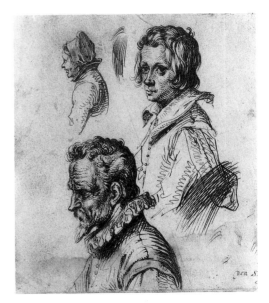

5a: Jacques de Gheyn, *Sheet of studies*. Drawing. Rotterdam, Museum Boymans-van Beuningen.

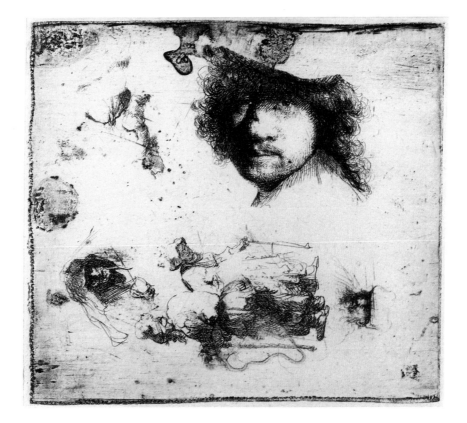

6

Seated female Nude

Etching, 177 × 160 mm; 2 states
Signed: *RHL.* c. 1631
B./Holl. 198; H. 43; White pp. 172–73

Berlin: II (288–16)*
Amsterdam: I (61: 1108)
London: II (1843–6–7–126)

6a: Wenzel Hollar, *Seated female nude.*
Berlin, Kupferstichkabinett SMPK.

'He chose no Greek Venus as his model, but
rather a washerwoman or a treader of peat from
the barn, and called this whim "imitation of
nature". Everything else to him was idle
ornament. Flabby breast, ill-shaped hands, nay,
the traces of lacings of the corsets on the
stomach, of the garters on the legs must be
visible if nature was to get her due. This is *his*
nature which would stand no rules. No
principle of proportion in the human body.'[1]
This unambiguous condemnation, drawing on
the classicist aesthetic norms of the late
seventeenth and early eighteenth centuries, is
in marked contrast to the appreciation for this
etching registered at the time of its creation, as
shown by the copy of it made as early as 1635
by Wenzel Hollar (Fig. 6a).[2]

The *Seated female Nude*, together with two
other prints which also may date from 1631,[3]
record Rembrandt's earliest preoccupation with
the nude in his etched œuvre. Rembrandt
shows the woman sitting sideways on a mound
but with her torso turned towards the viewer.
The shapes formed by the female body are
recorded with great realism, as in the case of
the folds of skin caused by the twist of the
torso. The figure is lit from the right, and the
gradations of light and shaded flesh give the
etching its sensual allure. The woman looks
intently at the viewer, but her eyes remain in
shadow. The subtle tension established
between the lighting and this direct stare, also
a quality of Rembrandt's early self-portraits,
gives the image its distinctive stamp.

While the early etching *Jupiter and Antiope*
(Fig. 40a) depicts a mythological subject and
thus belongs to the realm of *historia*, the other
two show single figures. The subject of one of
these has been identified: *Diana at the bath* (Fig.
6b). Our print, however, has until now only
been given titles such as *Naked Woman seated on
a mound* or, even more simply, *Seated female
Nude*. In this way, albeit not explicitly, it has
come to be understood as having no subject.
It is possible that this impression may have
been encouraged by the loosely-structured
composition of the print, in which Rembrandt
makes a draughtsman's use of the blank sheet.
The brightly lit area of the drapery is conveyed
with only a few cursory strokes. The work is
distinct in this respect from the more pictorial
construction and carefully considered back-
ground of the Diana etching. The current title
is only a slight modification of that adopted by
Gersaint in his catalogue raisonné of 1751—
'*femme nue*'.[4] Gersaint, admittedly, also treated
other, now thematically identified etchings,
such as the *Diana*, as '*femmes nues*', including
these under the heading '*Sujets libres, Figures
nues, & Figures académiques.*'

Rembrandt's female nude sits on raised ground which it is not possible to define more precisely,[5] though several sprigs of leaves indicate an outdoor setting. In this respect the work is fundamentally distinct from Rembrandt's drawings and etchings of the 1640s in which male nudes are clearly presented as studio models.[6] This etching is linked with *Diana at the bath* not only through the almost identical dimensions—a plate size that Rembrandt appears to have used only for these two etchings. Furthermore, the two female figures are seated on their drapery with complementary turns of the torso, each rests one arm on a higher level of the bank, and each gazes directly at the viewer. Diana, however, protectively turns her body away from the viewer—for mortals were forbidden to gaze on her.[7] In the case of the present etching one would, then, be less likely to think perhaps of an Old Testament subject such as that of Susanna or Bathsheba—a model of chastity or a moral exemplar—than of a figure from classical mythology, even perhaps the figure of a nymph from among Diana's maidens. It is unlikely that we will be able to determine how far the two etchings were intended to be seen as a pair. Wenzel Hollar, in any case, made a copy of only one of them. The omission of unambiguous thematic references—in the case of the Diana too these are also more clearly defined in the preparatory drawing than in the completed etching—might have been understood by Rembrandt's contemporaries as having been removed from its traditional iconographic context.[8] If not the specific subject itself, then certainly its thematic associations, would have been immediately obvious to Rembrandt's contemporaries, though not to Gersaint more than a century later. Thus, neither did Wenzel Hollar feel the need to add attributes to the figure in his own copy.

In contrast to the *Diana*, which was preceded by a detailed preparatory drawing[9] and, after tracing, executed in a relatively schematic manner, the etching in question impresses by its freer use of line. A clear contour, for example, is only found where light and shade meet each other directly, as on the woman's stomach. In other areas several outlines are set alongside each other and then rendered less distinct through the use of hatching running across them. In the region of the eyes, for example, planes which are not defined by an outline are filled in with hatching, which is used to create shadow, and is drawn right across the shapes. Within areas of shadow the forms are made less distinct at the edges. A systematic use of cross-hatching is eschewed,

in contrast to the procedure in the *Diana* etching.[10]

In view of this approach it is not surprising that preparatory drawings have survived.[11] The differences to be detected between the two states of the etching are not in the composition, but entirely in the lighting. In state II new areas of shading are introduced. Certain individual passages of shadow in state I, for example on the woman's right foot, are burnished out, in order more effectively to contrast light and shade. Both the detailed *modello* and the pictorial composition of the *Diana* etching could well indicate a commissioned work. One is tempted to assume that Rembrandt later produced a second composition of a nude, mythological subject which was freer in every respect. As indicated by the copy made only a few years later by Wenzel Hollar, Rembrandt's contemporaries fully appreciated this version.

B.W.

1. A. Pels, *Gebruik en misbruik des toneels*, Amsterdam, 1681, pp. 35–36.
2. B. 603.
3. B. 201, B. 204.
4. G. 190.
5. The literature follows Gersaint in speaking exclusively of a mound, even though the etching itself fails to define the setting fully.
6. See Cat. No. 21.
7. On the myth and its presentation as a painted *historia* in Rembrandt's œuvre, see Paintings Cat. No. 16.
8. The concept of '*Herauslösung*' was introduced by Tümpel (1969) in his enquiry into the iconography of Rembrandt's biblical narratives.
9. Benesch 21; London, British Museum.
10. It is possible that in the case of the *Diana* one should once more consider the collaboration of studio assistants in the production of the etching. On this point, though not with regard to this etching, see Royalton-Kisch, 1984.
11. On questions in this area, see the discussion in Cat. No. 39, and also the ones regarding other etchings.

6b: Rembrandt, *Diana at the bath*. Berlin, Kupferstichkabinett SMPK.

7

The Raising of Lazarus

Etching and burin, 366 × 258 mm; 10 states
Signed: *RHL van Ryn* (I–IV), *RHL van Ryn f.*
(V–X). c. 1632
B./Holl. 73; H. 96; White pp. 29–33

Berlin: V (314–1893) and VIII (132–16)*
Amsterdam: III (O.B. 595) and VIII (O.B. 597)
London: IX (1973 U. 823)

7a: Jan Lievens, *The Raising of Lazarus*.
Brighton City Art Gallery.

7b: Rembrandt, *The Raising of Lazarus*.
Los Angeles, County Museum of Art.

With a impressive gesture, Christ summons the
dead Lazarus back to life. In the first stirrings
of his resurrection, Lazarus struggles to sit up
in his grave. The onlookers react with surprise
and alarm.[1] The etching, which dates from
about 1632, is the largest made by Rembrandt
up till that date; and it surpasses his earlier
etched works in both emotion and baroque
theatricality. It is the first of a series of prints
in which Rembrandt—probably in daring
competition with the work of Rubens—lays
claim, through the use of a large scale, to the
status of a painted representation of the
subject. This aim is also suggested by the
introduction of a black frame. While other
prints by Rembrandt, such as the *Ecce Homo*
(Fig. 38b) and *The Good Samaritan*, are not
universally seen as the work of his own hand,[2]
The Raising of Lazarus has been accepted as an
authentic work. The work-process may be
described as complex in several respects.[3] Not
only is the etching known in a large number of
states, ten in all, but it is also obvious that its
original motivation was to surpass a painted
composition by Jan Lievens (Fig. 7a), which
Rembrandt may even have owned.[4] Like
Lievens, Rembrandt seems to have started on
a painting of the *Raising of Lazarus* (Fig. 7b).[5]
During work on this painting he turned to
treating the subject in the print medium.[6]
While Rembrandt took the principal
arrangement of the composition in his painting
from that adopted by Lievens (though with
decisive modifications in the use of gesture and
thus in the character of the narrative), in his
etching he altered the composition as a whole.
Christ is no longer viewed from the front but,
rather, from behind and in lost profile. Light
streams out from the central area of the

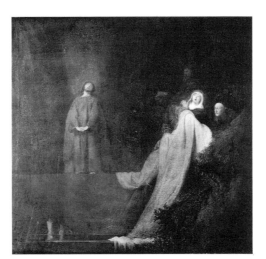

composition, so that the figures of Christ, of the man shrinking away on the left, and of the woman in the right foreground—Martha, the sister of Lazarus—are perceived by the viewer largely as silhouettes. This dramatic illumination reveals Rembrandt's attention to the work of the Utrecht Caravaggists, above all Ter Brugghen.

Research into Rembrandt's painting technique suggests that the picture and the etching are intimately linked in their development. Rembrandt did not produce a reproductive print after his own painting; he evolved, rather, a distinct solution to suit each medium. Although most of Rembrandt's etchings survive in several states, we know of only a few genuine trial proofs printed before the completion of the full composition. Often the various states differ only in the correction of details. In the case of *The Raising of Lazarus*, however, working proofs have survived (they show unsmoothed plate edges, occasional interrupted contours, and spots of etching fluid) dating from a stage before the full composition, in its third state, was satisfactorily established on the plate. Although, from this point, Rembrandt maintained the basic arrangement of the scene, he nonetheless altered the figures of the onlookers in terms of both pose and gesture. The first alteration is drawn in on a impression of state III in London (Fig. 7c).[7] After an intermediate state, IV, in which the frame is completely registered with cross-hatching, the changes to the figure are incorporated in state V. Here Rembrandt alters the pose of Martha. No longer shown bending back behind the grave in a pose corresponding to that of the man with his shrinking gesture, Martha is a sharp silhouette moving towards the resurrected Lazarus. The next re-working concerns the figure of the man with outstretched arms to whom Rembrandt gives a cap, the emphasis provided by its shaded part marking off the group of figures against the still brightly lit background. At the same time, a more distinct character is given to Lazarus's second sister, Mary Magdalen. In a third stage of alteration, the three men behind the above-mentioned figures, were re-worked in order to give the group a greater relief-like compactness. The subsequent two states may be understood as final corrections.

It has frequently been observed that, as well as Lievens's composition, Rembrandt drew on other works, above all compositions by Raphael: Marcantonio Raimondi's engraving after Raphael's *Saint Peter preaching* being cited in this connection.[8] It is doubtful, however, that really specific borrowings are to be detected here; one might, rather, ask if it would not be more reasonable to speak of general similarities to the figurative style of Raphael—particularly in the case of Rembrandt's figure of Christ, both in its statuesque quality and in the firm, imposing character of its gesture. It is known that Rembrandt constantly added to his own collection of works of art, above all his collection of prints. It is thus possible that Muller's engraving after *The Raising of Lazarus* by Abraham Bloemaert may have provided Rembrandt with an artistic challenge.[9] Rembrandt would certainly also have been familiar with the compositional solutions devised by his teacher, Pieter Lastman.[10] The number of specific models that Rembrandt may have used in evolving his own compositional solution (which, as the various states show, was only reached through the working process) is itself a reflection of his aim to present a new and exciting record of the Biblical episode. B.W.

1. John 11: 1–44.
2. B. 81, B. 77; B. 90. On the *Ecce Homo* and the *The Decent from the Cross*, see Royalton-Kisch, 1984.
3. Münz, 192 did not deny the possibility that Van Vliet may also have worked on the etching. Hind (No. 96) regards the composition, but not the later states, as authentic.
4. Now in the collection of the City Art Gallery, Brighton; Sumowski 1983, No. 1193. The 1656 inventory of Rembrandt's estate lists a painting of *The Raising of Lazarus* by Jan Lievens (*Urkunden* 169, No. 42. Lievens himself made a reproductive print of his painting—and according to the most recent considerations of Royalton-Kisch, it remains to be established whether this was made directly after the completion of the painting or at a later stage. In an as yet unpublished article, Royalton-Kisch also proposes a date different from that accepted in previous research for the drawing Benesch 17, suggesting that is was made in the mid-1630s, and thus after the production of the etching. Consideration of the drawing is therefore omitted from the present discussion.
5. Los Angeles, private collection, *Corpus* A30.
6. See *Corpus* A30, with bibliography.
7. Benesch 83 a, London, British Museum.
8. B. 44; Münz 192; discussed most recently in *Corpus* A30.
9. B. 18; see Berlin 1970, No. 73.
10. Mauritshuis, The Hague; also Sale: Dobiaschowsky, Berne, May 1990.

7c: Rembrandt, *The Raising of Lazarus*, State III, with correction. London, British Museum.

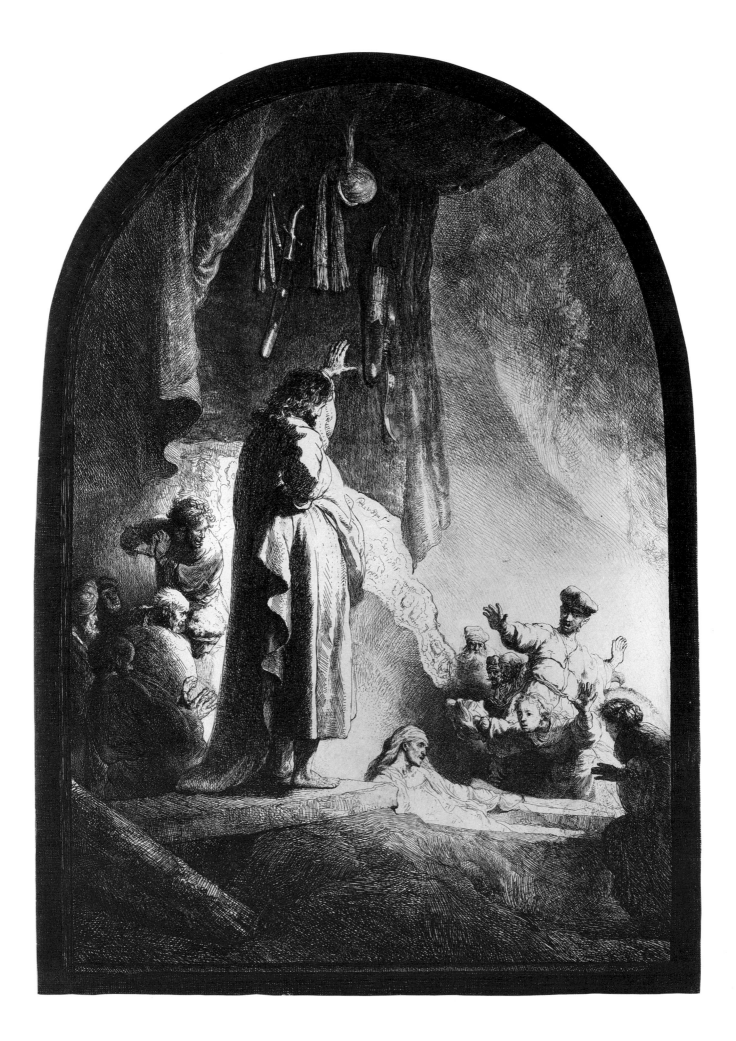

8

Joseph and Potiphar's Wife

Etching, 90 × 115 mm; 2 states
Signed and dated: *Rembrandt f. 1634*
B./Holl. 39; H. 118; White p. 36

Berlin: II (59–16)*
Amsterdam: I (O.B. 78)
London: I (1933-9-9-11); II (F4-64)

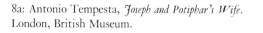

8a: Antonio Tempesta, *Joseph and Potiphar's Wife*.
London, British Museum.

Unambiguously bared, a woman lying on a bed attempts to pull back towards her a man who, defending himself, turns to flee. The print shows a scene from the story of Joseph who, after being sold to the Egyptians by his brothers, was employed in the house of Potiphar, treasurer to the Pharaoh. 'And it came to pass after these things, that his master's wife cast her eyes upon Joseph; and she said, Lie with me. But he refused, and said unto his master's wife, Behold, my master wotteth not what is with me in the house, and he hath committed all that he hath to my hand; There is none greater in this house than I; neither hath he kept back any thing from me but thee, because thou art his wife: how then can I do this great wickedness, and sin against God? And it came to pass, as she spake to Joseph day by day, that he hearkened not unto her, to lie by her, or to be with her. And it came to pass about this time, that Joseph went into the house to do his business; and there was none of the men of the house there within. And she caught him by his garment, saying, Lie with me: and he left his garment in her hand, and fled, and got him out.'[1]

In the *Aniquitates Judaicae* by Flavius Josephus, the episode was further embellished in order emphasise Joseph's self-control and his success in protecting his chastity against the women's urgent entreaty. It was possible to see the same interpretation of the subject in Antonio Tempesta's engraving (Fig. 8a)[2] that inspired Rembrandt.[3] Rembrandt, however, reduces the indication of spatial depth and background detail to leave only the bed; the door is sketchily indicated, and there is no view through it to a landscape beyond. He has, indeed, 'increased the blunt realism according to the subject'.[4] While the woman's recumbent posture, above all her bared pudenda, emphasises her lascivious intent, Joseph, by contrast, is vehemently abrupt in his movement as he turns away, overcome with disgust. While Joseph does not even touch the woman and shrinks back to rebuff her importunate demand, her own impulse is, quite literally, grasping. The use of *chiaroscuro* in the composition is especially determined by the moral exemplar the scene conveys: while the figure of Joseph is set against a light background, Potiphar's wife is shown against the darkly shaded area of the bed.

So frank a treatment of the episode was later found disturbing. In a impression of the etching from the Mariette collection, for example, the impact is corrected by the addition of a cloth drawn in to cover the woman.[5]

In this work from 1634 Rembrandt uses two distinct styles of etching: the linear treatment used for the left background and the figure of Joseph with very restrained shading, and an approach based on modelling through the accumulation of planes defined largely by light and shade, as seen in the body of the woman and in the treatment of the right background. Both methods were to retain a determining role in Rembrandt's work as an etcher.

B.W.

1. Genesis 39: 71–12.
2. B. 71.
3. Berlin 1970, No. 18.
4. Berlin 1970, No. 18.
5. Fitzwilliam Museum, Cambridge; see White 1969, p. 36.

9

The Angel appearing to the Shepherds

Etching, dry-point, burin and sulphur tint
262 × 218 mm; 3 states
Dated: (from II) *1634*
B./Holl. 44, H. 120, White pp. 36–39

Berlin: III (471–1901)*
Amsterdam: III (62: 19)
London: I (1973 U. 850); III (1868–8–22–662)

The darkness of the night is suddenly shot through with light. Men and animals scatter in terror. The brightly illuminated and imposing figure of the angel announces the message of Christmas; but only a few figures—such as the kneeling shepherd, who raises his arms in fright—even notice this. 'And there were in the same country shepherds abiding in the field, keeping watch over their flock by night. And, lo, the angel of the Lord came upon them, and the glory of the Lord shone round about them: and they were sore afraid. And the angel said unto them, fear not: . . . And suddenly there was with the angel a multitude of the heavenly host . . .'[1]

Rembrandt succeeds here in capturing the full impact of the event. The deep black of the night sets off the glittering light of the divine apparition. The angel, a large-scale figure poised on a cloud-bank, calmly dominates the scene. This is in dramatic contrast to the alarm and tumult below. The reactions of those picked out by the light range from sheer terror to panic-stricken flight. Still in darkness, however, are the two shepherds clambering out of a hollow on the right—probably coming to see what is happening. The animals too are shown to react in various ways. Those caught in the stream of light scatter, while others remain quite unaffected. The dove of the Holy Ghost is depicted in the bright centre of the sky, which opens up into a funnel of light. *Putti* circle around the light. Rembrandt offers here a bravura exercise in *scorci* (foreshortening) and in variations of movement. In the valley below, lit up as if in a fairy-tale, one can make out a river, spanned by an imposing bridge. Figures standing in front of a fire reflected in the water are just detectable.

The evolution of the print is not recorded in surviving drawings, but two working proofs

from the unfinished plate exist (Fig. 9a).[2]• Rembrandt first established the entire composition on the plate with sketch strokes. As the same time he established the principal division of light and shade. The deepest blacks and all of the background were virtually completed at this stage. This approach is also found in other Rembrandt etchings, for example in *The Artist drawing from the Model* (Cat. No. 15). It is, however, important to note that such a procedure parallels that found in painters' working methods. Through establishing gradations of grey tones in his etching of *The Angel appearing to the Shepherds*, Rembrandt creates a scene that is not only painterly, but also composed in pictorial terms. With his impressive range of velvety-black tones Rembrandt here reaches the virtual limits of the technical possibilities of etching. First Rembrandt established the dark areas of the print through a fine network of hatching, and bit these lines deeply, then went over the plate-surface with the burin once again. By doing this he avoided sharp contours outlining dark areas. Rather, the forms are marked through areas made up of hatching of varying degrees of fineness. By this procedure, the atmosphere of the night is captured in a most suggestive manner.

The signed second state shows the composition at its most complete. In state III, finally, Rembrandt has shaded through additional hatching a number of details such as the lower branch of the large tree and the angel's wings. It has not, however, been previously remarked that Rembrandt is less specifically concerned here with aesthetic effect, than with the correction of technical aspects. Almost all the passages worked with additional hatching in state III, were apparently bitten with sulphur tint in state II.[4] Rembrandt made a few trial proofs of this state[5] and, not satisfied with the result, re-worked the areas concerned.

Night scenes had been popular in art since the sixteenth century. The paintings of Elsheimer exerted a considerable influence that had spread even more widely through their reproduction in prints by Goudt as well as through the engravings of Jan van der Velde that drew on these. In *The Angel appearing to the Shepherds*, as in many of his works, Rembrandt re-worked suggestions borrowed from earlier sources. Rembrandt's fleeing shepherds, for example, are to be found in a print by Sadeler after M. de Vos; and Rembrandt may also have known Saenredam's reproductive prints after Abraham Bloemart.[6] Rembrandt himself developed his composition further in the painting of the *Ascension* (1636) commissioned

by Prince Frederik Hendrik.[7] Even in drawings from a later period, Rembrandt revised this idea.[8] The adoption of the compotition by other seventeenth-century painters[9] testifies to the popularity of Rembrandt's print.

Although nocturnal scenes are found in some of Rembrandt's early paintings, *The Angel appearing to the Shepherds* is his first etched example. Rembrandt conceived of nocturnal scenes as an artistic challenge, which became important again in his late work.[10]

B.W.

1. Luke 2: 8–10 and 13.
2. London; Dresden.
3. On this manner of working, see Van de Wetering: 'Painting materials and working methods', in *Corpus*, pp. 111–33, especially 29.
4. On this technical procedure, see Cat. No. 22.
5. Only three proofs of II are known: these are now in Amsterdam, London and Vienna.
6. Berlin 1970, 41; Münz 199.
7. Munich, Alte Pinakothek, *Corpus* A118; Paintings Cat. No. 13.
8. Benesch 501; Benesch 502; Benesch 999, Schatborn 1985, No. 38; Benesch 1023, Schatborn 1985, No. 44.
9. Flinck, Louvre; Berchem, Louvre; Bout, Braunschweig.
10. See Cat. No. 37.

9a: Rembrandt, *The Angel appearing to the Shepherds*, State I. London, British Museum.

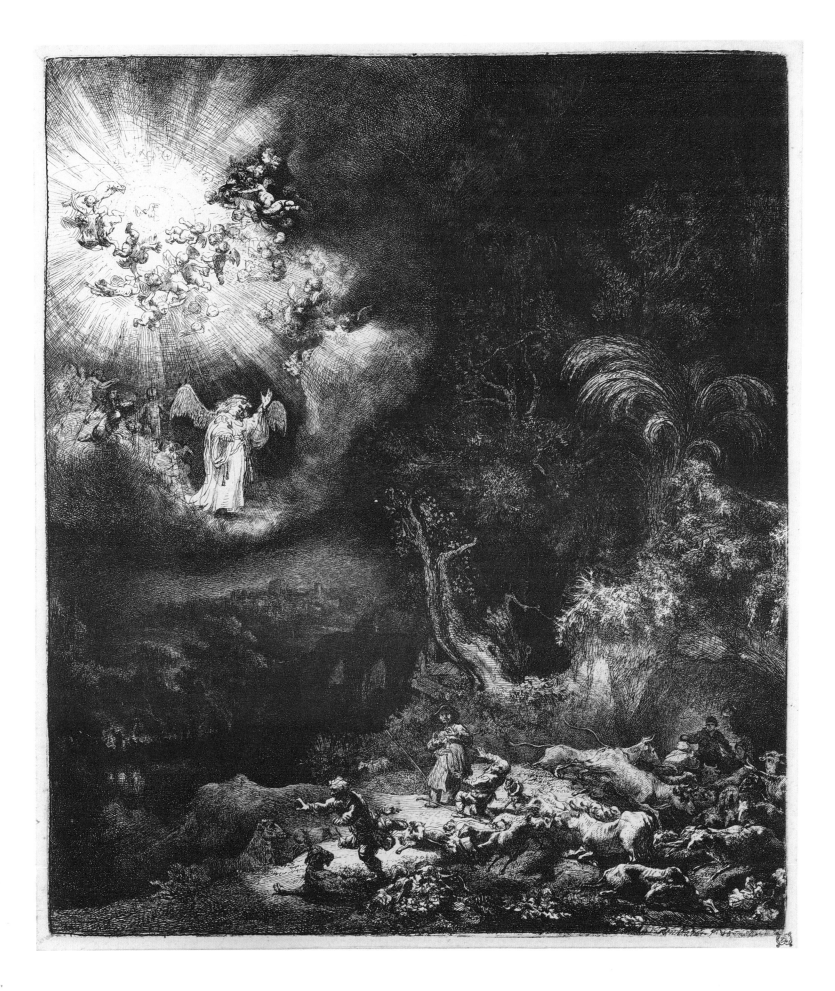

The Pancake Woman

Etching and drypoint, 109 × 77 mm; 3 states
Signed and dated: *Rembrandt. f 1635*
B./Holl. 124; H. 141; White, pp. 156–58

Berlin: II (473–1901)
Amsterdam: II (61–1056)*
London: II (1973 U. 880)

This small etching shows a popular subject of seventeenth-century Dutch genre. In the centre an old woman sits making pancakes in a large pan. This attracts the attention of a group of children: two boys, in the background, look at a coin which they will probably use to buy a pancake, while three children of various ages— one in a broad-brimmed hat already devouring a pancake with relish—look on as the old woman prepares the next batch. An inquisitive toddler is held back by his mother, and a boy in the foreground, watched by a black cat, tries to save his pancake from an over-eager dog.

The iconography of this subject may be traced back to the mid-sixteenth century. In scenes of the 'Fools' Kitchen' and the 'Feud between Carnival and Lent' from the circle of Pieter Bruegel the Elder one can find similar pancake women.[1] In the seventeenth century the motif became a subject in its own right in Dutch genre painting, for example in the work of Willem Buytewech, Jan van de Velde and Adriaen Brouwer.[2] Rembrandt's etching is close in its composition to an engraving by Van de Velde (of about 1626) (Fig. 10a) and also to a painting by Brouwer (of about 1620–30) in Philadelphia that may have been owned by Rembrandt.[3] The subject of the pancake woman was often treated moralistically. In Jan van der Veen's emblem book (1642), for example, the preparation of undercooked pancakes is used as a symbol for stupid jollity, and the idle chatter that corrupts good manners.[4]

A pen drawing of about 1635 by Rembrandt, now in the Rijksprentenkabinet in Amsterdam

10: State I

10a: Jan van de Velde, *The Pancake Woman*. Berlin, Kupferstichkabinett SMPK.

(Fig. 10b), treats the same subject yet differs considerably from the etched scene in its composition. In the drawing, the pancake woman is seen almost from the front and she is placed right at the edge of the scene. In the etching—following the iconographic tradition for the subject—she is shown in pure profile at the centre of the sheet. Rembrandt appears to have taken account here of the fact that a more ordered arrangement was required in a print intended for sale.[5] A pen drawing from about 1635, formerly in the Kunsthalle in Bremen, might have been made in connection with the etching (Fig. 10c).[6] It shows a woman with five children in various poses. The mother, who holds a baby in her arms, has a certain similarity with the corresponding figure in the group in *The Pancake Woman*. There is also an almost identical a child, who turns its head and reaches away with bent, thrusting legs, on the left in the drawing and in the foreground of the etching.

The motif of the sprawling boy appears to have been popular in seventeenth-century Dutch art.[7] It has not previously been remarked that Rembrandt is here citing a celebrated model: the *putto* skimming the waves in Raphael's *Triumph of Galatea*, a composition widely known through reproductive engravings by, among others, Marcantonio Raimondi and Hendrick Goltzius (Fig. 10d).[8] Rembrandt did not transfer the figure mechanically, but rather keyed the splayed pose to a context in employing it to show the boy's effort to save his pancake from the eager dog. This motif—with other examples—shows to what extent Rembrandt drew on foreign models as well as on sources found in works in his own collection; studies from life often played a minor role or served only as starting points for freely devised versions of a figure. In his scenes with children, in particular, which at first glance seem so closely observed from life, the stereotypical, formulaic record of certain figures and motifs stands out: these may be traced back to Rembrandt's reference to ancient sculpture, among other sources.[9]

Within the network of lines in the background, one can make out the mouth, potato-shaped nose and eye of a grimacing face. It remains open to question whether Rembrandt has here allowed a bizarre idea, appearing perhaps by chance in the etching process, to remain.[10]

In state I, which is rare, the pancake woman's dress and hat are principally indicated only in outline; in state II they are heavily hatched, in part with emphatic drypoint lines, so that the old woman now stands out more boldly from the band of children than in state I.
H.B.

1. See, for example, the *Fools' Kitchen* of about 1560, a drawing from the Bruegel circle, in the Albertina in Vienna (Benesch 1928, p. 12, No. 75) and the engraving after it by Pieter van der Heyden (Holl. IX, p. 28, No. 48). In Bruegel's painting of 1560, *The Feud between Carnival and Lent*, (Vienna, Kunsthistorisches Museum), there is a pancake woman (Grossmann 1955, plates 6 and 8). On this subject see Trautscholdt 1961 and Lawrence, Kansas; New Heaven and Austin 1983/84, pp. 110 ff., Nos. 25–26.
2. On Buytewech see Haverkamp-Begemann 1959, pp. 107–8, Nos. 38–38a, Figs. 60 and 56; on Van de Velde, Holl. 148.
3. In the 1656 inventory of Rembrandt's estate there is mention of a painting by Brouwer with this subject; it remains, however, a matter of speculation as to whether this is to be identified with the picture in Philadelphia; see *Urkunden*, p. 190, No. 169; 'Een Stuckie van Ad. Brouwer, sijnde een koekebakker (A work by Ad. Brouwer, being a [pan]cake maker). On Brouwer's panel see Berlin 1984, p. 122, No. 20.
4. Amsterdam 1976, p. 87, No. 16, with illustration.
5. Benesch 409; Schatborn 1985, pp. 16–17, No. 6. See also Bruyn 1983, p. 57, who regards the Amsterdam drawing as a free variant on Brouwer's composition.
6. Benesch 402.
7. Schatborn 1975, p. 11. A drawing in the Louvre, Paris, Benesch 112, which shows a young boy and a dog in a similar way, albeit reversed, has on occasion been seen as a preparatory study for this group. This must, rather, be a copy drawn by another hand, after the etching; see Schatborn 1985, p. 16, No. 6, note 3.
8. Marcantonio Raimondi: B. 350; Hendrick Goltzius: B. 270.
9. Bruyn 1983, especially p. 53. Meder points to the tradition, especially for scenes with children, of using models taken from ancient or contemporary works of art; Meder 1923, p. 402.
10. It has also been suggested that this face symbolises the childrens' fears, or images that could trigger those fears; Robinson 1980, p. 166.

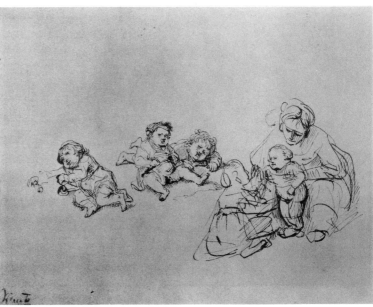

The Fall of Man

Etching, 162 × 116 mm; 2 states
Signed: *Rembrandt. f. 1638*
B./Holl. 28; H. 159; White, pp. 41 ff.

Berlin: II (48–16)
Amsterdam: II (61:992)
London: II (1843–6–17–16)*

Rembrandt's etching of 1638 may well be
claimed as one of the most psychologically
penetrating images of the subject of the Fall of
Man in the history of art. In the Bible we read:
'Now the serpent was more subtle than any
beast of the field which the Lord God had
made. And he said unto the woman, Yea, hath
God said, Ye shall not eat of every tree of the
garden? And the woman said unto the serpent,
We may eat of the fruit of the trees of the
garden: But of the fruit of the tree which is in
the midst of the garden, God hath said, Ye
shall not eat of it, neither shall ye touch it, lest
ye die. And the serpent said unto the woman,
Ye shall not surely die: For God doth know
that in the day ye eat thereof, then your eyes
shall be opened, and ye shall be as gods,
knowing good and evil. And when the woman
saw that the tree was good for food, and that it
was pleasant to the eyes, and a tree to be
desired to make one wise, she took of the fruit
thereof, and did eat, and gave also unto her
husband with her; and he did eat.' (Genesis 3:
1–6).

 Adam and Eve are shown completely naked,
in the state of paradisaic innocence, of which
they only become aware after the Fall.
Following iconographic tradition, Rembrandt
shows the moment when Eve is about to give
the apple to Adam; she seems to have
persuaded him with her seductive voice. In
reaching for the apple, Adam pauses, raising his
right hand as if to remind Eve that God had
forbidden them to eat from the tree of
knowledge. His body, bent as if in pain, seems
to be an expression of his awareness of guilt
and his fear of punishment. Rembrandt shows
Eve's tempter lurking in the tree, in the form
of a dragon, not a snake. The bible says that it
was only after the Fall that God the Father
condemned the beast to crawl on the ground,
which implies that it must have had another

10b: Rembrandt, *The Pancake Woman*. Drawing.
Amsterdam, Rijksprentenkabinet.

10c: Rembrandt, *Sheet of studies with a mother and
five children*. Drawing. Destroyed.

10d: Marcantonio Raimondi, after Raphael,
The Triumph of Galatea.
Berlin, Kupferstichkabinett SMPK.

appearance until that moment. The use of a dragon in place of a snake was not unusual in the iconography of the subject.[1] Rembrandt was inspired by Dürer's scene of *Christ in Limbo* from the *Engraved Passion* (1512) (Fig. 11a).[2] In adopting this motif, Rembrandt also adopted the further meaning it conveyed: it is possible that there is here an allusion to Christ's victory over Satan, who had seduced Adam and Eve, and thus to the Redemption of Humanity after the Fall.[3]

As Adam and Eve are lit from behind, their bodies—with surfaces modelled by the play of light and shade—stand out clearly against the background. Possibly in order to emphasise Eve's role as seductress, Rembrandt places her at the centre of the scene—an exception in the iconographic tradition—and draws attention both to the apple and to her pudenda through their strong contrasts of light and shade.

From the time of Van Eyck's Ghent Altarpiece scenes of Adam and Eve had been associated with anatomically correct studies of the nude. The nude was often idealised, and Adam and Eve were shown as a young and handsome couple. Rembrandt has shown them quite differently. In the tradition of classicist art criticism, Gersaint and Bartsch censured the exaggerated naturalism and ugliness of Adam and Eve in Rembrandt's scene.[4] They accused him of incompetence in drawing the nude, failing to see that Rembrandt had deliberatly employed these stylistic means to convey the full impact of the psychological conflict.

Rembrandt had previously treated the subject of the Fall in two drawings.[5] The sheet in the Prentenkabinet of the Rijksuniversiteit in Leiden is a study for the etching (Fig. 11b). In it, Rembrandt experiments with two different means of conveying the tense relationship between Adam and Eve. In the left-hand sketch, executed in detail, Eve holds out the apple to Adam with one hand only, while he uses both hands in a gesture of self-defence. The smaller sketch resolves the composition into the arrangement found in the etching: here Eve holds the apple to her breast with both hands, while Adam reaches one hand out towards it, while pointing upwards in warning with the other.[6] The elephant seen trotting along in the sunny landscape of Paradise is based on the chalk drawings of elephants, made in about 1637 (see Drawings Cat. No. 13).[7]

The states of the etching differ only slightly from each other. In state 1 the upper edge of the over-grown stoney bank to the left of Adam is not yet marked in with an unbroken line. In the example of state 1 in London, Rembrandt has drawn in a tree stump to the left of Adam with black chalk.

H.B.

1. See, for example, *The Fall of Man* by Hugo van der Goes, of about 1470, in the Kunsthistorisches Museum in Vienna; Panofsky 1953, Plate 298.
2. B. 16.
3. Tümpel 1970, No. 1.
4. Gersaint 1751, pp. 18–19, No. 29. 'Comme Rembrandt n'entendoit point du tout à travailler le nud, ce Morceau est assez incorrect, & les têtes sont tout-à-fait désagréables' (As Rembrandt did not understand at all how to draw the nude, this scene is rather incorrectly treated, and the heads are altogether ugly). B. 28.
5. Benesch 163–64.
6. Benesch 164; Schatborn 1986, pp. 30–31. The red chalk study of about 1637 of a *Nude Woman with a Snake* (*as Cleopatra*) in the Getty Museum in Malibu, shows a striking similarity with Rembrandt's Eve in its distribution of light and shade across the naked figure, and it might have served as a preparatory study for this; see Benesch 137; White 1969, p. 42; Goldner/Hendrix/Williams 1988, p. 256, No. 114.
7. Benesch 457–460.

11b: Rembrandt, *Sheet of studies with Adam and Eve*, Drawing. Leiden, Prentenkabinet der Rijksuniversiteit.

11a: Albrecht Dürer, *Christ in limbo*. Berlin, Kupferstichkabinett SMPK.

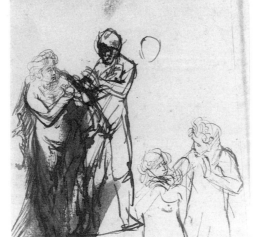

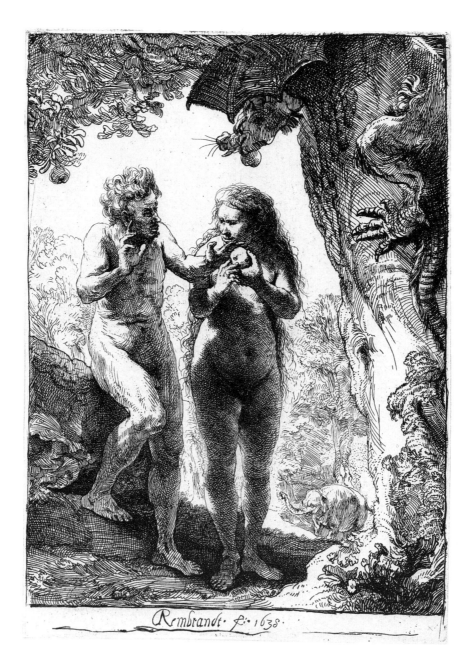

Rembrandt f. 1638.

12

Sheet of sketches with a portrait of Saskia

Etching and drypoint, 127 × 103 mm;
3 states
Signed: (only in II) *Rembrandt*; c. 1637
B./Holl. 367; H. 153; White, pp. 119–20

Berlin: I (493–16) II (494–16)
Amsterdam: I (O. B. 769), II (62:120)*
London: I (1848–9–11–189), III (1973 U. 892)

12: State I

Rembrandt had been married since 1634 to Saskia van Uylenburgh and he often used his young wife as a model in allegorical, symbolic portraits as well as for free sketches. Several drawings and etchings show her in her sickbed; in 1642, after a long illness and at the age of only 30, Saskia died.[1]

In the period 1636–37 Rembrandt made three etchings with head studies of Saskia (Fig. 12a).[2] In the first state of B. 367 she is shown *en face*, looking out at the viewer and supporting her head with her right hand. Both head and hand are carefully modelled with fine hatching, but the arm and shoulder areas are only sketchily indicated. The apparent spontaneity of the execution and the alert presence of Saskia lead one to assume that Rembrandt worked directly on the plate in front of his model. The same directness of expression is conveyed in the 1633 silverpoint *Portrait of Saskia* in the Kupferstichkabinett in Berlin (Drawings Cat. No. 3).[3] Here Saskia, four years younger than in the etching and newly betrothed to Rembrandt, is shown with a much brighter expression and her hand rests only lightly against her face (Fig. 12b). In the etching, on the contrary, she looks out broodingly and seems to lean her head heavily on her hand.

In state II, there are two heads as well as the barely legible signature; the carefully hatched head at the lower right shows Saskia again, and the unfinished sketch immediately next to it, would also appear to be a record of her. This head, indicated with only a few strokes, provides an insight into Rembrandt's working method: first he made his sketch in the wax covering of the plate, then he carried it out in detail (see Introduction p. 160). In state III, the scratches on the upper part of the plate, and also the signature, have been smoothed away. A drawing, also dating from 1636–37, with four studies of Saskia, in the Museum Boymans-van Beuningen in Rotterdam, reveals a similar appearance.[4] Rembrandt transferred the free character of the drawn sheet of sketches to the etching; the fact that he did not produce the etching in one process but, rather, prepared three states, questions the assumed 'random' quality of the head studies. Rembrandt must also have consciously etched the drypoint lines of the first two states—at least, he consciously allowed them to remain—in order to simulate the directness of a sketch (see Cat. No. 5). Even if Saskia's features are here recorded as in a portrait, the real purpose of the etching is different. The print-dealer Clement de Jonghe (see Cat. No. 30) had among his stock of printing plates several by Rembrandt, showing sheets of sketches, among them some of Saskia. This shows that works of this kind were desirable collectors' items, intended for the market.

H.B.

1. Among others Benesch 405, 425, 426; etching B. 369.
2. B. 365, 367, 368.
3. Benesch 427.
4. Benesch 360; Giltay 1988; p. 55, No. 109.
5. De Hoop Scheffer/Boon 1971, pp. 6 ff., No. 16 (probably the *Sheet of sketches with Saskia*, B. 365); No. 39 (probably the *Sheet of sketches with Saskia*, B. 367 or B. 368); No. 42 (probably the *Sheet of sketches with Rembrandt's Self-portrait*, B. 363).

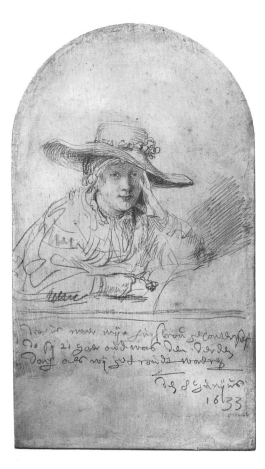

12a: Rembrandt, *Sheet of sketches of Saskia*. Amsterdam, Rijksprentenkabinet.

12b.: Rembrandt, *Portrait of Saskia*. Silverpoint drawing. Berlin, Kupferstichkabinett SMPK.

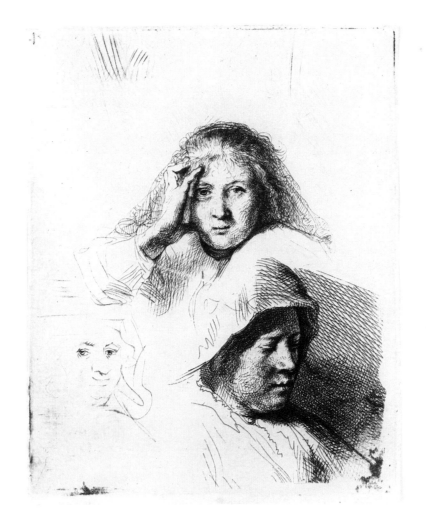

Self-portrait
leaning on a stone sill

Etching and drypoint, 205 × 164 mm; 2 states
Signed and dated: *Rembrandt f. 1639*
B./Holl. 21; H. 168; White pp. 120–22

Berlin: II (1–16)
Amsterdam: I with corrections (O.B. 37)*;
II (O.B. 38)
London: I with corrections (1868–8–8–3177);
II (1868–8–22–656)

13a: Renier van Persyn, after Titian, '*Ariosto*'.
Amsterdam, Rijksprentenkabinet.

13b: Rembrandt, drawing after Raphael,
Baldassare Castiglione.
Vienna, Graphische Sammlung Albertina.

In 1631, at the age of 24, Rembrandt etched his important self-portrait in daring competition with Rubens's self-portrait which had become widely known through a reproductive engraving.[1] However, in 1639, Rembrandt made what is perhaps his most ambitious etched self-portrait. The next year he enhanced its significance by producing a painted version of the work.[2] Again, Rembrandt referred to an important model from the past, probably indeed to two. Yet neither of these is an artist's self-portrait. Doubtless Rembrandt was intending to compete with, and to surpass, Titian's so-called *Ariosto*.[3] At the end of the 1630s this painting is known to have been in Amsterdam, and, as demonstrated by drawings and reproductive prints (Fig. 13a), it was seen by artists there.[4] In contrast to the current view, the sitter was then identified as the Renaissance poet Ariosto, whose influence may be traced in seventeenth-century Amsterdam.[5] In contemporary texts, such as those by Karel van Mander, Titian himself was presented as a an ideal artist. Raphael too was especially praised, and his work recommended as suitable for imitation. Raphael's portrait of *Baldassare Castiglione*[6] was in Amsterdam at the same time as Titian's *Ariosto*. Castiglione was the author of the *Libro del Cortegiano*, in which the ideal of the cultivated courtier had found its most striking formulation.

Rembrandt made a drawing after Raphael's portrait in April 1639 (Fig. 13b) during a sale of works from the collection of Alfonso López.[7] In contrast to the other records of this work, however, such as the painted version of about 1620 by Rubens,[8] or the comparable Dutch

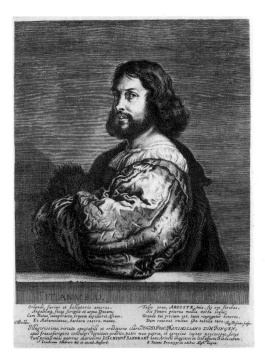

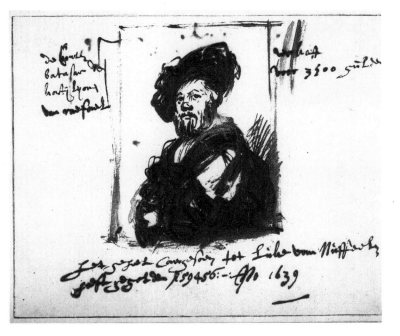

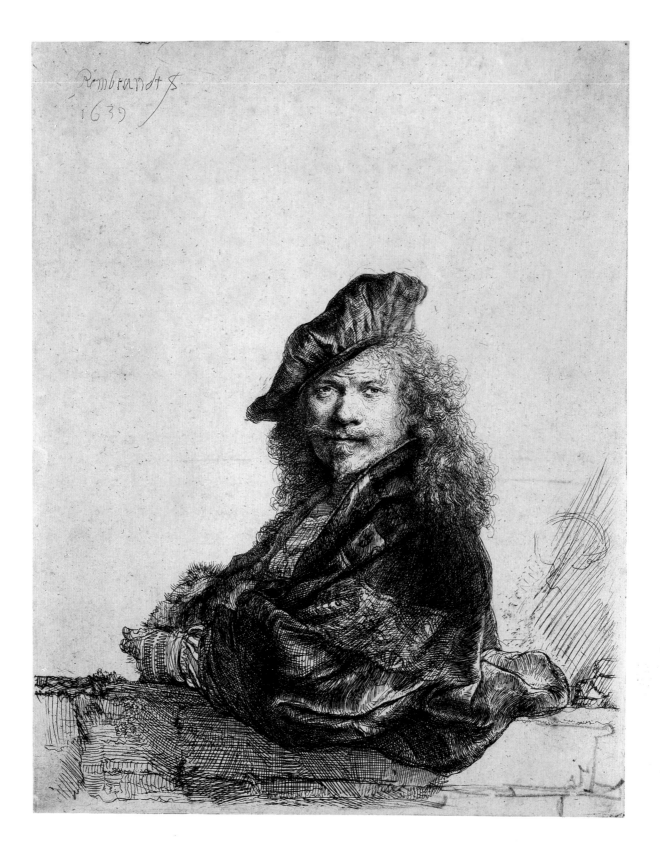

drawn copies and reproductive engravings,[9] Rembrandt's drawing is by no means an exact copy. On the contrary, it is closer to the Venetian portrait type. No longer viewed frontally, the sitter looks over his shoulder at the onlooker. The angle and proportions of the head covering have also been altered. The question of whether Rembrandt made the drawing before or after his portrait etching has caused controversy.[10] It is probable that Rembrandt's Titianesque portrait type was influenced by his record of Raphael's painting. At first glance, it seems as if Rembrandt has transferred this model into his own formal language. The drawing would then belong to the evolutionary process that led to the *Self-portrait* of 1639.

Resting his left arm on a ledge and turning his head, Rembrandt looks directly at the viewer over his shoulder. He wears a beret, its diagonal slant repeated in his upturned collar, an arrangement that both frames the face and at the same time gives structure to the composition. His hair falls in the shadow of his body on the right, but curls luxuriantly down over his left shoulder. While artists were commonly shown wearing such berets, the luxurious, fur-trimmed costume, so voluminous that it drapes over the paparet, seems to be more than a simple indication of social rank.[11] It must, rather, have been intended as a Renaissance costume, defining the portrait as *all'antica*. The size of the background is striking, its extent being emphasised through the placing of signature and date in the top left corner. Hatched strokes behind the shoulder indicate a dark area like a shadow. Nonetheless the figure is lit from the right.

The face turning towards the front, the cap, the turned-up collar, and the more marked integration of the hands taken from Raphael's work are combined by Rembrandt with Titian's picture structure characterised above all by the arm leaning on the ledge and the glance over the shoulder. Rembrandt evolved his self-portrait from a synthesis of the portraits by Titian and Raphael. The reference to tradition—to Raphael and Titian—must have been intended as a foil to the contemporary viewer's perception of this work. Rembrandt's solution should be understood in the sense of *aemulatio*.[12] In theoretical discussions, this term is used to describe competition between artists. The artist selected as a model was seen to present a challenge and, at the same time, to be surpassed through a personal artistic interpretation. Rembrandt thus presents himself in his 1639 self-portrait in artistic competition with Titian and with Raphael—representatives of two distinct

schools of Italian Renaissance painting. The self-portrait functions here not only as a representation of a personalised expression, but also as a programmatic formulation of the artist's identity and profession.

Although not documented through drawings, the etching provides evidence of Rembrandt's extrordinarily careful elaboration of this work. The etching is altered in its second state only in an apparently minor detail: The cap band continues right around the head. State I, with the more spontaneous effect of its nuances, was evidently corrected in the interest of greater formal unity. Six proofs of the first state are known, to all of which Rembrandt has added corrections.[13] These make it clear that Rembrandt was trying out further possible means of introducing greater firmness into the composition. Thus, in one proof, in London (Fig. 13c), Rembrandt strengthened the pilaster that had merely been suggested, while in another proof, in Amsterdam, he added further detail to the wall at the lower right. Only the corrections to the cap, however, were incorporated in the next state. Rembrandt had been interested, even before the first surviving state, in the exact shape of the cap. Traces of fine lines clearly used by Rembrandt to sketch outlines before he elaborated the image, reveal that a more drooping shape had at first been envisaged. The final correction may thus be seen as a result of careful experiment.

The next year (1640), Rembrandt made a painted version of the portrait after the print which he had probably intended for sale.[14] The similarities with Titian's painting are clearer in the painted image, which reverses that of the etching. Among Rembrandt's pupils, this iconographic solution is repeatedly adopted for artists' self-portraits.[15] Rembrandt's innovation, developed in a spirit of competition, was evidently judged to be a model in its own right.

B.W.

1. B. 7; Fig. 12 in the introduction.
2. National Gallery, London, *Corpus* A139; Paintings Cat. No. 32.
3. National Gallery, London.
4. Copy by Theodor Matham in the Herzog Anton Ulrich-Museum, Braunschweig; copy by Joachim Sandrart in the Fondation Custodia (F. Lugt collection), Instuitut Néerlandais, Paris; reproductive engraving by Reinier van Persyn, Holl., XVII, No. 15. See New York 1988, No. 25.
5. See De Jongh 1969.
6. Now in the Louvre, Paris.
7. Albertina, Vienna, Benesch 451; *Urkunden* 71.
8. Courtauld Institute Galleries, London.
9. Copy by Sandrart (Louvre, Paris), engraved by Reinier van Persyn (Holl. XVII, No. 41).
10. While De Jongh 1969, in particular, has argued that the drawing was made after the etching, Chapman 1990 has recently argued that the etching followed the drawing.
11. Chapman 1990, pp. 71 ff.
12. De Jongh 1969; Raupp 1984, pp. 168–81; Chapman 1990, pp. 69–78.
13. Amsterdam (2), London (2), Madrid (2), Melbourne.
14. Paintings Cat. No. 32.
15. Ferdinand Bol, Govert Flinck, Frans Mieris; see *Corpus* A139.

13c: Rembrandt, *Self portrait leaning on a stone sill*. State I, with corrections. London, British Museum.

202

14

The Death of the Virgin

Etching and drypoint, 409 × 315 mm;
3 states
Signed and dated: *Rembrandt f. 1639*
B./Holl. 99; H. 161; White pp. 43–46

Berlin: III (316–1893)*
Amsterdam: I (62:2)
London: I (1973 U. 898)

In a stately bed a woman lies dying. Around
her is a large assembly of mourners. The
heavens open; an angel, surrounded by *putti*,
steps down from the clouds. While not
recounted in the Bible, the story of the death
of the Virgin had already been widely known
since the early Middle Ages, primarily from the
account in the *Golden Legend*. The death of the
Virgin is an important theme in catholic
iconography. For Calvinists, however, worship
of the Virgin was forbidden. As in the case of
the etching Rembrandt made two years later,
The Virgin and Child in the Clouds,[1] and *The
Virgin and Child with the Snake* (Cat. No. 36),
it would seem that this work was intended for
the Catholic connoisseurs in Amsterdam.

The point of departure for Rembrandt's
print was the corresponding episode in Dürer's
etched *Life of the Virgin*, produced between
1502 and 1510 (Fig. 14a).[2] A year earlier, in
1638, Rembrandt had bought a set of Dürer's
series at auction.[3] Rembrandt sought to surpass
Dürer even in the dimensions of his etching, for
Dürer's woodcut measures 295 × 210 mm.
While Dürer shows the death of the Virgin as a
liturgical ceremony in the presence of only the
twelve Apostles, Rembrandt depicts a large
group of mourners, including both men and
women, an arrangement found in the earlier
engraving by Philip Galle after Pieter
Breughel.[4] It would appear that Dürer's
composition was already known to Rembrandt
indirectly, through a work by Dirk Crabeth.[5]
Specific aspects of Rembrandt's composition,
such as the altered spatial arrangement, would
seem to have been prompted by what
Rembrandt found here.

The effect of his wife's illness[6] on
Rembrandt is shown both in a poignant sheet
of etched sketches (Fig. 14b)[7] and in the
artist's rendering of the Virgin. While none

of the sketches should be understood as a preparatory drawing for the etching, it is probable that observations made from the model left their mark on Rembrandt's treatment of the scene, giving the figure of the Virgin as authentic an appearance as possible. Departing from iconographic tradition, Rembrandt introduces the figure of a doctor, who takes the Virgin's pulse, a motif familiar from other death-bed scenes.[8]

Rembrandt varies the crowd of mourners thronging around the bed through their different expressions of sorrow. Individual figures stand out from the group because of their imposing appearance. Especially striking is the figure of the priest who, accompanied by a server, approaches at the left of the death bed. Both figures, indeed, find a loose parallel in Dürer's print where in the foreground one of the apostles kneels and holds a crucifix, and Peter, identified by his mitre as the first bishop of Rome, stands in the left background. In Rembrandt's print, however, the figure of the priest does not participate in the religious ceremony. The dress of the figures is something of an orientalising fantasy costume, intended to place the event in the ancient Jewish Middle East. Among several figures who indicate the time-honoured sanctity of the event is the man sitting in the left foreground in front of the boldly illuminated bible. Lastly, prominent because of their size, the lamenting woman in front of the bed and the brightly-lit figure whose outstretched arms lead the eye on to the high curtain, set the tone of strongly expressive sorrow. The enormous curtain, which would

seem out of place as the furnishing of an interior as Dürer shows it, is employed by Rembrandt as a symbol of majesty. It is also possible that it symbolises a boundary between the earthly and heavenly kingdoms.[9] In addition to establishing distinct groups among the figures—those who mourn and those whose presence alludes to the sanctity of the event—Rembrandt adds a third group of figures: the angels and *putti* belonging to the heavenly realm. Three types of space seem to be adopted: the 'normal' space of the interior, an intermediate, 'sanctified' space, and the space of the heavenly sphere.

Rembrandt's range of techniques is exciting to behold, for it embraces both a painstaking record of details and a bold sketchy style. Only the lighting is minimally altered in the three states of the etching: the chair in state II, for example, is heavily shaded with dry-point while the foreground bedpost in state III is more strongly shaded. In any case, it is possible that Rembrandt rejected his first design for *The Death of the Virgin*, and then executed the design of the print as we now know it on a new plate. Impressions of the *Landscape with the three trees* (Cat. No. 19) show traces of a re-working of the plate which appears to be a compositional outline for *The Death of the Virgin*.[10] If this is indeed the case, this would constitute clear evidence that Rembrandt based some of his compositions not on detailed preparatory drawings, but rather on hasty sketches drawn directly on to the plate.
B.W.

14a: Albrecht Dürer, *Death of the Virgin*. Berlin, Kupferstichkabinett SMPK.

14b: Rembrandt, *Sheet of studies*. Amsterdam, Rijksprentenkabinet.

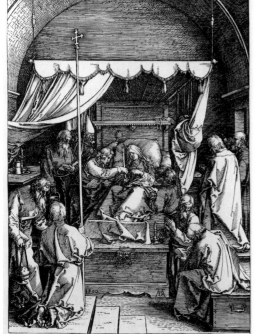

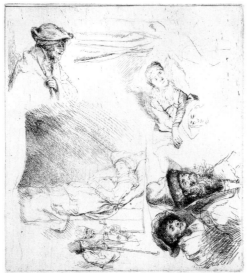

1. B. 61.
2. B. 93.
3. *Urkunden* No. 56. See Cat. No. 11; on Rembrandt's adoption of elements from the work of Renaissance masters such as Dürer and Lucas van Leyden, see also the commentary on the *Ecce Homo* (Cat. No. 38).
4. See Campbell 1980.
5. Glass painting in the Oude Kerk in Amsterdam; see White 1969, p. 45.
6. For example, Benesch 379, Schatborn 1985, No. 12, Amsterdam.
7. B. 369.
8. Tümpel 1969, p. 194.
9. Campbell 1980, p. 4.
10. Campbell, 1980.

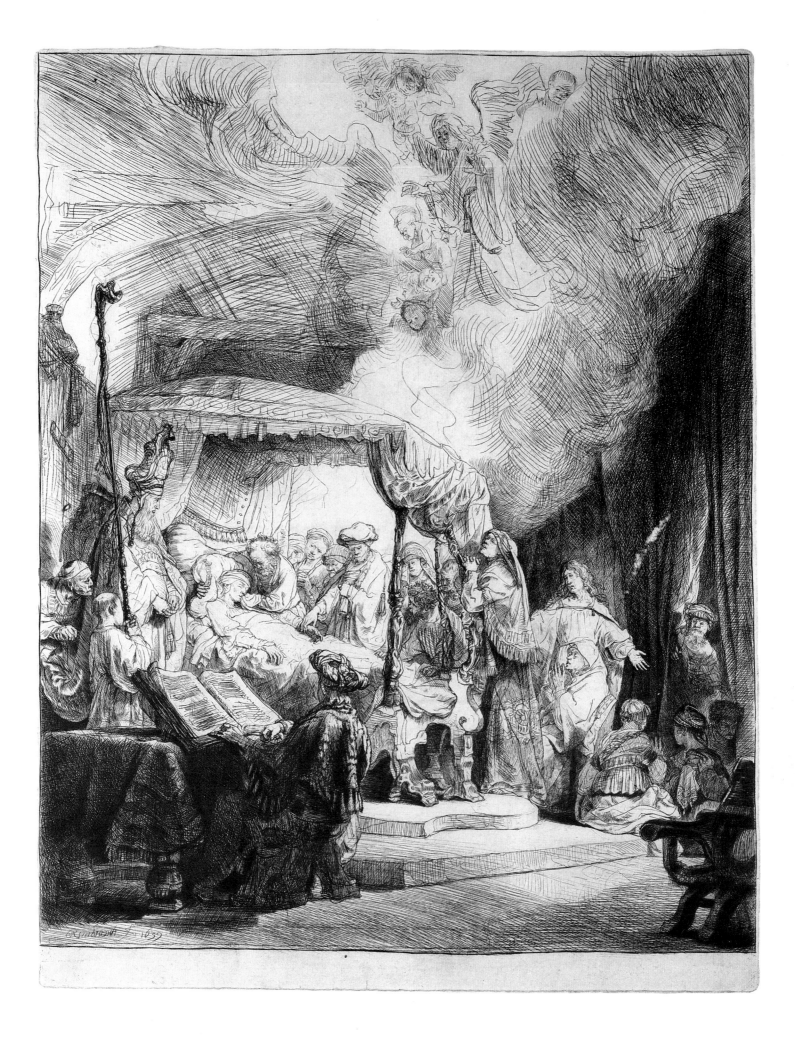

15

The Artist drawing from the Model (Allegory of the Glorification of Drawing)

Drypoint, etching and burin, 232 × 184 mm;
2 states; c. 1639
B./Holl. 192; H. 231; White, pp. 160 ff.

Berlin: II (279–16)
Amsterdam: II (1962:66)
London: II (1973 U. 995)*

15a: Pieter Feddes van Harlingen, *Pygmalion*.

15b: Jacopo de' Barbari, *Allegory of Fame and Victory*. London, British Museum.

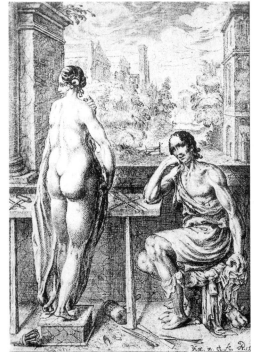

VOLGHT·NIET·Pygmalion·
DEYGHEN·LIEFD'HEM·VERWON·
DOER·EEN·BEELD·VAN·SIN·WERKEN

VEEL·BOLEN·NOCH·DEES·TYDT
IN·EYGHEN·ZIN·SO·WYDT
EN·KOE NENT ZELF NIET MERC

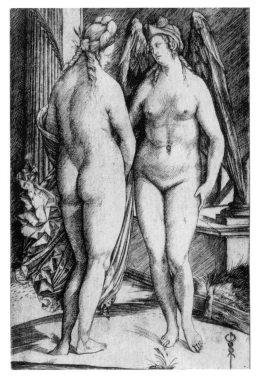

The sheet produced in about 1639 is only partially executed: the background, where one can see just the upper section of an easel, a bust on a high pedestal and suggestions of an arch, is carefully worked out in various kinds of hatching, while the remainder of the scene is only shown in a few sketchy drypoint strokes. An artist, whose facial features recall those of Rembrandt is engaged in drawing a nude female model who stands on a low footstool with her back to the viewer. The position of the model's supporting leg and her leg at rest, her pose and the turn of her head suggest the inspiration of a statue of Venus from Antiquity. The model has a cloth draped over her left arm, and she holds a long palm spray in her right. In both the left and right corners of the scene, there are suggestions of a chair. The canvas on the easel and the props on the wall—a shield, a sword and a feathered hat, objects owned by Rembrandt which appear in his works—show that the setting is an artist's studio.

With regard to the composition and the figure of the model, there are certain parallels with an etching made earlier by Pieter Feddes van Harlingen (Fig. 15a).[1] This shows Pygmalion, the sculptor from Antiquity who, falling in love with a female statue he had himself made, begged Venus to breathe life into the figure.[2] In the eighteenth century Rembrandt's sheet too was given the title *Pygmalion*.[3] Rembrandt's artist, however, is not shown as if overcome

with love for his own creation, but looks at the model in order to record her on the paper.

Scenes of artists at work in their studios were a common motif in the seventeenth century. The most famous examples are *Las Meninas* of Velázquez and Vermeer's *Art of Painting*. The central element of this motif, the relation of artist to model, was usually treated allegorically; thus, for example, the artist shown by Vermeer is painting Clio, the Muse of History, and his scene may thus be understood as an allegory on the Glory of History Painting. Rembrandt's model holds a palm spray, the symbol of fame. Rembrandt's immediate source—as also that of Feddes van Harlingen—must have been the corresponding figure in an engraving by Jacopo de' Barbari of about 1498–1500, showing the *Allegories of Fame and Victory* (Fig. 15 b).[4] The palm spray in the hands of an undraped female figure could, however, also indicate that Rembrandt here intended to show the Allegory of Veritas (Truth). The embodiment of Fame or Truth is also, in an extended sense, the artist's model here: as the Muse that inspires him. The real subject of this sheet is, therefore, the Glorification or the Truth of Drawing.[5] From the Renaissance, *disegno*—meaning both a drawing and an idea—was regarded as the basis of all the arts, because it was the most direct embodiment of the artist's conception. Rembrandt illustrates this theoretical connection by showing the draughtsman sitting in front of the canvas on his easel. For it is only after making the preparatory sketch that the painter—and here Rembrandt is probably alluding to himself—reaches for brush and palette, in order to transfer to the canvas, with the help of colours, the theme he has observed.[6] In this conceptual context, the bust in the background might perhaps be understood as a symbol of *Sculptura*.

The old title of the etching probably had its source in the classicist art criticism of the late seventeenth and the eighteenth centuries, which censured self-love in artists (Rembrandt too was seen to be guilty of this) through the image of Pygmalion.[7]

But why was the plate left unfinished? By this time Rembrandt enjoyed widespread fame in Europe as an etcher. He might have deliberately published the unfinished plate in order to reveal to the public his own print-making technique.[8] It is possible that Rembrandt intended to incorporate in the unfinished sheet a challenge to his pupils to enter into artistic competition with their master by nobly completing the studio scene on which he had embarked.[9] It is also probable that the plate was not further worked up on

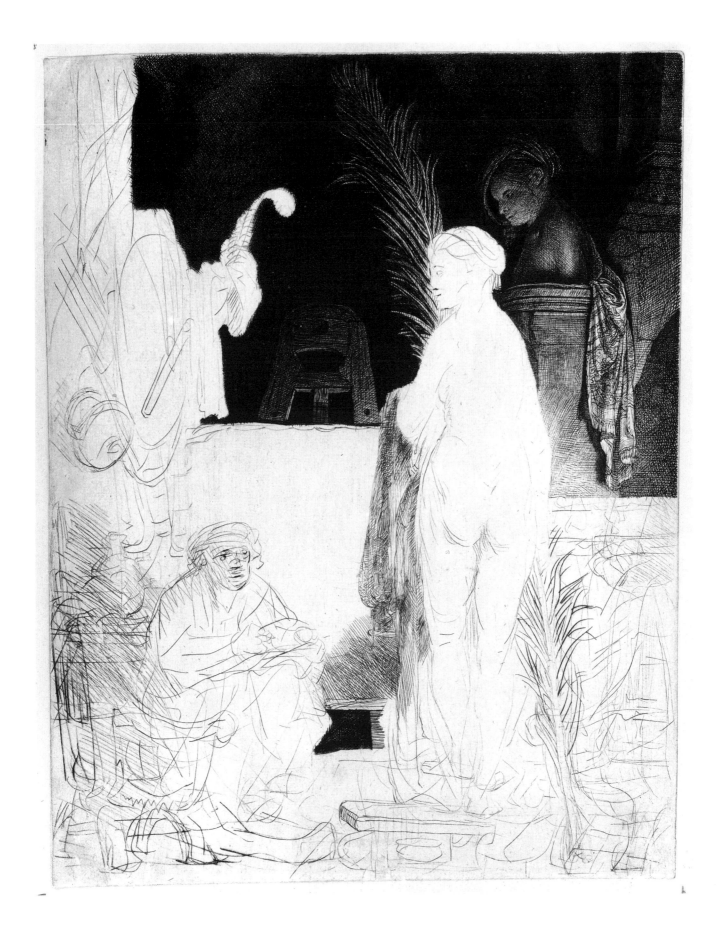

account of deficiencies in the drawing and inconsistencies in the composition. It is not absolutely clear, for one thing, how the draughtsman is sitting; he seems to sit near the chair rather than on it, as the four chair legs are scratched on to the plate to his left. Curious uncertainties are revealed in the allegorical figure's two pairs of legs. One pair is too long in proportion to the rest of the body, but the feet are correctly placed on the footstool, while the other pair of legs is in proportion to the body, but floats unsupported in the air. The elongated legs supported by the footstool are more weakly sketched-in.

In state I, the uncertain record of the model's feet is even more obtrusive; here the footstool is only lightly marked in (Fig. 15c). In the related drawing in London, which shows the composition in reverse and on about the same scale, the model's pose is fully resolved (Fig. 15d). The confused tangle of lines at the right of the etching is also lacking here, being replaced by the base of a pillar. This indicates that the drawing was only made during the preparation of the etching and, indeed, after this had reached state II, presumably with reference to a counter-proof bearing the reversed imprint of the etched composition.[10] It is evident that Rembrandt sketched the scene directly on to the plate without any preparatory study, and only later, and with the help of the London drawing, attempted to correct his rather botched composition.

The fact that the etching was published as a fragment is witness to collectors' appreciation of such unfinished sheets. They would have seen them as works in which the artist's first thoughts were revealed. Unfinished engravings had already been published by Hendrick Goltzius and Jacob Matham; in these it almost appears as if the scenes depicted were deliberately left in a fragmentary state.[11]

In the rare state I, in which the drypoint passages are still very strong, the upper part of the easel and the drapery on the model's arm are not yet hatched; between the draughtsman and his model, and in front of the blank canvas on the easel, there is a small printing press. The London example of this state reveals black pencil corrections in Rembrandt's hand on the turban-like head covering of the bust as well as on the chimney or pillar to the right; in state II hatching is added in these areas.

Hind gave a late dating to the unsigned etching, around or after 1648, but it must have been made earlier, in about 1639.

H.B.

1. Holl. 21; Saxl 1910, pp. 42 ff.
2. Ovid, *Metamorphoses*, X, 243 ff.
3. Yver 1756, p. 61, No. 184.
4. B. 18, Hind 26; Saxl 1910, p. 43; Amsterdam 1985–86, pp. 66 ff., Nos. 53–55.
5. Emmens 1968, p. 160.
6. It is not possible to deal exhaustively here with the complex content of the scene. See Held 1961, pp. 73 ff., Figs. 1–2 on a painting by Guercino with a related subject, in which the Father of Drawing shows his daughter, the Allegory of Painting, a sketch from which she then executes the scene shown in the picture.
7. Emmens 1968, pp. 159 ff.
8. In this connection, Emmens argued that the uncovered bust in the background alluded to this function; Emmens 1968, pp. 160 ff.
9. Emmens 1968, pp. 160 ff. It is perhaps worth considering, once again, whether the rather weak finished part of the etching, already ascribed by Francis Seymour Haden to Ferdinand Bol, really was executed by Rembrandt himself and not, rather, by one of his pupils; Haden 1877, pp. 41–42.
10. On the drawing, see Benesch 423; Schatborn 1986, pp. 18–19. The correct identification has been established by Martin Royalton-Kisch, who will publish it in the catalogue of the London Rembrandt drawings now in preparation. Münz attributed the etching, as also the related drawing, to Gerbrand van den Eeckhout; Münz 1952, Vol. II, pp. 182–83, No. 339. Two counter-proofs of the etching survive, one in Cambridge and one in Vienna.
11. Three engravings of this kind by Goltzius are known: *The Adoration of the Shepherds*, Holl. 15; *The Massacre of the Innocents*, Holl. 17; and a *Standing Female Allegory*, Holl. 54.

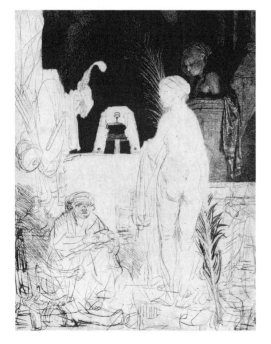

15c: Rembrandt, *The Draughtsman drawing the Model*. State I. London, British Museum.

15d: Rembrandt, *The Draughtsman drawing the Model*. Drawing. London, British Museum.

16

Portrait of the Preacher
Cornelis Claesz. Anslo

Etching and drypoint, 188 × 158 mm; 2 states
Signed and dated: *Rembrandt f. 1641*
B./Holl. 271; H. 187; White pp. 124–25

Berlin: I (78–1887)*
Amsterdam: II (O.B. 524)
London: II (1973 U. 945)

Cornelis Claesz. Anslo (1592–1646), a cloth
merchant successful in both domestic and
overseas trade, was a member of the 'Water-
landse Gemeende' (Waterland congregation) in
Amsterdam. This was a liberal group in
comparison with the rather stricter
Mennonites, who had taken their name from
the Frisian Anabaptist, Menno Simonsz.
However, the Waterland congregation also held
that the spoken word had absolute priority
over the visual image in the transmission of
Christian faith. The group had no ordained
preachers and preferred, rather, to select from
among its number those gifted in expounding
the Scriptures. In Amsterdam, Anslo presided
as spiritual adviser and preacher at the Grote
Spijker, the congregation's chapel on the River
Singel. Cornelis Anslo was distinguished,
apparently, by his talent as a speaker, but
equally by his deep religious faith and, at a
time of often dogmatic religious opinion in
Amsterdam, by his tolerant attitude towards
Baptists of differing persuasions. A double
portrait of 1642 shows Anslo with his wife,
Aeltje Scholten Gerritsdr. (Paintings Cat.
No. 33).[1]

The portrait etching of 1641 shows Anslo
expounding the word of God to an imaginary
listener, with his eyes not looking directly at
the observer. His right hand, holding a pen,
rests on an upturned book, while with his left
hand he points to a large open volume of the
Scriptures. His dress—fur collar, ruff and
hat—demonstrates that he belongs to the
wealthy bourgeoisie. Behind him, a picture is
turned to face the wall, apparently having been
removed from the illusionistically painted nail
above. As Busch has shown, Rembrandt is
alluding here to the dispute over the relative
importance of word and image in the imparting
of the message of Salvation, a question
unambiguously resolved in this case in favour

of the written and spoken word.[2] One might however ask if it is mere chance that the etching is signed on the reversed painting.

The preparatory drawing (Fig. 16a) matches the etching in both its dimensions and (though reversed) in its composition, and it reveals signs of tracing.[3] Because it has been so carefully executed, one may assume that it served not only as preparatory material for the artist, but also as a *modello* to be submitted to the patron.[4] Very few of Rembrandt's drawings which were intended for direct transfer to the etching plate survive.[5] In the case of other portrait etchings, for example the *Posthumous portrait of the preacher Sylvius* (Cat. No. 22), where preparatory drawings have survived, no *modelli* are known.

While the figure of Anslo is transferred in almost every detail from the drawing, the backgrounds show alterations in several respects. Most important is Rembrandt's addition of the picture taken down from the wall. The arrangement of light and shadow in the etching eschews specific emphasis in favour of very evenly distributed illumination; and the execution is more schematic than in the case of other portrait etchings.

The first state shows a minimally altered picture area, which in state II is enlarged both below and, to a small degree, at the left, thus the image as a whole is expanded to fit the size of the plate. A few shadows are marked in more precisely with drypoint.

This portrait of Anslo bears no text, nor does it reveal any space for the insertion of a handwritten panegyric. However, on both the mounting of the preparatory drawing and on a proof of state II in London, there is an epigram by Joost van den Vondel, arguably the most important Dutch poet of the baroque era, in a seventeenth-century hand:

'Ay Rembrandt, mael Kornelis stem.
Het zichtbre deel is 't minst van hem;
't Onzichtbre kent men slechts door d'ooren.
Wie Anslo zien wil, moet hem hooren'.[6]

(Ah Rembrandt, paint Cornelis's voice
the visible is the least important part of him
One can experience the invisible only through
 the ears
Whoever wants to see Anslo, must hear him.)

Scholars have been much concerned with the relationship between Rembrandt's print and this poem. Emmens proposed that the text be understood as a reference to the etching, and that it was the import of this text that had spurred Rembrandt to lay more stress on the word in his painting.[7] This theory has been disputed on several grounds.[8] It is especially striking that, even in the etching, Anslo turns towards an invisible listener with his mouth slightly open, that is to say, speaking, thus clearly stressing the word and the voice. In addition, it is necessary to consider the purpose of poems of this sort. They conform to a literary tradition of their own, rather than making direct reference to contemporary artistic practice. 'Regarding Vondel's lines it has to be suggested that Rembrandt was well aware of the poet's ill-will towards him, but had on the other hand—and according to his commission—shown in his picture the priority of the word over the image, at least the divine word, and in this respect being fully in accordance with Vondel.'[9]

B.W.

1. Berlin, *Corpus* A143.
2. Busch 1971.
3. Benesch 758; London, British Museum.
4. A comparable *modello* for the figure of Anslo in the Berlin double portrait also survives, Paris, Benesch 759.
5. An early example is the etching of *Saint Paul*, B. 149, and the related drawing Benesch 15; see also the *Diana* etching B. 201 and the drawing Benesch 21, as well as the portrait etching of *Jan Six* (Cat. No. 23).
6. *Urkunden* No. 100.
7. Emmens 1956.
8. Busch 1971; *Corpus* A143.
9. Busch 1971, p. 199.

16a: Rembrandt, *Cornelisz Claesz. Anslo*. Drawing. London, British Museum.

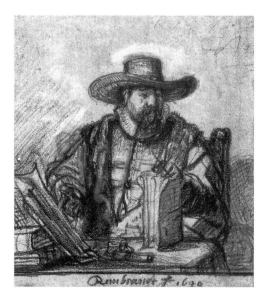

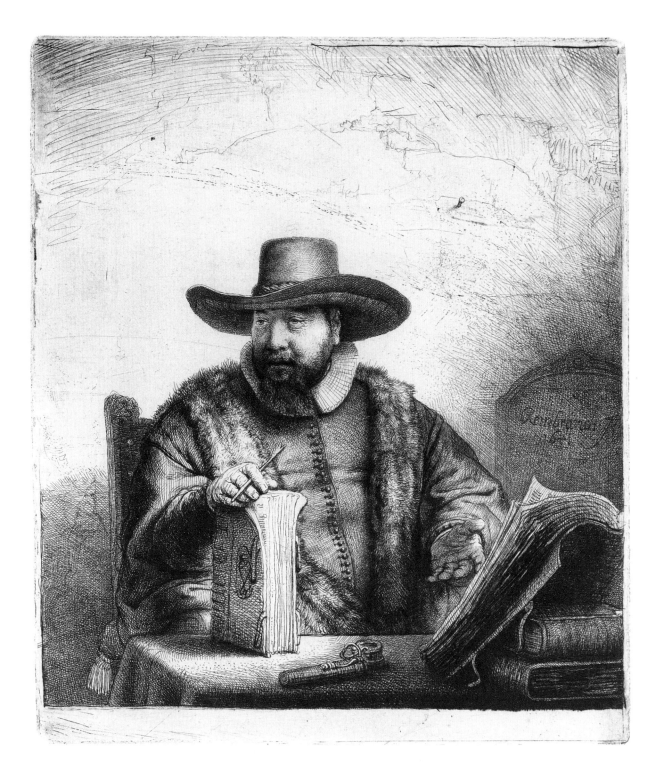

17

The Flute-Player

Etching and drypoint, 116 × 143 mm;
4 states
Signed (from II): *Rembrandt. f 1642*
B./Holl. 188; H. 200; White, pp. 164 ff.

Berlin: II (182–1878)
Amsterdam: II (61:1096)*
London: III (1973 U. 958)

In 1642, the year Rembrandt finished painting *The Nightwatch*, he etched a small-scale genre scene that was known, until the eighteenth century, by the misleading title *Till Eulenspiegel (L'Espiègle)*.[1] A young man is seen lying on the bank of a stream, his crook shows him to be a shepherd. An owl is perched on his shoulder, and in his hands he holds a flute. He seems to have only just broken off playing and is now eyeing the legs of his young companion. She wears a broad-brimmed straw hat and is seen plaiting flowers into a garland. In the background, sheep and goats crowd towards the water. At first glance this seems to be a pastoral love scene. Influenced by pastoral poetry such as P.C. Hooft's *Granida* (1605), scenes with shepherds, or pastorals, were very popular in Holland from the 1620s. Central to such scenes was the joyful gathering of shepherds to sing and make love.[2] Rembrandt only rarely treated this subject: apart from half-length portraits of *Saskia as Flora in the Costume of a Shepherdess*, only a few drawings and etchings with a bucolic theme are known.[3]

The Flute Player, nonetheless, breaks with the tradition of pastoral scenes in containing motifs that disturb the normally peaceful, idyllic character. The young man's face, in contrast, to the tradition for such figures, is ugly, almost vulgar; Rembrandt may have been inspired here by the figure with a flute in a woodcut after Titian.[4] The vulgar character of the shepherd is supported by the way in which he surreptitiously and voyeuristically peers up the girl's skirt. The owl on his shoulder, which appears to be wearing a collar with fool's bells, is an old symbol of folly and sinfulness. The

young man is seen to point his flute towards the revealed crotch of the shepherdess, and not by chance: the flute was often described in contemporary commentaries as a phallic symbol. In a pastoral scene by Abraham Bloemaert (1627), in the Niedersächsische Landesgalerie in Hannover (Fig. 17a), a shepherd pushes his flute, in an equally unambiguous manner, under the skirts of his female companion.[5] The floral garland may be understood in direct relation to the motif of the flute. Since the Middle Ages, the making of floral garlands had served as a metaphor for entering into an amorous relationship. The garland itself, however, was also a symbol of the female genitalia, or of the virginity that a girl declares she is ready to sacrifice by offering a garland to her lover. The purse of the shepherdess too may be understood, in this context, as a sexual symbol. The lascivious allusions in this scene are finally stressed through the presence of the sheep and the goats, as these animals were widely associated with sexual excess. Rembrandt repudiates the traditional pastoral scene in exaggerating the erotic aspects of the subject through bold sexual symbols and allusions. Iconographically, the *Flute Player* may be traced back to the moralising love scenes in German and Netherlandish prints of the fifteenth and sixteenth centuries, although it is impossible to point to a specific model. It seems that Rembrandt wished to comment satirically on the pastoral genre.[6]

The head emerging from the bushes towards the upper right corner remains a mystery: is it a faun or a wood spirit peeping out? But why,

17a: Abraham Bloemaert, *Shepherd scene*.
Hannover, Landesgalerie.

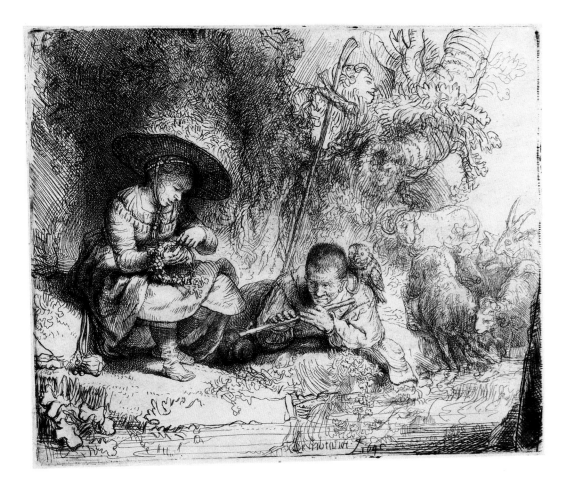

then, is its gaze turned away from the main scene? Or is this all that remains of a figure from an earlier scene, worked in part on the plate and then abandoned?[7] As the face appears in a corner, one might assume that an originally larger plate had been cut down. It seems that Rembrandt valued the charm of bizarre motifs of this sort, looking as if they had come about by chance. In the *Virgin in Glory* (B. 61), for example, he allowed an etched head of the Virgin to remain in the proofs (visible upside down in the Virgin's dress).[8]

In the four states of the *Flute Player* it is above all the relation of light and shade that is varied. In state I, shadows lie across the hat of the shepherdess; in the signed and dated state II these are thoroughly lightened and reworked as delicate foliage. In state III, the area above the hat is once again substantially darkened with drypoint lines. In state IV, changes in the foreground can be detected, and the face in the bushes has been removed. In all four states certain areas, for example in the bushes behind the shepherd, show a fair amount of surface tone.

In the Berlin example of state I, and long unnoted, there are pen additions in grey ink—in one place also in brown wash—on the shepherd's costume, on his face, on the right corner of the girl's skirt as well as on the ground visible at the right between the shepherd's shoulders and the goats (Fig. 17b). The London impression of state I shows almost the same corrections. Thicker shading is tried out with the brush additions; these must be in Rembrandt's hand as, in state II they are followed in the additional drypoint hatching lines on the plate.

H.B.

1. Gersaint 1751, pp. 148–49, No. 180.
2. On this, see McNeil Kettering 1977.
3. *Corpus* A93, A112; Benesch 424, 748; B. 189, 220.
4. McNeil Kettering 1977, p. 35, Fig. 19, p. 39.
5. Braunschweig 1978, pp. 48 ff., No. 3.
6. It is difficult to be precise about the meaning of Rembrandt's scene. Emmens interprets it as the artist's commentary on the pastoral inspiration of poetry. He claims however, that, in the vulgar character of the scene, Rembrandt was not referring to the high lyrical form of poetic inspiration, but rather to the lower, erotic form of inspiration which served the *poeta vulgaris* (Emmens 1968, pp. 147 ff.). White assumes that Rembrandt is illustrating a particular pastoral poem (White 1968, p. 164).
7. McNeil Kettering 1977, p. 21, note 7.
8. On this matter in general see Robinson 1980.

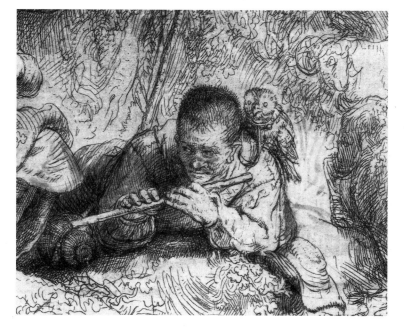

17b: Detail of Cat. No. 17, State I.
Berlin, Kupferstichkabinett SMPK

18

The Hog

Etching and drypoint, 145 × 184 mm;
2 states
Signed and dated: *Rembrandt f. 1643*
B./Holl. 157; H. 204; White, pp. 165 ff.

Berlin: I (240–16)
Amsterdam: I (61:1081)*
London: I (1910–2–12–364)

One of the oddest records of everyday life among Rembrandt's prints is this scene of a tethered pig lying on the ground with its trotters tied. A boy walks past, laughing, with a pig's bladder in his hands, while an old man is seen making ready to slaughter the animal. In his right hand he holds a basket and what appears to be a cleaver, in his left a bent wooden stick which will be used to hang the slaughtered pig up on a bar. A wooden trough hangs on the wall. A small boy, supported by his mother, looks at the animal with slightly anxious surprise.[1] Another laughing boy, wearing a hat, is indicated in the background.

Scenes of pig slaughtering, for example in late medieval book illumination, were originally incorporated into series of the months of the year, mostly representing the month of December. November was illustrated by pig fattening.[2] Late autumn was the traditional time for slaughtering, as the animals had been fattened during the summer and early autumn. In Dutch, November was also known as *slachtmaand* (the slaughtering month), and during November the *varkensfest* (pig festival) or *varkenskermis* (pig fair) was celebrated.[3] The calendrical tradition endured into the seventeenth century. In a series of months of the year by Cornelis Dusart (about 1690) pig slaughtering represents November.[4] By this time, however, the subject had taken on a certain independence as a genre scene. An etching by Adriaen van Ostade (Fig. 18a), from about the same time as Rembrandt's print, shows the event without integrating it into a series of months.[5] Children, looking on with amusement or scepticism, were a traditional element in scenes of pig slaughtering. Rembrandt's scene, however, departs from iconographic tradition in one significant respect. It does not show the slaughter itself,

18a: Adriaen van Ostade, *The Pig Killers*.
Berlin, Kupferstichkabinett SMPK.

but rather the moment preceding it. Interest is focused on the pig, which seems to have resigned itself to its tragic fate; almost smiling, and without a trace of agitation, it lies there peacefully.

The laughing boy holds an inflated pig's bladder as if it were a toy. This motif was exceptionally popular in Dutch painting, mostly in slaughter scenes.[6] Like the soap bubble, the animal bladder is found in contemporary emblem books as a symbol of earthly transience: *Homo Bulla*—man is like a bladder, puffed up with wind only to burst.[7] The pig's bladder in Rembrandt's etching could be pointing to the animal's inescapable fate, but perhaps also in a wider sense to that of man. In contemporary literature and art, pig slaughtering was treated as an allusion to earthly transience in the widest sense: 'You that see fit to slaughter your oxen, pigs and calves, think of God's verdict on the Day of Judgment'.[8]

A sheet of studies from life in the Louvre in Paris (Fig. 18b) shows two pigs, of which the recumbent one is similar in many respects to the one in the etching, though one could not speak here of a preparatory drawing in the strict sense.[9]

Rembrandt has almost exclusively etched the plate. While the background figures are marked in sketchily, the pig is precisely drawn, even down to the details of its hide. Here, Rembrandt has strengthened the contours with a few drypoint lines. In state II, of which only one example—in London—is known, a few strokes were added to the toddler's ear, to the face of the boy with the pig's bladder, and in particular to the pig.

H.B.

1. This group of mother and child was often used by Rembrandt (see Cat. No. 10); Schatborn 1975, p. 10.
2. For example, in the *Breviarum Grimani*, c. 1510–20.
3. Lawrence, Kansas; New Haven and Austin 1983/84, p. 176, No. 48.
4. B. 30, Holl. 30.
5. B. 41, Holl. 41; Lawrence, Kansas; New Haven and Austin 1983/84, pp. 176 ff., No. 48.
6. Amsterdam 1976, p. 116, No. 24.
7. Amsterdam 1976, pp. 44 ff., No. 4.
8. Amsterdam 1976, pp. 116 ff., No. 24, (from a source from 1667). 'Ghy die naer u welbehagen Os en Swijn en Kalf doet slaen; Denckt hoe ghy ten Jongsten Dage Voor Godts Oordeel sult bestaen'.
9. Benesch 777. Schatborn 1977, pp. 10–11. Paris 1988/89, p. 36, No. 25.

18b: Rembrandt, *Sheet of studies with two pigs*. Drawing. Paris, Musée du Louvre, Département des arts graphiques.

19

Landscape with three trees

Etching, worked over with engraving and drypoint; in places, sulphur tint etching
213 × 279 mm; 1 state
Signed and dated: (barely visible) *Rembrandt f. 1643*
B./Holl. 212; H. 205; White, pp. 198 ff.

Berlin: (303–1898)
Amsterdam: (O. B. 444)*
London: (1868–8–22–678)

19a: Rembrandt, *The Shepherd and his family.* Amsterdam, Rijksprentenkabinet.

19b Detail of Cat. No. 19.

The *Landscape with three trees* is Rembrandt's largest and, on account of its painterly execution, perhaps most celebrated landscape etching. The view, from about eye level, is of the gentle slope of a hillock with three large trees, and of a broad low plain with a silhouetted city in the distance.
The foreground is in dark shadow, while the landscape in the distance is brightly lit. The trees are shown against the light and form a powerful contrast to the sky, which has lightened in this region. Thick parallel hatching strokes run across the upper left corner. Whether, as has mostly been assumed, these are intended to represent a shower, remains to be established, as comparable etching clusters in the *Three Crosses* (see Cat. No. 35) are used to embody rays of light. It is equally uncertain whether a turbulent, stormy sky is really shown here, as has usually been claimed by commentators. In that case it would be difficult to explain why the figures, for example the farmers and cowherds in the plain, do not react to the storm. In spite of the turbulent sky, the landscape exudes complete calm. The treetops sway only slightly in the wind; and sun and cloud, bringing light and shadow, seem to pass swiftly, in turn, over the earth. To this extent Rembrandt has, indeed, recorded the effects of weather—perhaps the atmosphere of morning or evening, with a rising or setting sun—but not a storm in the real sense.[1]

In the left foreground we can see a fisherman with a woman sitting beside him; to the right, hardly detectable in the thick bushes on the

slope of the hillock, there are two lovers. Along the ridge of higher ground, a horse and cart are moving slowly along, carrying several passengers; and nearby there is a seated man who is drawing. The motif of the draughtsman in the landscape was often used in the sixteenth century in the circle of the Netherlandish Mannerists, for example in the work of Lukas van Valckenborch or Paulus van Vianen. Rembrandt made this his central subject in an etching of 1642–43.[2] The draughtsman seen in the *Landscape with three trees*, however, differs from the traditional treatment of this motif in one key respect: he is not looking at the landscape that is shown in the scene that the viewer of the etching beholds, instead he looks to the right where the landscape, hidden from the viewer, is apparently sunnier. Rembrandt is perhaps alluding here to the notion that the landscape artist is inspired more by his inner imagination than by the direct observation of nature.[3] Lying behind the trees, brightly lit by the sun, is a farmhouse.

It is probable that Rembrandt has here reworked his own impressions of the region around Sint-Anthoniesdijk (Diemerdijk) or around Haarlemmerdijk, not far from Amsterdam, which itself seems to be visible, silhouetted in the distance.[4] The *Three Trees*, however, is not intended to be a reliable, topographical view but, rather, a freely composed one. In a far greater measure than in Rembrandt's other landscape etchings with motifs from the environs of Amsterdam or Haarlem (see Cat. No. 20, 28 & 32), the present etching shows an idealised landscape and, indeed—because of the trees pushed into such an exposed position in the scene and the dramatically presented sky—even a 'heroic' landscape. Rembrandt's success in capturing the atmosphere, and the different appearance of illuminated and shadowed regions, recalls the ideal landscapes of the French painter active in Rome, Claude Lorraine, whose work may have inspired Rembrandt's treatment of the *Landscape with three trees*.[5] Also evident are connections to pastoral landscapes with rural, idyllic scenes of shepherds, that had been very popular in Holland since the 1620s.[6] The man and woman by the water—as in Rembrandt's small etching, *The Shepherd's Family* (Fig. 19a)[7] —are shown as a shepherd and shepherdess, the broad-brimmed straw hat of the seated woman and the basket by her side (Fig. 19b) being the traditional attributes of a shepherdess (see Cat. No. 17). A clear erotic component is added through the introduction of the pair of lovers in the bushes on the slope—hidden in the manner of the couple in Rembrandt's *Omval* of 1645.[8] The barely-visible goat near to them,

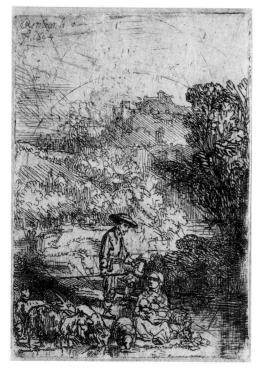

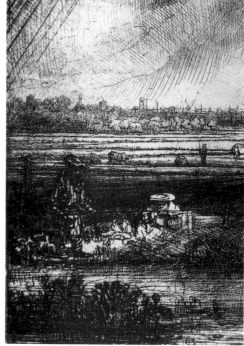

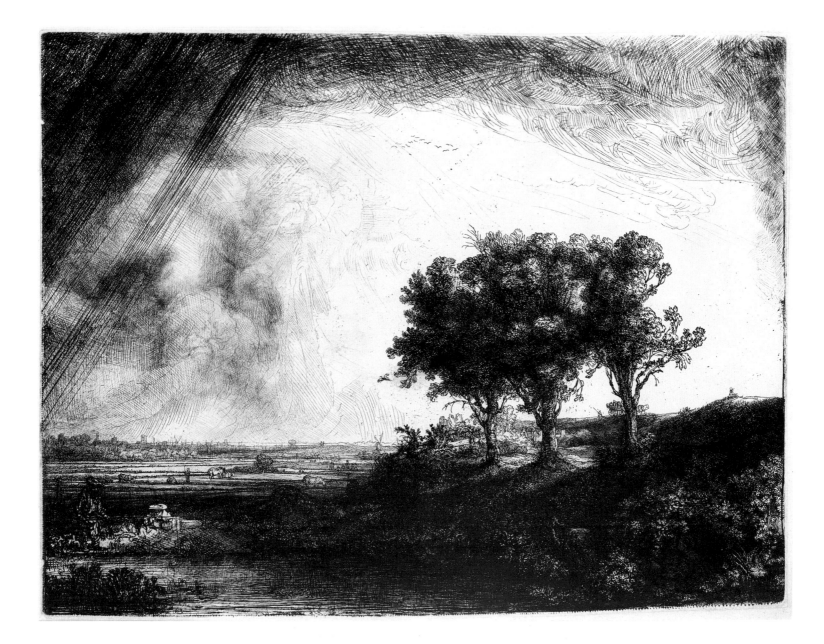

a symbol of unbridled sexuality, stresses the erotic strain of this scene (see Cat. No. 17).[9]

The Three Trees is close to Rembrandt's landscape paintings of the late 1630s and early 1640s, for example the *Hilly Landscape* in the Herzog Anton Ulrich-Museum in Braunschweig (Fig. 19c).[10] Rembrandt very deftly transfers the contrast of light and shade found in the coloured painting to the black and white print. Most of the sheet is etched, although parts of the foreground and of the sky are worked over with engraving and with drypoint. This is the earliest of Rembrandt's landscape etchings to be so extensively worked with drypoint.[11] The view of lowland, so reminiscent of the work of Hercules Seghers, has a grainy, painterly surface tone, obtained through the use of sulphur tint; and this enables Rembrandt to bring out the most delicate nuances of light and shade.

The treatment of the cloud-covered parts of the sky developed from an earlier scene, on the same plate, with a Death of the Virgin. If one turns the sheet on its side, traces of an angelic aureola can be detected, resembling that in the *Death of the Virgin* of 1639 (see Cat. No. 14). Quite cleary, Rembrandt had tried out a first version of this subject and then rejected it. He polished most of the plate smooth, in order to start work on it anew while retaining, in part, his rendering of the clouds. This procedure is also revealed in the occasional small strokes and spots from the earlier scene that remain around the trees.[12] Similarly, the cumulus cloud appearing in the background emerged as a chance product of the previously etched lines.[13]

H.B.

1. The description of this sheet as a stormy landscape could have arisen because of the way the etching was interpreted by artists: in a reproductive engraving by William Baillie from the end of the eighteenth century, the landscape is supplemented with, among other additions, a flash of lightning, and it appears much more dramatic than it is in the original; see Campbell 1980, pp. 19 ff., Fig. 21.

2. B. 219; Washington 1990, pp. 85 ff., No. 7.

3. Washington 1990, p. 241, No. 75.

4. Lugt 1920, p. 146; Filedt Kok 1972, p. 126; Campbell 1980, pp. 14 ff.

5. Rembrandt must have known Claude Lorraine's etchings, which were published since about 1630. Their compositions are often arranged in a similar manner to that found in Rembrandt's etching, with a group of trees on higher ground and a distant view over lower country; pastoral elements are also to be found in the work of Claude Lorraine. See Mannocci 1988, Nos. 8, 14, 18.

6. McNeil Kettering 1977.

7. B. 220.

8. B. 209.

9. McNeil Kettering 1977, p. 38. The goat is clearly visible on the counterproof in Boston; Washington 1990, p. 242, note 17.

10. *Corpus* A137; Schneider 1990, p. 175, No. 3.

11. White 1969, p. 200.

12. Campbell 1980, pp. 10 ff.

13. A comprehensive essay on the *Three Trees* has recently appeared, in which the landscape is interpreted, after examination of its geometrical structure and of the figures with symbolic significance, as an expression of the '*Verstandeskultur des 17. Jh.*' (seventeenth-century cult of the intellect), a '*jardin d'intelligence*' (nursery of intelligence); see Werbke 1989.

19c: Rembrandt, *Mountain Landscape*.
Braunschweig, Herzog Anton Ulrich-Museum.

20

Six's Bridge

Etching, 129 × 224 mm; 3 states
Signed and dated: *Rembrandt f 1645*
B./Holl. 208; H. 209; White, p. 202.

Berlin: III (301–16)
Amsterdam: III (O. B. 268)
London: III (1868–8–22–674)*

The sketchy quality of this etching conveys
the impression of a drawing made directly from
nature on a warm, sunny summer's day.
A river crowded with boats flows in a broad
curve from the right into the background.
A bridge at the point where the river bend
appears to continue over a side canal. On the
bridge there are two men who seem to be deep
in discussion; and beyond one can see the roofs
of village houses and the spire of a church. The
old title *Six's Bridge* stems from the inventory
drawn up by Valerius Röver in 1731 and from
an eighteenth-century inscription—'*den Heer
Six en Brugh*'—on the example in the
Rembrandthuis in Amsterdam.[1] Gersaint uses
this title in his 1751 catalogue raisonné of
Rembrandt's etchings. The traditional
identification is not correct, however. The
estate of Jan Six was near Hillegom; but the
tower in the left background of the etching
appears to be that of Ouderkerk on the Amstel,
not far from Amsterdam; the view must
have been obtained from near to the estate
Klein-Kostverloren on the Amstel which,
at the time of the etching, belonged to Albert
Coenraadsz. Burgh, one of the Burgomasters of
Amsterdam.[2]

Gersaint also relates an anecdote, in which
Rembrandt, on a visit to the estate of his
friend Jan Six, bet Six that he could draw on a
plate the view from the house of his friend, in
the time that a servant would take to collect
from a neighbouring village the mustard that
had been lacking from the table. Rembrandt,
who always carried wax-covered plates with
him, won the bet.[3] Gersaint's apochryphal
story is witness to the aesthetic judgment of
the eighteenth century, in which the sketchy
quality of Rembrandt's etched landscapes,
recalling the spontaniety of a drawing, was
admired in its own right. Since the
Renaissance, the ability to make a sketch in

a few well-placed lines met with the highest admiration from writers on art and from collectors; indeed such a sketch was often judged to be of more value than a carefully prepared, finished drawing, as the former revealed the artist's first thoughts. The appreciation of swift execution is implied in the story.[4] Gersaint was thus adopting a traditional *topos* of artistic theory; in relating his apochryphal tale of the origin of the print, he must have had an older artistic anecdote in mind.[5] It is also difficult to believe in Gersaint's claim that Rembrandt always carried with him a sketch block of prepared copper plates, allowing him to draw on the plate while he was in front of his subject. *Six's Bridge* with several other etchings, was often counted as an example of a landscape etching *naer het leven*, that is to say drawn directly from nature, because of this supposition.[6] The low view-point, the exclusion of any middle ground, and the fragmentary record of the sailing boat that is cropped at the right edge certainly do prompt one to think of a direct record of nature. Nonetheless, it is clear that a conscious artistic purpose is at work here, for the composition is devised in a very well-thought-out manner: through the complementary positioning of the trees and the boat, as well as of the balustrade of the bridge on the left and the figures on the right, the two halves of the sheet have a pleasing balance.

We only know of one drawing made by Rembrandt directly from nature (Fig. 20a)

which serves, with slight changes and additions, as the model for an etching (Fig. 20b) (drawing in the Rijksprentenkabinet, Amsterdam).[7] However, there are further landscape drawings which are directly connected with printed sheets, that is to say drawings that record views that have then been etched in a modified form (see Cat. No. 28 & 34).[8] From this evidence one can conclude that Rembrandt always carried out his landscape etchings in the studio, but referred, in doing so, to landscape studies drawn *naer het leven*. Both etching and drypoint require, from the very beginning of the process (whether marking lines in the wax or scratching the plate), so high a measure of control that, purely from the technical viewpoint, it would be most improbable for work on the plate to be carried out *en plein air*.[9] It is possible that Rembrandt consciously selected this 'spontaneous' character recalling a landscape sketch for *Six's Bridge*, because he was aware how highly such sketches were appreciated by collectors.[10]

In state II, only the hat of the man in the foreground is lightly hatched; in state III, also that of the man talking to him.

H.B.

1. Van Gelder/Van Gelder-Schrijver 1938; Filedt Kok 1972; p. 124.
2. Lugt 1920, pp. 114 ff.
3. The key passage reads: '. . . & comme Rembrandt avoit toujours des planches toutes prêtes au vernis, il en prit aussi-tôt une, & grava dessus le Paysage qui se voyoit du dedans de la salle où ils étoient: en effet, cette planche fut gravée avant le retour du Valet'. Gersaint 1751, pp. 162–63, No. 200 and p. XXVIII.
4. Held 1963, pp. 88–89.
5. Carlo Malvasia (1678) records a similar anecdote: the painter Elisabetta Sirani was said to have been so inspired by the account of a scene of the Baptism of Christ that she reached at once for paper and so swiftly recorded her own *Baptism of Christ* that this was finished before the end of the conversation; Held 1963, p. 88.
6. Amsterdam 1983, p. 7. Washington 1990, p. 26. Schneider cites as examples for etchings probably made directly from nature: *Six's Bridge*, B. 208; *View of Amsterdam*, B. 210; *Farmhouse with the Draughtsman*, B. 219; *The Fence in the Wood*, B. 222; *The Goldweigher's Field*, B. 234. On B. 234, see also Cat. No. 28.
7. Benesch C41; Schatborn 1985, pp. 68–69, No. 30.
8. Washington 1990, pp. 207 ff., Nos. 58–59; pp. 253 ff., Nos. 81–84.
9. Emmens 1968, pp. 155 Slatkes 1973, p. 260.
10. Held 1963, pp. 86–87.

20a: Rembrandt, *Cottage with paling*. Drawing. Amsterdam, Rijksprentenkabinet.

20b: Rembrandt, *Cottage with paling*. Amsterdam, Rijksprentenkabinet.

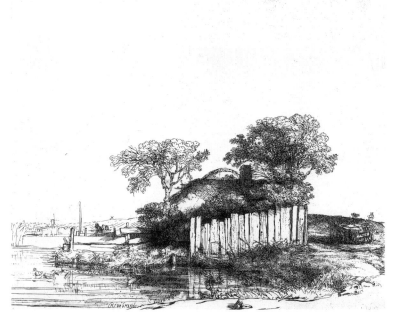

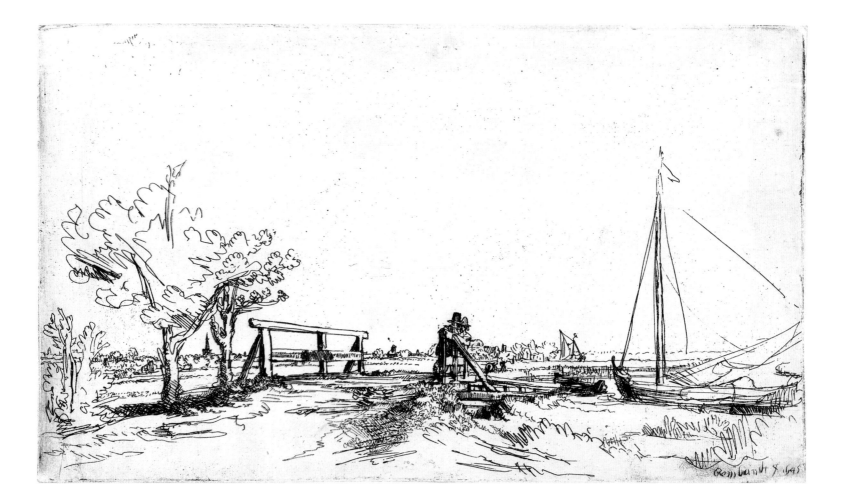

Two male Nudes and a Mother and Child ('Het Rolwagentje')

Etching, 194 × 128 mm; 3 states
c. 1646
B./Holl. 194; H. 222; White, pp. 178 ff.

Berlin: I (171–1898)
Amsterdam: II (O. B. 251)*
London: I (1973 U. 983)

21a: Rembrandt pupil (?), *Standing male nude model*. Vienna, Graphische Sammlung Albertina.

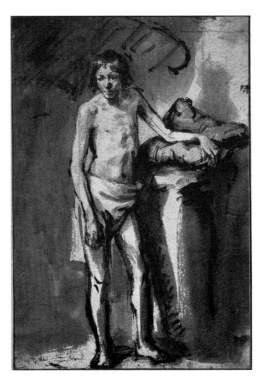

In 1646 Rembrandt made three etchings with male nudes, which were studies from the same model (Fig. 21b).[1] The etchings are identical in style and technique, yet one differs from the others in including a background scene. In the foreground we find two male nudes, one seated, the other standing. Behind, Rembrandt has sketchily indicated the figure of a mother teaching her child to walk with a walking frame.

During his long career, Rembrandt often employed various pupils and assistants, and traditionally, drawing from the model counted as part of the young artist's training. Four drawings by Rembrandt's pupils record the same model as seen in the etchings.[2] Three of these drawings show the same standing boy as in the etching with the walking frame. As he is recorded from a slightly different viewpoint in each case, one may conclude that three pupils—or even more—as well as the teacher drew from the model at the same time. The drawing in Vienna is closest to the etched figure (Fig. 21a).[3] The reversal occasioned by printing shows that Rembrandt himself drew directly on the prepared copper plate during the studio sitting.[4]

Rembrandt's etchings with male nudes were probably planned as models for the instruction of his pupils. The French art critic, d'Argenville, reported in 1745 that Rembrandt had produced a small teaching manual: 'Son livre à dessiner est de dix à douze feuilles' (His drawing (instruction) book has ten to twelve pages).[5] Not a single example of this has survived, but it is certainly possible that Rembrandt assembled a drawing instruction booklet of this sort from etched illustrations. Among these would have been sheets with nude models and perhaps also studies of heads (see Cat. No. 5).[6] The similarity of Rembrandt's models to both the nude figures in surviving drawings by pupils, and to models in contemporary drawing instruction manuals, supports the assumption that these works served as models in Rembrandt's studio. In *'t Light der teken en schilder konst* (Guide to Drawing and Painting) (1643) by Crispijn de Passe II, we find, for example, a seated male nude (Fig. 21c) in the same pose as that of the seated model in the etching B. 196 (Fig. 21b).[7]

What, though, in this context, is the meaning of the background scene? Is this a sheet of studies in which thematically unconnected scenes are brought together because of their aesthetic appeal? In 1751, Gersaint had already declared that he could find no thematic connection between the motifs: '. . . y ayant plusieurs choses gravées, qui, quoique finies, n'ont aucun rapport entre

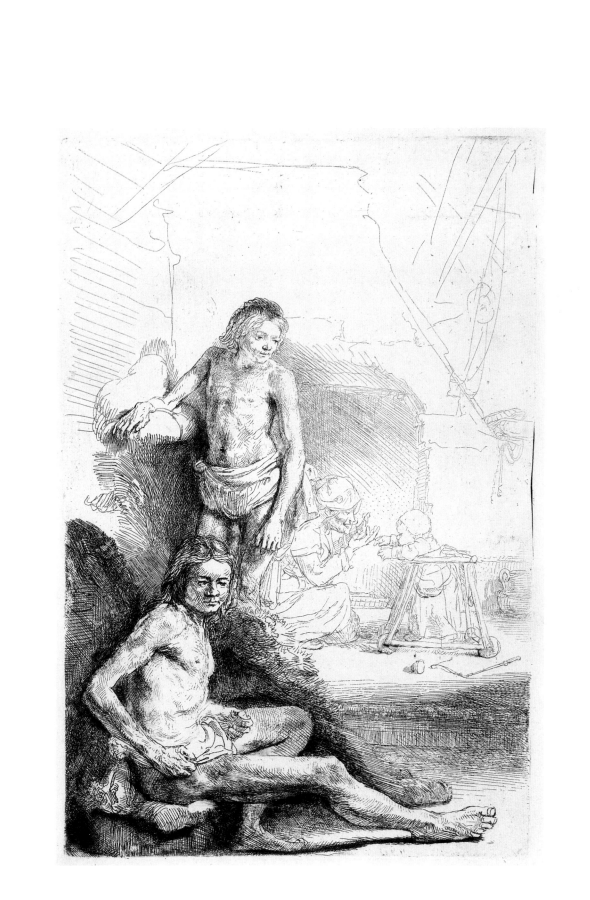

elles' (showing several engraved motifs which, though finished, have no connection with each other).[8] On occasion, the child and woman have been interpreted as Rembrandt's son Titus and the child's nurse Geertje Dircks.[9] The background scene, however, is not in itself without significance: in an extended sense, it points to the role that the nude model plays in the teaching of drawing.[10] The child in its walking frame was used in seventeenth-century literature and emblem books as a symbol of man growing to maturity only through learning and exercise. Franciscus Junius and Joost van den Vondel compared the constant exercise of training artists with a small child's laborious attempts to walk. The sketched scene in the background thus alludes to the role of the model sheets: the young pupil is presented with nude models, who he is to draw, and at the same time he is advised that art is to be mastered only through constant exercise: *Nulla dies sine linea*—no day should pass without drawing—so went the saying. Rembrandt's etching *The Artist drawing from the Model* also takes as its subject the significance of study from life and of the art of drawing (see Cat. No. 15). Despite their didactic intent, Rembrandt's works were also desired collectors' pieces.[11]

The differences between the states are not significant; in state I several white spots of etching fluid, especially on the figure of the seated model, can be seen; in state II they have been covered over with fine, short hatching lines. State III underwent further small reworkings. A maculature and a counterproof, in both cases of state I, have also survived.
H.B.

1. B. 193, 194, 196.
2. Benesch A 48, A 709, A 55, 710; Amsterdam 1984–85, pp. 4 ff. and pp. 30 ff., Nos. 18 ff.
3. Benesch IV, 709; Amsterdam 1984–85, p. 33, No. 21.
4. The same goes for the two other etchings with male nudes. The fourth pupil's drawing in this group shows a seated boy similar to the corresponding model in the etching B. 193, here also reversed; Benesch A 48; Amsterdam 1984–85, pp. 30–31, Nos. 18–19.
5. Emmens 1968, p. 157.
6. Emmens 1968, p. 158; Bruyn 1983, S. 57.
7. Emmens 1968, Figs. 36–37; Bolten 1985, pp. 27 ff.
8. Gersaint 1751, p. 152, No. 186.
9. For example in Münz 1952, Vol. II, p. 80, No. 136.
10. On this, see Emmens 1968, pp. 154 ff.
11. Amsterdam 1984–85, pp. 6–7.

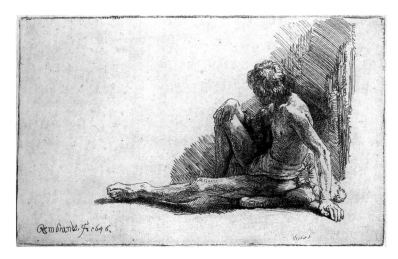

21b: Rembrandt, *Seated male nude model*. Berlin, Kupferstichkabinett SMPK.

21c: Crispijn de Passe II, *Seated male nude model*, from *'t Light der teken en schilder konst*, Plate XXVI.

22

Portrait of the Preacher
Jan Cornelisz. Sylvius

Etching, drypoint, burin and sulphur tint
278 × 188 mm; 2 states
Signed and dated: *Rembrandt 1646*
B./Holl. 280; H. 225; White pp. 127–28

Berlin: II (372–16)
Amsterdam: II (62:107)*
London: I (1973 U. 984)

Translations of the Latin inscriptions read:
'My hope is Christ. Johannes Cornelisz.
Sylvius, Amsterdamer, filled the function of
preaching the holy word for forty-five years
and six months. In Friesland, in Tjummarun
and Firdgum, four years; in Balk and Haring
one year; in Minnertsga four years; in Sloten,
Holland, six years, in Amsterdam twenty-eight
years and six months. There he died, on 19
November 1638, 74 years of age.'

'Thus is how Sylvius looked—he whose
 eloquence taught men to honour Christ /
And showed them the true path to heaven. /
We all heard him when with these lips /
He preached to the burghers of Amsterdam. /
Those lips also gave guidance to the Frisians. /
Piety and religious service were in good hands /
As long as their strict guardian looked over
 them. /
An edifying era, worthy of respect on account /
Of Sylvius's virtues; he tutored full-grown
 men /
In catechism until he himself was old and
 tired. /
He loved sincere simplicity and despised false
 appearance. /
He did not attempt to ingratiate himself /
To society with outer display. /
He put it this way: Jesus can better be taught /
By living a better life /
Than by raising your voice. /
Amsterdam, do not let his memory fade; he
 edified you /
Through his righteousness and represents you
 illustriously to God.'
C. Barlaeus

'This man's gift I cannot paint any better. /
I attempt to emulate him, but in verse I fail.'
P. S. [Petrus Scriverius][1]

Jan Cornelis Sylvius (1564–1638), who 'preached the holy word for forty-five years and six months' as a member of the reformed congregation, embarked on his church career with a long series of country posts in Friesland. In Amsterdam from 1610, Sylvius was pastor at the city hospital from 1619 to 1622, before becoming minister at the Oude Kerk. During the course of his 16 years in office, there were many passionate disputes about church policy and administration, in which the remonstrants finally prevailed. The fact that Sylvius was able to retain his place on the church council until his death, despite the quarrels between the Reformed Church and the Remonstrants, may have owed much both to his tolerance and to his liberal attitude in political and religious matters.

In 1595 Sylvius married Saskia's elder cousin, Aaltje van Uylenburgh. In 1634 Sylvius acted as proxy for Saskia, who was then still living in Friesland, at her official betrothal to Rembrandt in Amsterdam. It may have been on the occasion of his engagement to Saskia in 1633 that Rembrandt produced his first portrait of the cleric (Fig. 22a).[2] This shows Sylvius in his study, in concentrated mood and with his hands laid, one over the other, on the open Bible. Two years later Sylvius and Aaltje were godparents to Rembrandt and Saskia's first child, and in 1638 Sylvius performed the baptism of their second child.

In 1646 Rembrandt etched a second, posthumous portrait, which shows Sylvius within an oval frame surrounded by an inscription and with an obituary added below. Significantly, the inscription does not come from the hand of a scholar who belonged to the Reformed Church. Caspar Barlaeus, whose 14-line Latin poem honours equally the piety, virtue, simplicity and eloquence of the cleric, was a Remonstrant, as was the author of the succinct commemorative poem, Petrus Scriverius.[3]

Only two of Rembrandt's portraits have added inscriptions, the other being the portrait of Johannes Uytenbogaert of 1635,[4] which is presumed to be the first 'official' portrait by Rembrandt who had previously produced etchings of members of his own family. As the early portrait of Sylvius also shows the sitter without an inscription, it would seem that Rembrandt portrayed him there as a relative. It was, however, usual in the seventeenth century for portraits to bear inscriptions; and it would thus seem that the later portrait of Sylvius uses an official formula.[5] It is possible that, in producing the posthumous etching of 1646, Rembrandt was trying to strengthen his relations with Saskia's family.[6] These had

swiftly deteriorated after Saskia's death in 1642, although Rembrandt remained dependent on the Uylenburghs. Although it is also possible that the portrait was commissioned,[7] there is no record of such a commission. An attempt to follow the evolution of the posthumous portrait of Jan C. Sylvius is, not least, dependent on the dating of the two preliminary sketches; for it is only from this moment that one can establish Rembrandt's preoccupation with the portrait.[8]

The first of the two preparatory drawings marks out the basic elements of the composition (Fig. 22b).[9] In the London drawing the figure does not lean out of the frame, but the drawing shows the forward-leaning pose which engages with the viewer, though still lacking the crucial distribution of light and shadow and the dramatic use of the frame-cutting figure (Fig. 22c).[10] In contrast, for example, to the drawing for the portrait etching of Anslo (Cat. No. 16), the London drawing is not finished in the manner of a *modello*, but is rather sparing in its indication of the intended appearance of the portrait.

The ensuing etching strengthened the theatrical effect. Sylvius leans forwards in an illusionistic movement out of the frame, so that a bold shadow is cast by his hand gesturing as if to accompany his words, by his profile and by the book in which he is careful to keep his place. In Dutch painting there are a number of earlier examples of such an illusionistic use of an oval frame;[11] however and in the case of Rembrandt's etching it can be shown that there is a specific model—the engraving made by Jan van der Velde after the portrait of Petrus Scriverius painted by Frans Hals (Fig.

22a: Rembrandt, *Portrait of the Preacher Jan Cornelis Sylvius*. Berlin, Kupferstichkabinett SMPK.

Spes mea Christus. Iohannes Cornelÿ Sylvius Amstelodamo bat: functus S.S. Ministerio: aõs 45. et 6. menses. In Frysia, in Tzummarum et Phirdam aõs 4. In Balc et Harich unicum.

Hollandiā Slotis aõs 6. Amstelodami aõs 28. et 6. menses, ibidemq obÿt aõ 1638. 19. Novembr. natus aõs 74.

Cuius adorandum docuit Facundia Christum.
 Et populis veram pandit ad astra viam.
Talis erat Sylvi facies. audivimus illum
 Amstelÿs isto civibus ore loqui.
Hoc Frisÿs praecepta dedit; pietasq severo
 Relligioq diu vindice tuta stetit.
Praeluxit, veneranda suis virtutibus, atas.
 Erudytq ipsos possa senecta viros.

Simplicitatis amans fucum contemsit honesti.
 Nec sola voluit fronte placere bonis.
Sic statuit: Iesum vita meliore doceri
 Rectius, et vocum fulmina posse minus.
Amstela, sis memor extincti, qui condidit urbem
 Moribus, hanc ipso fulsÿt illo Deo.
 C. Barlaeus.
Haud amplius depraedico illius dotes,
 Quas aemulor, frustraque persequor versu.
 P.S.

22b: Rembrandt,
Study for the Portrait of Jan Cornelis Sylvius.
Drawing. Stockholm, Nationalmuseum.

22c: Rembrandt,
Study for the Portrait of Jan Cornelis Sylvius.
Drawing. London, British Museum.

22d).[12] As Petrus Scriverius was one of the two authors of the inscriptions in Rembrandt's etching, it would seem that he might have drawn Rembrandt's attention to this portrait. This may explain the most significant of the differences between the London preparatory drawing and the final etching—the use of the figure gesturing out of the frame. At the same time the innovations made by Rembrandt become more evident through comparison with the earlier work by Frans Hals, dated 1626. Rembrandt has transformed the calm gesture recorded by Hals into a most lively one. Sylvius directly addresses the viewer.

Rembrandt has achieved a subtle gradation of grey tones by creating a network of fine lines. The technique employed for the rendering of the face and the texture of the frame is particularly striking. Here Rembrandt uses a special method of etching—sulphur tint. Grains of sulphur, suspended in an oily liquid, are applied to the plate.[13] Rembrandt used this technique on several occasions in the 1640s,[14] and it is possible that he may also have done so even earlier.[15] The richly rendered grey tones, achieving the effect of a soft wash, were greatly praised in the early eighteenth century as a precursor of the mezzotint process which was then just coming in to fashion. Houbraken, for example, drew particular attention to the

delicate and brilliant softness of the shading achieved through this technique.[16]

B.W.

1. English translation cited from the English edition of Schwartz (1985), p. 185.
2. B. 266.
3. On the two scholars, see Schwartz 1987 and also Kauffmann 1920.
4. B. 279.
5. Amsterdam 1986/87, pp. 15 ff.
6. Amsterdam, 1986/87, p. 23.
7. Schwartz 1987, p. 135, for example, supports this view, arguing that the etching was possibly made on the occasion of the marriage of Wendela de Graeff and Willem Schrijvers (Scriverius).
8. The evolution of the first sketch (Benesch 762a) has repeatedly been fixed in the period 1639–40 (Welcker 1954, Boon 1956; see White 1969, p. 127). If this dating is correct, art-historical research would no longer have to explain the late and very markedly posthumous award of the commission of the Sylvius etching but, rather, the fact that Rembrandt allowed more than five years to elapse between the sketch and the completion of the etching.
9. Benesch 762a; Stockholm, Nationalmuseum.
10. Benesch 763; London, British Museum.
11. For example, the portrait of the musician Jan Pietersz. Sweelinck, ascribed to Gerrit Pietersz. Sweelinck (1566–1616) now in the Gemeente Museum in The Hague; see Slatkes 1973.
12. The painting by Frans Hals is now in The Metropolitan Museum, New York; see also Washington 1989, No. 20.
13. For discussion on this technique, see White, and Boston 1980/81, No. 97. I regard as correct the unequivocal assessment of the technique of this last item as an etching procedure, a conclusion also supported by examination with a microscope.
14. See the *Landscape with the three trees* (Cat. No. 19).
15. For example, *The Angel appearing to the Shepherds* (Cat. No. 9).
16. Houbraken 1718, p. 271.

22d: Jan van der Velde, after Frans Hals, *Petrus Scriverius.* Amsterdam, Rijksprentenkabinet.

23

Jan Six

Etching, drypoint and burin, 244 × 191 mm;
4 states
Signed and dated: (from II) *Rembrandt f. 1647*
B./Holl. 285; H. 228; White pp. 130–32

Berlin: III (369–16)
Amsterdam: I on Japanese Paper (O.B. 578)*
London: III (1973 U. 986)

A notary's certificate of 1655 remarks of an apparently unexecuted portrait etching to be made for Otto van Kattenburch that it was to equal in quality the portrait etching of Jan Six. The proud sum of 400 gilders is cited as the estimated price: '. . . en conterfeytsel van Otto van Kattenburch, twelck de voorsz. van Rijn sal naer 't leven etsen, van deucht als het conterfeytsel van d'Heer Jan Six, ter somme van f 400, 0'.[1]

It seems that the portrait etching of *Jan Six* was commissioned by the sitter. Jan Six (1618–1700) came from a noble Huguenot family which had fled at the end of the sixteenth century from Saint Omer in France to Amsterdam, being active there in both the textile trade and silk dying. Until about 1652 Jan Six had carried on the family business, in 1656 he became a lawyer specialising in marital disputes. In 1691 he was made a burgomaster of Amsterdam.

Six devoted a considerable part of his time to the arts, in particular poetry. He was a member of the so-called 'Muiden Circle' that gathered around the successful man of letters, Pieter Cornelisz. Hooft (1581–1647), and which had, at times, also invited the poet Joost van den Vondel to its meetings.[2] Like Rembrandt, Jan Six was a passionate collector of works of art (Dutch and Italian Masters, antique sculpture, engraved gems etc.). In about 1640 Six, like Hooft, had travelled to Italy. Although his taste tended rather towards the classical artistic ideal, Six is known to have purchased paintings by Rembrandt, for example *John the Baptist preaching* (Paintings Cat. No. 20).[3]

A series of drawings and etchings in particular allow one to assume that Rembrandt and Jan Six enjoyed a friendly relationship that, at times, went beyond a mere business connection. Documentation such as letters has

not survived. A year after the 1647 portrait etching of Jan Six, Rembrandt created the title page for Six's tragedy *Medea*.[4] Two drawings for Six's *Pandora*, an *album amicorum* of the sort then in use in Humanist circles, and dated 1652. A variety of *symbola amicitiae*, dedications, poems, emblems and, in particular, portraits of celebrated authors and artists, served to embody the idealised presence of friends as well as the memory and the strengthening of friendship. For Six, the devotee of Italian art, Rembrandt produced two drawings with classical themes: *Homer reciting verses*, which bears the dedication 'Rembrandt aen Joanus Six' (From Rembrandt to Johannes Six),[5] and *Minerva in her Study* (Drawings Cat. No. 31 A & B).[6] In 1654, Six married Margaretha Tulp, daughter of the anatomist and burgomaster Nicolaes Tulp, one of Rembrandt's first patrons in Amsterdam. It was probably in the same year that Rembrandt painted the portrait of Jan Six that is still in the collection of the Six family.[7]

The work process of the portrait etching dated 1647 is documented in three drawings. The earliest of these (see Drawings Cat. No. 23, here Fig. 23a)[8] shows the sitter looking relaxed and suave. Leaning on the window ledge, he looks at the viewer, a dog jumping up to his knee. It appears, however, that this arrangement failed in the end to meet with the sitter's approval. In a small, sketchy study, the pose of the figure is altered,[9] and it is then elaborated in a thoroughly composed preparatory drawing (Fig. 23b).[10] This last drawing has been traced on to the copper-plate, indicating that it served as an direct *modello*.

In his portrait etching, Rembrandt managed not only to acknowledge the social status of Jan Six, but also to present him as a cultivated man of letters and an art collector. This becomes especially clear in comparison with earlier portraits, for example the engraving of Scriverius after the portrait by Frans Hals (Fig. 22d). There the pose of the sitter reveals none of the virtues praised in the inscription: 'This is the portrait of a man who shunned office, / protected the Muses with his own money / and who loved the seclusion of his house . . .'.[11] Pose and text complement each other. In Rembrandt's portrait of Jan Six, on the other hand, praise of the scholar and a record of his social position are incorporated into the visual presentation. This etching does not require an added explanatory inscription.

At the window, framed by a heavy curtain—a traditional motif associated with worthiness in formal portraits—and thus standing in the light, Jan Six leans, reading a book. The unmarked paper surface used for the

window is skilfully integrated into the composition and leads the viewer's attention to the face of the sitter. It is possible that the elegance of the pose points to the ideal of the educated courtier that had found its literary formulation in the *Libro del Cortegiano* of Baldassare Castiglione.[12] Books and manuscripts on the chair in the foreground as well as the painting on the wall—provided with a curtain as was usual in the seventeenth century—acknowledge the sitter's erudition and connoisseurship. The sophisticated iconography allows one to assume an intensive dialogue between the artist and his patron.

Although the first state of the etching (only known in two examples in Amsterdam and Paris) is not signed and is apparently a trial proof, it shows the completed composition, apart from later corrections of detail. The work is striking for the richness of its technical execution. With the use of a fine network of hatching, worked up with the burin and, in certain places, with drypoint, Rembrandt achieves subtle gradations of the velvety black and grey tones. This artful execution stresses the high standard to which Rembrandt was working—as if in competition with a painted portrait—apparently as requested by Jan Six. Thus, as Röver wrote in 1731, he possessed impressions of burgomaster 'den ouden burgemester Jan Six, een van de allerraarste van alle de printen van Rembrandt, omdat de familie deze plaat en affdrukken altijt onder zig heeft gehouden en de printen overal a tout prix opgekogt'[13] (the old Jan Six, [which was] one of the rarest of Rembrandt's prints because the family [of Six] still owned the plate and sold

the prints everywhere at the full price) (Fig. 23c).

B.W.

1. *Urkunden* 163. The appreciation of this etching is already documented within Rembrandt's lifetime in the form of a panegyric by Lascaille (*Urkunden* 223).
2. See R. P. Meijer 1971, pp. 104 ff.
3. *Corpus* A106.
4. B. 112.
5. Benesch 913.
6. Benesch 914.
7. Bredius 276.
8. Benesch 767, Amsterdam, Six collection.
9. Benesch 749 verso, Amsterdam Historisch Museum.
10. Benesch 768, Amsterdam, Six collection.
11. English translation cited from English edition of Schwartz (1985), p. 25.
12. On this, see Smith 1988.
13. Van Gelder/Van Gelder Schrijver 1938, p. 4. The plate is still in the possession of the Six family (Six 1969, p. 69).

23a: Rembrandt, *Jan Six*. Drawing. Amsterdam, Six Collection.

23b: Rembrandt, *Jan Six*. Drawing. Amsterdam, Six Collection.

23c: The etching plate for the Portrait of Jan Six. Amsterdam, Six Collection.

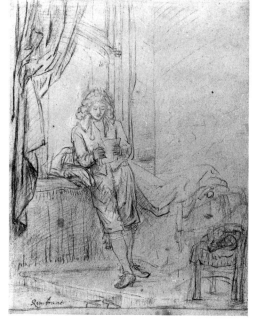

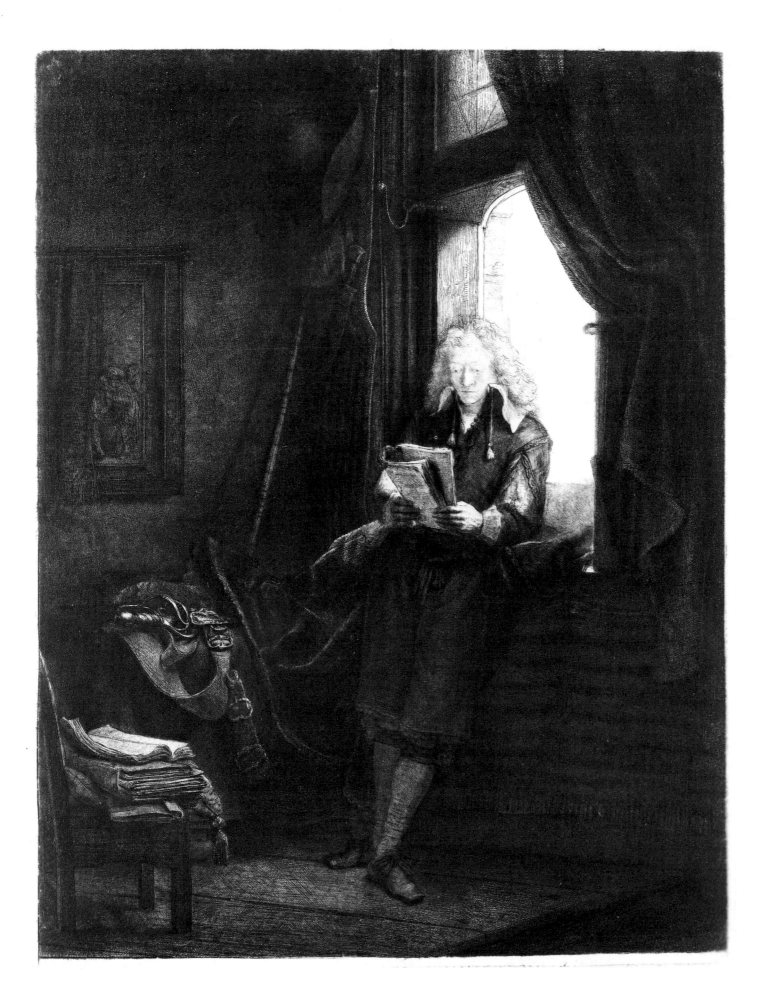

24

Saint Jerome
beside a pollard willow

Etching and drypoint, 180 × 133 mm;
2 states
Signed and dated: (only in II) *Rembrandt. f.*
1648.
B./Holl. 103; H. 232; White, pp. 206 ff.

Berlin: I (155–16)
Amsterdam: I (O. B. 168)*
London: I (1973 U. 996)

24a: Rembrandt (?), *The pollard willow.*
Drawing. Turin, Biblioteca Reale.

234

Rembrandt, who was a Protestant, treated a great many biblical subjects; yet scenes with saints worshipped by the Catholic church are rarely found in his work. Only the figure of Saint Jerome, who appears in a number of Rembrandt's etchings, preoccupied the artist over many years (see Cat. No. 31).[1] Rembrandt would have been fascinated by the combination of the ascetic and the scholarly in the life of this saint and Church Father. On account of his self-denying way of life—for several years he retreated to the wilderness to live as a hermit—and his translations and expositions of the Bible, he had become an honoured model for scholars and Humanists both north and south of the Alps during the Renaissance. As one of his attributes, Jerome is accompanied in pictorial representations by a lion, out of whose paw, according to legend, he had pulled a thorn.

Rembrandt shows the saint cut off from the world in a peaceful, sunny landscape. Jerome sits, absorbed in his writing, next to the gnarled stump of a willow at the water's edge, more a philosopher and learned author than a hermit doing penance. In front of him lie a skull and a crucifix—alluding to the expectation of Salvation in the life to come and to the saint's piety—and next to him lies his cardinal's hat. The lion looks out from behind the tree trunk. In the background, indicated with only a few strokes, a hilly landscape rises up with a waterfall cascading down it.

The plate was worked in two clearly separate stages. The central motif, the willow stump and a few sprays of grass and reeds, were etched first; and the remaining elements of the picture—the saint with his desk, the lion and the large, lower branch of the willow—were added with drypoint in the second working. In addition, drypoint reworkings are to be found on the base of the trunk and on the reed in the foreground. It thus seems as if the study of a dormant willow was the starting point for the scene, and one might speculate that the figure of the saint was only added as an afterthought, perhaps because Rembrandt regarded the subject of a single tree as too trivial for an etching intended for sale. This thesis is supported by the fact that a drawing in the Biblioteca Reale in Turin records a very similar willow stump, significantly in reverse (Fig. 24a).[2] The attribution of the drawing, however (which scholars have usually regarded as a study for the tree in the etching) is no longer secure; and the fact that comparable willow stumps are also to be found in the *Omval* (1645) and *Saint Francis* (1657) etchings[3] indicates that the tree found in the *Saint Jerome* is not necessarily to

be seen as a study from nature.

There is also iconographic evidence that the scene was conceived from the start as a unified whole. The ancient tree stump with new shoots of greenery, accompanied by a crucifix, was a traditional motif in scenes with Saint Jerome, where it symbolised the renewal of life.[4] Rembrandt apparently first intended to show the crucifix attached to the tree trunk, but then decided to show it lying on the desk behind the skull; for somewhat below the short branch that could have served to show the bar of the cross, traces of a re-working of the plate can be seen. Rembrandt's *Jerome* is, however, closer to iconographic tradition than is often assumed.

As in the later Jerome scene of 1654 (see Cat. No. 31), here too Rembrandt was re-working Venetian models. An engraving by Marcantonio Raimondi after Titian, or a reversed reproductive engraving by Agostino Veneziano after that, may have served as his inspiration. In these the saint is shown seated in a similar manner at a desk fastened to a tree trunk.[5]

State I has the strongest drypoint passages, especially in the foliage of the projecting branch and in the reeds in the foreground. In state II, printed with less drypoint burr, the foreground is somewhat altered, and the signature and date are added; as well as this, both the lion's head and several reed stems are modelled with delicate short strokes.

H.B.

1. B. 100–6.
2. Benesch 852 a; White 1969, Vol. I, p. 206; Vol. II, Fig. 313; Washington 1990, pp. 164 ff., No. 41, note 1.
3. B. 209, 107.
4. Kuretsky 1974; Wiebel 1988, p. 112.
5. Marcantonio Raimondi: B. 102; Agostino Veneziano: B. 103. See also Washington 1973, pp. 396–97, Fig. 19–6. Dürer's dry-point print B. 59 is often cited, though in my view without any real justification, as a model for Rembrandt's *Jerome*; see, for example, Washington 1990, pp. 164 ff., No. 41.

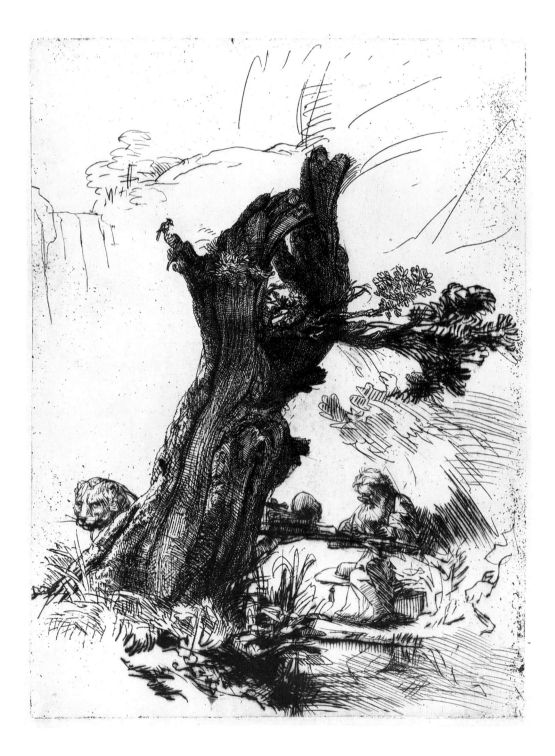

25

Self-portrait drawing at a Window

Etching, drypoint and burin, 160 × 130 mm; 5 states, the last 2 probably not by Rembrandt
Signed and dated: (from II) *Rembrandt. f 1648*
B./Holl. 22; H. 229; White pp. 132–34

Berlin: I (305–1898)*; II (2–16)*
Amsterdam: I on Chinese paper (O.B. 39);
II (62:9)
London: I (1855–4–14–260);
II (1910–2–12–357)

After his ambitious self-portrait of 1639 (Cat. No. 13), it was not until 1648 that Rembrandt made another etched self-portrait. Particularly in comparison with the earlier work, this representation of the self seems to have an unpretentious air. Nonetheless the half-length portrait with the view through a window to one side reflects a traditional portrait type that, in varying forms had been used increasingly by artists since the fifteenth century.

Rembrandt looks at the viewer with unswerving directness. He shows himself working. The copper plate—or, possibly, as a reference to the superiority of *disegno* in art theory—the drawing sheet on which Rembrandt is at this moment working, rests on a thick book.[1] While, in his self-portrait of 1636 (Fig. 25a)[2] the artist is indeed similarly depicted engaged in drawing—though there, he is shown in a double-portrait with his wife Saskia—in the present etching he is not dressed to emphasise his social rank. On the contrary, he wears a simple hat and a plain smock. This outfit is also seen in a drawing from a few years later (about 1655/60), one of Rembrandt's few full-length self-portraits (Fig. 25b).[3] A Dutch inscription, probably not from before the eighteenth century, is added to this sheet: 'Getekent door Rembrandt van Rijn naar sijn selves, sooals hij in sijn schilderkamer gekleet was' (Rembrandt van Rijn, drawn by himself, as he was usually dressed when in his studio).[4]

In the etched self-portrait, it is not only

25a: Rembrandt, *Self-portrait with Saskia*. Berlin, Kupferstichkabinett SMPK.

25b: Rembrandt, *Self-portrait*. Drawing. Amsterdam, Museum het Rembrandthuis.

25 State I

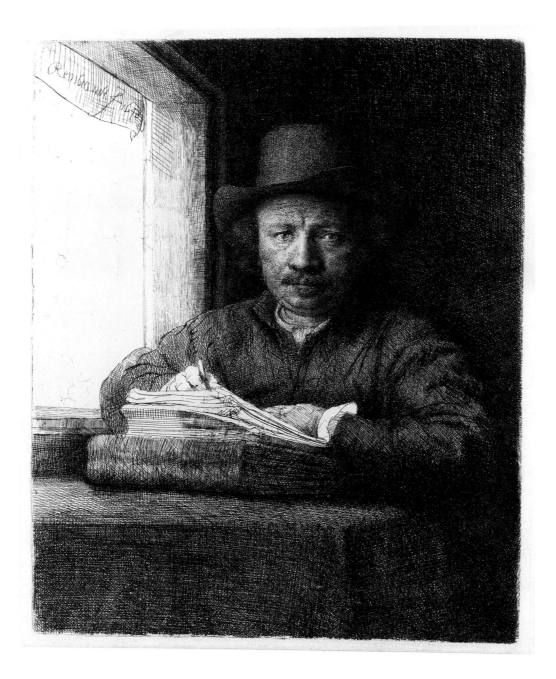

composition and lighting that focus attention on Rembrandt's face. The detailed and sensitive record of physiognomy provokes greater interest in contrast to the more summary treatment of both the torso and the setting. The light, entering from the left through the window, is closely studied in its effects. Trial proofs of the unfinished plate (state I) give an insight into Rembrandt's working method. To begin with, the composition as a whole is bitten, with the distribution of light and shadow. The evidence of some burnishing-out of the worked plate, for example below the artist's right hand, indicates that corrections have been made. While the face is already modelled in detail at this stage, the other forms are at first recorded only as simple shapes. Rembrandt has included the deepest blacks with heavy drypoint strokes. Not until the second state does Rembrandt fully establish the gradual changes within the passages of shadow, using further bitten cross-hatching and lines applied with the burin and with drypoint. Rembrandt signed this version and only made some final, minor corrections in state III. Only three states of the etching come from Rembrandt's hand; and the decorative provision of the landscape in the view from the window in the two other known states is probably a later addition.

Keen attempts have been made to find traces of biographical information in Rembrandt's facial expression in this portrait. It has been claimed that after his luxurious and self-conscious way of life in the 1630s, Rembrandt was deeply marked by Saskia's death but gradually found a new inner calm. Such interpretations will always depend on personal associations. We should also probably see in this portrait a comment on the artist's own position. Rembrandt has here defined his self-representation in direct reference to his activity as a draughtsman. This form of artist's self-portrait is taken up once again in an etching dated 1658 and now generally accepted by Rembrandt's hand (Fig. 25c).[5] Obviously, even in Rembrandt's late work, with its quite distinct style, the self-presentation of the artist as a draughtsman, as invented in the 1648 etching, was still found to be appropriate.
B.W.

1. On the discussion of this matter, see most recently Chapman 1990, p. 82, with bibliography.
2. B. 19.
3. Rembrandthuis, Amsterdam, Benesch 1171.
4. A French inscription on the mounting makes the same claim; Filedt Kok 1972, No. 1.
5. Holl. S 279. Only two impressions of this etching are known (Vienna, Albertina and Paris, Dutuit collection).

25c: Rembrandt, *Self-portrait*. Drawing. Vienna, Graphische Sammlung Albertina.

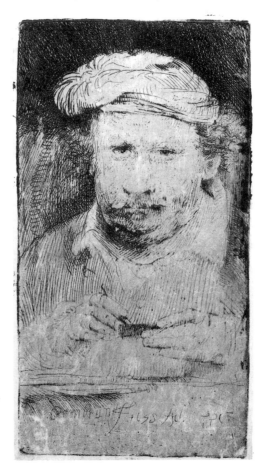

26a: Jan Steen, *The Burger of Delft and his daughter*. Penrhyn Castle, Lady Janet Douglas-Pennant.

26

The Hurdy-Gurdy Player and his Family receiving Alms

Etching, slightly worked over the burin and drypoint, 165 × 128 mm; 3 states
Signed and dated: *Rembrandt. f. 1648.*
B./Holl. 176; H. 233; White, pp. 167 ff.

Berlin: I (13–1892)*
Amsterdam: I (62:65)
London: I (1868–8–22–673)

In both drawings and prints from the 1640s, Rembrandt took up again the beggar subjects that had so fascinated him as a young artist in about 1630, during his Leiden period (see Cat. No. 3).[1] The etching of 1648 shows a young woman with a walking stick and a basket, carrying a baby in a sling on her back. She reaches out her hand to take alms from an elderly man who appears at the open door of a house. Next to the woman, and viewed from the back, is a boy in a broad-brimmed hat, and beyond the woman stands an old man. While the domestic realm of the alms-giver, even the gutter in front of his house, is shown in detail, the area associated with the pedlar family is left vague.

The etching has been given the rather inaccurate title *Beggars at the Door of a House* since Gersaint's reference to it (1751).[2] From the point of view of iconography, the scene belongs to another tradition, that of the wandering hurdy-gurdy player.[3] The shoulder and hat of the boy mask a hurdy-gurdy. This, and the bagpipes, were the musical instruments traditionally associated with pedlars. The hurdy-gurdy was played above all by the blind; and in the etching the curiously blank stare of the old man must be intended to show him to be blind. The subject of the blind hurdy-gurdy player whose wife collects alms goes back to the sixteenth century and was probably popularised at the start of the seventeenth century by David Vinckboons in Amsterdam.[4] Rembrandt himself had treated this subject before, in two etchings of about 1634–35 and of 1645.[5]

Rembrandt's scene of 1648 is distinct from his beggar scenes of about 1630 (see Cat. No. 3) not only stylistically but also in terms of content.[6] Constantin Huygens, in his *Zedeprinten* (Descriptions of Customs) made fun of

lazy beggars who used the raucous din of the bagpipes and the hurdy-gurdy as a way of forcing people to give them money.[7] The title page of Jan Joris van Vliet's beggar series of 1632 takes as its subject the giving out of alms, and in its title at least—*By 't geeve bestaet ons leeve* (Our life depends on [your] gift)—seems to suggest criticism of charity for lazy beggars.[8] In Rembrandt's etching, however, the young woman and the old man are not presented as caricatures; indeed, they almost appear respectable. They certainly wear poor people's clothes, but not the rags and tatters of beggars, such as one finds in the earlier scenes. Clearly, these are not inveterate wandering pedlars, but rather the needy who have fallen into poverty through no fault of their own. Rembrandt treats them objectively, and without any satirical implications: he presents the act of charity as it is advocated in the Bible (Matthew 25: 31–46).

In the *Zedekunst* (Art of Customs), published several times during the sixteenth century, the Haarlem Humanist and writer Dirck Volkertsz. Coornhert had emphasised the difference between poverty encountered through a man's own guilt and with the aim of cheating others, and poverty honestly come by.[9] Charity played an important part in public life in Holland. But only needy town dwellers profited from it, and not the rootless pedlars scattered throughout the countryside.[10] Rembrandt appears to show a rich citizen's private act of charity towards a poor fellow citizen. Through this sociable act, the giver and the receiver of alms are linked in the context of social convention, although they remain clearly separated by the doorstep of the house.

The subject of street vendors and musicians, shown standing in the street at the edge of the domestic sphere of the citizen, is often seen in Dutch painting in the mid-seventeenth century. Rembrandt's etching itself had some influence on the treatment of this subject. Jan Steen's painting of 1655, for example, shows a rich man with his daughter on the outer step of a house, in front of which a poor woman is asking for alms; the woman's pose and gestures are taken from Rembrandt's scene (Fig. 26a).[11]

From the point of view of both style and content, a chalk drawing of about 1647–48 in the Amsterdam Historisch Museum (Fodor collection), also showing a needy family, is closely connected to Rembrandt's etching (Fig. 26b). The people here, however, are differently arranged to those in the etching; the blind man, who stands on the left, carries a hurdy-gurdy. The family turns the right, seemingly towards someone giving alms, who would be needed to complete the scene. This might be

an initial preparatory study for the etching.[12]

The differences between the states are only slight; they principally concern the shading on the door arch above the head of the alms giver.
H.B.

1. See, among others, Benesch 721 and 750–51.
2. Gersaint 1751, p. 141, No. 170.
3. On this, see the study by Hellerstedt 1981.
4. Hellerstedt 1981, pp. 17 ff. Various versions of the subject by Vinckboons show the old hurdy-gurdy player surrounded by village children, while his wife begs for alms at the door of a house.
5. B. 119, 128.
6. Stratton 1986; Lawrence, Kansas; New Haven and Austin 1983/84, pp. 81 ff., No. 16.
7. Huygens 1623–24, p. 212.
8. B. 73.
9. Stratton 1986, p. 79; Braunschweig 1978, pp. 133 ff., Nos. 28–29.
10. Schama 1987, pp. 570 ff.
11. Schama 1987, pp. 573 ff., Smith 1988, pp. 54 ff., Fig. 57.
12. Benesch 749 r; Broos 1981, p. 55 ff., No. 13. On the verso of the sheet there is a sketch showing Jan Six reading (see Cat. No. 23).

26b: Rembrandt, *The Hurdy-Gurdy Player and his Family*. Drawing. Amsterdam, Historisch Museum.

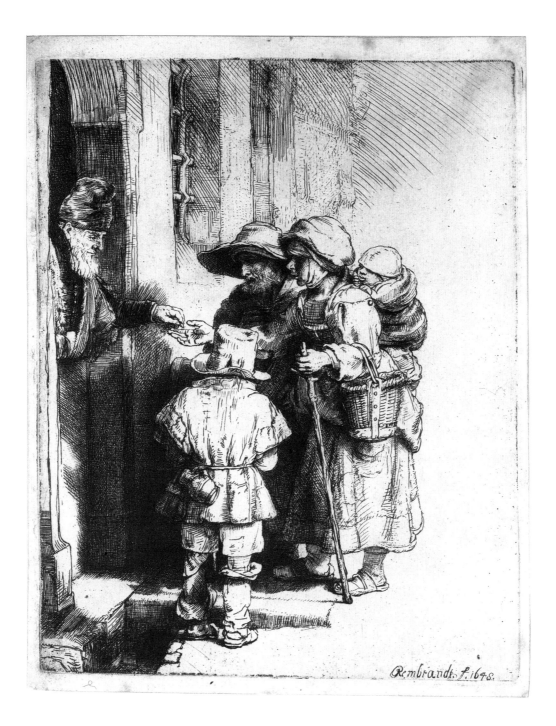

27

'The Hundred Guilder Print'

Etching, drypoint and burin, 278 × 388 mm;
2 states
Unsigned and undated; c. 1647/49
B./Holl. 74; H. 236; White pp. 55–65

Berlin: II on Japanese paper (302–1898)
Amsterdam: I on Japanese paper (O.B. 601)*
London: I on Japanese paper (1973 U. 1022)

Inscriptions on the reverse of the example in
Amsterdam:
(in brown ink)
'Vereering van mijn speciale vriend Rembrandt
tegens de Pest van m. Anthony'[1]

(also in brown ink but in another hand)
'ici-dessous est decrit en pierre noire
vereering van mijn speciaele
vriend Rembrand, tegens de
pest van M. Antony.

Rembrand amoureux d'une
estampe de M. A. savoir la
peste, que son ami J. Pʳ.
Zoomer, avoirt de fort belle
impression, & ne pouvant
l'engager a lui vendre,
lui fit present, pour l'avoir,
de cette estampe-ci, plus-
rare & plus curieux encore
que l'estampe que l'on . . . oine
de Hondert Guldens Print, par
les addition dans clair obscur
qu'il y a dans celle-ci, dont
il n'y a eu, suivant le raport
qui m'en a ete fait, que
tres peu d'impressions, dont
aucune n'a jamais été vendue
dutemps de Rembrand, mais
distribuées entre ses amis.'

Gersaint, the author of the first printed
catalogue raisonné of Rembrant's etchings
(1751), praised the *Hundred Guilder Print* as
the best etching from the master's hand.
He drew particular attention to the variety in
Rembrandt's record of human expression,
which was shown 'avec tout l'esprit
imaginable'.[2] Houbraken too celebrated the
work as supreme, but as a result of his own
artistic ideals and of his view of Rembrandt, he
regarded it as unfinished. 'This is particularly
clear in the so-called Hundred Guilder Print,
at the treatment of which we can only wonder,
because we cannot understand how he
[Rembrandt] could have worked this up from
what was originally nothing but a rough
sketch . . .'[3]

The title *Hundred Guilder Print* is not given
by Rembrandt himself.[4] Already used in the
eighteenth century, it provoked a number of
fanciful explanations. Gersaint, for example,
reports—probably following the inscription on
the Amsterdam example—that the artist had
been able to give this etching to a Roman art
dealer in exchange for several engravings by
Marcantonio Raimondi which, together, were
valued at a hundred guilders.[5]

The original significance of the work was
obscured by the title *Hundred Guilder Print* until
the end of the nineteenth century when its
meaning was reconstructed.[6] The subject is not
a single episode ('suffer the children come unto
me' or 'the healing of the sick'), but rather the
whole of the nineteenth chapter of the Saint
Matthew's Gospel.[7] This interpretation was
supported by the later discovery of a poem by
H. F. Waterloos (a contemporary of
Rembrandt), inscribed on an impression in
Paris:

'Aldus maalt Rembrants naaldt den zoone
 Godts na 't leeven;
en stelt hem midden in een drom van zieke
 liên:
Op dat de Werelt zouw na zestien Eeuwen
 zien,
De wond'ren die hij an haar allen heeft
 bedreeven.
Hier hellept Jezus handt den zieken. En de
 kind'ren
(Dat's Godtheyt!) zaalicht hij: En strafftze die'r
 verhind'ren
Maar (ach!) den Jong'ling treurt. De
 schriftgeleerden smaalen
't Geloff der heiligen, en Christi godtheits
 straalen.'

(And so Rembrandt drew from life, with his
 etching tool,

The Son of God in a world of sorrow,
Showing how, sixteen centuries ago,
He gave the sign of His miracles.
Here Jesus' hand helps the sick. And to the
 children
(Mark of Divinity!) He gives His blessing, and
punishes those that hinder them.
Yet (oh!) the young man wails. And the scribes
 sneer
At the faith in Holiness that crowns Christ's
 Divinity).

Rembrandt stresses the varied nature of the
miracles performed by Christ, in amalgamating
different episodes from the account in the
Bible. The viewer is introduced to the crowded
scene through the diagonal arrangement of the
composition and, above all, through the use of
lighting. The darkness that appears to deepen
behind the figure of Christ evokes the
suggestion of a monumental, arched structure.
Christ's nobility, however, is enacted as the
Redeemer shines forth against the depths of
this darkness.

The *Hundred Guilder Print* is striking for the
variety of printing techniques Rembrandt uses.
Its large scale is apparently matched by its
ambition to compete with painting; and the
graphic range of etching is united with its
painterly scope in an unusually broad
spectrum. In this respect, the work cannot be
compared directly with any single work from
Rembrandt's printed œuvre. Related examples
among the etchings of the period around 1640
may be found for the figures on the left treated
in cursory outlines.[9] The participants on the
right, however, are characteristic of work from
no earlier than the second half of the 1640s in
their shading, which is elaborately modelled
with short, delicate lines.[10] For this reason,
there is unanimity regarding a date of 1647/49
for the completion of the print. There has,
however, been disagreement as to when
Rembrandt started work on the plate. Was the
Hundred Guilder Print produced in its totality in
about 1647/49, incorporating earlier stylistic
means, or should one, rather, posit an
interruption in the work, and date
Rembrandt's first version to the late 1630s?[11]

Those arguing for an early dating have
eagerly pointed to Rembrandt's dated oil
sketch of 1634 for *John the Baptist preaching*.[12]
At first glance, the similarity of the
compositional arrangement seems convincing—
the view is led diagonally into the picture and
the protagonists are arranged diagonally to the
picture plane. However, the compositional
principle of the London painting of 1644, *Christ
and the Woman taken in Adultery*,[13] is on the
whole nearer to that of the *Hundred Guilder*

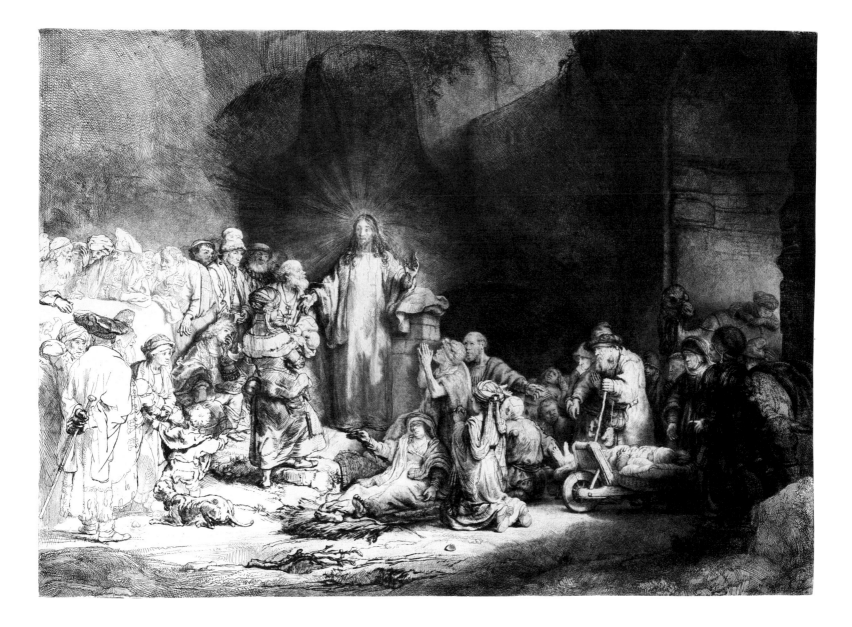

Print. Here one finds the arrangement of figures as if in 'relief', and the careful control of both the view and the lighting across the figures seen from the back to the meeting of Christ and the woman kneeling in front of him.

The surviving states of the etching give no insight into the process of its development. The alterations in state II are concerned only with minor details. The less resolved passages are more insistently enclosed through finer incised hatching strokes (the back of the donkey's neck, the area of the right background behind Christ's head). Nevertheless, the various traces of alterations, clearly reveal Rembrandt's intensive work on the plate.[14] Christ's face and the position of his arms are re-worked; and even his right foot was originally placed somewhat higher. The woman with a child in her arms was initially posed stepping forward more vigorously. None of these visible traces of the working process points to an alteration of the composition as a whole or to a full re-arrangement of any individual figure.

Various preparatory drawings were made for the figures that are crucial in the arrangement of the composition and in guiding the viewer's attention. The sick woman on the bier[15] held particular interest for Rembrandt (Fig. 27a), and he worked out this whole group in a sheet now in Berlin (Fig. 27b).[16] In further surviving studies one can see the blind man,[17] the man with an outstretched arm,[18] and the woman with a child in her arms who stands in front of Christ.[19] These drawings and the etching must be assessed in relation to each other. The drawings have, accordingly, been dated from the late 1630s to, more recently, about 1647.[20]

The basic compositional arrangement of the etching is not affected by any of these figure-studies.

The repeatedly stated assumption that one of Rembrandt's painted study heads for Christ is a preparatory work for the face of Christ in the *Hundred Guilder Print* can now be dismissed.[21] It would be most unusual for Rembrandt to make an oil sketch in preparation for a single figure in a multi-figure etching. The surviving heads of Christ are, moreover, now all given a later date (about 1655/56), and to a large extent no longer ascribed to Rembrandt.[22] In the *Hundred Guilder Print*, on the contrary, Rembrandt used the type of Christ that is characteristic of his work in the 1640s[23]— the type described by contemporaries, such as Waterloos in his poem, as 'een Christus tronie nae't leven' (a face of Christ from life)'.[24]

In summary, we can say that neither the visible traces of alterations made on the plate nor the surviving drawings lead to the conclusion that Rembrandt fully re-worked in about 1647/49 a version of the *Hundred Guilder Print* he had made in the 1630s. Nonetheless, neither are the variations within the finished work satisfactorily explained by the theory that Rembrandt used a new style to complete the unfinished parts of a plate he had long abandoned.

One of the strands of tradition to which research has as yet paid too little attention constantly describes the *Hundred Guilder Print* as extraordinarily rare. In the inventory drawn up by de Burgy, for example, it is called 'extraordinairement rare'; Gersaint too calls it 'very rare'; and, finally, the Amsterdam

27a: Rembrandt, *Studies of a sick woman*. Drawing. Amsterdam, Rijksprentenkabinet.

27b: Rembrandt, *A group of figures*. Drawing. Berlin, Kupferstichkabinett SMPK.

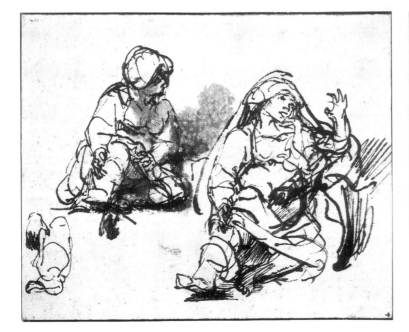

impression is similarly celebrated: 'deze is een alder eerste en dus raarste druk van deze plaat . . .'[25] (this is one of the first, and very rare, impressions of this plate). When Captain Baillie re-published the print in 1775 heavily re-worked, he added the inscription: 'The Hundred Guilder-Print. Engraved by Rembrandt about the year 1640 after a few Impressions were printed was laid by and thought to be lost.'

The second inscription on the reverse of the impression in Amsterdam perhaps offers an explanation for this: here it says that Rembrandt had not made this work for the art market, but rather presented it as a gift of friendship. Even the unusual portrait of Aert de Gelder, now in Leningrad,[26] in which the sitter appears with an impression of the *Hundred Guilder Print* in his right hand, could play a part in this tradition. In this connection, one might also consider again the fact that Rembrandt, surprisingly, did not sign the *Hundred Guilder Print*. Thus one might imagine that Rembrandt is making a pragmatic demonstration of the totality of his abilities as an etcher. The printing styles used here range from the sketchiness that Houbraken mistook for unfinished work, to the tonal gradations of painterly *chiaroscuro* values that are possibly to be understood as experimental competition with the new mezzotint technique.[27] The variety of methods in print-making should not, in this case, be understood to indicate that Rembrandt evaluated the work over several years, but rather as a record of Rembrandt's reference to his own œuvre—a deliberate display of virtuosity.

B.W.

1. See *Urkunden* 266, there claimed to be the handwriting of the Amsterdam art collector Jan Pietersz. Zoomer. This identification has been opposed by Dudok van Heel 1977, p. 98.
2. Gersaint 1751, No. 75, pp. 6 ff.
3. '. . .als inzonderheid aan de zoo genaamde honderd guldens prent en andere te zien is, waar omtrent wy over de wyze van behandelinge moeten verbaast staan; om dat wy niet konnen begrypen hoe hy het dus heeft weten uit te voeren op een eerst gemaakte ruwe schets . . .' Houbraken 1718, p. 259.
4. See also Cat. No. 33.
5. Gersaint p. 60; see Dudok van Heel 1977, p. 98.
6. Jordan 1893.
7. On the significance and the iconographic tradition see, most recently, Tümpel 1986, pp. 255–61.
8. *Urkunden* 266. Haak 1969, 214.
9. *The Presentation in the Temple*, B. 49; *The Triumph of Mordechai*, B. 40; see also Cat. No. 14.
10. See Cat. No. 26.
11. This argument is put forward at length by White 1969, pp. 55–65.
12. Gemäldegalerie, Berlin; Paintings Cat. No. 70. See White 1969, p. 57.
13. Bredius 566.
14. See White 1969, pp. 62 ff.
15. Amsterdam, Benesch 183, Schatborn 1985, No. 21; Benesch 388, Sale: Sotheby, London, 1970.
16. Kupferstichkabinett, Berlin, Benesch 188.
17. Louvre, Paris, Benesch 185.
18. Courtauld Institute, London, Benesch 184.
19. Pushkin Museum, Moscow, Benesch 1071. It is possible that in this figure Rembrandt made use of the insights obtained from his very varied studies of mother and child from the late 1630s. A drawing in Rotterdam (Benesch 288) shows—albeit not in reversed form—striking similarities with the figure in the etching. An impression in the British Museum has black chalk corrections in the figure of the standing woman with the child.
20. Schatborn 1985, No. 21.
21. See White 1969, p. 61.
22. The *Hundred Guilder Print* has been discussed in connection with, among others, the painting in the Fogg Art Museum, Cambridge/Mass. (Bredius 624A; Tümpel 1986, Cat. 79). Only the work in Berlin (Bredius 622, Tümpel 1986, Cat. 78, Paintings Cat. No. 20) is still assumed to be by Rembrandt. See also Bredius 626 / Tümpel A20; Bredius 621 / Tümpel A17; Bredius 624 / Tümpel A19.
23. This type can be seen, for example, in the 1648 painting of *Christ at Emmaus*. Louvre, Paris, Bredius 578.
24. See also the sale inventory of 1656. *Urkunden* 169.
25. *Urkunden* 266.
26. See, most recently, Chapman 1990, Fig. 170.
27. See the considerations of Holm Bevers in the introduction to this catalogue.

28

Landscape with the Goldweigher's Field

Etching and drypoint, 120 × 319 mm; 1 state
Signed and dated: *Rembrandt. 1651*.
B./Holl. 234; H. 249; White, pp. 213 ff.

Berlin: on Japanese paper (97–1887)
Amsterdam: (1962:91)
London: (1973 U. 1037)*
Berlin: II (242–16)

The most panoramic of Rembrandt's landscapes is the *Landscape with the Goldweigher's Field*. The long, narrow sheet shows the view, looking down from higher ground, over the area around Haarlem. In the left background the city of Haarlem can be seen in silhouette, dominated by the medieval Grote Kerk. The centre of the middle ground is taken up by the Saxenburg estate of Christoffel Thijsz., and to the right of this is the church of Bloemendaal.[1] In the fields in front of this there are people bleaching linen.

Somewhat later in about 1670, the view from the dunes not far from Haarlem of the bleaching fields and the city with the Groote Kerk in the background was a favourite subject of Jacob van Ruysdael. In the early seventeenth century, Hendrick Goltzius had already made several panoramic landscapes of the area around Haarlem, drawn from observation—a milestone in the development of the naturalistic Dutch landscape.[2] Rembrandt must have been inspired by comparable panoramas by Hercules Seghers. The etching by Seghers, *View of Amersfoort* (of about 1630) has a long, narrow shape similar to that of Rembrandt's etching (Fig. 28a); moreover, the view is taken from higher ground, and the horizon line is high, above the vertical mid-point of the sheet.[3]

The old title of Rembrandt's etching derives from the inventory made by Valerius Röver (1731); it is also the title used by Gersaint.[4] It alludes to the tax-collector Johan Uytenbogaert, whom Rembrandt had portrayed as a gold-weigher in the etching B. 281. It appears, however, that the landscape etching shows the estate of Christoffel Thijsz. Rembrandt had bought his house in the Sint-Antonisbreestraat from him in 1639. As he still owed a great deal of money to Thijsz in 1651, the etching of the view of his estate might have been made to appease him.[5]

The fields, the groups of trees, and the houses in *The Goldweigher's Field* are almost reduced to abstract forms. As far as the eye can see, the landscape is ordered through a series of intersecting diagonal lines. A sense of depth is sparked by the emphatic inky, black drypoint passages distributed across the sheet. The whole foreground forms a long, curved line, creating an optical impression that the landscape is slowly turning around an imaginary point in the distance. A drawing by Rembrandt in the Museum Boymans-van Beuningen shows a similar view of Haarlem from a slightly altered and higher viewpoint.[6] This study from nature was not used as direct preparatory material for the etching; but Rembrandt may have referred to it, without slavishly transferring the details. The foreground, which is left blank in the drawing, stands out in the engraving through the use of powerful drypoint strokes; this was also perhaps a device to increase the impression of depth in the landscape to counteract the breadth of the view.[7] The drawing, in which the church of Bloemendaal is placed on the left and the city of Haarlem in the right background, corresponds to topographical reality; and it is surprising that, in producing the plate, Rembrandt did not take the reversal of left and right into account. The fact that there are six surviving counterproofs (Fig. 28b)—showing the landscape in mirror image, and thus topographically correct—might indicate that Rembrandt later became aware of this.[8]

The Landscape with the Goldweigher's Field exists in only one state, though the proofs of this state vary a great deal according to the degree of burr still found along the drypoint lines and the amount of surface tone; the proofs on Japanese paper are also striking for their varying appearance.

H.B.

1. Lugt 1920, p. 157, note 1. Van Regteren Altena 1954. The identification of the individual groups of buildings has been disputed. Van Regteren Altena thinks that the large building with a tower on the right is the manor house of Thijsz., while other commentators interpret this building as the church of Bloemendaal.
2. Reznicek 1961, Vol I, pp. 131–32, pp. 427 ff., Nos. 400, 404–5; Vol. II, Figs. 380–81, 351.
3. Haverkamp-Begemann 1973; Holl. 30.
4. Gersaint 1751, pp. 182–83, No. 226.
5. Van Regteren Altena 1954, p. 9; Washington 1990, p. 260. No. 84.
6. Benesch 1259; Giltaij 1988, p. 78, No. 21; Washington 1990, pp. 258–59, No. 83.
7. The marked panoramic elongation of the view, the curvature of the foreground, and the striking effect of distortion of the image in the corners of the sheet through the velvety tone of the dry-point burr, all prompt one to think of the view through a wide-angle lens. It would be tempting, though risky, to speculate as to whether Rembrandt had perhaps conceived the *Landscape with the Goldweigher's Field* with the help of such lenses. The use of lenses to help with picture construction played an important part in the work of pupils of Rembrandt such as Carel Fabritius and Samuel Hoogstraten; and Constantin Huygens was interested in optical instruments. There is no evidence, however, that Rembrandt himself used lenses; see Wheelock 1977, especially pp. 206 ff.
8. Schneider does not exclude the possibility that the etching was itself made from observation; Washington 1990, pp. 26, 31 (note 40) and 261, No. 84. On this, see Cat. No. 20.

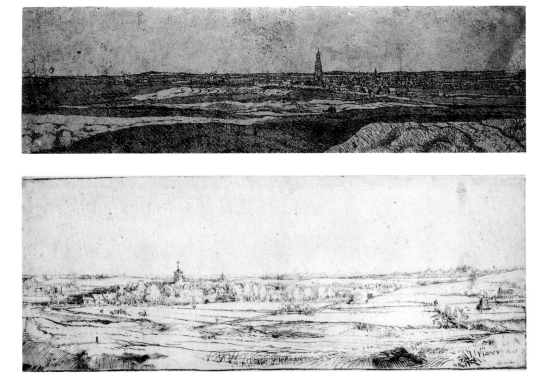

28a: Hercules Seghers, *View of Amersfoort*. Amsterdam, Rijksprentenkabinet.

28b: Rembrandt, *The landscape with the Goldweigher's field*. Counterproof. London, British Museum.

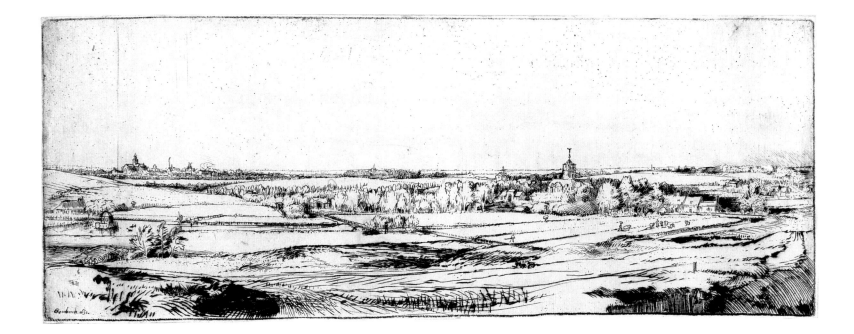

The Shell
(*Conus marmoreus*)

Etching, re-worked in drypoint and burin
97 × 132 mm; 3 states
Signed and dated: *Rembrandt. f. 1650.*
B./Holl. 159; H. 248; White, p. 169

Berlin: II (242–16)
Amsterdam: I (O. B. 241), II (O. B. 242)*
London: I (1973 U. 1035), II (1973 U. 1036)

The only still-life among Rembrandt's prints—and one of few examples of still-life in his work as a whole—is the small etching of a conical shell.

Rare mussel and mollusc shells, brought back to Holland from exotic lands by the great trading companies, were popular collectors' items in the seventeenth century. The collecting of mussel shells had almost become an obsession.[1] On account of their beauty and value, these objects were seen to embody the transition from Nature (*Natura*) to Art (*Ars*), or their union. Conchylia (the shells of molluscs) and other natural objects were to be found alongside man-made works of art in the collections amassed by princes and displayed in a *Kunst-* or *Wunderkammer*. A *Kunstkammer* of this time is described as follows: 'In our *Kunstkammer* we now delight to look at the empty shells and houses of the most beautiful and rarest conchylia in their many wonderous shapes and beauties; these are the work of nature and yet, at the same time, they seem like the product of art; we are both diverted by the sight and prompted by it to praise the Creator of these

works.' The writer adds that the greatest artist could not compete with the richness of colour to be found in these natural images.[2]

The *Kunstkammer* was also a feature of life in the cities of Holland. The objects from Rembrandt's own encyclopaedic *Kunstkammer* are well documented in the inventory of 1656, and among them were the shells of mussels and molluscs.[3]

Conchylia are to be found in records of such collections, for example in the case of the *Kunst-* and *Wunderkammer* of Frans Francken the Younger.[4] Almost as if disengaged from such scenes, there are the rare pure still-lifes with shells painted by Balthasar van Ast (Fig. 29a), in which many prized conchylia from distant lands are displayed.[5] Shells are found also in flower paintings and *vanitas* still-lifes where, as symbols of natural beauty that are also very fragile, they point to the transience of all that is earthly.[6]

Rembrandt shows a conical shell (*conus marmoreus*), which comes from the East Indies. He appears to have been moved above all by the play of light and shade on the rounded

29 State I

29a: Balthasar van Ast, *Still life with shells*. Rotterdam, Museum Boymans-van Beuningen.

Rembrandt. f.1650.

surface of this lovely creation; and it almost seems as if he wished to show that art could still use its own means to rival nature. It is in any case clear that Rembrandt's etching is not a scientific illustration in the manner of the shells depicted by Wenzel Hollar that are often invoked as direct models for Rembrandt's sheet. Hollar's series might have served as inspiration only for the idea of taking a single shell as the subject of an engraving (Fig. 29b).[7]

State I—executed in drypoint over an etched outline—shows the shell isolated in front of a background that is left white. The shell casts a shadow, without occupying a real space; and this contradiction may have prompted Rembrandt to shade in the background in state II and to suggest a cabinet or shelf, so that the shell now seems to lie on a board. Reworking with the burin on the surface of the shell reduces the highlights of state I. In state III (only surviving proof in Amsterdam) Rembrandt has extended and more sharply defined the central spiral form that in state II appears rather flat.

Just like a real mollusc shell, Rembrandt's *conus marmoreus* would have been acquired by collectors as an item fit for a *Kunstkammer*.

H.B.

1. On this see, in particular, Schneller 1969, pp. 119 ff. The fashion for collecting shells was censured in Roemer Vischer's *Sinne-poppen*. The picture of shells, bears this emblem: 'Tis misselijck waer een geck zijn gelt aen leijt' (it is disgusting [to see] what a fool will pay good money for); see Bergström 1956, pp. 156–57; Boston 1980/81, pp. 91 ff., No. 54.
2. Scheller 1969, p. 120.
3. *Urkunden*, p. 199, No. 190, item 179.
4. Scheller 1969, Figs. 5–8.
5. Bergström 1956, pp. 70 ff., Fig. 60.
6. Bergström 1956, pp. 154 ff.
7. A *conus imperialis* from Hollar's series has been seen as a model for Rembrandt: see Pennington 1982, p. 337, Nos. 2187–224, in this case No. 2195. Van Regteren Altena 1959, pp. 81 ff.

29b: Wenzel Hollar, *Conus Imperialis*. Berlin, Kupferstichkabinett SMPK.

The Print-Dealer
Clement de Jonghe

Etching, re-worked with burin and drypoint
207 × 161 mm; 6 states
Signed and dated: *Rembrandt f 1651.*
B./Holl. 272; H. 251; White, pp. 135 ff.

Berlin: II (359–16)*
Amsterdam: III (O. B. 527)
London: II (1843–6–7–158)

The etching was first cited as a portrait of
Clement de Jonghe in the inventory drawn up
by Valerius Röver in 1731, and it has generally
been accepted as such. Rembrandt must have
known Clement de Jonghe well. Born in
Schleswig-Hollstein in 1624 or '25, he came to
Amsterdam in about 1650 according to some
sources, and in about 1656 according to others.
He was active there as a publisher of, and
dealer in, engravings, maps and books.[1] His
first shop was at the weighhouse on the
Nieuwmarkt, and in 1658 he moved to a new
address, Kalverstraat 10, near the Dam, the
centre of the Amsterdam art trade. Among
other things, De Jonghe published engravings
and etchings by Roelant Roghman and Jan
Lievens, and he must have had access to a large
stock of printing plates. Nevertheless, it seems
that his business did not really flourish. After
De Jonghe's death in 1677, his son took over
the business; in 1679 he drew up an inventory
of his father's estate. Here, among other things,
74 etched plates by Rembrandt are cited by
their titles.[2] Surprisingly, in view of what one
might have expected, the plate with De
Jonghe's own portrait was not in the print-
dealer's estate. This, as has often been
observed, could argue against the identification
of the sitter as De Jonghe.[3]

The print dealer is dressed in a cloak and a
broad-brimmed hat that lightly shadows his
face: he is sitting in a chair in front of a white,
undefined background. No reference at all is
made to a profession or activity (see the very
different case of Cat. No. 16). De Jonghe faces
the viewer and looks at him, but he is pushed
slightly away from the centre of the sheet,
towards the left, where he leans his elbow on
the arm of his chair. On his left hand, which
hangs almost nonchalantly, De Jonghe wears a
glove, the traditional sign of a nobleman.[4]

Rembrandt, who made portraits throughout his life, only rarely used the three-quarter length form.[5] This type had its roots in Venetian art, for example in the work of Titian, Tintoretto, Veronese and Lorenzo Lotto, where it was first developed in 'official' portraits for persons of high rank, but became more widely used.[6] Rembrandt had himself seen Venetian paintings; but in the case of this etching, he might, nonetheless, have been inspired by a Flemish model, perhaps the *Portrait of Martin Ryckaert* by Anthony van Dyck, that appeared in engraved form in 1646 in the *Iconografie* (Fig. 30a).[7] For, even in Venetian painting, there are hardly any models for the sitter being both seated and boldy placed facing the viewer in a comparable manner. It is this that gives extraordinary presence to Clement de Jonghe in the etching. Yet, at the same time, the severe frontality of the figure—ultimately deriving from the hieratic image of Christ—establishes a distance between the sitter and the viewer. The subject—whether or not he is indeed the print-dealer Clement de Jonghe—must have commissioned the plate from Rembrandt, and himself chosen the tense pose that expresses both his retiring nature and his official and social rank.

The plate exists in six states, all of which were considerably altered in the region of the eyes and mouth, with corresponding changes in De Jonghe's facial expression: in one case he seems to be smiling, then again somewhat sullen, elsewhere almost peering out drowsily. In state I the facial expression is extraordinarily clear and transparent (Fig. 30b), and yet it seems almost like that of an old man, which must have led to the transformation into the features of a youngish man in state II. States I and II show the sitter in front of a white background; in state III a simple, rounded arch was introduced; and in state IV this was emphasised with hatching (Fig. 30c).
H.B.

1. The biographical details regarding De Jonghe vary. It has been claimed that the print-dealer was born in Braunschweig and was active in Amsterdam from about 1650 (De Hoop Scheffer/Boon 1971, p. 4); elsewhere, Schleswig-Hollstein is cited as the region of his birth, while the start of his activity in Amsterdam is given as c. 1656 (Amsterdam 1986–87, pp. 58–59, No. 42.
2. De Hoop Scheffer/Boon 1971.
3. Van Eeghen 1985 and Voûte 1987 take issue with the traditional attribution. On account of a certain similarity in physiognomy and dress between the sitter in the etching and those of Jan Six in the celebrated painting of 1654 in the Six collection, Amsterdam (Bredins/Gerson 276), Voûte puts forward the argument that this etching also shows Jan Six. Whatever the truth of the matter, the identity of the sitter in the etching does now have to be reconsidered.
4. Smith 1988, p. 46.
5. On this point in general, see Chapman 1990.
6. Chapman 1990, pp. 93 ff.
7. Chapman 1990, pp. 93–94, Fig. 137.

30a: Anthony van Dyck, *Portrait of Martin Ryckaert*. Berlin, Kupferstichkabinett SMPK.

30b Rembrandt, *Clement de Jonghe*. State I. Amsterdam, Rijksprentenkabinet.

30c: Rembrandt, *Clement de Jonghe*. State IV. Amsterdam, Rijksprentenkabinet.

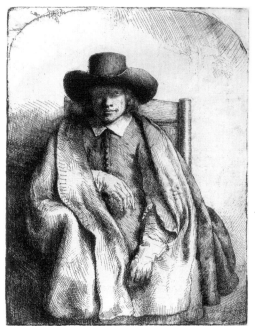

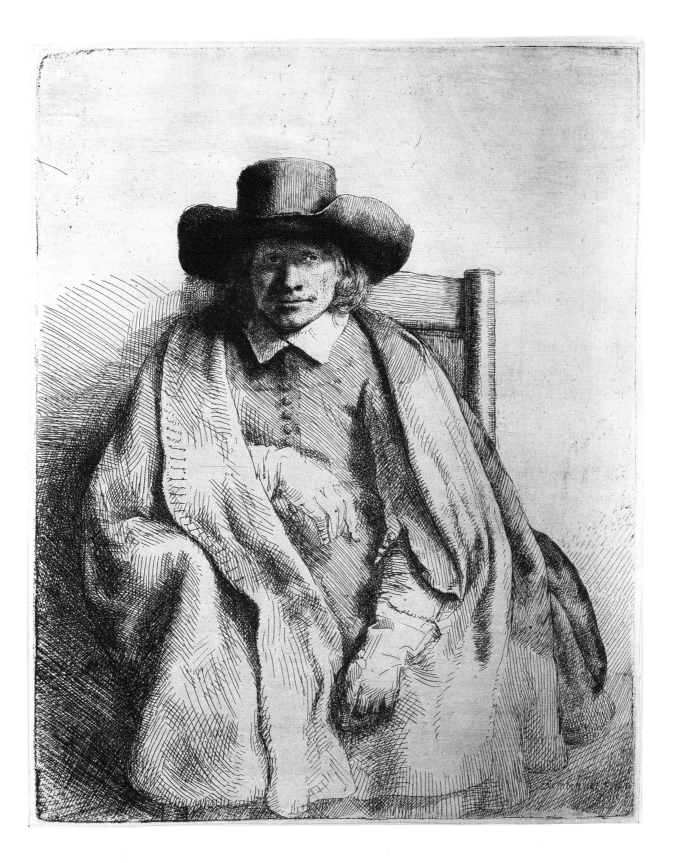

Saint Jerome
in an Italian Landscape

Etching and drypoint, with some sulphur tint,
259 × 210 mm; 2 states
c. 1653–54
B./Holl. 104; H. 267; White, pp. 220 ff.

Berlin: I on Japanese paper (444–1908)*
Amsterdam: I on Japanese paper (O. B. 184)
London: I on Japanese paper (1973 U. 1151)

31a: Cornelis Cort, *St Jerome*.
Amsterdam, Rijksprentenkabinet.

31b: Rembrandt, *St Jerome reading in a landscape*.
Drawing. Hamburg, Kunsthalle.

One of the finest examples of Rembrandt's endeavours to capture light and atmosphere in the 1650s is the etching from 1653–54 showing *Saint Jerome in an Italian Landscape*. The saint sits, turned towards the viewer, on a large rock, and appears absorbed in his reading; next him stands a lion, looking towards the background which shows a hilly landscape with a group of buildings. Without the presence of the lion, it would not be obvious that this is a scene of Saint Jerome, for the other traditional attributes—crucifix and skull—are missing and, instead of the usual cardinal's hat, the saint wears a sort of sunhat as protection against the dazzling light, while he reads. The sandals which he has removed might at first be taken for a genre motif; but they may be found in the iconography of this subject and symbolise the saint's readiness to meet God.[1]

The scene is enlivened by the play of light and dark on the sheet. Parts of the hilly land in the background are caught in bright, almost harsh light, others lie in deep shadow. Gersaint and Bartsch thought the sheet unfinished, not recognising that Rembrandt, in leaving the foreground substantially free, and indeed only sketchily treated, wished to indicate a bright summery light.[2]

The subject of Saint Jerome shown in meditative mood in a charming landscape, more as a philosopher than as a penitent, may be traced back to sixteenth-century northern Italian and Venetian painting.[3] Rembrandt could have taken his cue from a composition by Titian known through an engraving by Cornelis Cort (1565) (Fig. 31a).[4] In both cases, the foreground scenery establishes a powerful diagonal thrust into the picture-space, and beyond this the view opens on to a

hilly landscape with human settlements. The immediate source for Rembrandt's figure of the saint could have been an engraving by Giulio Campagnola which shows *Saint Jerome reading* (1503–4).[5] Rembrandt's background landscape too, with its apparently northern European buildings, was inspired by corresponding landscapes in engravings and woodcuts by Giulio and Domenico Campagnola.[6] Considered as a whole, the present sheet, with its light-flooded, atmospheric landscape, owes much to Rembrandt's intensive study, during the 1650s, of Venetian painting. A sheet of about equal size with a reversed study for the etching is in the Kunsthalle in Hamburg (Fig. 31b).[7] It reveals that Rembrandt had originally planned to show the rocky ledge and the saint in shadow, but discarded this plan in favour of a brightly lit foreground (see Drawings Cat. No. 26).

The early proofs of state I, mostly printed on japanese paper, show extremely powerful drypoint passages, above all in the area of the bushes in the middle ground as well as on the lion's mane, with the effect of further intensifying the opposition of warm light and deep shadows. In state II, the bridge piers at the right edge are worked over with drypoint strokes. Several examples of this state are printed on a rough paper of a grey-brown colour, similar to packing paper—in English known as 'oatmeal paper' or 'cartridge paper'.
H.B .

1. Wiebel 1988, p. 96.
2. Gersaint 1751, pp. 90–91, No. 104.
3. See Wiebel 1988, pp. 123 ff.
4. Bierens de Haan 1948, p. 141, No. 134; Wiebel 1988, p. 123, Fig. 57.
5. Hind 7; Washington 1973, pp. 396–97, Fig. 19–7.
6. See, for example, the group of buildings, inspired by Dürer, in the above cited engraving by Giulio Campagnola, Hind 7. Further examples in Washington 1973, pp. 390 ff., Chapters XIX–XX. Rembrandt's familiarity with northern Italian models from the circles of Titian and Campagnola is shown by the fact that he copied a landscape drawing by Titian, and also worked over a landscape drawing in his own possession that has often been attributed to Domenico Campagnola (Benesch 1369). See Washington 1990, pp. 156 ff., Nos. 38–39.
7. Benesch 886; Schatborn 1986, pp. 22–23.

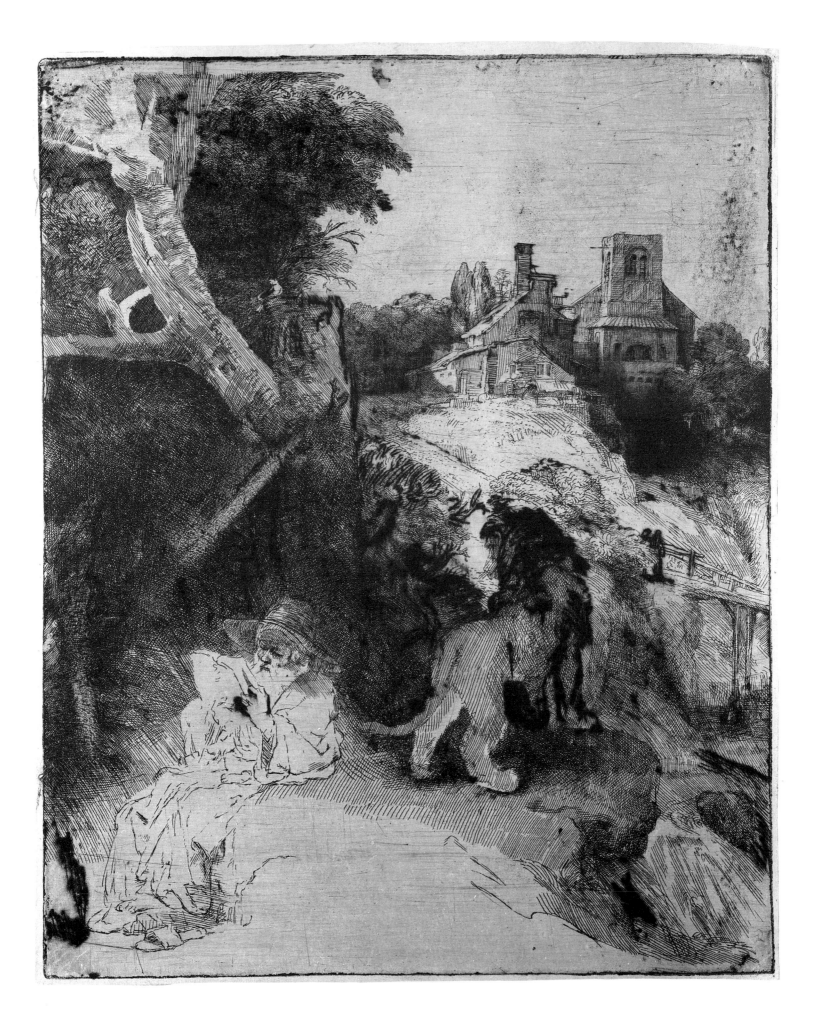

32

Landscape with three gabled cottages

Etching and drypoint, 161 × 202 mm; 3 states
Signed and dated: *Rembrandt f. 1650*
B./Holl. 217; H. 246

Berlin: I (317–1893)*
Amsterdam: III (O.B. 275)
London: I (1847–11–20–6)

Even the shape of this scene, with its rounded corners such as were used for ambitious history paintings, emphasises the monumental character of the composition. The structure is based on two powerful diagonals: a steep plunge into the depth of the depicted space in the form of a road leading from the immediate foreground to the horizon, and the imaginary line that divides the trees and houses from the sky. The sky itself is very effectively integrated into the scene as a surface left white. On the right, an enormous tree occupies the full height of the sheet, dominating the three handsome cottages along the road. A few people have gathered in front of the middle one. The depiction of the scene becomes less precise at a greater distance towards the low horizon, although further trees and houses can be made out. The strong sense of spatial recession is emphasised by the marked difference of scale between the tree and the cottages with the people standing in front. The tree is given heroic prominence, as if it were the protagonist of the composition.

Excellent impressions of this landscape etching show traces of Rembrandt's process of working. Rembrandt obviously fundamentally re-worked the appearance of the tree. Its left half, at first recorded in etching with feathery foliage, was altogether smoothed away at a later stage of work. Traces of a whole mass of foliage can be made out on the left, below the dead branch that is now visible. The thick branches and the summarily noted foliage are drawn in with powerful drypoint strokes that give the scene its imposing quality. Further details are altered accordingly: in the first version the roof of the nearest house was delineated in a very meticulous fashion. Similarly, the bushes behind this house first sketched have been summarised with drypoint hatching.

The small alterations between the three extant states consist merely in varied distribution of light and shade; thus patches in front of the nearest house, left white in the first state, are filled in with hatching in state II, giving this region more visual unity. On the contrary, the compositional changes in the treatment of the tree took place before any of the recorded phases of the work. The sheet thus appears to have been already completed in the exclusively etched version, before Rembrandt subjected it to a fundamental alteration. We do not know, however, how much time passed between the work on these two versions.

The visible alterations have, on occasion, led scholars to the assumption that Rembrandt started work on the etching *en plein air*, and then completed it in the studio.[1] The first sketch of the tree was then judged to be a freely formulated image made from nature. There seems, however, to be no evidence that seventeenth-century artists carried etching plates around with them to be used like a sketch book.[2] We must, on the contrary, regard both versions of the etching as made in the studio and assume that, during the second stage of the working process, Rembrandt abandoned the original composition in favour of one of greater formal value.

At least two drawings record the same property on the Sloterweg near Amsterdam.[3] Only one drawing (Benesch 835), however, is generally dated to the year of the etching; the second drawing was apparently not made before 1652/53.[4] Rembrandt seems to have made the earlier drawing (Fig. 32a) *en plein air*; and this drawing may have served as general inspiration for the composition of the etching.[5] However, Rembrandt altered the architectural setting by adding a third building. The heroic picture structure contradicts the concern for an exact topographical record.[6] There are several sources for Rembrandt's compositional

arrangement in Netherlandish art of the seventeenth century, for example an engraving by Hieronymus Cock also shows a road with houses along it, leading diagonally into the picture space.[7]

Rembrandt, however, increased the dramatic treatment of the landscape through the structure of the composition. The altered treatment of the motif is also the decisive difference between the etching and the Berlin drawing. The drawing is centred on one of the houses, in front of which a tree sways in the wind. Further trees bend in the same direction, allowing one to sense the atmosphere of the landscape. In the etching, interest in mood gives way to concern for a tightly organised picture structure, as if the artist had wanted to avoid the impression of a scene glimpsed by chance. Instead, the tree, with the emphatic incorporation of branches that are already dead as well as leafy tree tops, becomes a symbol of growth and decay, of the transience of all life.
B.W.

1. For example C. P. Schneider, (Washington 1990, No. 20), reports a discussion with J. P. Filedt-Kok.
2. See Cat. No. 22.
3. Benesch 835, Berlin and Benesch 1293, Berlin. See Bakker 1990, who identified the location.
4. See, most recently, Bakker 1990.
5. Benesch 835; the connection between the drawing and the etching was first recognised by Haverkamp-Begemann 1961, 57.
6. See the *Landscape with a Tower* (Cat. No. 37).
7. V. Bastelaer 1908, No. 22; see Amsterdam 1983, No. 17.

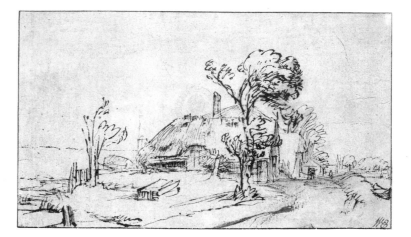

32a: Rembrandt, *Landscape with cottages*. Drawing. Berlin, Kupferstichkabinett SMPK.

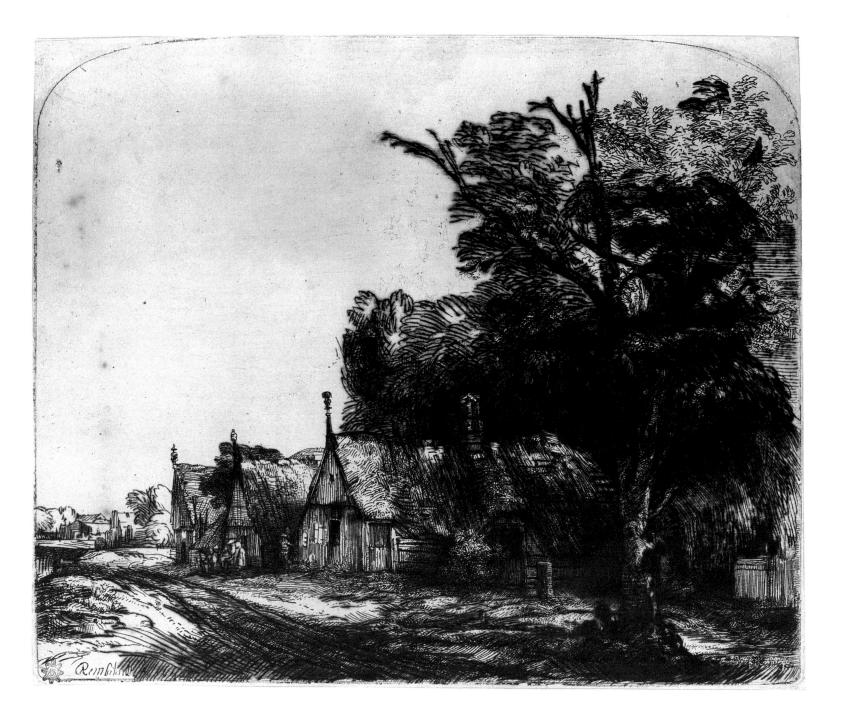

33
'Faust'

Etching, drypoint and engraving,
210 × 160 mm; 3 states
Unsigned and undated; c. 1652
B./Holl. 270; H. 260

Berlin: II (355–16)*
Amsterdam: I on Japanese paper (62:122)
London: I (1982 U. 2752)

Anagram inscribed in concentric circles from
centre outwards:
INRI
+ ADAM + Tϵ + DAGERAM
+ AMRTET + ALGAR + ALGASTNA + +

33a: Rembrandt, *Old man in meditation.*
Amsterdam, Rijksprentenkabinet.

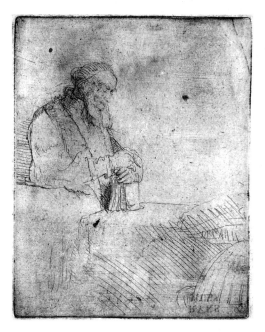

Rembrandt made his so-called *Faust* etching in about 1652. It shows an elderly man who concentrates on an apparition forcing its way through the closed window. The head of this apparition is made up of a circle of light with an anagram inscribed within it; and its hand points to a mirror-like object. The man's surroundings, including an astrolabe, a skull and books, indicate his learning.

The elaborate composition of the etching, almost like that of a painting, is especially notable. This prompts one to wonder if Rembrandt had devised the etching in response to a formal commission—although the existence of such a commission is pure speculation. The etching could just as well have been made for the market. The meticulous elaboration of the scene shows the work to have been an ambitious venture. Both the use of several kinds of paper and the variation in the impressions through the differences in the inking of the plates, further reveal Rembrandt's concern for this work.

It is exceptionally difficult to interpret the subject of this print.[2] The difficulties appear the more severe in that it has not proved possible to identify precisely the meaning of the anagram. The same sequence of letters has been found on amulets.[3] It is perhaps intended merely to suggest a magic formula, rather than a precise message that requires decoding.[4]

There are no surviving drawings in which Rembrandt resolved the composition of the etching. Therefore the etching seems to have been executed without any significant interruptions.[5] The three states differ only in details. For example, in state II, Rembrandt more strongly shaded the book placed on the right with further hatching, probably to soften the brightness that, in state I, had competed with that of the apparition. The development of the etching would seem to give no explanation as to the meaning of the work.

In the earlier eighteenth century (1731), Valerius Röver listed in the inventory of his art collection, an etching by Rembrandt with the title *Dr. Faustus*.[6] Research has, probably correctly, taken this entry to refer to our sheet. Since Gersaint, the work has been universally listed with the title *Faust* in catalogues raisonnés. A decisive factor in the subsequent history of the reception of the work was the fact that in 1790 Goethe commissioned a copy of the sheet to serve as the engraved title page for his early *Faust* fragment. In the early twentieth century there were efforts to find an older version of the Faust legend that Rembrandt might have been illustrating in his etching. A Dutch version of Christopher Marlowe's play, *Doctor Faustus*, known to have

been performed in Amsterdam in Rembrandt's lifetime, was cited.[7] There was even an attempt to determine precisely which moment in the play Rembrandt was illustrating.[8] Such views are no longer accepted for a number of reasons, for example the known illustrations of the Faust legend usually showed the devil.[9] Finally, Van de Waal (1964) argued that the man shown in the etching was a disguised portrait of Faustus Socinus, founder of the sect of the Socians, who had died in 1604.[10] This interpretation had the advantage of explaining how the title *Faust* referred to the figure shown. According to this theory, Rembrandt did not so much intend to show Socinus himself, as the entity of his ideas.

This explanation fails, however, to do full justice to Rembrandt's etching.[11] In no other of his portraits does Rembrandt show his sitter in lost profile. For this reason, the sitter can hardly have been intended to be identified. The subject of the etching is, rather, the event that Rembrandt illustrates. By precise control of perception of the scene, Rembrandt leads the viewer's attention, like that of the man himself, towards the apparition. A third area of emphasis is established by the astrolabe at the lower right edge, which stands out both through its brightness and for its size. Thus both composition and the pictorial narrative make clear that we are here observing a scholar concerned with astrology and confronted by an apparition.

As early as 1679, Clement de Jonghe mentioned an etching with the '*Practisierende Alchemist*' (Alchemist at Work).[12] Without exception, research has found this entry to refer to our etching. De Jonghe's entries and those of Röver have been seen as equally reliable. While De Jonghe must have known Rembrandt personally,[13] Röver's designation comes from a period when other works were also given new titles apparently because their original significance was no longer known or possibly because they had lost their former interest— one may recall the case of the *Hundred Guilder Print*[14] or that of the *Nightwatch*.[15] The title *Alchemist at work* might, indeed, have become accepted had it not been recognised that the seventeenth-century iconographic tradition for the presentation of alchemists was quite different from this. Thus, for example, paintings by Teniers always show a fire as the most important attribute of the alchemist.[16]

Rembrandt, on the contrary, takes up a motif from earlier scenes with scholars:[17] he shows a man of learning, looking up from his books and, indeed, holding a writing instrument in his right hand. In his own etching of a scholar, made in 1645 (Fig. 33a),[18]

258

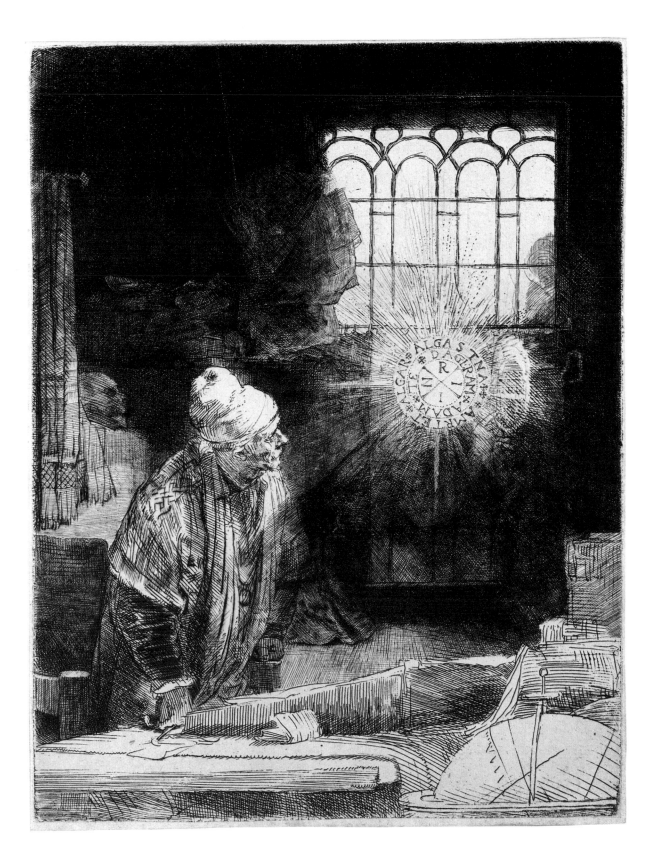

the figure is placed next to a table. In this earlier sheet the figure leans on a book, with a pen in his hand, and looks up thoughtfully. The two etchings show an altogether comparable arrangement of planes: in the earlier work, the figure of the scholar is set off against the brightly lit plane on the right, and in the *Faust* etching this area is occupied by the window and the apparition. In both sheets, the lower right corner is emphasised through the cropped image of an astrolabe. The 1645 scene with the scholar may have served as inspiration for Rembrandt's *Faust* etching. Starting from the iconography of the earlier sheet, Rembrandt presents a new interpretation of scholarship. The room, only sketchily indicated in 1645, is as detailed as a painting in the later sheet and becomes a setting that is used to define the protagonist.

Recently, Carstensen and Henningsen have drawn attention to a tradition of scenes of cabbalistic conjuration, apparently well-known in Amsterdam at the start of the seventeenth century.[19] Literary scholarship and magical rites were unified in this form of astrological belief, in which a Magus sought to invoke the ethereal spirits of the stars. Rembrandt might have learned these ideas from Menasseh-ben-Israel, who could have passed on to him various ideas from cabbalistic tradition.[20]

It seems that Rembrandt has here established for the first time a visual representation for a form of alchemy that had previously only been recorded in literary tradition. This novel iconographic formula—unlike earlier scenes with alchemists—shows the union of literary scholarship and magic. It introduces a personality that was to receive its classic literary formulation in Goethe's *Faust*. This may be seen to explain the persistent appeal of the essentially ahistorical title.

B.W.

1. As claimed, for example, by Carstensen/Henningsen 1988, p. 300.
2. A survey of the history of research on this matter is provided by Van de Waal 1964, pp. 45–46, *Documents* p. 14, and, most recently, Carstensen and Henningsen 1988.
3. See Van de Waal 1964, pp. 9–11; Rotermund 1957.
4. Carstensen/Henningsen 1988, p. 302.
5. On the question of the relation between drawings and etchings, see, for example the, *Hundred Guilder Print* and the drawings accompanying its own evolution (Cat. No. 27).
6. *Urkunden* 346.
7. Leendertz 1921.
8. Leendertz 1921, p. 136.
9. Van de Waal 1964, Figs. 1–3.
10. Van de Waal 1964.
11. See, most recently, Carstensen/Henningsen 1988.
12. Van Gelder/Van Gelder-Schrijver 1938, p. 1.
13. See Cat. No. 30.
14. Cat. No. 27.
15. *Corpus* A146.
16. For example, Prado, Madrid; Musées Royaux des Beaux-Arts, Brussels.
17. See the examples given by Van de Waal, as well as B. 105, B. 147 and B. 148.
18. B. 147.
19. Carstensen/Hennigsen 1988, who, following Panofsky, elaborate on the context of Rembrandt's *Faust* etching in terms of intellectual history.
20. See the Menetekel inscription in the London *Belshazzar's Feast* painting Paintings Cat. No. 22.

Etching and drypoint, 213 × 319 mm; 4 states
Unsigned, c. 1651
B./Holl. 223; H. 244; White pp. 212–13

Berlin: I (94–1887)*; III on Japanese paper
(120–1894)*
Amsterdam: I on Japanese paper (O.B. 456);
IV (O.B. 457)
London: II (1973 U. 1028); III (1973 U. 1029)

The principal motif in this print of about 1651
with its strip-like format is a compact entity
surrounded by trees, between which a path
leads. A flock of birds sweeps over the
buildings. On the left the view stretches,
uninterrupted, to the horizon. Darkness has
already crept up on the first group of trees—
in one half of the sky the hatching lines close
up—and those nearby appear to bend in the
wind. The broad, lit foreground emphasises the
falling darkness of the evening sky.

The location depicted here has been
identified as '*Het Huys met Toorentje*' (The
House with a Turret) on the Amstelveen road
very near to Amsterdam.[1] A drawing by
Rembrandt formerly in the Hirsch collection
(Fig. 34a)[2] cannot have served as direct
preparatory material because of its completely
different treatment of the main motif.
However, in it Rembrandt has drawn the same
group of houses, recognisable through the
tower, but from a greater distance and, rather,
as the silhouette of a village not dominated by
any individual motif. For his etching
Rembrandt selects a closer view, in which the
main motif, surrounded by trees, becomes the
focus of attention. In the drawing the
unworked paper surface is already incorpated
into the formal structure of the composition.
In the printed version even more is made of
this device. The dramatic use of light is crucial
for the effectiveness of the etching.

In many of his landscape etchings
Rembrandt seems to conceive the images in
pictorial terms.[3] These works stand out for
their formal compactness and, above all, their
fully elaborated foregrounds. 'First, it seems
that our foreground is detailed and emphasised,
in order to let the rest [of the composition]
retreat behind it, and so that we are persuaded

34a: Rembrandt, *Landscape with a tower*. Drawing.
Malibu, J. Paul Getty Museum.

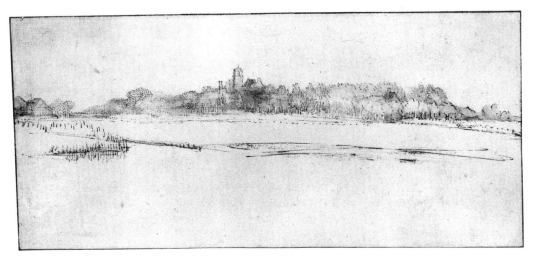

that something important is to be introduced into the foreground [. . .]'[4] In this etching, however, Rembrandt selects a compositional arrangement that is deliberately not taken from the sphere of traditional landscape painting. Obviously he is seeking to give the impression of a spontaneous study of light effects. The etching owes its particular allure to the contrast between the open foreground and the tightly organised composition in the central area.

The house is sheltered by the trees which sway in the wind. The swelling foliage is captured in short, light strokes. In state I Rembrandt uses line to contrast the solidly constructed wall and the feathery lightness of the thatched roof. In the later states Rembrandt denies the material aspects of the subject through his use of even, unifying cross-hatching. At the same time his interest in the topography wanes: in state III the cupola of the tower is burnished out, so that it no longer dominates the scene. The compact quality of the group of house and trees is now emphasised. A realistic record of the village is eschewed in favour of a composition based on formally determined passages, and where the principal concern is the effect of light and shadow.

The further, small corrections, ultimately insignificant for the composition as a whole, add to the intended effect of the image. Spots of etching fluid, visible in state I as black patches in the dark passages of the sky, are burnished out, though the triangular patch on the left near to the house persists through all the states. The lengths to which Rembrandt has gone in establishing the final version of this landscape etching are documented in the four states, each of them surviving also in the form of counterproofs. In some impressions Rembrandt experimented with different sorts of paper as well as with several inks and various degrees of wiping of the plate before printing. The manner in which the *Landscape with a Tower* evolved—a process during which composition, lighting, and printing technique were all re-worked—reflects Rembrandt's obsessive concern with the possibilities of the landscape etching.

B.W.

1. Van Regteren Altena 1954, 12–17; Washington 1990, No. 81.
2. Getty Museum, Malibu; Benesch 1267; see Washington 1990, No. 82.
3. A particularly clear example is *Landscape with the three trees* (Cat. No. 19).
4. 'Alvooren onsen voor-gront sal betamen Altijts hart te zijn / om d'ander doen vlieden / En oock voor aen yet groots te brenghen ramen'. Karel van Mander (1916), p. 204.

34

State I

State III

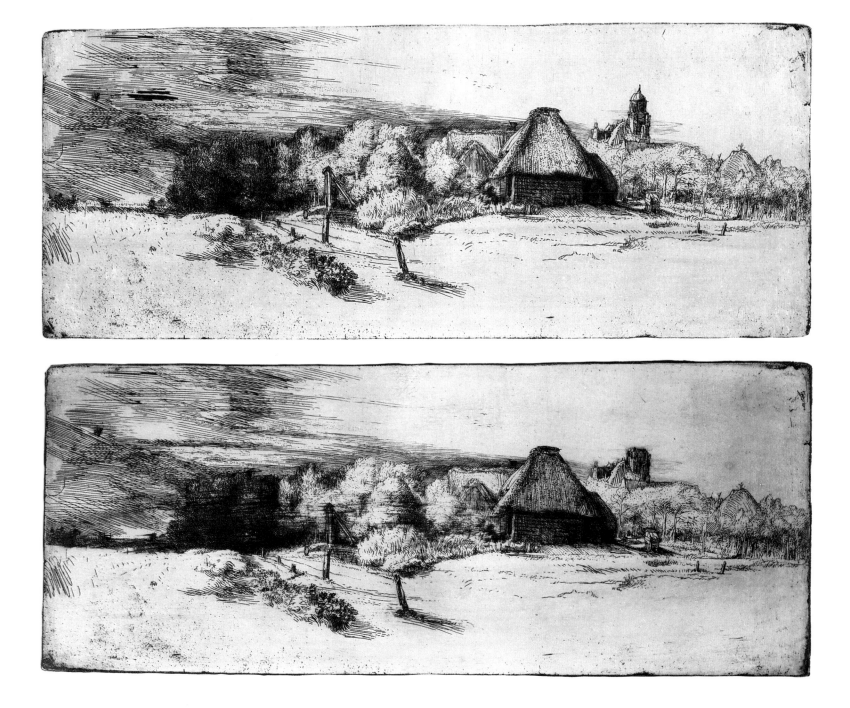

35

The Three Crosses

Dry point and burin, 385 × 450 mm; 5 states
Signed and dated: (in III, also still detectable in
IV) *Rembrandt. f. 1653*.
B./Holl. 78; H. 270; White, pp. 75 ff., 99 ff.

First version (I–III)
Berlin: III (646–16)*
Amsterdam: III (62:39)
London: III (1973 U. 941)

Second version (IV–V)
Berlin: IV (643–16)*
Amsterdam: IV (62: 40)
London: IV (1973 U. 942)

35a: Detail of Cat. No. 35, State III.

35b: Detail of Cat. No. 35, State I, on parchment.

35c: Master B with the Die, *The Crucifixion with
the Conversion of the Centurion*.
Vienna, Graphische Sammlung Albertina.

In 1653, or shortly before, Rembrandt made one of the masterpieces of his printed œuvre: *The Three Crosses*. The scene has the scale of a painting; and it was radically reworked in a later state, and in a way that is unique in the history of printmaking.

The first three states—the first version of the subject—show a crowded Calvary. This type of scene had its roots in fifteenth- and sixteenth-century Netherlandish art, but it was something of an exception in Dutch painting of the seventeenth century. Rembrandt's depiction of the Crucifixion is based, to a large degree, on the text in the Gospel according to Saint Luke: 'And it was about the sixth hour, and there was a darkness over all the earth until the ninth hour. And the sun was darkened, and the veil of the temple was rent in the midst. And when Jesus had cried with a loud voice, he said, Father, into thy hands I commend my spirit: and having said thus, he gave up the ghost. Now when the centurion saw what was done, he glorified God, saying, Certainly this was a righteous man. And all the people that came together to that sight, beholding the things which were done, smote their breasts, and returned. And all his acquaintance, and the women that followed him from Galilee, stood afar off, beholding these things.'[1]

The cross itself forms the centre of the scene; and, following tradition, Rembrandt included the two thieves who were crucified with Christ. On the left are the Roman soldiers; and the Centurion who was converted at the death of Christ has already dismounted

and kneels at the foot of the cross with outstretched arms. On the opposite side are the mourning Disciples. Mary has fainted in the arms of a companion; John presses his hands to his head as if to tear at his hair (Fig. 35a). Mary Magdalen, consumed with sorrow, embraces the cross. Rembrandt omits some elements in the narrative of the Passion that are frequently found in Calvary scenes, such as the motif of the soldiers casting lots for Christ's clothing. He enhances the scene, however, by including the figures of the onlookers, described in Luke's account as turning away so as not to witness the horror of the event. Two men in the foreground, apparently Jewish scribes, run in panic towards a cave, and further to the left a man, possibly Simon of Cyrene, who is clearly deeply shocked, is led away by his companions. One man covers his face with his hand, another shields his eyes, and fleeing people are thrown to the ground in their haste. It is not always clear whether these are intended as followers or opponents of the crucified Christ; but they all appear to be in a state of great shock. Rembrandt's psychologically penetrating study of terrified humanity has no equal in the iconography of Calvary.

We are shown the climax of the Passion: the moment of Christ's death. The natural phenomena—the quaking earth, the darkness—are illustrated with a powerful use of *chiaroscuro*. Vast beams of bright light pierce the turbulent black sky, falling in a cone to illuminate Christ on the cross and the converted thief on his left who persists in his

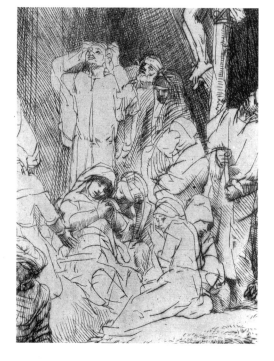

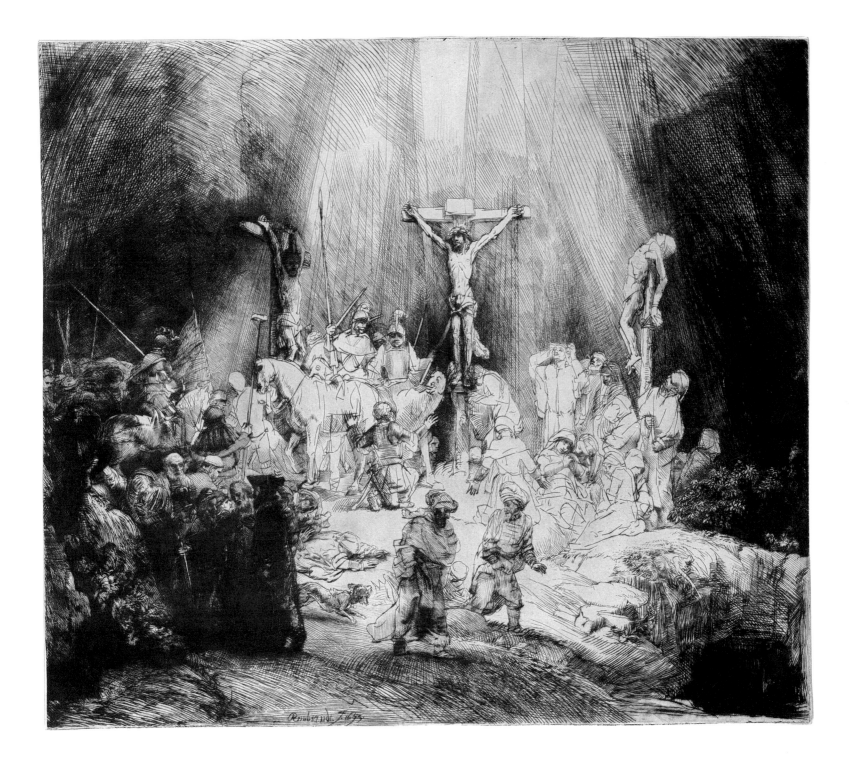

refusal to believe in the Lord.[2] The violent contrasts in illumination create an impression of chaos. Christ triumphs over this earthly tumult; he shows no trace of sorrow, and exudes a solemn air of peace. Rembrandt must have consciously adopted the form of the crucified Christ found in medieval art, with the feet placed next to each other and each nailed separately to the cross, a presentation that emphasises the idea of Christ's composure and his essential 'distance' from the surrounding confusion.

The angular style of the figures, often only shown in outline, corresponds to the style of Rembrandt's pen drawings of the same period. Apart from a disputed sheet of studies in Weimar, perhaps made in preparation for the group with the man led away by his companions, no preparatory drawings have survived.[3] One can, however, assume that there may have been further preparatory studies for the individual figures and for the composition as a whole. Rembrandt apparently transferred the scene directly on to the copper plate in drypoint, and in a few places also with the burin. Only in the case of small landscapes, are there earlier examples of works by Rembrandt executed exclusively in drypoint.[4] The transfer of a technique allowing a high degree of control to a large-scale work is witness to the artist's technical virtuosity. In his presentation of darkness, Rembrandt exploited in a unique way the effect peculiar to the drypoint stroke—it appears velvety and 'painterly' when printed because of the burr thrown up at the edges of the lines.

The Calvary scene may have been conceived as a pendant to Rembrandt's *Ecce Homo* of 1655 (see Cat. 38).[5] Both sheets were, perhaps, planned as parts of a Passion cycle which was, however, left unfinished. This possibility is supported by two observations: the *Ecce Homo*, in its first state before the plate was cut down, has almost the same scale as the *Three Crosses*, and both works are executed in the same technique. In addition, there are other groups of biblical cycles of the 1650s, for example the Passion of 1654 (see Cat. No. 37).[6]

Rembrandt's *Ecce Homo*, in its basic conception, follows Lucas van Leyden's engraving of the same subject from 1510 (see Cat. No. 38).[7] The *Three Crosses* would also seem to have evolved in conscious relation to the large Calvary scene by Lucas van Leyden of 1517,[8] yet not in the sense of a direct formal reference to the earlier work, but rather as a reinterpretation of the subject. It appears that Rembrandt wished to demonstrate that he was able to surpass his great Dutch predecessor, whose two most important works Rembrandt

had acquired for large sums. Rembrandt reworked other models directly. The figure of the converted Centurion is derived from an engraving by the Master B with the Die (1532), an Italian engraver from the circle of Raphael (Fig. 35c).[9] It is perhaps in this source that the image of the group of Disciples found its inspiration. For the group leading away the old man, a corresponding group from the *Conversion of Saint Paul* by Lucas van Leyden could have been the source.[10] The *Horse Tamers* of Antiquity, from the Palazzo del Quirinale in Rome, served as a model for another group in the left half of the scene in the first version (this is even more evident in the second version): the Centurion's horse and the servant holding its reins.[11] In spite of these formal borrowings, however, Rembrandt's Golgotha scene is totally original in its composition and iconography.

States I and II differ only minimally; Rembrandt experimented incessantly at these stages, in order to try out various pictorial effects. He used different kinds of paper; many proofs of state I are printed on thick vellum (Fig. 35b), which is very unabsorbent, so that the drypoint lines appear blurred, producing deep black passages in places. In addition, the plate was inked in varying degrees, or wiped with uneven pressure, so that, in one and the same proof, certain areas of the picture may emerge brighter or darker. Each proof is unique. In state III, signed and dated 1653, individual strokes are added to the groups of figures, especially on the left and in the foreground, and also in the areas of sky at the sides, which are now shown as heavier and darker. Only with this state were the proofs printed, without exception, on white paper with slight and even surface tone. The fact that this state is also signed shows that Rembrandt viewed state III as finished and intended it for sale.

The fourth state of *The Three Crosses* shows a thoroughly altered composition. Opinion has been divided as to whether Rembrandt reworked the plate in 1653, or shortly thereafter (that is to say, in direct connection with the third state), or did so only several years later, in about 1661. Important evidence in support of the second of these possibilities is to be found in the striking similarity of the newly introduced figures, above all that of the soldier right next to the cross, to the figures of Rembrandt's painting in Stockholm, *The Conspiracy of Claudius Civilis*, finished in 1661.[12] Acceptance of the later date has generally prevailed.[13] One can only speculate on the reasons for the alteration; the most obvious

explanation would be that the old plate, with its numerous drypoint passages, no longer allowed a satisfactory print to be made, and that Rembrandt took this opportunity to make a new scene.

The plate was substantially and smoothly polished and then reworked with drypoint and burin; in certain passages the lines from the first version are still clearly recognisable under the new strokes. Powerful hatching lines now steep the whole scene in a deep darkness. Only the Crosses with Christ and the thief on his right, and also one of the fleeing men in the foreground, are retained in their original form, though even here there is slight reworking. Even the group of mourners differs from that in the first version, for the characterful figure of John now stands out from those of the other young men, isolated through the beseeching gesture of his raised arms. The figure of the converted Centurion appears almost erased, and it is now superceded by that of a man on horseback. There are, nonetheless, some alterations in the treatment of the figure of the Centurion. Christ has been finely modelled: the facial features are more human, and more sorrowful; the eyes and the mouth are slightly open. It seems as if Rembrandt here shows us the dying Christ, rather than Christ who has just died as in the first version. This could also explain the suppression of the figure of the kneeling Centurion, who was converted to the message of the Gospels only in the very moment of Christ's death.

The role of the main figure on the left, derived from the equestrian figure of Gian Francesco Gonzaga on a medal by Pisanello (of about 1444), remains a mystery (Fig. 35d).[14] Possibly he is intended to be the personification of those in power, and thus a symbol of earthly injustice and unbelief; or he might be Longinus with his spear, or Pontius Pilate. The identification of this equestrian figure as Pontius Pilate is subtantiated by iconographic tradition; for even in crucifixions of the fifteenth and sixteenth centuries the equestrian figure of Pilate is, on occasion, depicted in his capacity as a military commander. This is also suggested in the long stick carried by the figure on horseback here; this would seem to be the same stick as Rembrandt gave to the figure of Pilate in the *Ecce Homo* (Cat. 38), as a sign of his power as a judge.[15] The greater emphasis on the figure of the Apostle John in state IV in relation to the earlier version, also indicates that the figure on horseback is Pilate. John, in his Gospel, speaks throughout of the presence of the Roman Governor at Calvary; it was Pilate that had prevailed in his disputes with the Jews and, for this reason, had insisted that

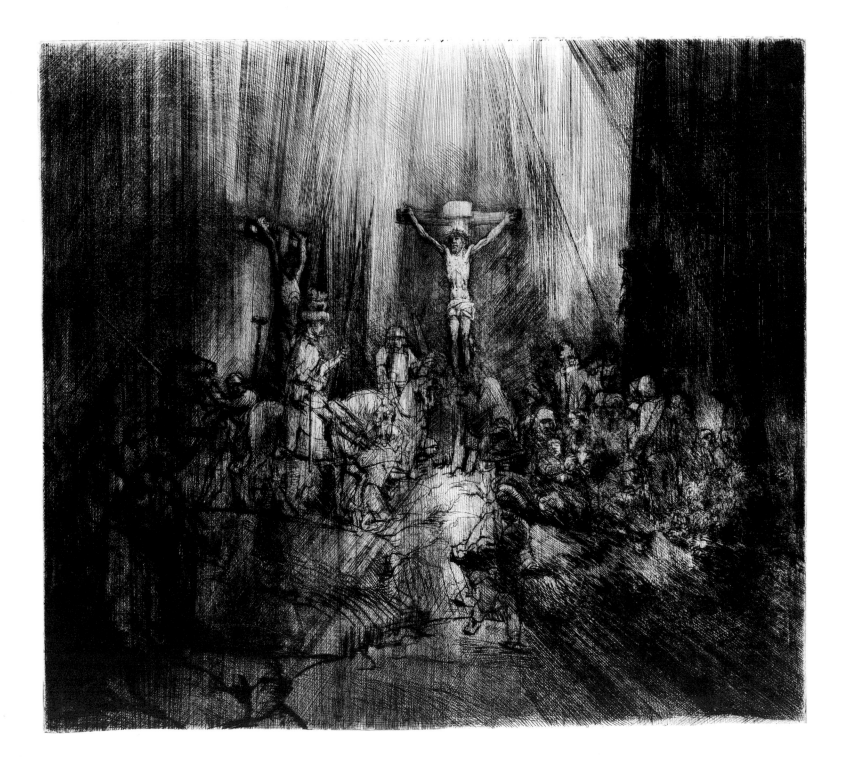

Jesus should be given the title 'King of the Jews' which was to appear on a plaque attached to the cross. It would seem that, in the later version of the *Three Crosses*, Rembrandt had wanted to show the crucifixion as a documented historical event, for John was an eye-witness to the Passion: 'And he that saw it bare record, and his record is true: and he knoweth that he saith true, that ye might believe.'[16]

Both versions of *The Three Crosses* are informed by one of the themes underlying Rembrandt's treatment of religious subjects: the tragic entanglement of sinful man in his own guilt. Rembrandt often characterised the sinner who had come to see the error of his ways—for example, the Prodigal Son—not as a damned being but as an individual fated to be sinful.[17] This explains his emphasis on the Roman Centurion in the early version of *The Three Crosses* and on the figure of Pontius Pilate in the later one. Both men were responsible for the death of Christ: the Centurion recognised his own guilt and repented, and the Governor, convinced of Christ's innocence, made himself guilty in a tragic manner, because he was too weak to resist the High Priest, who had demanded Christ's death. But even the sinner who fails to see the error of his ways merits understanding. It is perhaps for this reason that the unconverted thief on Christ's left in the first version appears in a bright light: he will eventually attain understanding and inspiration. The thief on Christ's right, meanwhile, is already converted, and is now repentant.

The proofs of state IV also vary considerably, depending on the burr remaining in the dry-point passages, the kind of paper used, and the manner of inking the plate. There are proofs with so much surface tone that the scene is almost entirely drowned in the blacks. Rembrandt made counterproofs (of which three survive) (Fig. 35e)—that is to say, images printed off freshly made proofs and so recording the composition unreversed as it appears on the plate. In addition there is a maculature, a second proof taken from the plate before re-inking, in which the individual parts of the composition are more clearly legible than in the proof itself. Both images allow one better to study the intended alterations to be made on the plate.

It seems that Rembrandt wanted to alter the scene once more, perhaps in order to achieve a yet more penetrating account of the Crucifixion, this turning point in world history. In the end he settled for the sombre picture of human catastrophe he had achieved in the two versions of *The Three Crosses*.
H.B.

1. Luke 23: 44–49.
2. As the thief on Christ's left is caught in the bright rays of light, he has usually been seen as the converted thief, even though, in iconographic tradition, he belongs on Christ's right. He does, however, hang painfully bent upon his cross, that is to say in a pose usually characterising the bad thief, who is seen to writhe in agonising death throes. It is also significant that his eyes are bound, suggesting that he refuses to recognise the truth. The body of the man crucified on the right of Christ does not hang in such a contorted fashion on his cross, and may thus be supposed to be in

35d: Antonio Pisano, called Pisanello, Medal of Gian Francesco Gonzaga.
Berlin, Staatliche Museen, Münzkabinett.

35e: Rembrandt, *The Three Crosses*. Counterproof.
Berlin, Kupferstichkabinett SMPK.

less agony; he must be the thief who believes in the innocence of Jesus. It would also be fair to assume that Rembrandt was familiar with iconographic tradition and that he was well aware that he was reversing the two sides. Wolfgang Stechow, proceeding from the conventional interpretation, suspected that Rembrandt had altered the plate in state IV, in order to make his own iconographic error less evident; but why then would he have fully altered the plate simply on this account?

3. Benesch 1000. Haverkamp-Begemann accepted the sheet in Weimar as a study for this group; Haverkamp-Begemann 1961, p. 86, on Benesch 1000. The sketch for a man leaning forwards in the Staatliche Graphische Sammlung in Munich has been connected with the figure of the Magdalen embracing the cross; Benesch 925; Wegner 1973, No. 1124.
4. B. 221–22; Washington 1990, p. 126, No. 25, p. 132, No. 27.
5. B. 76.
6. B. 50, 83, 86, 87.
7. B./Holl. 71.
8. B./Holl. 74.
9. B. 3. Less convincing is the comparison with a Calvary scene by J. B. Fontana (B. 14), which Rembrandt is said to have used as a source; Münz 1952, Vol. II, p. 104, No. 223.
10. B./Holl. 107.
11. It was known, among other examples, through an Italian engraving dated 1584; Münz 1952, Vol. I, Fig. 70, Vol. II, p. 104, No. 223.
12. See Stechow 1950, p. 254. On this matter, see also Paris 1986, p. 230, No. 115.
12. Bredius/Gerson 482; White 1969, p. 99.
13. It has, in any case, been overlooked that the signature and the date 1653 were not fully polished away and can still be clearly recognised under the new application of hatching. However, Rembrandt may not have regarded this as important.
14. This is the reverse of the medal for the Duke of Mantua, that must have been in Rembrandt's possession; see Münz 1952, Vol. I, Fig. 69; Vol. II, p. 104, No. 223.
15. B. 76.
16. John 19: 35.
17. Białostocki 1973.

36

The Virgin and Child with the Snake

Etching, 95 × 145 mm; 2 states
Signed and dated: *Rembrandt. f. 1654.*
B./Holl. 63; H. 275; White, pp. 80 ff.

Berlin: I (118–16)
Amsterdam: I (62:33)*
London: I (1910-2-12-380)

There are only a few print cycles in Rembrandt's œuvre. However, in 1954, he made two etched series of biblical scenes: a Passion (see Cat. No. 37), and a series of five or six sheets with scenes from the Childhood of Jesus.[1] There is only a loose connection between individual scenes within each of the series, and each print can stand as a work in its own right. The cycle with scenes from the Childhood of Jesus includes *The Virgin and Child with the Snake*.

The Virgin sits in a room, warmly cuddling the child. Joseph looks in from outside, with almost sad eyes. A cat is playing with the hem of the Virgin's dress. She places her foot on a snake: the motif, common in Catholic iconography indicates that she is to be seen as the new Eve, who will overcome original sin. The armchair and the curtain opening above it suggest a throne with a canopy, a traditional symbol of honour used to present the Mother of the Lord as the Queen of Heaven. The Virgin has not, however, taken her place in the armchair; instead she sits on the floor. Rembrandt is here adopting the motif of the *Madonna dell'umiltà* originating in Italian art of the fourteenth century, and in the North in the fifteenth century.[2] The Virgin confronts the viewer not in a distanced manner, in majesty, but as if humanised; and this impression is increased through the familiar, domestic surroundings—the fire in the hearth, the playful kitten and the open laundry basket. The holy scene takes place in a simple room. Joseph is excluded in that he stands outside; but he can take part in this moment indirectly, as Rembrandt shows him, looking in through the window. The visible traces of a reworking of the plate on the right at the chimney could indicate that Joseph was first placed here, inside the room.[3] The circular central pane of the leaded glass seems to form a halo around

the heads of the Virgin and child.

A comparably intimate atmosphere is to be found in Rembrandt's painting *The Holy Family* of 1646, in Kassel (Fig. 36a).[4]

As in fifteenth century Netherlandish painting, there is a deeper meaning hidden within Rembrandt's apparently secularised scene. The closed, doorless room, into which Joseph has no right to enter, points to Mary's virginity, just as the dividing window-pane is a symbol of her purity. It is not only the snake that alludes to original sin; the cat too must be intended as an embodiment of evil, and of Satan, who dwelt, according to popular superstition, in the chimney.[5] As early as 1641 Rembrandt had shown, in the etching *The Virgin on the clouds*, an explicitly Catholic motif: the worship of the Mother of God.[6] These works must have been intended principally for members of the Catholic merchant classes, who were also to be found in Protestant Holland.[7]

Iconographically and compositionally, the scene is based on models in earlier Netherlandish art. Various pictures of the Virgin from the circle of the Master of Flémalle, for example, show the Virgin and child in an interior, sitting on the floor in front of a bench near the hearth. The motif of the Virgin's halo represented symbolically by an everyday object is also derived from the Master of Flémalle.[8]

An engraving by Andrea Mantegna, meanwhile, provided a direct model for the Virgin and Child (Fig. 36b).[9] Rembrandt was especially interested in the motif of the tender, intimate embrace, and he adopted this almost literally. Mantegna shows the group slightly *di sotto in su*, like a stone sculpture in a niche; however, Rembrandt softened monumentality by placing it at eye level and rejecting the sharply folded and creased drapery in favour

of more supple cloth. The preoccupation with Mantegna is evident not only in the adoption of motifs and in the clear organisation of the picture planes, but also in the use of relatively restrained line and regular parallel hatching strokes.

In state I white spots are visible on the upper right edge; in state II these have been filled in with hatching. There is further reworking in the upper left corner.

H.B .

1. *The Passion*: B. 50, 83, 86, 87; *The Childhood of Jesus*: B. 47, 55, 60, 63, 64 and probably also B. 45, *The Adoration of the Shepherds*, although the sheet differs a little in size from the other scenes.
2. See Meiss 1936, pp. 434–64. Haverkamp-Begemann 1980, p. 168.
3. Filedt Kok 1972, p. 60.
4. Bredius/Gerson 572.
5. Slatkes 1973, pp. 257–58.
6. B. 61.
7. Tümpel 1977, pp. 29–30.
8. See, for example, the *Virgin at the hearth* in London, and the middle panel of the *Mérode Altar*; Panofsky 1953, Vol. I, pp. 163 ff., Vol. II, plates 90–91.
9. B. 8, Hind 1. Haverkamp-Begemann 1980, p. 168.

36a: Rembrandt, *The Holy Family with the curtain.* Kassel, Staatliche Kunstsammlungen, Gemäldegalerie Alte Meister.

36b: Andrea Mantegna, *The Virgin and Child.* Berlin, Kupferstichkabinett SMPK.

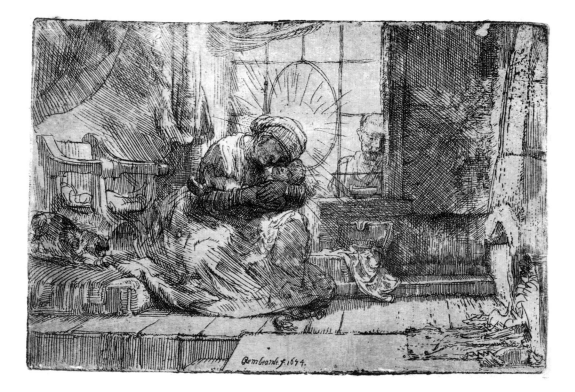

The Descent from the Cross by torchlight

Etching, worked over with drypoint, 210 × 161 mm; 1 state
Signed and dated: *Rembrandt.f.1654.*
B./Holl. 83; H. 280; White, p. 81

Berlin: (143–16)
Amsterdam: (O. B. 147)
London: (1973 U. 1084)*

In the early 1650s Rembrandt focused his attention on a subject that had concerned him throughout his career: the Life and Passion of Christ. In his capacity as a printmaker, he produced various biblical scenes that were probably intended as groups or cycles, even if the relationship of the sheets seems relatively loose and the series incomplete. Rembrandt's interest in the iconographic tradition in sixteenth-century printmaking of treating subjects in a series would have given a decisive impetus to his own cyclical arrangement of biblical material.[1]

As well as a small-scale series of scenes from the *Childhood of Jesus* of 1654 (see Cat. No. 36), Rembrandt produced a large-scale *Passion of Christ*.[2] *The Presentation in the Temple*, *The Descent from the Cross*, *The Entombment* (Fig. 37a) and *Christ at Emmaus* belong to this series.[3] The sheets are alike in size, technique and use of line; two of them are dated 1654, including *The Descent from the Cross*.[4] Characteristic of this group is the block-like construction of compositions dependent on strong horizontal and vertical lines.

The deposition takes place in darkness; a torch at the left is the only source of light. The dead body of Christ has just been taken down with the help of a large white cloth, and lies in the arms of a helper. Another helper, standing below the earthen bank, stretches out his arms, in order to take hold of the corpse. In the foreground, Joseph of Arimathea spreads a shroud out on the bier that is to serve as Christ's last resting place.

In the Gospels the event is only briefly described: a rich councillor, Joseph of Arimathea, asked Pilate for the dead body of Christ; he took it down from the cross, wrapped it in a cloth, and laid it in a rock tomb. From the Middle Ages the scene was shown with increasingly more attendants, above all Mary and a group of mourners. The group around Mary, in particular, often took on an important place in the depiction; in Rembrandt's etching, however, this group is pressed into the background and can hardly be detected in the darkness.

Rembrandt's scene differs decisively from iconographic tradition in another way: the cross is not at the centre of the scene, but is visible only as a fragment at the left edge. The group of helpers around the cross with the body of Christ is isolated by the horizontal line of the earthen bank and the vertical lines of both the cross on the left and the building in the right background, and thus constitutes an independent subject within the scene as a whole. The bright lighting of the group also adds to this effect. One almost has the impression that the figures are carrying out their tasks in the narrow space of a reliquary, and this prompts a contemplative viewing of the scene.

Another skilfully devised motif, on the other hand, takes up the whole of the foreground: the preparation for the Entombment. Here we see the bier with the shroud laid across it; it is as brightly lit as the cloth and the body of Christ being taken down from the cross, and in terms of the composition it constitutes a clear parallel to the corpse. Rembrandt does not show the moment at which Christ is wrapped in the cloth, but rather the individual phases of action that lead up to this moment. The gestures of the friends seem to be made in calm understanding: while one helper, notable for the heavy load he bears, supports the body in his arms—for the remaining nail has yet to be removed from Christ's foot—another companion already stretches out his hands in order to take the body, and Joseph of Arimathea, meanwhile, is seen spreading out the shroud. The composition culminates in the motif of the hand, picked out by the light from the torch and so set off against the darkness, towards which Christ's head sinks.

In combining the Deposition with the preparation for the Entombment, Rembrandt's etching constitutes an iconographic exception. Rembrandt had often treated the subject of the Deposition.[5] The painting of 1633 from the Passion cycle for Frederik Hendrik emerged from a close concern with Rubens's Antwerp *Deposition*.[6] The 1633 etching closely follows the pictorial arrangement of the painted version albeit in reverse, (see Introduction, Fig. 6) but it adds the motif of the shroud that was to retain its central place and importance in the later, 1654, version.[7]

Like the other three sheets of the Passion, the *Deposition* is almost entirely etched; additions with drypoint are only to be found in isolated places. The application of line with long, diagonally drawn parallel hatching strokes was a result of Rembrandt's interest in the copper engravings of Andrea Mantegna (see Cat. 36).

H.B.

1. Tümpel 1977, p. 103.
2. The following belong to the first series: B. 45, 47, 55, 60, 63 and 64.
3. B. 50, 83, 86, 87.
4. The view that the four sheets were intended as a cycle is not undisputed; Münz Vol. II, p. 110, Nos. 240–241 denies the connection between them and give the two undated sheets B. 50 and B. 86 as later, to the late fifties.
5. On this, see Stechow 1929.
6. *Corpus* A65.
7. B. 81. The *Deposition* in Leningrad, dated 1634 and signed by Rembrandt, where the motif of the shroud in the foreground is even more strongly stressed, is no longer accepted by the Rembrandt Research Project as authentic; *Corpus* C49.

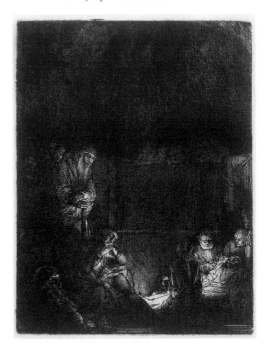

37a: Rembrandt, *The Entombment*. Amsterdam, Rijksprentenkabinet.

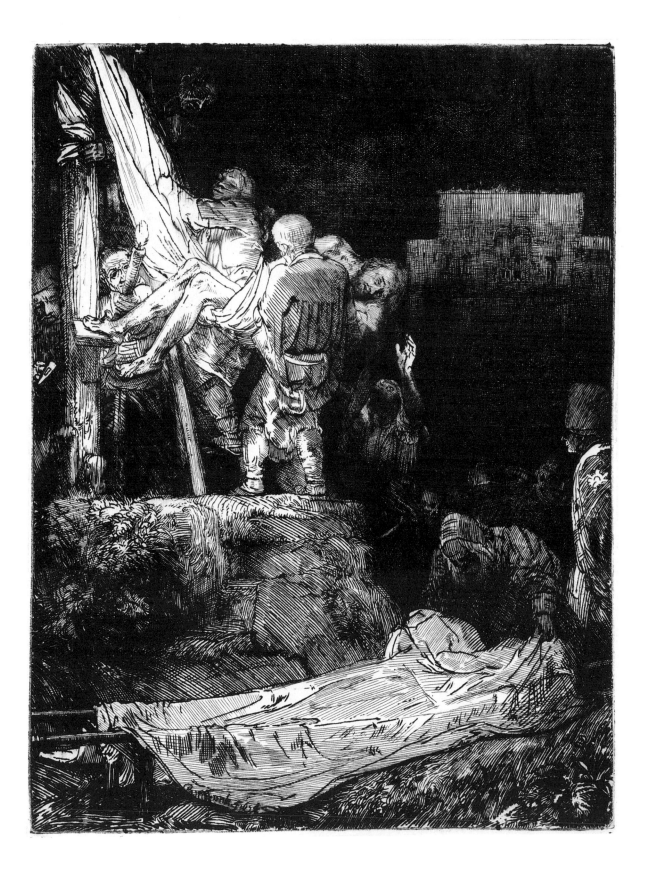

Ecce Homo

Drypoint, 383 × 455 mm;
from IV 358 × 455 mm; 8 states
Signed and dated: (from VII) *Rembrandt f. 1655*
B./Holl. 76; H. 271; White pp. 87–92

First version (I–V)
Berlin: I on Japanese paper (93–1892)*
Amsterdam: III on Japanese paper (75:1; cited
in Holl. as English private collection)
London: IV (1868–8–22–665)

Second version (VI–VIII)
Berlin: VIII (635:16; *with later additions at the
upper edge*)
Amsterdam: VIII (62:121)
London: VIII on Japanese paper (1973 U. 931)*

38
State I
State VIII

38a: Lucas van Leyden, *Ecce Homo*.
Berlin, Kupferstichkabinett SMPK.

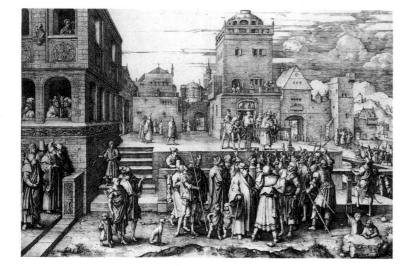

It was not only in the seventeenth century that
competition with the inventions of masters of
previous generations was a part of artistic
practice. Theorists celebrated competition
between artists, and art collectors valued this
programmatic demonstration of virtuosity.
The work of Lucas van Leyden, above all his
engravings, constituted a special model for
emulation in seventeenth-century Holland.
In 1614 the Humanist Scriverius (Fig. 22d) said
of Rembrandt's home town, Leiden: 'This city
has been praised as much through Lucas's fame
/ As for the wools and linens that also bear its
name'.[1] The deceased Leiden artist Willem van
Swanenburg, the brother of Rembrandt's
teacher Jacob Isaacsz. van Swanenburg, was
praised by Scriverius as a 'new Lucas van
Leyden'.[2] The appreciation for Lucas van
Leyden as a virtually unsurpassable engraver
was a provocation to artists to enter into
competition with him. Thus Goltzius engraved
a Passion series in the manner of Lucas van
Leyden, yet with his own distinct style in the
movement of figures and other aspects of the
work, which should not be underrated.[3] Thus
for seventeenth-century connoisseurs it was
obvious that Rembrandt's late *Ecce Homo* was
based on a critical examination of Lucas van
Leyden's version of the scene (Fig. 38a).
Rembrandt had acquired works by this
predecessor for a vast sum, as early as 1637,
among them the *Ecce Homo*.[4] It was only in the
period around 1655, however, that Rembrandt
made his own *Ecce Homo*, to compete with
Lucas van Leyden. Possibly conceived as a
pendant to the *Three Crosses* (Cat. No. 35), the
Ecce Homo is similarly executed throughout in
drypoint, and it marks a further highpoint in
Rembrandt's late work as an etcher. As in the
Three Crosses, Rembrandt embarked on a full re-
working of the plate after the first version had
gone through several states.

Rembrandt had turned to the subject of the
Ecce Homo as early as the 1630s. A grisaille
sketch[5] was made in preparation for the earlier
etching, which was then largely executed by
Van Vliet (Fig. 38b).[6] In this work from
Rembrandt's first Amsterdam period, the
dialogue between Pilate and the High Priest,
who have taken upon themselves the power of
judgment, is recorded with theatrical gestures.[7]
The thrusting mob must be appeased. The
confusion of figures and contrary movements in
the narrow space establish a mood of dramatic
disturbance. Christ is removed from this
aggressive bustle, through the patience
conveyed in the expressive power of both his
pose and his face.

Our etching, on the other hand, clearly
shows the altered narrative style of
Rembrandt's work of the 1650s. A strongly
centred figural narrative has taken the place of
the earlier lively, diagonally arranged
composition. We are presented with figures
who act with rather restrained gestures, placed
as if in a relief, in front of the architectural
façade. The spacious setting evoked on the
sheet is taken up with imposing buildings.
Stone figures of Justice and Fortitude identify
this as the place of judgment and constitute a
frame for the main scene. The principal figures
rise up in front of the black hollows of the
entrance to the palace. Christ, with his hands
bound and his head bare, is shown to the
people. Pilate, wearing a turban and carrying
the justicial rod, points to him. Behind them
stands Barabbas, the real criminal. It is unusual
for Barabbas to be included in scenes of the *Ecce
Homo*; and only a few examples are to be found
in iconographic tradition.[8]

Rembrandt here defines his own pictorial
narrative through deliberate reference to the
biblical text. The variety of his motifs
accurately reflects the complexity of the
biblical account.[9] Thus he illustrates the full
breadth of the narrative. For example, a figure
standing next to the left stone pedestal, already
holds a water jug and a bowl, in which Pilate
will innocently wash his hands. The
Governor's wife leans at a window on the left;
and, in the shadowy interior of the palace, only
detectable as a silhouette, is the messenger who
has just taken his leave of her in order to
report her warning dream to her husband.

In the *Ecce Homo* etching Rembrandt does
not use a uniform scale for his figures. With a
form of hierarchical perspective, the figures on
the platform are shown larger than those
among the crowd in the foreground, thus
negating their greater distance from the viewer.
Particularly striking is the figure seated by the
left parapet who seems to be recording the

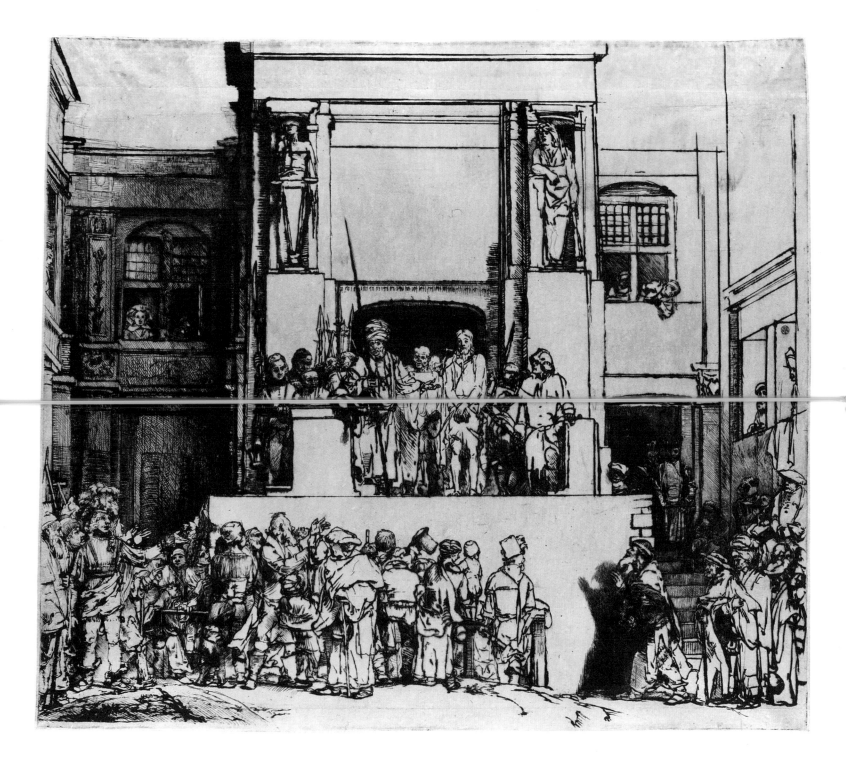

event in writing or, more probably, in a drawing. Rembrandt integrates an 'artist-chronicler' of this sort into other scenes, for example the oil sketch for *John the Baptist preaching*,[10] and some of the landscape etchings.[11] However, it remains uncertain whether Rembrandt intended this figure as a commentary on the role of the artist.

Rembrandt obviously selected the Renaissance model (Fig. 38a) as the starting point for the composition of his own *Ecce Homo* etching.[12] The marked spaciousness of Lucas van Leyden's print, where the view is drawn to the far distance in an almost calculated manner, is replaced in Rembrandt's scene with an imposing building that runs across the whole picture plane with hardly any recession in depth. One has the impression, nonetheless, that Rembrandt had been looking at Lucas van Leyden's engraving while he was at work on the first version of his own drypoint etching. If one considers the way an etched image comes about, with the drawing as marked on the plate reversed in the printed form of the image, a large number of borrowed motifs are apparent. Thus, for example, the architectural façade on the left, with figures leaning out of the windows, and the staircase placed nearby, are conceived in analogy with Lucas van Leyden's sheet. The group of figures in the earlier work standing in front of this staircase, and so linking the figures at the side with the main event, has been concentrated, in Rembrandt's scene, into a single male figure, dramatised both through its pose and through the lighting which repeats its gesture in the form of a sharp cast shadow. The figure with a stick and a purse standing out from the crowd in the foreground is also derived from a model in the earlier work, although without in the least being a copy. While the bare-headed man between Christ and Pilate is only one of Pilate's henchmen in the Lucas van Leyden scene, Rembrandt makes him Barabbas.

Around 1600, appreciation for Lucas van Leyden had focused, above all, on his engraving manner. Thus, Karel van Mander writes of Goltzius: 'In as far as he could realise that which constituted the particular character of the style of any master whose works he had previously come to know, he could, with his own hand alone, bring to expression the peculiarities of several hands in compositions that were of his own invention.'[13] It was above all in the imitation of earlier manners of engraving that Goltzius and other artists of his generation saw a challenge.

Competition with Lucas van Leyden's manner did not correspond to Rembrandt's artistic ideal. The *Ecce Homo* etching is, indeed, executed in Rembrandt's own, unmistakeable 'handwriting'. The figures are established with a few, broken lines. Continuous contours are avoided. This use of line clearly stems from his experience as a draughtsman. In contrast to this, the shaded regions are darkened through the use of concentrated hatching. By these means, Rembrandt clearly establishes a different form of competition with his source than that undertaken by artists of the previous generation.

It is striking that in the *Ecce Homo* and *The Three Crosses*, possibly conceived as pendants and with linked subjects and a similar size, the difference of narrative style is crucial: in *The Three Crosses* the powerful drama of the event dominates the composition. One could ask, however, if in these two etchings Rembrandt has substituted variations of narrative style for the variations in engraving style so praised by Karel van Mander in the work of Goltzius.

The first version (states I to V) of the *Ecce Homo* is not signed. However, a large number of impressions have survived; some of them—for example, the sheet in London—on Japanese paper. For this reason, one is tempted to describe this as a final composition intended for sale and not as a rejected working stage.

For the fourth state of the etching, Rembrandt reduced the size of the plate, presumably to make it compatible with standard paper sizes. The impressions of the earlier states are printed on paper with a narrow strip attached to the upper edge. After five states the artist introduced a fundamental change into the composition, comparable to the full re-working of *The Three Crosses*. After making the trial proof state VI, Rembrandt signed and dated (1655) this second variant of the *Ecce Homo* in state VII, thus acknowledging it as finished. The eighth and last state simply corrects a few shadings. Rembrandt had re-polished the plate in the foreground and removed the crowd grouped below the tribune. The most striking of a large number of changes is the introduction of the two dark cellar arches and, between them, the sculpted, half-length figure of a bearded old man, who supports his head with his right hand. Through an emphatic distribution of light and shade, the figure of Fortitude acquires a greater liveliness and, above all, a fierce facial expression. Lastly, Rembrandt re-works the physiognomies of the main group.

Lucas van Leyden's exemplary status plays no part in Rembrandt's second version of the *Ecce Homo*, as is immediately apparent. Rembrandt now finds his starting point exclusively in his own composition. There has been much controversy over Rembrandt's motivation in subjecting the already finished plate to this fundamental re-working. Was it principally aesthetic considerations that caused dissatisfaction with the first version? Or was Rembrandt striving to articulate distinct aspects of content? Probably, it would not be constructive to pursue these possibilities in strict opposition to each other. The meaning of the second version must, in any case, count as yet unexplained in many respects. Above all, the stone figure remains a mystery. It has been identified as Neptune,[14] but also as Adam. The Father of Mankind had committed the original sin, but he is redeemed by Christ in his role as the 'new Adam'.[15] It is, however, to be observed that Rembrandt challenges the viewer to a new form of dialogue with the event. The removal of the foreground arena with the gesticulating crowd reduces the sense of depth. By means of this device, the side figures draw closer towards the main group, while still retaining their framing role. The imposing block of the tribune is strongly balanced through axial symmetry, and this increases the impression of restrained action. The scene is concentrated on the two protagonists. The pictorial narrative reaches its climax in Pilate's decision of conscience, a decision in which the viewer participates.

The *Ecce Homo*, with its elaborate process of development and radical alteration into a second independent version, is yet another witness to Rembrandt's constant concern with his own narrative style.

B.W.

1. English translation cited from English edition of Schwartz (1985), p. 24.
2. See Schwartz (1985), p. 24.
3. Karel van Mander (1906), p. 247.
4. B. 71; *Urkunden* 51.
5. National Gallery, London; Paintings Cat. No. 15.
6. B. 77; Royalton-Kisch 1984.
7. Berlin 1970, No. 96.
8. See Winternitz 1969.
9. Matthew 27: 15–26.
10. Gemäldegalerie, Berlin; Paintings Cat. No. 20.
11. See *The Three Trees*, Cat. No. 19.
12. Münz 235 has referred to further possible sources of inspiration for individual elements of the composition.
13. 'Want bedenckende wat hij [Goltzius] over al voor handelinghen hadde ghesien, heeft hy met een eenighe hant verscheyden handelinghen van zijn inventie getoondt'. Karel van Mander 1906, p. 243.
14. White 1969, p. 90.
15. Winternitz 1969.

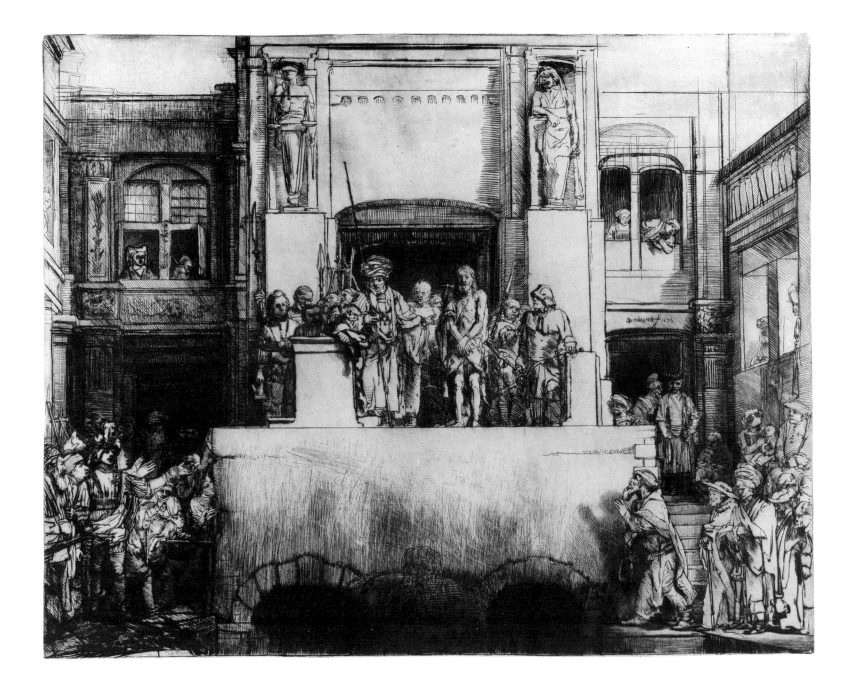

39

Abraham's Sacrifice

Etching and drypoint, 156 × 131 mm; I state
Signed and dated: *Rembrandt f 1655* ('d' and '6'
reversed)
B./Holl. 35; H. 283; White pp. 92–93

Berlin: I on Japanese paper (53–16);
I (54–16)
Amsterdam: I (62–14)*
London: I on Japanese paper (1973 U. 1091)

39a: Rembrandt, *Abraham and Isaac*.
Leningrad, Hermitage.

In 1655, the year of the dated state of the *Ecce Homo* (Cat. No. 38), Rembrandt etched *Abraham and Isaac*. Abraham is about to sacrifice Isaac at God's bidding. At the last moment, however, he is restrained by an angel. Rembrandt had already treated this subject in 1635, at the high-point his first Amsterdam period. The large-scale painting (Fig. 39a) depicts the event in terms of powerful physical action.[1] Abraham roughly pushes down the head of the bound Isaac while the angel suddenly grasps Abraham's arm, so that the knife falls from his hand. In 1645 Rembrandt etched another scene from this biblical story— the dialogue between Abraham and Isaac before the sacrifice.[2] In 1655 Rembrandt turned once again to the sacrifice itself. Here the mood of the event is thoroughly altered. Rembrandt 'interprets the Biblical text with greater independence of descriptive details and with deeper human insight. Isaac is no longer stretched out like any sacrificial victim. He kneels with an innocent submissiveness beside his father, who presses the son's head to his own body. It is a gesture infinitely more human than the one in the earlier version. The angel appears from behind Abraham, grasping both his arms with an embrace that is powerful and highly symbolic.'[3] Rembrandt has succeeded in making abundantly clear both Abraham's obedience and his inner torment.

The change of narrative style, in which dramatic, theatrical action and exaggerated gesture give way to an increasingly psychological record of the event, is a typical measure of Rembrandt's artistic development. The change in approach to this subject may also have been prompted by the treatment of the event in the *Antiquitates Judaicae* of Flavius Josephus. Occasionally, Rembrandt drew on this work, treating it as a supplement to iconographic tradition and the biblical text.[4] After describing the walk to the place of sacrifice, the dialogue between father and son, and Abraham's declaration of his intention to sacrifice Isaac, Josephus goes on: 'Isaac, however, noble-minded as the son of such a father, responded obediently to what had been said and, in turn, declared that it would not have been worth his being born if he did not obey what God and his father had decided for him, as it would be wrong enough to be disobedient even if it had been his father alone who had issued the order. And thereupon he approached the altar in order to be slaughtered. And certainly he would have been, had God had not prevented it. For he called Abraham by his name and told him to refrain from the killing of his son. He, the Lord, was not thirsty for human blood, nor had he demanded the

death of Isaac in order so grimly to take back from the father that which he had himself given him. He had done this, rather, because he wished to test Abraham'[5]

Rembrandt refers to this interpretation of the event with its stress on Isaac's obedience, by depicting him unbound. The readiness to be sacrificed is especially clear in the fact that Isaac has lain aside his clothing. The scene takes place on a cliff ledge, and below one can see the servants left behind and with an ass. This arrangement of motifs is found in the iconographic tradition for this subject, the servant boys embodying, beyond the context of the narrative, 'the blind of spirit, who do not perceive the divine hand of God in human affairs'.[6]

The figures are set off against the finely detailed background as simply and boldly outlined forms with only summary shading. Divine light floods the darkness falling on the group from behind. In this region the etching shows traces of re-working: the outline of the angel's left wing has been burnished out and replaced. As also in the etching of *Jupiter and Antiope* (Cat. No. 40) the whole scene has been bitten, deepening the shadows with the burin and with drypoint. Thus, one can detect several distinct working processes taking place before the production of the first surviving state. In contrast to what we find in *The Three Crosses* (Cat. No. 35) or in the *Ecce Homo* (Cat. No. 38), the corrections concern details, but not the interpretation of the event.

Rembrandt used the same composition, albeit reversed, in the background of his painting *Old Man as Saint Paul*, dated 165(9?).[7] Rembrandt's pupils also used his motif, reversed, as a model; for example Ferdinand Bol, in a drawing ascribed to him,[8] and a pupil of the 1660s (Titus van Rijn?) in a painting[9] and the preparatory drawing for it.[10] No detailed drawings survive in Rembrandt's hand, which prepare the etching in reverse. What we now know of Rembrandt's working methods suggests that it is unlikely that there were any such drawings.[11] On the contrary, he must have sketched the composition directly on the plate. Rembrandt did, however, make counterproofs (prints taken from the wet proof) of the etching, of which one is in Berlin (Fig. 39b) and one in London. These counterproofs of the 1655 etching were apparently used by Rembrandt and his workshop as models for further images of the *Sacrifice of Isaac*.[12]

B.W.

1. Leningrad; paintings Cat. No. 21.
2. B. 34.
3. Rosenberg 1968, p. 176.
4. See Tümpel 1984.
5. Flavius Josephus (1979), p. 51.
6. Berlin 1970, No. 9.
7. London 1988/89, No. 15.
8. Stichting P. and N. de Boer, Amsterdam; Sumowski Vol. I, No. 173; see also Amsterdam 1985 ('Bij Rembrandt in de leer'), No. 50.
9. Private collection. Sumowski, Vol. IV, 1990, No. 1976; Bruyn 1990.
10. Musée Vivenel, Compiègne. In contrast to Sumowski (1971 and 1990, No. 1976) Bruyn 1990 ascribes this drawing to the same pupil as had produced the painting.
11. On this print, see the general essay by Van de Wetering; 'Painting materials and working methods', in *Corpus* I, pp. 11–33; Giltaij 1989 and Royalton-Kisch 1989.
12. Surprisingly, Bruyn 1990 does not consider the counterproofs of the etching of *Abraham and Isaac*, though in 1983, pp. 55 ff. he had pointed in general form to the use of counterproofs as composition models in the Rembrandt workshop.

39b: Rembrandt, *Abraham and Isaac*. Counterproof. Berlin, Kupferstichkabinett SMPK.

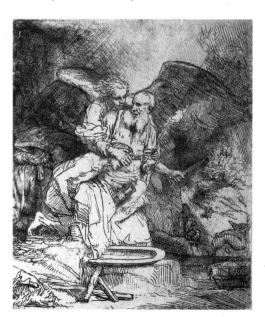

40

Jupiter and Antiope
(the large plate)

Etching, burin and drypoint, 138 × 205 mm;
1 state (a second state is not by Rembrandt)
Signed and dated: *Rembrandt f. 1659*
B./Holl. 203; H. 302; White pp. 185–86

Berlin: I on Japanese paper (297–16)
Amsterdam: I on Japanese paper (O.B. 435)
London: I (1855–4–14–266)*

A satyr, approaching from behind, cautiously uncovers the body of a sleeping woman. In older inventories and sale catalogues, for example those of De Jonghe,[1] De Burgy[2] and Röver,[3] the scene is identified as *Venus and a Satyr*. Gersaint accepts this title in his catalogue raisonné of 1751.[4] The second state of the etching, not executed by Rembrandt himself, adds an inscription that calls the scene *Jupiter and Antiope*. This identification has prevailed with time.

Jupiter approached the sleeping Antiope, daughter of the king of Thebes, in the guise of a satyr. Made pregnant by him, the young woman fled, but was captured and then enslaved. Her twin sons, Amphion and Zethos, once grown to manhood, avenged their mother's suffering. In painting, and above all in sixteenth- and seventeenth-century prints, the subject was very popular. Rembrandt himself treated it in an early etching in about 1631, at the end of his Leiden period (Fig. 40a).[5] The character of this early print is, however, entirely different. Behind the brightly lit female nude, the shadowy male figure intrudes into the woman's chamber. The later print, on the other hand, shows Antiope and Jupiter as a couple. The composition is based on an engraving by Annibale Carracci (Fig. 40b).[6] Rembrandt adopted the general arrangement of the figures and the composition, but he made significant changes. The scene is reduced to, and attention concentrated on, the actions of the two protagonists. Amor with his bow is excluded and Annibale's landscape view is not adopted. Instead, Rembrandt integrates the unworked paper surface into the composition. Finally, Rembrandt's scene lacks the curtain that Carracci uses to separate the action from the viewer's space. The narrative thus gains in

40a: Rembrandt, *Jupiter and Antiope*, (small plate). Berlin, Kupferstichkabinett SMPK.

40b: Annibale Carracci, *Jupiter and Antiope*. London, British Museum.

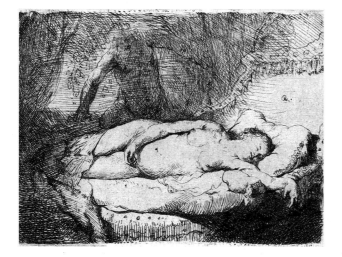

directness: the viewer becomes a witness to the satyr's cautious and intimate approach.

It seems also that the pose of the female figure has been deliberately altered. She bends one arm over her head. This reclining pose is part of a long tradition: it is found in the work, among many others, of Correggio[7] or Titian[8] and it is ultimately derived from the Antique model of the *Sleeping Ariadne* in the Vatican.[9] In this etching Rembrandt thus again displays his knowledge of Italian art. Röver, in his sale catalogue of 1731 speaks of 'de Nimph, (en de) satyr op zijn Italiaansch geetst' (a nymph and satyr etched in the Italian manner).[10]

The etching *Jupiter and Antiope* belongs to the group of Rembrandt's late prints.[11] Between 1658 and 1661 the artist was once again more strongly preoccupied with the female nude. As well as etchings,[12] a series of drawings has also survived, for example the sheet in Amsterdam (Fig. 40c).[13] In contrast to his earlier presentation of the nude,[14] Rembrandt here achieves a new monumentality. The exploration of the figure's undulating surface is no longer the main interest in the scene, but rather the study and record of *chiaroscuro*. The etching *Jupiter and Antiope* is striking for its refined distribution of light and shade to provide subtle modelling of the woman's body. On close examination, at least of the best proofs,[15] three printing techniques can be clearly detected: etching, engraving and drypoint, used by Rembrandt to develop the *chiaroscuro* effects. The figure as a whole is first established with etching. After the etching process, further refinements are added. Thus, for example, the face is first established through the dark, clear lines of the etching. In the second step, drypoint lines are added, recognisable in that, when printed, they are accompanied by burr—shadows running alongside them—where the printing ink has been caught on the upraised ridges of the plate. Finally, Rembrandt adds lines engraved with the burin. These have a so-called *taille* and taper off at the ends. The hatching strokes on the woman's cheek, for example, are made with the burin. Such refinements can also be found within the lines used on the stomach of the sleeping woman. The etched lines were overlaid with drypoint. On the lighter parts, the less incisive engraved lines are set off from the darkly etched ones. The scene of *Jupiter and Antiope* is thus evidence of Rembrandt's use of a variety of techniques.

The various working processes that have been described were all brought into play before the production of the first surviving state, even if one may assume that Rembrandt made trial proofs for himself during the working process. Thus the signature itself is etched. The completion with drypoint and burin is not a record of distinct stages of composition; this approach is intended, rather, to give the work its 'finish'.

B.W.

1. No. 30; *Urkunden* 346.
2. See White 1969, 185; Van Gelder/Van Gelder-Schrijver 1938, p. 12.
3. Van Gelder/Van Gelder-Schrijver 1938, p. 12.
4. G. 195.
5. B. 204. This sheet has been variously identified in the literature. It has also been cited as *Venus and a Satyr* or—because of the shower of golden rain—listed as *Jupiter and Danaë*, as in Röver's inventory.
6. B. 17; dated 1592.
7. Painting of *Jupiter and Antiope*; Louvre, Paris.
8. Painting of *Bacchanal* or *The Andrians*; Prado, Madrid.
9. A copy after a Hellenistic original in the Vatican; see Bober/Rubinstein 1986, No. 79. This sculpted figure was drawn, for example, by Goltzius during his travels in Italy (Teylers Museum, Haarlem).
10. Cat. No. 63; Van Gelder/Van Gelder-Schrijver 1938, p. 12.
11. In the last years of his life the artist seems to have made no more etchings (the single exception being the portrait of *Jan Antonides van der Linden*, dated 1665, B. 264). The reasons for this are not known.
12. B. 197; B. 199; B. 200; B. 202; B. 205.
13. Benesch 1137; Schatborn 1985, no. 52; see also Drawings Cat. No. 32 (Benesch 1122).
14. See Cat. No. 6.
15. The impression in London is one of the earliest made from the plate: it reveals rough plate edges, and the parts worked in drypoint are especially brilliant. The impression also shows traces of surface tone.

40c: Rembrandt, *Sleeping female nude*. Drawing. Amsterdam, Rijksprentenkabinet.

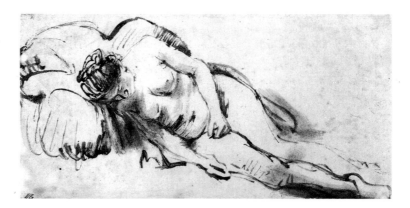

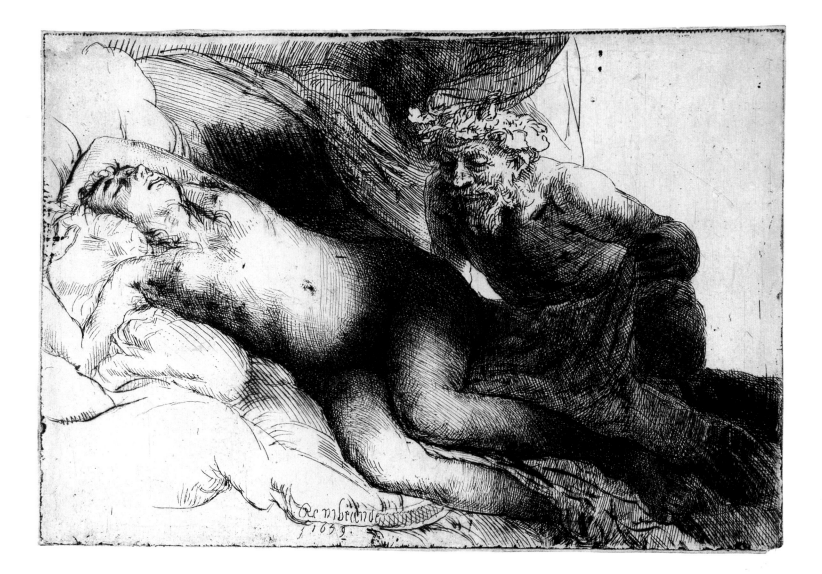

Bibliography

Albach 1979
Ben Albach, 'Rembrandt en het toneel', *De Kroniek van het Rembrandthuis*, 31 (1979), p.2–32.

Alpers 1989
Svetlana Alpers, *Rembrandt's Enterprise. The Studio and the Market*, Chicago 1988.

Anzelewsky/Mielke 1984
Fedja Anzelewsky and Hans Mielke, *Albrecht Dürer. Kritischer Katalog der Zeichnungen. Die Zeichnungen alter Meister im Berliner Kupferstichkabinett*, Berlin 1984.

B.
Adam Bartsch, *Toutes les Estampes qui forment l'œuvre de Rembrandt et ceux de ses principaux imitateurs, composé par les Sieurs Gersaint, Helle, Glomy et P. Yver*, Vienna 1797.

B.
Adam Bartsch, *Le Peintre-graveur*, I–XII, Vienna 1802–1821.

Bakker 1990
B. Bakker, 'Het onderwerp van Rembrandts ets De Drie Boerenheuzen', *Kroniek van het Rembrandthuis* (1990), pp. 21–29.

Baldwin 1985
Robert W. Baldwin, '"On earth we are beggars, as Christ himself was". The Protestant Background of Rembrandt's Imagery of Poverty, Disability and Begging', *Konsthistorisk tidskrift* 54 (1985), pp. 122–35.

v. Bastelaer 1908
R. van Bastelaer, *Les estampes de Peter Bruegel l'Ancien*, Brussels 1908.

Bauch 1960
Kurt Bauch, *Der frühe Rembrandt und seine Zeit. Studien zur geschichtlichen Bedeutung seines Frühstils*, Berlin 1960.

Benesch 1928
Otto Benesch, *Die Zeichnungen der niederländischen Schulen des XV. und XVI. Jahrhunderts (Beschreibender Katalog der Handzeichnungen in der Graphischen Sammlung Albertina, Vol. 2)*, Vienna 1928.

Ben.
Benesch 1954–1957
Otto Benesch, *The Drawings of Rembrandt*, I–VI, London 1954–1957.

Benesch 1973
Otto Benesch, *The Drawings of Rembrandt*, I–VI, enlarged and edited by Eva Benesch, London/New York 1973.

Bergström 1956
Ingvar Bergström, *Dutch Still-Life Painting in the seventeenth Century*, London 1956.

Białostocki 1973
Jan Białostocki, 'Der Sünder als tragischer Held bei Rembrandt', *Neue Beiträge zur Rembrandt-Forschung* ed. O. von Simson and J. Kelch, Berlin 1973, pp. 137–50.

Bierens de Haan 1948
J.C.J. Bierens de Haan, *L'œuvre gravé de Cornelis Cort, graveur hollandais 1533–1578*, The Hague 1948.

Blankert 1982
Albert Blankert, *Ferdinand Bol (1616–1680), Rembrandt's pupil*, Doornspijk 1982.

Bober/Rubinstein 1986
P.P. Bober and R. Rubinstein, *Renaissance Artists and Antique Sculpture. A Handbook of Sources*, London 1986.

Bock-Rosenberg 1930
E. Bock and J. Rosenberg, *Staatliche Museen zu Berlin. Die Zeichnungen alter Meister im Kupferstichkabinett. Die Niederländischen Meister*, Berlin 1930.

Bredius/Gerson 1935/1969
A. Bredius, *The Complete Edition of the Paintings*, revised by H. Gerson, London 1969; first edition 1935.

Broos 1977
B.P.J. Broos, *Index to the formal sources of Rembrandt's art*, Maarsen 1977.

Broos 1981
B.P.J. Broos, review of Walter L. Strauss and Marjon van der Meulen, *The Rembrandt Documents*, New York 1979, *Simiolus* 12 (1981–82), pp.245–62.

Broos 1981–A
Ben Broos, *Rembrandt en tekenaars uit zijn omgeving. Oude tekeningen in het bezit van de Gemeentemusea van Amsterdam, waaronder de collectie Fodor*, III, Amsterdam 1981.

Broos 1983
Ben Broos, 'Fame shared is fame doubled', *The Impact of a Genius, Rembrandt, his Pupils and Followers in the seventeenth Century, Paintings from Museums and Private Collections*, Amsterdam 1983; with contributions by Albert Blankert, Ben Broos, Ernst van de Wetering, Guido Jansen and Willem van de Watering.

Bruyn 1982
J. Bruyn, 'The documentary value of early graphic reproductions', *Corpus* I, 1982, pp. 35–51.

Bruyn 1983
J. Bruyn, 'On Rembrandt's Use of Studio-Props and Model Drawings during the 1630s', *Essays in Northern European Art presented to Egbert Haverkamp-Begemann on his sixtieth birthday*, Doornspijk 1983, pp. 52–60.

Bruyn 1990
J. Bruyn, 'An assistant in Rembrandt's Workshop in the 1660s', *The Burlington Magazine* 132 (1990), pp. 714–18.

Campbell 1980
Colin Campbell, 'Rembrandts etsen "Het sterfbed van Maria" en "De drie bomen"', *De Kroniek van het Rembrandthuis* 32 (1980), pp. 2–33.

Carstensen/Henningsen 1988
H. Th. Carstensen and W. Henningsen, 'Rembrandts sog. Dr. Faustus; zur Archäologie eines Bildsinnes', *Oud Holland* 102 (1988), pp. 290–312.

Chapman 1990
H. Perry Chapman, *Rembrandt's Self-portraits, A Study in Seventeenth-Century Identity*, Princeton 1990.

Kenneth Clark, *Rembrandt and the Italian Renaissance*, London 1966.

Corpus I/III
J. Bruyn, B. Haak, S.H. Levie, P.J.J. van Thiel, E.v.d. Wetering, *A Corpus of Rembrandt Paintings*, I, *1625–1631*, The Hague, Boston, London 1982; II, *1631–1634*, Dordrecht, Boston, Lancaster 1986; III, *1635–1642*, Dordrecht, Boston, London 1989.

Dickel 1987
Hans Dickel, *Deutsche Zeichenbücher des Barock. Eine Studie zur Geschichte der Künstlerausbildung*, Hildesheim, Zürich, New York 1987.

Documents
Walter L. Strauss and Marjon van der Meulen, with contributions from S.A.C. Dudok van Heel and P.J.M. de Baar, *The Rembrandt Documents*, New York 1979.

Dudok van Heel 1977
S.A.C. Dudok van Heel, 'Jan Pietersz. Zomer (1641–1724)—Makelaar in Schilderijen (1690–1724)', *Jaarboek Amstelodamum* 69 (1977), pp. 89–106.

Dudok van Heel 1979
S.A.C Dudok van Heel, 'Willem Bartel(omeu)sz Ruyters (1587–1639) Rembrandt's bisschop Gosewijn', *Maandblad Amstelodamum* 66 (1979), pp. 83–87.

Van Eeghen 1956
I.H. van Eeghen, 'De Kinderen van Rembrandt en Saskia', *Maandblad Amstelodamum* 43 (1956), pp. 144–46.

Van Eeghen 1985
I.H. van Eeghen, 'Rembrandt en de veilingen', *Jaarboek Amstelodamum* 77, 1985, pp. 62–63.

Emmens 1956
J.A. Emmens, 'Ay Rembrandt, maal Cornelis stem', *Nederlands Kunsthistorisch Jaarboek* 7 (1956), pp. 133–65.

Emmens 1968
J.A. Emmens, *Rembrandt en de regels van de kunst*, Utrecht 1968.

FM
Frederik Muller, *Beredeneerde Beschrijving van Nederlandse Historieplaten, Zinneprenten en Historische Kaarten* I/IV, Amsterdam 1863–1882.

Filedt Kok 1972
Jan Piet Filedt Kok, *Rembrandt etchings and drawings in the Rembrandt House*, Amsterdam 1972.

Freise 1911
Kurt Freise, *Pieter Lastman, sein Leben und seine Kunst*, Leipzig 1911.

G.
see Gersaint

Van Gelder/Van Gelder-Schrijver 1938
J.G. van Gelder and N.F. van Gelder-Schrijver, 'De "Memorie" van Rembrandt's prenten in he bezit van Valerius Röver', *Oud Holland* 55 (1938), pp. 1–16

Gersaint 1751
Edmé-François Gersaint, *Catalogue raisonné de toutes les pièces qui forment l'œuvre de Rembrandt*, Paris 1751.

Gerson 1961
H. Gerson, *Seven letters by Rembrandt*, The Hague 1961.

Giltaij 1988
Jeroen Giltaij, *De tekeningen van Rembrandt en zijn school in het Museum Boymans-van Beuningen*, Rotterdam 1988.

Giltaij 1989
Jeroen Giltaij, 'The Function of Rembrandt Drawings', *Master Drawings* 27, 1989, pp. 111–17.

Goldner/Hendrix/Williams 1988
George R. Goldner, Lee Hendrix, Gloria Williams, *The J. Paul Getty Museum, Malibu, California. Catalogue of the Collections. European Drawings*, I, Malibu 1988.

Grossmann 1955
F. Grossmann, *Bruegel. The Paintings*, London 1955.

Guratzsch 1980
F. Guratzsch, *Die Auferweckung des Lazarus in der niederländischen Kunst von 1400 bis 1700. Ikonographie und Ikonologie*, 2 Vols, Kortrijk 1980

H.
A.M. Hind, *Rembrandt's etchings*, London 1912; 2nd edition: *A Catalogue of Rembrandt's etchings*, London 1923.

Haak 1969
B. Haak, *Rembrandt. His Life, his Work, his Time*, New York 1969.

Haden 1877
Francis Seymour Haden, *The etched work of Rembrandt, critically reconsidered*, London 1877.

Hamann 1936
Richard Hamann, 'Hagars Abschied bei Rembrandt und im Rembrandt-Kreis', *Marburger Jahrbuch für Kunstwissenschaft* 8/9 (1936) pp. 471–578.

Haverkamp-Begemann 1959
E. Haverkamp-Begemann, *Willem Buytewech*, Amsterdam 1959.

Haverkamp-Begemann 1961
E. Haverkamp-Begemann, review of Otto Benesch, *The Drawings of Rembrandt*, London 1954–1957, *Kunstchronik* 14 (1961) pp. 10–14, 19–28, 50–57, 85–91.

Haverkamp-Begemann 1971
E. Haverkamp-Begemann, 'The Present State of Rembrandt Studies', *The Art Bulletin* 53 (1971), pp. 88–104.

Haverkamp-Begemann 1973
E. Haverkamp-Begemann, *Hercules Seghers. The complete etchings* (with a contribution by K.G. Boon) Amsterdam, The Hague 1973.

Haverkamp-Begemann 1976
E. Haverkamp-Begemann, 'The Appearance of Reality, Dutch Draughtsmen of the Golden Age', *Apollo* 54 (1976) nr. 177, p.103.

Haverkamp-Begemann 1980
E. Haverkamp-Begemann, 'Creative Copies', *The Print Collector's Newsletter* 11 (1980), pp. 168–70.

Henkel 1942
M.D. Henkel, *Tekeningen van Rembrandt en zijn school, Catalogus van de Nederlandse tekeningen in het Rijksmuseum te Amsterdam*, I, The Hague 1942.

HdG 1906
C. Hofstede de Groot, *Die Handzeichnungen Rembrandts*, Haarlem 1906.

HdG Urkunden
C. Hofstede de Groot, *Die Urkunden über Rembrandt (1575–1721). Quellenstudien zur holländischen Kunstgeschichte III*, The Hague 1906.

Held 1963
Julius S. Held, 'The early appreciation of drawings', *Latin American Art, and the Baroque Period in Europe. (Studies in Western Art. Acts of the Twentieth International Congress of the History of Art, III)*, Princeton, New Jersey 1963, pp. 72–95.

Held 1984
Julius S. Held, 'A Rembrandt "Theme"', *Artibus et historiae* 10, 1984, pp. 21–34.

Hellerstedt 1981
Kahren Jones Hellerstedt, 'A Traditional Motif in Rembrandt's Etchings: The Hurdy-Gurdy Player', *Oud Holland* 95 (1981), pp. 16–30.

Hind
A.M. Hind, *Early Italian Engraving*, 7 Vols, London 1938–48.

Hind 1912 and 1923, see H.

Hoekstra 1980–84
Hidde Hoekstra, *Rembrandt en de bijbel, Het Oude Testament*, 1–3, *Het Nieuwe Testament*, 1–3, Utrecht/Antwerp 1981–84.

Holl.
F.W.H. Hollstein, *Dutch and Flemish Etchings, Engravings and Woodcuts, ca. 1450–1700*, I ff., Amsterdam 1949 ff.

Holl.
C. White, K.G. Boon, *Rembrandt's etchings*, 2 Vols in: Hollstein's *Dutch and Flemish Etchings, Engravings and Woodcuts* Vol. 17–19, Amsterdam 1969.

Hoogstraten 1678
Samuel van Hoogstraten, *Inleyding tot de Hooge Schoole der Schilder-konst. . .*, Rotterdam 1678.

De Hoop Scheffer/Boon 1971
D. de Hoop Scheffer en K.G. Boon, 'De inventaris-lijst van Clement de Jonghe en Rembrandts etsplaten', *De Kroniek van het Rembrandthuis* 25 (1971), pp. 1–17.

Houbraken 1718–21
A. Houbraken, *De Groote Schouburgh der Nederlantsche Konstschilders en Schilderessen* 3 Vols, Amsterdam 1718–21.

Huygens
Constantijn Huygens, 'Zede-printen', *Profijtelijk Vermaak. Moraliteit en satire uit de 16e en 17e eeuw (Spectrum van de Nederlandse Letterkunde* Vol. 10), Utrecht/Antwerp 1968, pp. 209–56.

de Jongh 1969
E. de Jongh, 'The spur of wit: Rembrandt's response to

an Italian challenge', *Delta* 12 (1969), pp. 46–66.

Jordan 1893
A. Jordan, 'Bemerkungen zu Rembrandt's Radierungen', *Repertorium für Kunstwissenschaft* 16, 1893.

Josephus 1979
Flavius Josephus, *Jüdische Altertümer*, 2 Vols., trans. H. Clement (1899–1900), Wiesbaden 1979.

KdZ
see: Bock-Rosenberg 1930.

Kauffmann 1920
Hans Kauffmann, 'Rembrandt und die Humanisten vom Muiderkring', *Jahrbuch der Preussischen Kunstsammlungen* 41 (1920), pp. 46–81.

Kettering 1977
A. McNeil Kettering, 'Rembrandt's Flute Player: a unique treatment of Pastoral', *Simiolus* 9 (1977), pp. 19–44.

Konstam 1978
Nigel Konstam, 'Over het gebruik van modellen en spiegels bij Rembrandt', *De Kroniek van het Rembrandthuis* 30 (1978) 1, pp. 24–32.

Kris/Kurz 1980
Ernst Kris, Otto Kurz, *Die Legende vom Küunstler. Ein geschichtlicher Versuch*, Frankfurt a.M. 1980 (Vienna 1934).

Kruse 1920
John Kruse, *Die Zeichnungen Rembrandts und seiner Schule im National Museum zu Stockholm*, The Hague 1920, ed. Carl Neumann.

Kuretsky 1974
Susan Donahue Kuretsky, 'Rembrandt's Tree Stump: an iconographic attribute of St Jerome', *The Art Bulletin* 56 (1794), pp. 571–80.

Leendertz 1921
P. Leendertz jr., 'Nederlandsche Faust-Illustratie', *Oud Holland* 39 (1921), pp. 130–48.

Lieure
Jules Lieure, *Jacques Callot*, 5 Vols., Paris 1924–27.

Lilienfeld 1914
Kurt Freise, Karl Lilienfeld, Heinrich Wichmann, *Rembrandts Handzeichnungen*, II, Königl. Kupferstichkabinett zu Berlin, Parchim i.M. 1914.

L.
F. Lugt, *Les Marques de Collection de dessins et estampes*, Amsterdam 1921; *Supplément*, The Hague 1956.

Lugt 1920
F. Lugt, *Mit Rembrandt in Amsterdam*, Berlin 1920.

Lugt 1931
F. Lugt, 'Katalog der Niederländischen Handzeichnungen in Berlin', *Jahrbuch der Preussischen Kunstsammlungen* 52 (1931), pp. 36–80.

Lugt 1933
F. Lugt, *Inventaire général des dessins des écoles du Nord, Musée du Louvre, Ecole Hollandaise*, III, *Rembrandt, ses élèves, ses imitateurs, ses copistes*, Paris 1933.

Luijten en Meij 1990
Ger Luijten en A.W.F.M. Meij, *Van Pisanello to Cézanne, Keuze uit de verzameling tekeningen in het Museum Boymans-van Beuningen*, Rotterdam 1990.

Van Mander
K. van Mander, *Het schilder-boeck*, Haarlem, 1604.

Van Mander 1916
K. van Mander, *Das Lehrgedicht*, trans. R. Hoecker, The Hague 1916.

Mannocci 1988
Lino Mannocci, *The Etchings of Claude Lorrain*, New Haven and London, 1988.

Meder 1923
J. Meder, *Die Handzeichnung. Ihre Technik und Entwicklung*, Vienna 1923.

Meijer 1971

R.P. Meijer, *Literature of the Low Countries*, Assen 1971.

Meiss 1936
M. Meiss, 'The Madonna of Humility', *The Art Bulletin* 18 (1936), pp. 434–64.

Münz 1952
Ludwig Münz, *Rembrandt's Etchings*, 2 Vols, London 1952.

Panofsky 1953
E. Panofsky *Early Netherlandish Painting. Its Origins and Character*, 2 Vols, Cambridge Mass., 1953.

P.
G. Parthey, *Wenzel Hollar. Beschreibendes Verzeichnis seiner Kupferstiche*, Berlin 1853; 2nd ed. Berlin 1858.

Pennington 1982
R. Pennington, *A descriptive catalogue of the etched work of Wenceslaus Hollar 1607–1677*, Cambridge 1982.

R.Doc.
Walter L. Strauss, Marion van der Meulen e.a., *The Rembrandt Documents*, New York 1979.

Raupp 1984
H.-J. Raupp, *Untersuchungen zu Künstlerbildnis un Künstlerdarstellung in den Niederlanden im 17. Jahrhundert*, Hildesheim 1984.

Van Regteren Altena 1935
I.Q. van Regteren Altena, *Jacques de Gheyn. An Introduction to the study of his drawings*, Amsterdam 1935.

Van Regteren Altena 1954
I.Q. van Regteren Altena, 'Retouches aan ons Rembrandt-beeld II: Het Landschap van den Goudweger', *Oud Holland* 69, 1954, pp. 1–17.

Van Regteren Altena 1959
I.Q. van Regteren Altena, 'Rembrandt en Wenzel Hollar', *Kroniek van de vriendenkring van het Rembrandthuis* 13, 1959, pp. 81–86.

Van Regteren Altena 1983
I.Q. van Regteren Altena, *Jacques de Gheyn. Three Generations* 3 Vols., The Hague, Boston, London 1983.

Reznicek 1961
E.K.J. Reznicek, *Die Zeichnungen von Hendrick Goltzius*, 2 Vols, Utrecht 1961.

Robinson 1980
F.W. Robinson, 'Puns & Plays in Rembrandt's Etchings', *The Print Collector's Newsletter* 11 (1980), pp. 165–68.

Robinson 1980/81
W.W. Robinson, '"This Passion for Prints": Collecting and Connoisseurship in Northern Europe during the Seventeenth Century', exh. cat. Boston 1980/81, pp. XXVII–XLVIII.

Robinson 1988
William W. Robinson, review of Schatborn 1985 in: *Kunstchronik* 41 (1988) pp. 579–86.

Rosenberg 1968
J. Rosenberg, *Rembrandt. Life and Work*, London, New York 1968.

Royalton-Kisch 1984
Martin Royalton-Kisch, 'Over Rembrandt en van Vliet', *De Kroniek van het Rembrandthuis* 36 (1984), pp. 3–23.

Royalton-Kisch 1989
Martin Royalton-Kisch, 'Rembrandt's Sketches for his Paintings', *Master Drawings* 27 (1989), pp. 128–45.

Royalton-Kisch
Martin Royalton-Kisch, 'Tradition and Innovation: the Study of Rembrandt's Drawing of the Entombment over the Raising of Lazarus' (manuscript).

S.
see Seidlitz.

Saxl 1910
Fritz Saxl, 'Zur Herleitung der Kunst Rembrandts', *Mitteilungen der Gesellschaft für vervielfältigende Kunst*,

1910, pp. 41–48.

Schama 1987
Simon Schama, *The Embarassment of Riches. An Interpretation of Dutch Culture in the Golden Age*, New York 1987.

Schatborn 1975
P. Schatborn, 'Over Rembrandt en kinderen', *De Kroniek van het Rembrandthuis* (1975), pp. 9–19.

Schatborn 1977
P. Schatborn, 'Beesten nae 't leven', *De Kroniek van het Rembrandthuis* (1977) 2, pp. 3–31.

Schatborn 1981
Peter Schatborn, *Figuurstudies, Nederlandse tekeningen uit de 17de eeuw*, The Hague 1981.

Schatborn 1981–I
P. Schatborn, 'Van Rembrandt tot Crozat, Vroege verzamelingen met tekeningen van Rembrandt', *Nederlands Kunsthistorisch Jaarboek* 32 (1981), pp. 1–54.

Schatborn 1985
Peter Schatborn, *Tekeningen van Rembrandt, zijn onbekende leerlingen en navolgers, Catalogus van de nederlandse tekeningen in het Rijksprentenkabinet, Rijksmuseum, Amsterdam*, IV, The Hague 1985.

Schatborn 1985–I
Peter Schatborn, 'Tekeningen van Rembrandts leerlingen', *Bulletin van het Rijksmuseum* 33 (1985) 2, pp. 93–109.

Schatborn 1986
Peter Schatborn, 'Tekeningen van Rembrandt in verband met zijn etsen', *De Kroniek van het Rembrandthuis* 38 (1986), pp. 1–38.

Schatborn 1987
Peter Schatborn, 'Rembrandt's late drawings of female nudes', *Drawings Defined*, edited by Walter Strauss and Tracy Felker, New York 1987, pp. 307–20.

Schatborn 1989
Peter Schatborn, 'Notes on early Rembrandt Drawings', *Master Drawings* 27/2 (1989), pp. 125–26.

Schatborn 1990
Peter Schatborn, 'Met Rembrandt naar buiten', *De Kroniek van het Rembrandthuis* 1–2 (1990), pp. 31–39.

Scheller 1969
R.W. Scheller, 'Rembrandt en de encyclopedische verzameling', in *Oud Holland* 84 (1969), pp. 81–147.

Schneider 1990
Cynthia P. Schneider, *Rembrandt's Landscapes*, New Haven and London, 1990.

Schwartz 1987
G. Schwartz, *Rembrandt. Sämtliche Gemälde in Farbe*, Zürich and Stuttgart, 1984/87.

Seidlitz 1922
W. v. Seidlitz, *Die Radierungen Rembrandts*, Leipzig 1922.

Six 1969
J. Six, 'Jan Six aan het venster', *De Kroniek van het Rembrandthuis* 23 (1969), pp. 34–52.

Slatkes 1973
Leonard J. Slatkes, review of C. White and K.G. Boon, *Rembrandt's Etchings* and C. White, *Rembrandt as an etcher*, in *Art Quarterly* 36 (1973), pp. 250–63.

Slive 1953
S. Slive, *Rembrandt and his Critics 1630–1730*, The Hague 1953.

Smith 1988
David R. Smith, '"I Janus": Privacy and the Gentlemanly Ideal in Rembrandt's Portraits of Jan Six', *Art History* 11, 1988, pp. 42–63.

Stechow 1929
Wolfgang Stechow, 'Rembrandts Darstellungen der Kreuzabnahme', Jahrbuch der Preussischen Kunstsammlungen 50 (1929), pp. 217–32.

Stechow 1950
Wolfgang Stechow, review of J. Rosenberg, *Rembrandt*, *The Art Bulletin* 32 (1950), pp. 252–55.

Stratton 1986
Suzanne Stratton, 'Rembrandt's Beggars: Satire and Sympathy', *The Print Collector's Newsletter* 17 (1986), pp. 77–82.

Strauss 1983
Walter L. Strauss, 'The Puzzle of Rembrandt's Plates', *Essays in Northern European Art presented to Egbert Haverkamp-Begemann on his Sixtieth Birthday*, Doornspijk 1983, pp. 261–65.

Strauss/van der Meulen
see Documents

Sumowski Drawings
Werner Sumowski, *Drawings of the Rembrandt School*, I–, New York 1979–.

Sumowski 1961
Werner Sumowski, *Bemerkungen zu Otto Beneschs Corpus der Rembrandtzeichnungen*, II, Bad Pyrmont 1961.

Sumowski 1971
W. Sumowski, 'Rembrandtzeichnungen', *Pantheon* 29 (1971), pp. 125–38.

Sumowski 1983
Werner Sumowski, *Gemälde der Rembrandt-Schüler*, I–V, Landau/Pfaltz 1983.

Trautscholdt 1961
Eduard Trautscholdt, '"De Oude Koekebakster". Nachtrag zu Adriaen Brouwer', *Pantheon* 19 (1961), pp. 187–95.

Tümpel 1968/71
Christian Tümpel, 'Ikonographische Beiträge zu Rembrandt. Zur Deutung und Interpretation seiner Historien', *Jahrbuch der Hamburger Kunstsammlungen* 13 (1968), pp. 95–126, en 16 (1971), pp. 20–38.

Tümpel 1969
Christian Tümpel, 'Studien zur Ikonographie der Historien Rembrandts', *Nederlands Kunsthistorisch Jaarboek* 20 (1969), pp. 107–98.

Tümpel 1970
Christian Tümpel, *Rembrandt legt die Bibel aus. Zeichnungen und Radierungen aus dem Kupferstichkabinett der Staatlichen Museen Preussischer Kulturbesitz Berlin*, Berlin 1970.

Tümpel 1977
Christian Tümpel, *Rembrandt*, Reinbek b. Hamburg 1977.

Tümpel 1984
Christian Tümpel, 'Die Rezeption der Jüdischen Altertümer des Flavius Josephus in den holländischen Historiendarstellungen des 16. 17. Jahrhunderts', in: H. Vekeman, J. Müller-Hofstede, *Wort und Bild in der niederländischen Kunst und Literatur*, Erftstadt 1984, pp. 173–204.

Tümpel 1986
Christian Tümpel, *Rembrandt*, Amsterdam 1986.

Urkunden
C. Hofstede de Groot, *Die Urkunden über Rembrandt (1575–1721). Quellenstudien zur holländischen Kunstgeschichte III*, The Hague 1906.

Valentiner I 1925; II 1934
Wilhelm R. Valentiner, *Rembrandt, des Meisters Handzeichnungen* (Klassiker der Kunst 31), I Stuttgart/Berlin/Leipzig 1925; II Stuttgart/Berlin 1934.

Voûte 1987
J.R. Voûte, 'Clement de Jonghe exit', *De Kroniek van het Rembrandthuis* 39 (1987), pp. 21–27.

De Vries 1978
A.B. de Vries, Magdi Tóth-Ubbens, W. Froentjes, *Rembrandt in the Mauritshuis*, Alphen aan de Rijn 1978.

Waal 1964
H. van de Waal, 'Rembrandt's Faust Etching, a Social document, and the iconography of the inspired scholar', *Oud Holland*, 79 (1964), pp. 7–48.

Wegner 1973
Wolfgang Wegner, *Die Niederländischen Handzeichnungen des 15.–18 Jahrhunderts, Kataloge der Staatlichen Graphischen Sammlung München*, I, Berlin 1973.

Welcker 1954
A. Welcker, 'Een onbekende eerste ontwerp voor Rembrandt's ets van Jan Cornelis Sylvius (B. 280)', *Oud Holland* 69 (1954), pp. 229–34.

Werbke 1989
Axel Werbke, 'Rembrandts "Landschaftsradierungen mit drei Bäumen" als visuell-gedankliche Herausforderung', *Jahrbuch der Berliner Museen* 31 (1989), pp. 225–50.

Wheelock 1977
A.K. Wheelock, *Perspective, Optics, and Delft Artists around 1650*, New York 1977.

Wheelock 1983
A.K. Wheelock jn., 'The Influence of Lucas van Leyden on Rembrandt's narrative Etchings', in *Essays in Northern European Art presented to Egbert Haverkamp-Begemann on his Sixtieth Birthday*, Doorspijk 1983, pp. 291–96.

White 1969
Christopher White, *Rembrandt as an Etcher*, I–II, London 1969.

Wiebel 1988
Christiane Wiebel, *Askese und Endlichkeitsdemut in der italienischen Renaissance. Ikonologische Studien zum Bild des heiligen Hieronymus*, Weinheim 1988.

Winternitz 1969
E. Winternitz, 'Rembrandt, Christ presented to the people, 1655', *Oud Holland* 84 (1969), pp. 177–98.

Yver 1756
Pierre Yver, *Supplément au Catalogue Raisonné de MM. Gersaint, Helle et Glomy*, Amsterdam 1756.

Exhibition Catalogues

Amsterdam 1956
Rembrandt, Etsen, Amsterdam (Rijksmuseum) 1956;
catalogue by K.G. Boon.
Amsterdam 1964–1965
*Bijbelse inspiratie, Tekeningen en prenten van Lucas van
Leyden en Rembrandt*, Amsterdam (Rijksprentenkabinet)
1964–1965; introduction by C.W. Mönnich, catalogue
by L.C.J. Frerichs and J. Verbeek.
Amsterdam 1969
Rembrandt 1669—1969, Amsterdam (Rijksmuseum)
1969; catalogue of the drawings by L.C.J. Frerichs and
P. Schatborn.
Amsterdam 1973
Hollandse Genre-Tekeningen, Amsterdam
(Rijksprentenkabinet) 1973; introduction by K.G.
Boon, catalogue by P. Schatborn.
Amsterdam 1976
*Tot Lering en Vermaak. Betekenissen van Hollandse
genrevoorstellingen uit de zeventiende eeuw*, Amsterdam
(Rijksmuseum) 1976; catalogue by E. de Jongh e.a.
Amsterdam 1981
Work in process. Rembrandt etchings in different states,
Amsterdam (Museum het Rembrandthuis) 1981;
catalogue by E. Ornstein-van Slooten.
Amsterdam/Washington 1981–1982
See: Schatborn 1981
Amsterdam 1983
*Het beste bewaard, Een Amsterdamse verzameling en het
ontstaan van de Vereniging Rembrandt*, Amsterdam
(Rijksprentenkabinet) 1983; by Marijn Schapelhouman.
Amsterdam 1983–I
Landschappen van Rembrandt en zijn voorlopers, Amsterdam
(Museum het Rembrandthuis) 1983; catalogue by Eva
Ornstein-van Slooten, introduction by P. Schatborn.
Amsterdam 1984/1985
Bij Rembrandt in de leer/Rembrandt as teacher, Amsterdam
(Het Rembrandthuis) 1984/1985; catalogue Eva
Ornstein-van Slooten, introduction P.Schatborn.
Amsterdam 1985/86
Rembrandt en zijn voorbeelden/Rembrandt and his sources,
Amsterdam (Het Rembrandthuis) 1985/86; catalogue
by B. Broos.
Amsterdam 1986/87
*Oog in Oog met de modellen van Rembrandts protret-etsen/Face
to Face with the sitters for Rembrandt's etched portraits*,
Amsterdam (Museum het Rembrandthuis) 1986/87;
catalogue by R.E.O. Ekkart and E. Ornstein-van
Slooten.
Amsterdam 1987
Dossier Rembrandt/The Rembrandt Papers, Amsterdam
(Museum het Rembrandthuis) 1987–1988; catalogue by
S.A.C. Dudok van Heel, with contributions from E.
Ornstein-van Slooten and P. Schatborn.
Amsterdam 1988/89
*Jan Lievens (1607–1674). Prenten en Tekeningen/Prints and
Drawings*, Amsterdam (Museum het Rembrandthuis)
1988/89; catalogue by E. Ornstein-van Slooten and P.
Schatborn.
Berlin 1970
Rembrandt legt die Bibel aus. Zeichnungen und Radierungen

*aus dem Kupferstichkabinett der Staatlichen Museen
Preussischer Kulturbesitz, Berlin*, Berlin
(Kupferstichkabinett SMPK) 1970; catalogue by
Christian Tümpel, with a contribution by Astrid
Tümpel.
Berlin 1984
*Von Frans Hals bis Vermeer. Meisterwerke holländischer
Genremalerie*, Berlin (Gemäldegalerie SMPK) 1984;
catalogue by P.C. Sutton e.a.
Boston/New York 1969/70
Rembrandt: Experimental Etcher, Boston (Museum of Fine
Arts) and New York (Pierpont Morgan Library) 1969/
70; catalogue by C. Ackley e.a.
Boston 1980/81
Printmaking in the Age of Rembrandt, Boston (Museum of
Fine Arts), 1980/81; catalogue by C.S. Ackley e.a.
Brussel/Rotterdam/Paris/Bern 1968–1969
Dessins de paysagistes hollandais du XVIIe siècle, Brussel
(Bibliotheek Albert I), Rotterdam (Museum Boymans-
van Beuningen), Paris (Institut Néerlandais), Bern
(Musée des Beaux-Arts) 1968–1969; catalogue by
Carlos van Hasselt.
Braunschweig 1978
*Die Sprache der Bilder. Realität und Bedeutung in der
niederländischen Malerei des 17. Jahrhunderts*, Braunschweig
(Herzog Anton Ulrich-Museum), 1978; catalogue by R.
Klessmann e.a.
Chicago/Minneapolis/Detroit/ 1969
Rembrandt after three hundred Years, Chicago (The Art
Institute), Minneapolis (The Minneapolis Institute of
Arts), Detroit (The Detroit Institute of Arts) 1969–
1970; catalogue by J.Richard Judson, E. Haverkamp-
Begemann and Anne Marie Logan.
Hamburg 1987
Rembrandt. Hundert Radierungen, Hamburg (Kunsthalle)
1987; catalogue by E. Schaar.
Lawrence/Kansas, New Haven and Austin 1983/84
*Dutch Prints of Daily Life. Mirrors of Life or Masks of
Morals?* Lawrence, Kansas (The Spencer Museum of
Art), New Haven (Yale University Art Gallery) and
Austin (Huntington Gallery, University of Texas)
1983/84; catalogue by L.A. Stone-Ferrier.
Leiden 1956
Rembrandt als leermeester, Leiden (Stedelijk Museum De
Lakenhal) 1956; introduction by J.N. van Wessen.
London 1835
*A Catalogue of One Hundred Original Drawings by Sir Ant.
Vandyke and by Rembrandt van Rijn Collected by Sir Thomas
Lawrence*, London 1835; catalogue by S. and A.
Woodburn.
London 1929
Dutch Art, 1450–1900, London (Royal Academy of
Arts) 1929.
London 1969
Old Master Drawings from Chatsworth, London (Royal
Academy of Arts) 1969; catalogue by A.E. Popham.
London 1969–I
*The late etchings of Rembrandt: a study in the development of a
print*, London (The British Museum) 1969; catalogue by
C. White.
London 1988/89
Rembrandt. Art in the Making, London (The National
Gallery) 1988/89; catalogue by D. Bomford, C. Brown
and A. Roy.
Milaan 1970
Rembrandt, Trentotto Disegni, Milaan (Pinacoteca di
Brera) 1970; catalogue by Peter Schatborn,
introductions by Karel G. Boon and Lamberto Vitali.
New York/Cambridge 1960
Rembrandt Drawings from American Collections, New York
(The Pierpont Morgan Library) and Cambridge (Fogg

Art Museum) 1960; catalogue by Felice Stampfle and E.
Haverkamp-Begemann, introduction by J. Rosenberg.
New York/Boston/Chicago 1969
Drawings from Stockholm, New York (The Pierpont
Morgan Library), Boston (Museum of Fine Arts),
Chicago (The Art Institute) 1969; catalogue by Per
Bjurström.
New York 1972–1973
Dutch Genre Drawings of the Seventeenth Century, New York
(The Pierpont Morgan Library), Boston (Museum of
Fine Arts), Chicago (The Art Institute of Chicago)
1972–1973; introduction by K.G .Boon, catalogue by P.
Schatborn.
New York/Paris 1977–1978
*Rembrandt and his Century, Dutch Drawings of the
Seventeenth Century from the Collection of Frits Lugt*, Institut
Néerlandais, Paris, New York (Pierpont Morgan
Library), Paris (Institut Néerlandais) 1977–1978;
catalogue by Carlos van Hasselt.
New York 1988
*Creative Copies, Interpretative Drawings from Michelangelo to
Picasso*, New York (The Drawing Center) 1988;
catalogue by Egbert Haverkamp-Begemann and
Carolyn Logan.
Paris 1974
Dessins flamands et hollandais du dix-septième, Paris (Institut
Néerlandais) 1974.
Paris, Antwerp, London and New York 1979–1980
*Rubens and Rembrandt in Their Century. Flemish and Dutch
Drawings of the Seventeenth Century from The Pierpont
Morgan Library*, Paris (Institut Néerlandais), Antwerp
(Koninklijk Museum voor Schone Kunsten), London
(The British Museum), New York (The Pierpont
Morgan Library) 1979–1980; catalogue by Felice
Stampfle.
Paris 1986
*De Rembrandt à Vermeer, Les peintres hollandais au
Mauritshuis de La Haye*, Paris (Grand Palais) 1986;
catalogue by Ben Broos.
Paris 1986–I
Rembrandt et son école, dessins du Musée du Louvre, Paris
(Musée du Louvre, Cabinet des dessins), 1988/89;
catalogue by M. de Bazelaire and E. Starcky.
Paris 1988–1989
Rembrandt et son école, dessins du Musée du Louvre, Paris
1988–1989; catalogue by Menehould de Bazelaire and
Emmanuel Starcky.
Rotterdam/Amsterdam 1956
Rembrandttentoonstelling tekeningen, Rotterdam (Museum
Boymans) and Amsterdam (Rijksprentenkabinet) 1956;
introduction by J.C. Ebbinge Wubben and I.Q. van
Regteren Altena; catalogue by
E.Haverkamp-Begemann.
Sacramento 1974
The Pre-Rembrandtists, Sacramento (E.B. Crocker Art
Gallery) 1974; introduction and catalogue by Astrid
Tümpel, essay by Christian Tümpel.
Stockholm 1965
Rembrandt, Stockholm (Nationalmuseum) 1965.
Washington 1973
Early Italian Engravings from the National Gallery of Art,
Washington (National Gallery of Art) 1973; catalogue
by J.A. Levenson, K. Oberhuber, J.L. Sheehan.
Washington, Denver and Fort Worth 1977
*Seventeenth Century Dutch Drawings from American
Collections*, Washington (National Gallery of Art),
Denver (The Denver Art Museum) and Fort Worth
(Kimbell Art Museum) 1977; catalogue by Franklin W.
Robinson.
Washington 1989
Frans Hals, Washington (National Gallery of Art),

London (Royal Academy of Arts), Haarlem (Frans Halsmuseum) 1989/90; catalogue by S. Slive. Washington 1990

Rembrandt's Landscapes. Drawings and Prints, Washington (National Gallery of Art) 1990; catalogue by Cynthia P. Schneider.

The exhibition in Amsterdam is supported by
The City of Amsterdam
Golden Tulip Barbizon Centre Hotel
Ministry of Welfare, Health and Cultural Affairs

KLM Royal Dutch Airlines is the official carrier of the Rijksmuseum, Amsterdam